GALEN ROWELL'S VISION

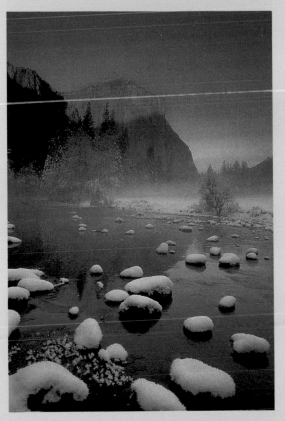

THE ART OF ADVENTURE
PHOTOGRAPHY

Galen Rowell's Vision
The Art of Adventure Photography

By Galen Rowell
A Mountain Light Press Book

Foreword by Steve Werner

PUBLISHED BY
SIERRA CLUB BOOKS
SAN FRANCISCO

The Sierra Club, founded in 1892 by John Muir, has devoted itself to the
study and protection of the earth's scenic and ecological resources—mountains, wetlands, woodlands,
wild shores and rivers, deserts and plains. The publishing program of the Sierra Club
offers books to the public as a nonprofit educational service in the hope that
they may enlarge the public's understanding of the Club's basic concerns. The point of view
expressed in each book, however, does not necessarily represent that of the Club. The
Sierra Club has some sixty chapters coast to coast, in Canada, Hawaii, and Alaska. For information
about how you may participate in its programs to preserve wilderness and the quality of life,
please address inquiries to Sierra Club, 730 Polk Street, San Francisco, CA 94109.

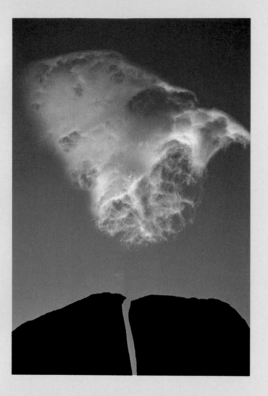

Library of Congress Cataloging-in-Publication Data
Rowell, Galen A.
Galen Rowell's vision : the art of adventure photography / Galen Rowell.
p. cm.
Includes index.
ISBN 0–87156–357–6
1. Travel photography. 2. Photography, Artistic. I. Title.
TR790.R7 1993
778.9'991—dc20 93–6892 CIP
10 9 8 7 6 5 4 3 2 1

Portions of the text were originally published in slightly altered form in
Outdoor Photographer magazine. *Galen Rowell's Vision* was created and produced by Mountain Light Press
in Albany, California, in association with Sierra Club Books.

Design by Jennifer Barry
Edited by Galen Rowell and David Sweet
Computer-generated layout by M. Violeta Díaz
Text composition by Marcia Roberson
Sierra Club Books production by Janet Vail
70mm duplicate transparencies by The New Lab

Printed in the United States of America. Text printed on acid-free paper containing
a minimum of 50% recovered waste paper, of which 10% of the fiber content is post-consumer waste;
color inserts printed on acid-free paper containing a minimum of 50% recovered waste paper,
of which 15% of the fiber content is post-consumer waste

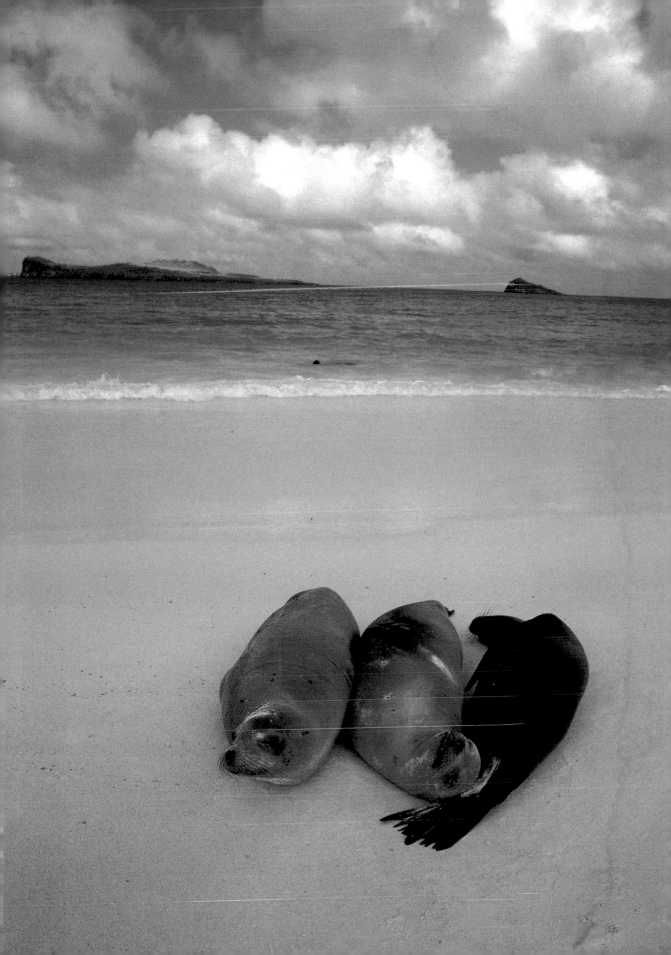

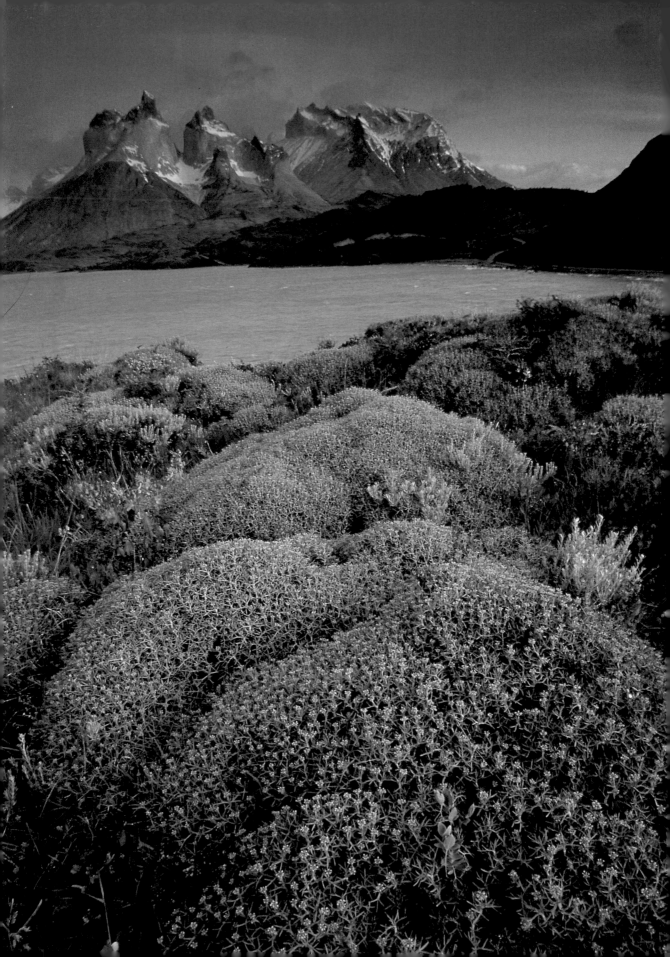

CONTENTS

Transforming dreams into realities through personal vision

Pushing the limits of equipment, film, and technique

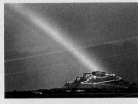

Merging visions with realities

Communicating your worldview through photography

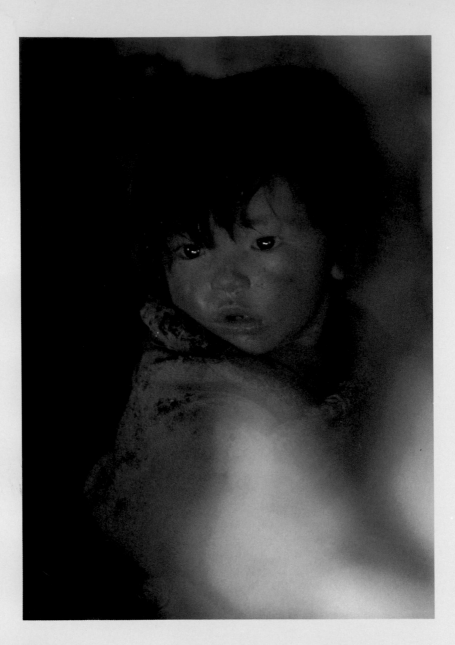

Photo page 1:
Winter sunset at Gates of the Valley, Yosemite, California.

Photo pages 2–3:
Essay pages 98–100
Photographing the Maine coast at Pemaquid Point.

Photo page 4:
Essay pages 35–36
The new science of chaos helps explain the visual power of this image of a cirrus cloud rising over a split rock in the Eastern Sierra that graced the cover of my 1986 book, Mountain Light: In Search of the Dynamic Landscape.

Photo page 5:
Essay pages 64–68
On an around-the-world shakedown with a Nikon F4 in 1988, I gained confidence in auto-exposure for the first time. Matrix metering gave me just the right automatic exposure in this tricky scene of dark sea lions surrounded by bright sand, surf, and clouds in the Galápagos Islands.

Photo page 6:
Essay pages 71–72, 82–83
I give Torres del Paine National Park in Chilean Patagonia the highest marks of any national park in the world for combined landscape and wildlife photography. I used a three-stop graduated neutral-density filter to open up the exposure in the shadowed foreground of this sunrise over Lago Pehoe.

Foreword

I suppose there was a time, before I became acquainted personally with Galen Rowell, when it could be said that he was an adventurer first and a photographer second. I was aware of his name through my preoccupation with noticing photo credits and bylines in magazines, books, travel brochures, and outdoor equipment catalogs. To my recollection, Galen's early credit lines most often accompanied pictures—though well crafted—that simply documented the rigors and the climax of a "first" ascent or record-breaking expedition. The photography was clearly the tool of the adventurer.

As Galen's credits and bylines continued to appear over the next twenty years, the impartial outsider could recognize the gradual supplanting of those pictures of record by more interpretive and sensitive images that tested the limits of film and proficiency: last-light alpenglow on a snow cornice; starlight over Mount Kailas; twilight behind a Serengeti acacia; catchlight in the eye of a Mongol herder; a rainbow above Tibet's Potala Palace.

Left: Essay pages 244–48
I caught the rapt expression of a Tibetan nomad boy staring through the flames of the family hearth by using a 10-second self-timer with an automatic exposure of about one second while I stood several feet from my camera on a tripod. I had been photographing the boy's mother, and I was able to get off only this one frame before he realized what had happened and became self-conscious before the camera.

By the time I launched *Outdoor Photographer* magazine in 1985, I had envisioned Galen as my prototype reader: a fairly even blend of outdoorsman and photographic artist. Although he wasn't truly representative of the layman, he was what a great many people wished they could be. Galen would disappear for months at a time into the mythical regions of the world, then return to mesmerize the "folks back home" with tales of his exploits and exquisite images of the sights he witnessed. For it was during the sixties and seventies that this photojournalist became a modern-day Edmund Hillary, Lowell Thomas, and Eliot Porter rolled into one, capable of not only accomplishing adventures and reporting them, but also translating his own achievements and experiences into visual icons.

As the archetypal photographer/adventurer, Galen was the subject of our first interview/portfolio feature in the premier issue of *Outdoor Photographer*. I recall Galen's wife, Barbara, commenting (with some indignance) that publishers often used Galen's work and took advantage of his reputation in their first issues, then dropped the relationship thereafter. We never made this mistake. In addition to writing feature articles, Galen soon came on board as a regular to author his "Photo Adventure" column in each issue. Only in our hybrid outdoor-and-photography magazine and in the hands of Galen could such material—equal parts wanderlust and methodology—make sense. Ultimately, my hunch about Galen's fit with our audience was right on the money, for he is clearly our most popular columnist as verified by reader letters and reader surveys.

You can't be an editor of a magazine that features Galen as a columnist without becoming involved in occasional discussions of why Galen succeeds as he does. On a purely physical level, Galen simply outdistances most of his peers by sheer endurance and enterprise. He embodies the rare attributes of artist

and entrepreneur (though Barbara has had a very significant influence on energizing the latter). What he produces in quality, he multiplies in quantity with his unusual physical energy and mobility. Galen is not only capable of making an outstanding photograph and marketing it, but he is also in more places more of the time than most others. He'll leave you far behind on the trail, match road miles with a teamster, and compare air miles with any secretary of state. If that's not enough, Barbara is a pilot who has flown Galen from Alaska to Patagonia.

Galen was well placed and well timed to take advantage of the several major and minor revolutions that have unfolded almost simultaneously during the few decades of his career. First, of seemingly little consequence to photography was the development of super lightweight expedition gear and apparel that made it possible to be not only a self-contained traveler, but also a self-financed adventurer. Many of the leading companies working with down, nylon, and aluminum first set up shop in or around Galen's hometown of Berkeley. As a fellow climber and explorer, Galen became friends with many of the company founders, who asked him to try out their latest products and photograph them in use.

Of more direct significance was the introduction of the 35mm single-lens-reflex (SLR) camera. Early exploration had been recorded only with words and sketches and evidenced by souvenirs and plunder brought back home. Before the midtwentieth century, photography—if accomplished at all—was a cumbersome and therefore restricted endeavor. The 35mm SLR camera came into its own in the sixties with interchangeable lenses, battery-powered strobelights, and through-the-lens metering that enabled self-sufficient adventurers to carry both home and studio arsenal compactly on their back. Thus photographs—taken on rolls of thirty-six at a crack, each frame worth a thousand words—easily and eloquently related the adventure experience.

In today's tourist-besieged world, where travelers are encouraged to take only pictures and leave only footprints, the photograph is rapidly becoming the only memento an environmentally correct and culturally conscious adventurer *should* bring home.

This last statement leads us to the development that has had the greatest impact on Galen's professional success as a photographer: the growth of adventure travel and ecotourism.

Again, Galen was ideally situated. Nowhere was the movement more active than around San Francisco, the home of the Sierra Club. Admittedly, Galen was "country before country was cool," but the new wave of interest in wilderness travel and environmentalism broadened Galen's audience from his localized enclave of California climbers and armchair mountain adventurers to the wider public.

All environmental religions need their icons. Whales and seals symbolize Greenpeace. The original shrine of the Sierra Club was the High Sierra of California. From there, worship spread to the extreme high points of the world—the ranges of Alaska and Canada, the Andes, and ultimately the Himalaya—before it focused on the condition of the everyday environments we live in. Galen has turned these wild locales into both the subject and the title of his business, Mountain Light Photography.

Success in photography, like that in any other adventure, depends a great deal on luck (cooperative weather is one obvious manifestation). Being well prepared for luck's arrival is the other part of the equation. Galen has not only ridden the crest of all these developments and trends, but he has also made a few waves of his own. He has pursued his photography in the same way a climber pursues a peak: planning the logistics, overcoming the hardships, and conquering the unknown. He finds satisfaction in the disciplines, the sensations, and the subtleties.

Both photography and adventure are fueled by relentless challenge. The pair are symbiotic. Like partners in a good marriage, one leads where the other might not. One sees what the other might miss. When they travel together, the experience becomes exponential.

—*Steve Werner*

Preface

"Leave only footprints and take home only photographs" has become an ecological dictum for visitors to the earth's wild places. The phrase also implies that people who venture outdoors these days are quite likely to have a camera with them. Outdoor photography has become more popular than any of the more singular adventure activities with which it is often combined, such as hiking, biking, skiing, sailing, climbing, and even running.

My style of photography is adventure. The art of this adventure is highly participatory, but not necessarily in the physical sense of carrying a camera to the top of the highest mountain to get the best picture. Even if taken on the summit, passive snapshots made from the point of view of a spectator are rarely considered art. The art of adventure implies active visual exploration that is more mental than physical. The art becomes an adventure and vice versa. Where there is certainty, the adventure disappears.

Both conventional outdoor adventure and photography depend on outcomes that cannot be exactly foreseen. The most successful participants actively previsualize and strategize how to achieve creative results without altering the natural scene. Great photographs are not the chance result of a photographer being in the right place at the right time any more than the first ascent of a mountain is the chance result of a mountaineer being on its summit.

The reason outdoor photography has challenged and engaged me so intensely for a quarter of a century is that I clearly understand that it does not exactly replicate what I see and never can. My limitations are far more biological than technological. I know that the buck stops here, inside my own head. If I'm having a bad day, I take bad pictures. My camera almost never has a bad day. If my pictures didn't come out well last week, I remind myself that they were taken with the same device that has also produced fantastic pictures.

The sixty essays in this book explore the art of adventure photography from without and within. The outer journeys of adventure photography are depicted all around us in magazines, books, and travel ads. The inner journeys, however, remain largely untold. Calling attention to the medium itself with any description of how photographs are made is likely to distract readers away from the outer message the publication or advertiser wants to convey. The public is left with the impression that had they been there with the same kind of camera, they would have seen the same vision and made the same photograph. The opposite is closer to the truth. One reward of teaching or participating in photo workshops is seeing a group of capable people visit the same place at the same time and always produce uniquely different photographs, even when a miraculous natural event takes place before their eyes.

Only one of my ten previous large-format books of adventure looks inward to explore the creative process of photography. Published in 1986 by Sierra Club Books, *Mountain Light: In Search of the Dynamic Landscape* outsold my other titles. The text follows an autobiographical timeline of my personal learning process and the photo captions are essay-length explanations of the making of my favorite photographs.

This book takes a different approach. The text has been structured like an old-fashioned adventure narrative, while the photographs have been chosen to illustrate concepts rather than to exhibit my best work. We begin with goals and preparations before embarking on photo adventures in Alaska, Antarctica, Bhutan, Canada, the Galápagos Islands, Guatemala, Nepal, Pakistan, Patagonia, Siberia, and Tibet. After we return home, we find the adventure is far from over. Concluding essays describe realizations and decisions after the photographs have been made, such as how to get work published and how best to communicate our worldview through our photographs.

The text is based on a monthly column I have been writing for *Outdoor Photographer* magazine for the past six years. From the beginning, editor and publisher Steve Werner has encouraged me to tell the inner story behind the art of adventure photography in greater depth than any magazine has done before. His overall plan was to lean toward professional photographers who write from real experience and to avoid the standard fare of slick, secondary advice from professional writers that wears about as well in the field as a polyester suit in the Amazon or Antarctica.

I had the pleasure of turning the tables on Steve Werner by asking him to write a foreword on how our missions came together to produce the book you are now holding. I have rewritten and merged the original sixty articles into a text with a broader meaning than the sum of its parts. For those who lack the time to read the entire text, the story behind the photographs is told through extended captions with page references to pertinent text passages. Each essay also includes cross-indexed references to photographs that illustrate key points.

The elements of the art of adventure apply just as much to a walk through a city park as to photography of the most exotic places on earth. I didn't realize this when I started out. I have learned by experience that most of the power of photography comes from within us. When I connect emotionally with the world around me in my home city and state, I often get photographs that equal my best efforts in the far corners of the world.

—*Galen Rowell*

PART ONE GOALS:

Transforming dreams into realities
through personal vision

In Search of Style

"We usually pass over a photograph devoid of emotional reaction to its subject and say, 'This doesn't do anything for me.' Of course it doesn't! The photographer didn't have his or her heart in it."

Every photographer has a definable style, but I spent at least a decade worrying that I didn't. If someone asked me what my artistic goals were, I would mumble platitudes about capturing my vision of the wilderness and pursuing light. I feared that my diverse work was adrift in an ocean of outdoor photography. The individual pieces had about as much chance of coming together as splinters from a shipwreck joining on their own to form a boat again.

I also had a disdain for externally directed photographic styles, which continues to this day. For example, I was deeply offended by work that called attention to itself by some artificial device (such as an introduced color filtration, weird lens, strange darkroom twist, or exaggerated grain) to stylistically link photos that otherwise lacked an internal message. I liked deceptively simple pictures that drew more attention to honest vision than to technique.

After my work began to be published I was surprised when people told me they could often identify it before they saw the credit line. At first I didn't believe them. I thought they were just flattering me. I gained some insight into how a style emerges when I saw the shoots of several well-known photographers being edited at *National Geographic*. I knew the hallmarks of their various styles, but in their raw film, as in mine, inconsistent work greatly outnumbered pictures with strong vision. Yet after the final edit, each photographer had created key images that unmistakably showed a unique way of seeing.

Ansel Adams wrote eloquently about the difference between external and internal photographic events. The most meaningful photographic styles are always reflections of the internal. We react not so much to what a photographer sees, but to how he or she sees and renders the subject for us. Personal style comes from within, from a photographer's unconscious and conscious choices. We usually pass over a photograph devoid of emotional reaction to its subject and say, "This doesn't do anything for me." Of course it doesn't! The photographer didn't have his or her heart in it.

Devoting personal energy to a photograph isn't enough unless that energy is internalized. An easy way to block the internal message is to be overly concerned about results. For example, knowing their top images will be critiqued in front of the group, workshop participants out for an afternoon shoot often wander around shooting nothing because they have created unrealistic expectations for themselves. Thinking they have to present a dazzling piece of fine art, they beat themselves up emotionally, become very self-conscious, and fail to produce the kind of images they could have made with a calm mind.

Professionals fall prey to this syndrome, too. Pros on a major assignment can easily allow externally directed cues to block the very style that caused the client to hire them. The syndrome is quite similar to writer's block. Writers too conscious of their audience may spend days trying to get out the beginning paragraphs of an article. But if they drop the external direction momentarily to write a letter describing the article to a friend, words would probably pour out effortlessly in a style that separates the meaningful from the mundane. Just like a good photograph.

One solution for a blocked-up photographer is to write an imaginary letter to an internal self: Wish you were here to see this. You wouldn't take the boring photo I'm considering right now because you'd respond by . . .

During a field workshop in a blizzard in a Wild West ghost town, one student, a doctor, said to me, "I can't make a photograph here. Everything's too depressing. I deal with death all day long, and when I look into the windows of these buildings, I see things that belonged to dead people. There's nothing positive going on here."

"Okay, those are your feelings and they're genuine," I told him. "Drop any external ideas about making some upbeat artistic shot and tune into what you just described. Make those feelings come across in your photographs."

The doctor, whose earlier work had not been impressive, produced the best photos of the day. They symbolically communicated his melancholy feelings in that old town. No one else in the workshop made images as good as the doctor's, but even if someone had, his or her style would not have been the same.

People avoid developing a personal style by emotionally distancing themselves from their work. Some engineers and scientists seem especially proficient at this when they pick up a camera. They make images filled with information instead of emotion, because to put something of themselves into their work is contrary to their academic training. However, some sort of personal stamp does sneak through, even in the most banal photography. The balance of foregrounds to backgrounds and the choice of subject matter are among the subtle clues that the images were made by a thoughtful human being rather than by a monkey or some machine.

The central process of art is not to render something exactly as it appears, but to simplify it so that meaning, clarity, emotional response, and a sense of order combine to create a style from within. Each photographer has the potential to select out powerful personal visions that other people may find beautiful. Ordered natural forms strike universal chords within us that, as photography critic Robert Adams describes, lessen "our worst fear, the suspicion that life may be chaos and that therefore our suffering is without meaning."

Like poetry, fine photography communicates by metaphor. We often think that a photograph represents reality, yet by that very phrase "represents reality" we admit that the clearest two-dimensional calendar image on paper is less a direct copy of a reality than a metaphorical symbol of it.

Most people find lines from Shakespeare more inspiring than lines from the owner's manual of their camera. The former have become art through fulfillment of the metaphorical potential of their medium. The latter, by their attempt only to be precise, are forever doomed to be judged by how closely they approach a reality they can never truly match. Because photographs are by their very nature imprecise, the possibilities for stylistic interpretation are nearly infinite.

Photographs: Pages 41, 77,
110–11

*"Just being in a different part
of the world isn't enough.
Internal perceptions over
which the artist has a great
degree of personal control
guide the finished image far
more than does the exotic
nature of the subject matter."*

Travel and Enlightenment

One of the unspoken motivations for world travel has always been ego gratification. Society regards the returning traveler as a cut above the crowd, someone who has gained an extra measure of wisdom, purpose, and insight into the meaning of life. How this process of enlightenment works has never been quite clear to me, yet travelers frequently return with solutions to old problems, changes in life-style, and fresh goals. Even our use of language reinforces the image: We say the traveler is "worldly" while people who stay at home are "provincial."

But underneath this notion of the enlightened traveler lies a faulty assumption. It is widely believed that mountaineers who reach great summits have noble thoughts right there on top. I began to suspect something was wrong because my thoughts on mountaintops were usually limited to taking some pictures, checking my watch, and worrying about how to get down.

A British friend who had climbed a new route up Mount Everest was pressed by reporters to relate the noble thoughts that had come to him on the summit. He said that he hadn't had any because the air had been too thin to think clearly. He thought his most powerful revelations had happened in a bar long after the climb was over.

As I write these words, I recall a trip my wife, Barbara, and I planned to Patagonia at the tip of South America. A couple of years ago, a major travel magazine had given me an assignment to photograph the wild mountain landscape there. Barbara and I got our visas, shots, air tickets, hotel reservations, maps, and film. We packed our bags and also prepared for the journey in many other ways. We organized our home

so that a friend could house-sit. We caught up on personal correspondence, business projects, and generally put our lives in order. We considered the possibility that something might happen to us or our loved ones at home and made special arrangements.

Then came the phone call, just two days before Barbara and I were to leave. An editor at the top had changed his mind and canceled the assignment. Although I was to be paid exactly the same fee to publish my existing stock photos from a previous Patagonian coverage, I felt a sense of loss as soon as I hung up the phone. An adventure had just fizzled, and with it, I presumed, all those clear revelations that make foreign travel so good for the spirit.

For the first few days, Barbara and I felt shocked and displaced. Then a strange clarity emerged. Because our organizing had freed us from our normal daily routine, we began to notice things about our hometown that we hadn't seen before. I have a vivid memory of running down a Berkeley street I'd been on thousands of times as the architecture of homes that I'd previously taken for granted jumped into my perception, as if some external voice were telling me what to look for. Both Barbara and I talked about taking more photographs around Berkeley and possibly even doing a book someday. We seemed unusually open to new ideas and experiences. In the comfort of home, we began having the kind of legendary "noble thoughts" you are supposed to have atop Mount Everest or in the other far reaches of the world. We had stumbled onto the idea that much of the source of enlightenment through exotic travel is not the travel itself so much as the pretravel discipline of getting one's life in order.

The same phenomenon has long been understood by Tibetan Buddhists. When I interviewed the Dalai Lama for our joint book, *My Tibet*, I commented on the similarity between a Tibetan pilgrimage around a holy mountain and a wilderness trek on which we in the West often go. (Both are undertaken for spiritual reward and rejuvenation, without material gain or desire to change the land.) He furrowed his brow and said, "Some people are so highly developed spiritually that they can gain full enlightenment by staying at home, even if they live in an unholy place. A pilgrimage is not important for them, because they are already on the path to spiritual rewards without leaving their normal lives to seek out some sacred place. Pilgrimages are of more benefit for ordinary people who find it difficult to gain the proper spiritual outlook in daily life."

I may never be enlightened enough to stop traveling, but I find it comforting to know that the insights I have gained over the years have really come from within myself and are accessible to everyone. Fine photography evolves from a similar mental state. Just being in a different part of the world isn't enough. Internal perceptions over which the artist has a great degree of personal control guide the finished image far more than does the exotic nature of the subject matter.

"Secondary visualizations of others guide our thoughts. Unless we have real memories of living through it, the Great Depression is likely to be Dorothea Lange's vision of a migrant mother and child."

The Photographer as a Visionary

If asked on a true-false quiz whether the outcome of a photograph can be altered by an image held in the mind, most photographers would mark *false* without hesitation. Yet the greatest photographers of the natural world have been visionaries who either consciously or unconsciously used mental imagery to influence their results. The existence of pictures in the mind is difficult enough to prove without having to consider whether they affect images recorded by a camera wholly outside the photographer's body.

"That's just your imagination" is a common put-down we have heard since childhood from well-meaning parents, teachers, and friends who deny the validity of the mental images we try to describe in words. Yet the pictures in our minds are no more imaginary than other aspects of human consciousness we all acknowledge as real, such as love and creativity. We have the choice of holding them in and letting them come to naught or using them as we pursue images of the real world. When I have only a hazy mental image of the kind of photograph I want to make, I wander around and rarely do as well as when I have a crystalline image that guides me to specific light and form that I already see in my mind's eye in much the same way as it will be recorded in the different language of film for others to see.

I am no more capable of using my real visual perception to see like film than to see through solid objects like Superman. Yet with a camera in my hand, I can play Superman by imagining light and form that is not before my eyes and figuring out where and how to record that vision on film. Like Superman, I don't just happen to appear at the right place at the right time.

Both mental and photographic images normally depict absent things that are not really before us at the moment. On the flat paper pages of books and magazines we see grand visions of the rocks, water, plants, and wildlife that make our planet unique. These are examples of artificial visual input that we associate with real phenomena. Our ability to experience apparent reality through photography is physiologically related to our even more remarkable ability to create a mental image from memory or exercise of our imagination with no similar input whatsoever. As children we count apples better than numbers because we can visualize apples more clearly than imaginary numbers. We create mental pictures of absent visions to help us guide our futures. Our direct vision is quite unremarkable in its acuity or detection of motion compared to that of an eagle or a bighorn sheep, yet these creatures cannot look at pages in a book and see representations of nature as we do.

Imagination has been called the act of imaging things we cannot see and moving them around into new configurations. Although we can consciously limit imagination to words or numbers, creative imagery is predominantly visual. Great writers work from mental images to create word pictures that in turn become images in the reader's mind. Multiple visual worlds apart from what our eyes see empower virtually every form of artistic expression. Images of absent things dominate our everyday memory, dreams, and fantasies as well as more unusual visions brought on by illness, extreme fatigue, sensory deprivation, drugs, seizure, or the guided states of hypnotism and certain religious disciplines.

Society's dim view of visionary behavior is clearly expressed in this current definition from *Webster's New Lexicon Dictionary:* "Someone who imagines how things should be and pays little regard to how they actually are or are likely in fact to be." The people we label as visionaries are not at all unique in their ability to visualize. All of us experience absent visions, but we would never think of sharing our wildest imagery with anyone except our therapist for fear of being labeled weird, crazy, or worse yet, a visionary.

Among the flaky characters of history who didn't hide their visionary experiences are folks like Van Gogh

and Einstein. It's quite obvious Van Gogh didn't paint what he actually saw, but his description of visionary seeing could just as easily have been uttered by a great nature photographer: "A terrible lucidity at moments when nature is so beautiful...pictures come to me as in a dream."

While still a teenager, Einstein began to envision himself sitting astride a beam of light. As he visualized how the appearance of things not moving at the speed of light would change, he "saw" the basis for his theory of relativity. Thus a fanciful vision in one person's mind's eye forever changed our perception of energy, mass, space, and time. Yet Einstein's imaginary ride on a beam of light was far from original. In an ancient Greek legend, Icarus tried to ride a light beam but fell out of the sky when the sun's heat melted the wax that held on his wings. In a Tibetan legend, Milarepa proved the superiority of Buddhism over the older faith of Bon by riding the first sunbeam of dawn to the center of the universe, the summit of Mount Kailas. My favorite photograph of this same mountain (page 43) came after I held a mental image of it as the center of the universe. I made a time exposure of the moonlit snow peak pointing into a great arc of star streaks leading into the heavens.

Our ancestors were far more attuned to the processes of the visionary wilderness than we are today, but there are still shamans among us who know how to escape the limited world of sight that Plato once called a prison house. Instead of someone else's wild imagery scratched on a rock or described in a trance, our generation favors equally strong symbolic visions captured on film by the chosen ones who see most deeply. The internal structure of our society has remained much the same as it did in prehistoric times, despite drastic changes in appearance. In spite of our best intentions, we have not risen above the basic condition of expressing our being through symbolic visions of absent things. To do so would be to lose our appreciation of art, metaphor, and perhaps even humor, which so often depends upon the imaginary meeting of dissimilar mental images. I've concluded that today's visionary photographs of earth and humanity are presented to us in at least as ritualized a fashion as prehistoric imagery.

Secondary visualizations of others guide our thoughts. Unless we have real memories of living through it, the Great Depression is likely to be Dorothea Lange's vision of a migrant mother and child.

The Vietnam War is Eddie Adams's frozen moment of a pistol held to a wincing man's head during a roadside execution. Even when we visualize our planet, we are more apt to bring forth a mental image of a photograph taken from outer space than any visual perception we might have from living on it every day of our lives.

Great photography of the natural world is a window into the way certain human minds have ordered the universe. These images never show us what we ourselves would normally see if we stood where the image was made (although viewers of a photograph have precisely this illusion). When we don't like a photographer's sense of order, we don't like the photograph. But we rarely say this. Instead, we reject the scene itself as holding a reality not worthy of our contemplation, as if we had stopped peering out a tour bus window to return to the novel in our lap because its word imagery engages us more actively than the visual imagery of the real landscape we are passing through.

Our connection to reality is inescapably interpretive, regardless of whether we believe we are perceiving it directly through our senses, recognizing it in a photograph, reading about it, or reflecting on what we think is an undeniable record in our memory. Photography is the source of the absent visions we constantly "see" in travel magazines, mail-order catalogs, and newspapers. Without being there we "see" a constant barrage of exotic places, products, and personal tragedies in a way that our ancestors never experienced, but this apparent enlightenment has a downside. In many ways our sensory perception is now being exploited. Sophisticated pattern recognition developed between our eyes and brains over hundreds of millions of years warns us of sudden, life-threatening events. False alarms are set off in our visual cortex each time we walk a city street beneath flashy signs or watch a TV commercial in the security of our own home. We have become conditioned to cry wolf not only at flashy ads, but also at hunger, tragedy, and homelessness.

No wonder average scenes of the natural environment in which we evolved do so little for us when we see them in the secondary medium of photographs. Our jaded brains are now geared to respond only to heightened symbolism, either genuinely discovered by visionary methods or falsified by manipulating image content. I am devoting my life to the visionary path because, among other things, it has a far longer track record of success in human history.

"Wouldn't there be greater survival value in having perfect vision at birth? Recent experiments suggest that neural connections are more plastic in early years to allow visual response to be fine-tuned to each person's particular set of environmental conditions."

Seeing Through the Eyes of Science

Most of us who aspire to take fine photographs put more effort into keeping up-to-date on the latest technical innovations than into learning how to see. Before auto-exposure and auto-focus, Henri Cartier-Bresson captured decisive moments. Before Fuji Velvia, Ernst Haas found a world full of saturated color.

Seeing with heightened awareness is the common denominator of all good photography, but there is no clear-cut method of teaching people how to see. I took the title for one of my earlier books from the first five of these words uttered by an old Sherpa around a camp fire below Mount Everest: "Many people come, looking, looking, taking picture . . . No good . . . Some people come, *see*. Good!"

We all know that photographs that look without seeing have little meaning, and that those that truly see visually "excite" us (page 44). But few of us have sought scientific answers to the question of how we see. One who has is neurobiologist David H. Hubel, a 1981 Nobel Prize winner for research into human vision and author of *Eye, Brain, and Vision*, published in 1988 by Scientific American Press.

Most of us had a well-meaning parent or teacher tell us that our eye resembles a camera. Light comes through a lens, is controlled by a variable aperture called an iris, and records itself on a film-equivalent called a retina. But here the similarity ends. According to Hubel, we should compare our eye to an incredibly automated TV camera that feeds digitized information "into a computer with parallel processing capabilities so advanced that engineers are only just starting to consider similar strategies for hardware they design. The gigantic job of taking the light that falls on the two retinas and translating it into a meaningful visual scene is often curiously ignored, as though all we needed in order to see was an image of the external world perfectly focused on the retina." To

see, rather than to merely look, allows us "to extract information that is biologically useful to us."

Similarly, technically perfect photographs fail without the photographer's personal vision to make them exciting. I began reading Hubel's book in search of new ways to align my photography with my eyesight. I knew I was on the right track when he said that technical data about the nuts and bolts of a subject doesn't lead to comprehension any more than "knowledge of the chemistry of ink equip[s] us to understand a Shakespeare play."

Thus our brains serve not only as a supercomputer, but also as a control center for "an organism that reacts to outside events and that influences the outside world by its actions." In a parallel way, fine photography supersedes technical record-keeping to become selectively reactive and particular about visual communication.

Our visual pathways are not hard-wired into our heads. They follow a series of seemingly open circuits that connect only when chemical and electrical conditions allow impulses to fire across synaptic gaps. In an almost infinite number of ways, the system can process the visual information that is delivered to your retina when your lover's lips have just parted into a smile. The particular synapses that fire have to do with your present mood, your inherited behavior, your learned behavior, and your visual environment as a child.

We all know that babies don't process visual information well until they have considerable experience in the outside world. Why? Wouldn't there be greater survival value in having perfect vision at birth? Recent experiments suggest that neural connections are more plastic in early years to allow visual response to be fine-tuned to each person's particular set of environmental conditions.

Hubel played it safe in 1988 by saying that we lack the evidence on why the visual cortex can be modified early in life. He does provide an intriguing example of

how an adult cat with one eye patched for months regained normal vision immediately, but a kitten with an eye patched at birth became permanently blind in that eye after the patch was removed. In the kitten's blind eye, neurons appeared to be firing normally at the retina, but the information wasn't being processed into visual perception.

Further experiments with translucent patches showed that form deprivation, rather than light deprivation, caused "observable, physiological and morphological changes in the nervous system without actual physical intervention." In other words, without severing the optic nerve the passage of visual information from the eye to the brain was irrevocably destroyed by not looking at forms during a critical period of development. It is hard not to avoid a comparison with the central nervous system here. As surely as a broken neck stops the flow of nerve information from reaching the lower body, the transmission of nerve impulses related to vision was prevented by the nontraumatic process of not focusing on objects outside the body.

Cells in the eye respond to different kinds of information about form. Some cells help us construct colors; others allow us to see only black-and-white in dim light. Some cells are biased toward vertical edges; others toward horizontal or diagonal edges. Natural selection to link up certain types of cells in the eye either before or after birth may have far-reaching ramifications. For example, a creature that looked hard at vertical lines of high contrast during its formative years may better perceive a zebra standing in a distant acacia thicket than a creature that focused more on horizontal lines.

Early-life linkups in the visual system may help explain how a native porter in the Himalaya suddenly exclaimed, "Bara Sahib and Memsahib" ("leader man and wife"), as he gazed in the distance at two approaching figures with his naked eyes. With 10X Leitz binoculars, I saw only two dots on a glacier miles away. We had camped together for a week, and he had no more information than I did about who might be coming from base camp. An hour later, our expedition leader and his wife arrived.

I read Hubel's book with, if you'll pardon the metaphor, an eye for how visual research relates to making photographs that please other people's eyes. Hubel concludes with some much broader implications. Was Freud right in a way he never imagined when he attributed neuroses to early childhood behavior? If so, psychotherapists may be discouraged to learn that some early events, like the kitten's eye patch, may produce permanent changes in the physical brain that determine behavior. Consciously purging thoughts and beliefs to achieve "wellness" may be impossible in these situations. I wonder how much of the seeing ability of our greatest photographers was hard-wired into their heads before they ever picked up a camera.

The positive side of all this is a plausible explanation for why each person has a uniquely different capacity for such things as art, music, and athletics. Hubel leaves us on the brink of a major shift in perception about what it means to be human. Galileo liberated us from believing that the earth was the center of the universe. Darwin taught us that creation is an ongoing process called evolution, rather than a fixed event in the past. According to Hubel, "If mind and soul are to neurobiology what sky and heaven are to astronomy and The Creation is to biology, then a third revolution in thought may be in the offing." As vision research unlocks the door to how mind and soul work, photographers who tune in to each new discovery about perception have a head start on how future generations will "see" the world.

*"Many of our photographs
fail to 'come out' because,
when we look at them, we
are dealing with innate
responses to visual material
that are quite unlike what
our perceptual system
evolved over millions of
years to perceive."*

If the Truth Be Told

We who photograph the natural world are inescapably drawn into a double bind. A telltale clue: Despite our noble intentions to show wild places as they are, our photographs almost never show the world objectively. We're very choosy about our subjects. The random clutter of a typical scene may be pleasant to walk through on a warm summer evening, but we can't communicate the same feeling in a random photograph of that place. We find ourselves searching out the exceptional to reveal the norm of our personal experiences (pages 50, 154, 164, 258–59). The role of impartial observer simply doesn't translate into great nature photography.

Our favorite photographs communicate a rare sense of order out of the usual chaotic jumble of visual forms. In the real world we love to discover this sense of order on our own, but in a photograph we are easily put off if we have to search for it. As with fast food, we expect instant delivery. If we don't get it, we cancel our order with a spoken or unspoken "That doesn't do anything for me," even though the same scene might enthrall us in person.

In a primary way, the natural world remains alien to us. No matter how connected to it or comfortable in it we believe we are, the disparity between our warm, breathing, loving, caring selves and the reality of a world that is beyond our understanding sets up a tremendous double bind. The objective, uncaring world terrifies us in different ways. Throughout history, we have sought to hide our primal terror of the earth's wildness through mysticism, religion, pursuit of objective knowledge apart from emotions, conspicuous consumption, altered mental states, just plain denial, and, more recently, outdoor photography.

For the brief one hundred and fifty years that photography has been around, the gulf between images and reality has been explained away as the result of the audience not being there with the photographer to touch the earth, smell the flowers, and breath the air. But the truth is more profound. Photographs are illusions of absent scenes. When we look at an image on a piece of paper or a sheet of film, we see a representation of something that is really somewhere else. We all accept this and take it for granted. What we have far more trouble accepting is that even at the original scene our sensory perceptions aren't reality either. We don't directly experience all those sights and smells even when we are physically present at the "real" scene.

Although the senses of a young and healthy person usually deliver more complete "pictures" of the world than do photographs, both are personal, interpretive, secondary renditions of the world we live in. We have all had the experience of being around people who were not turned on by a scene that moved us deeply. And we have all photographed scenes that moved us deeply, only to find that our results utterly failed to convey what we thought we saw there. Many of our photographs fail to "come out" because, when we look at them, we are dealing with innate responses to visual material that are quite unlike what our sensory system evolved over millions of years to perceive. Colors, edges, dimensions, and reflectance all differ radically from those of the original subject. It is indeed remarkable that we are able to perceive as much as we do from any kind of flat art.

Our photographs succeed not when we like them, but when they evoke the strong emotional response in others that we intended. If you doubt this statement is true because your best images accidentally convey a more powerful message than you intended, consider your success as evidence not of a spontaneous creation of great art, but of the lack of consistent control of your chosen medium. To be a top professional photographer, or even a run-of-the-mill free-lancer who isn't starving or a closet trust-funder, you must learn to consistently control your results.

Given a choice of two postcards depicting a natural wonder, tourists invariably choose the more dramatic over the more accurate representation of their own experience. What's going on here is not deceit. We never compare photographs directly with reality. We compare only our secondary perceptions. To make a cluster of colored dots on a 4-by-6 card evoke a perception that has anything of the power we feel standing before the Grand Canyon or Old Faithful requires turning up the voltage of the photo.

We judge photographs of nature far more by our emotional response to them than by the information they contain. If we accept this concept and pursue genuine situations in nature that show up as powerful photographic imagery, we are on the right track. Nature photography will maintain its voltage a thousand years from now, regardless of the medium used to create the mechanical image. If, however, we use tools like colored filters or digital manipulation to create something that wasn't there, we risk being caught, like a political candidate, with our deception hung out for public display. Once people discover that a Cokin sunset filter was used to turn gray clouds into a glorious sunset, they begin to doubt not only the individual image, but also the efforts of other photographers. Such deception has begun to happen with nature photography in recent years. Rich sunset colors, full moons, and subjects in too-perfect positions are becoming reasons for doubt rather than enjoyment.

In the wilderness, the use of shortcuts erodes the narrow path of access for future visitors. In photography of the wilderness, shortcuts erode the very path we depend on to lead viewers to our vision. We may get away clean with the first shortcuts, but the cumulative damage will eventually cut off our own use of the path, too. In the long run, we cannot help but limit the emotional response of our audience if we mislead them. As this happens, those of us who wish to evoke genuine emotional responses through symbolic imagery of real natural events must probe ever deeper into the wilderness of our experience, both physical and emotional. We must bring back ever more powerful imagery to satisfy a more jaded public.

The chief alternative to creating false emotional voltage with gimmicks is to tune into the differences between photography and visual perception and make them work for us rather than against us. A disappointing loss of shadow detail for one photographer can become a bold graphic element in a far more powerful image made by another photographer (page 118). It makes little difference what the foreground looks like when you actually peer into the Grand Canyon, but all the difference in a photograph that tries to deliver that same visual voltage without all the depth cues of direct perception.

Properly used, tools such as filters, films, and lenses allow us to deliver more visual power from subject matter than is really there. The reason outdoor photography has challenged and engaged me so intensely for a quarter of a century is that it does not exactly replicate what I see and never can. Only through understanding the differences between our camera's visions and our natural perceptions, either intuitively or empirically, can we hope to up the voltage of our results, year after year.

"Certain subjects and audiences are less mature than others. Unless photographers size up both subject and audience in advance, they are likely to end up with a potpourri of selects that have no clear style or continuity."

Image Maturity

Travel and adventure photography are relatively immature fields of endeavor. The kind of maturity I am talking about is not the state of mind of travel photographers, although I could make a strong case for their extended adolescence. It relates not only to a profession that requires no licenses or degrees, but also to a certain quality about a photograph that makes or breaks its sales potential.

The market for travel images operates something like a Turkish bazaar. Hard rules are few. Newcomers with raw talent can go out in the field for the first time with an inexpensive camera and bring back images of publishable quality. Those who have a strong belief in their own ability are likely to think that their work is much better than what is being published.

Selling those seemingly publishable images is another matter. Those newcomers may walk into an office and get a big spread in a national magazine on their first try, but the odds of striking it rich this way are less than if they had spent all their film dollars on lottery tickets. People who have seriously tried their hand at travel photography have repeatedly heard a comment like this: "Your work is beautiful, but it's not quite what we're looking for."

Such a comment is not just a polite, euphemistic rejection of photographic chaff. It has a ring of honesty and does not mean your work isn't fit for publication somewhere else. I have had top-selling images rejected this way many times. But I have come to understand why my favorite images of the most beautiful places in the world were judged unsuitable for a certain use or even for an entire publication.

The elusive concept I call "image maturity" is one of the most common failings of photography. Just as travel photography is a less mature profession than neurosurgery, certain subjects and audiences are less mature than others. Unless photographers size up both subject and audience in advance, they are likely to end up with a potpourri of selects that have no clear style

or continuity. They may sell one here and there, or put together a mediocre slide show that friends and family praise to the heavens, but the great satisfaction of having images speak clearly and consistently to a far larger audience will remain elusive.

"Immature" subjects (or normal subjects photographed for immature audiences) require bold, direct imagery of the sort we are likely to find in schoolbooks. "Mature" subjects (or normal subjects photographed for mature audiences) require more subtle, original imagery that suggests the presence of something without stating the obvious. For example, a deer is a mature subject for almost everyone. A picture of the entire animal just standing there doesn't do much for us, but an image of only the deer's ears and eyes poking out of the grass could be tantalizing. People recognize the subject as a deer, and their mind fills in the missing part of the animal. But change the animal to an extremely rare creature hardly ever photographed in the wild such as a snow leopard, and the response to an image of ears and eyes poking out of the grass is more likely to be, "What a pity you didn't get a shot of the whole animal!"

Another example is Sir Edmund Hillary's famous photograph of Tenzing standing atop Mount Everest on the first ascent. This was unquestionably an immature image because, in 1953, the audience that had never seen the top of Mount Everest or any other high Himalayan peak now saw a new hero raising his ice ax in triumph on the summit. Today that image and others like it have become clichés, especially in mountaineering circles. If a photographer returns from a Himalayan expedition with only static summit photos of a companion standing with an ax in the air, an adventure magazine with a "mature" audience is likely to pass them by for shots of a climber caught between a rock and a hard place lower down. The magazine might even favor a photo of someone who didn't make the top photo-

graphed by someone else who didn't make the top, either. The summit photographer might feel slighted, but the failure was his or hers in not taking image maturity into account.

One of the first Americans to reach the top of Mount Everest was Barry Bishop, who was not only a *National Geographic* staffer, but also a mountaineer. He told me how he hadn't trusted himself to take the proper summit photographs in the cold, thin air and excitement of the moment, so he had taped a shot list to his wrist before setting out on that final morning. As I recall it, he conceived of a mix of mature and immature photo opportunities. That was in 1963, only a decade after the first ascent.

Up until about fifteen years ago, trekking in the Everest region was a very immature subject for most audiences. At the time I sold an image of a Sherpa standing in front of Mount Everest (page 51) for an adventure travel advertisement. As the subject of trekking became better known, the photo ceased to be chosen for magazine or catalog use. However, another photograph from the same trek (page 51) continues to be published even now because it is a far more mature image. Instead of showing a trekker in the mountains, it suggests the idea of a trek by showing a yak, a Himalayan peak, and a trail lunch spread on the ground.

At first, editors considered this photo a bit too subtle to stand alone outside a magazine spread or in an advertisement pitched toward people who hadn't trekked before. But times have changed in both Nepal and the United States. That image is right on target now, while much of my earlier Nepal imagery is far too immature for current publication. I have been to Nepal eight times, and many friends seem puzzled why I keep returning after having "done" the country already. My approach is always fresh when I am looking for new ways to make images match the times that will in turn make an editor say, "This is just what we've been looking for."

Photographs: Pages 45–47,
133

Cocktails in Kathmandu

*"Barbara and I didn't get to
Nepal by waiting beside the
phone for someone to call
and say, 'How would you
like to go trekking around
Annapurna, take pictures,
and get paid for it?'"*

Cocktails in Kathmandu. Those who haven't visited Nepal may conjure up a vision of the bar scene from *Raiders of the Lost Ark* or Sherpas smiling around a camp fire in the snow beneath Mount Everest. Kathmandu isn't quite like that these days.

Modern Nepal has three religions: Hinduism, Buddhism, and Tourism. The party I was attending was neither Hindu nor Buddhist. I stood in the living room of a Western-style home with electric lights, a VCR, and a computer. Every conversation was in English. Each guest had a career that somehow tied in with the country's newest religion—Tourism. I spotted a doctor who runs a clinic, another who researches mountain medicine, an agent for river trips, and another for luxury treks. When a guest asked me what I was doing in Nepal this time, I said that Barbara and I had just documented the newly created Annapurna Conservation Area for the World Wildlife Fund.

"Oh, what fun!" the guest replied with a knowing wink. "Getting paid to go trekking again. You guys are so lucky!"

"Well, I wasn't really—," I started to reply.

"Come now, you've got it made. You go trekking and take pictures like the rest of us. The only thing different about you is that your pictures are so good you get paid to take them."

"I don't think in terms of just *taking* a picture of what I see; I work to create a vision that begins in my mind."

"But the point is you both take great pictures. I saw yours, too, Barbara, in the latest *National Geographic.* Don't get me wrong. I think it's great you guys are able to scam dream trips. If I could do what you do, I'd jump at the chance to get paid to take a holiday."

Our conversation trailed off without resolution. The guest power-shifted into empathy with one of the doctors over the stress of his emergency-room work in the United States, never giving him a break to explain that he was using this work to staff and fund a medical research project, his major focus in life.

That night I made a diary entry about a confirmed sighting of the world's least-endangered species, the cocktail-party animal, easily identifiable by its curious habit of displaying knowledge about other people's lives and motivations without ever listening to what they have to say.

Cocktails parties are caricatures of modern communication. The less said by those with firsthand knowledge, the more oversimplified things become, and the more reality gets distorted by gossip. The guest's impression of travel photography indeed rings true to all but the handful of people who really work hard to make a living at it and care deeply about the effect of their work on the future of the areas they photograph. Barbara and I didn't get to Nepal by waiting beside the phone for someone to call and say, "How would you like to go trekking around Annapurna, take pictures, and get paid for it?" Had I received such a call, I would have first asked the purpose of the story. If it is just another travel story to promote more tourism in the most trekked-in and trekked-out part of the Himalaya, I would not be interested.

The goal of my Annapurna coverage was to create environmental awareness rather than to promote adventure or travel. In 1977, I had been the 500th foreigner to sign in at the first police checkpost on the newly opened "Around Annapurna" trekking route. By 1987, over twenty-five thousand trekkers had visited the Annapurna region. I used my first photography of the region to illustrate my 1980 book, *Many People Come, Looking, Looking,* which took a hard look at the history and consequences of Himalayan adventure travel. After the book was published, the World Wildlife Fund USA (WWF) asked me to join its Committee for Conservation in Nepal, along with Robert McNamara and Henry Kissinger.

When World Wildlife Fund USA became the major force behind a new way to preserve the entire Annapurna area, I smelled a good story, but I couldn't land a major magazine assignment after the Nepalese firmly rejected the idea of calling it Annapurna National Park. Without those buzzwords "national park," American editors at *National Geographic* and *Outside* thought the story lacked sufficient general interest. In their minds a preserve or a conservation area was something less than a true national park, which is at the top of the American hierarchy of scenic wonders and wilderness protection. Lesser places are made national monuments, state parks, or nature preserves.

Dealing with editors is often as abrupt and frustrating an experience as chatter at a Kathmandu cocktail party. The modern public responds to sound bites, and editors have a clear rationale for cutting an idea short if a journalist can't phrase it into a compelling one-sentence tag line. They know all too well that today's general interest readers are those very same people whose short attention spans stand out at cocktail parties.

Despite the rejections of my proposals, I continued to see a strong story that focused on why Annapurna had not become a national park and why the conservation area proposal was more appropriate even though its inventory of scenic wonders far exceeded those of any American national park. The thirty thousand people within the proposed boundaries feared that they would become second-class citizens in their own homeland, and they have a good point. Imagine trying to create Yellowstone National Park today if Native Americans presently lived in villages in all the most scenic and habitable valleys, planting fields, hunting wildlife, and herding goats and cattle.

WWF had worked with the local people to devise a boldly innovative Annapurna Conservation Area to be administered not by armed and uniformed outsiders in the manner of U.S. parks, but by the villagers themselves assisted by WWF and the King Mahendra Trust for Nature Conservation. The objective was not to contrive wilderness out of land with a long human history, but to create an ongoing planning process of action, education, and enforcement that would best preserve the inherent values of the land and its full range of living things, including both indigenous people and foreign visitors. As a member of the WWF Committee for Conservation in Nepal, I thought the best contribution I could make would be use of my photography.

Barbara and I volunteered to produce a set of photos for WWF to document the initial condition of the land, the people, and a project that we believed would become a blueprint for future Third World preserves. Seeing a unique opportunity to precisely document a decade of change, I selected thirty key images from the photographs I had taken in the same region exactly ten years before. Then I made duplicate slides and took them into the field with me. My goal was to re-create the exact compositions and compare the old with the new.

I found one scene that appeared to be unchanged. But when I tried to line things up as I did in my prior photo, I couldn't get all of the village to show over a foreground ridge until I piled up twelve inches of rocks on the trail at just the right spot to stand on. I hadn't gotten that much shorter with age. Heavy use had eroded the trail.

Another dupe showed two women at a hearth in a lone house. At the same spot I found a whole new village. The villagers did not know the women in my photo and doubted it had been taken there. Then a woman with a baby came up, took the slide from my hand, and touched it with reverence to her forehead. As someone translated, she said, "It is my mother. She died five years ago. Her room is locked and empty. Come with me. I'll show you."

A third dupe depicted a virgin alpine meadow where I now found a weed patch caused by overgrazing. A fourth showed another alpine meadow (page 47) that was now dominated by a ramshackle teahouse and trekker's lodge (page 46). A fifth further completed the sequence of change by showing a medieval town of stone that was now a morass of power poles, hotels, and tea shops.

I was able to reshoot about two-thirds of my thirty photos, and besides those repeats, to make over six thousand new images in five weeks from which Barbara and I gave six hundred selects to WWF. We also donated our usual photographic fees and full rights for all future nonprofit conservation photography uses. We asked only for direct expenses and referral of payment if any of our images were published in the commercial media

Why would we give away five-figure shooting fees (computed by the normal day rate of any major magazine)? For one thing, we were following a long and fine tradition of outdoor photographers who create images at no fee expressly to save subject matter they love, cherish, and depend on for their livelihood. We were making an investment in the future, both the future of the area and, we hoped, our own future assignments in that area. We had no way of knowing at the time that *National Geographic* would change its mind after seeing our coverage and run it as a hard-hitting feature article two years later. We were ever so glad that we hadn't either given up or given in to the temptation to cover Annapurna with the standard Shangri-la icing for a travel feature. We also turned down a lucrative offer from a large art book publisher who wanted only a set of alluring Annapurna photos without the environmental message.

By rejecting the basic fare of the tourism industry, we put ourselves more in touch with Nepal's more venerable isms, Hinduism and Buddhism. They call it karma and we say what goes around, comes around. In photography as well as in every culture on earth, things have a habit of coming around more quickly when there is give instead of take. Out there in the field, images aren't just sitting around waiting to be "taken" in the way that cocktail party guests—even in Kathmandu—imagine. The best come about after great effort by photographers who first create visions in their minds, then work with what the world has to offer to turn them into honest realities.

*"What's at stake here is far
more than the credibility of
my work and some current
publications. The long–term
dignity and viability of nature
photography as art and a
source of information about
our planet is becoming as
endangered as a rare species."*

Reality, Vision, and Photographs

I began photography not knowing that film sees the world differently than my eyes. When I made a picture with tones and colors I didn't like, I assumed the error was mine. Like most human beings, I accepted whatever I saw with my own eyes as the true reality of things. I also accepted whatever I saw in photographs. I had no proof of the inherent truth of those images formed from a bunch of black or colored dots I saw on a magazine page, but I had no reason to doubt them, either. The unquestioned acceptance of photographic truths was the cultural norm of the era in which I grew up. During the forties and fifties, *Life* was life. Magazines and books showed me the world as it was. I have no memory of ever questioning the validity of an editorial photograph.

My first photo assistant, a Berkeley intellectual, had a particular fascination for working with original transparencies. He saw them as witnesses to the events depicted on their emulsions. Duplicates and reproductions were not the same for him. The film hadn't actually been there at the scene. Too often, he had seen the truth stretched from what was in those pristine chromes.

A decade ago, I had a rude awakening after I sold the rights for a fine-art poster of my photograph of a rainbow over the Potala Palace in Tibet (pages 264–65). I checked press proofs and was overjoyed with the quality of the reproduction. I was sure I had a best-seller on my hands. But when it was introduced to poster buyers at a national trade show, sales were mediocre. The words of one nonbuyer summed up the problem: "That's too obvious." His gut reaction to a photograph of an extraordinary natural event was to doubt its authenticity.

From naive beginnings, I have grown into something of a professional doubter myself. I don't necessarily like how it feels. As I am taking a picture or thumbing through a magazine, I am forever trying to

sort out what I think are acceptable differences in the way photographs see the world from those purposeful distortions of reality that are now weakening the credibility of the entire medium and darkening its future. To seek out hard boundaries between right and wrong is analogous to the uncertainty of what country you will wake up in if you live where a border war is being fought. I have grown to accept the fact that the borders between real vision and photographic vision can never be precisely defined, but that's very different from conceding that there are no boundaries. I have given up the battle on the commercial front, where photographers have come to be considered illustrators with limited accountability for content, but I am ready to fight for my beliefs about the need for more integrity across the board in editorial photography.

There is no single visual reality. One night I stepped outside an airport terminal to get a ride with someone I had never met. I looked in my briefcase for a yellow Post-it note showing the time and place of my ride, but I couldn't find it. Then I glanced above and saw sodium lamps. I searched again without the mind-set of looking for yellow and quickly found a neutral gray note with my ride instructions.

It was cold and I was early, so I stepped back inside the terminal. I pulled out a letter from a well-meaning but critical reader of my *Outdoor Photographer* column that I had saved for more careful review. I noticed that the Post-it was now yellow again under normal artificial lighting while the letter was clean white. On a whim, I stepped back outside and watched the letter turn yellow under the sodium lamps. Moments later, it faded to white, still under the same illumination. I recognized these changes as the result of my brain's attempt to construct the proper color balance in unnatural lighting conditions,

although the total grayness of the Post-it may have been due all or in part to a gap in the wavelengths emitted by the lamps. All of a sudden I realized I wasn't reading the letter. The unnatural lighting and colors had distracted me from its contents.

A similar thing had happened while I was reading *Time* magazine on the airplane. My mind had stumbled over accepting a spread of war photos as reality because I had questioned their strange, brown dullness. Was this what Iraq was always like? Had all the photos been taken in sandstorms? Had the images been purposely manipulated? Or was the effect an accidental artifact of hasty digital transmission? I don't know the answer, nor will I ever know the contents of those war images, unless I go look them up again with a different mind-set for the subject they depict rather than the separate nature of their strangeness as photographs.

While in my own little thought world of light and form and doubt, I read the letter from the critical reader of my *Outdoor Photographer* column. He took me to task for what he saw as my logically inconsistent photographic ethics. If I truly believed in never using strong filters and other technical gimmickry to manipulate an image of nature away from what my eyes perceive, he politely suggested, I should forever cease using polarizers, graduated neutral-density filters, and slow exposures to create a silky effect from moving water.

Our thinking, like the lights inside and outside the airport terminal, was wavelengths apart. Wrongly assuming that my goal is to make photographs that replicate visual reality, he wanted me to define precise rules I should obey. I readily accept the basic differences between human and photographic visions, but not contrived distortions. For example, my eyes see motion in running water and my camera doesn't. I can

choose either to simulate that motion with a slow exposure or to freeze it with a high shutter speed into a reality more detailed than what my eyes see. But I will never consider turning the water a false color with a filter to grab the eye of my audience or editor.

As I began jotting down notes about my airport experience with the Post-it, I recalled a relevant incident from another airport ride. After I had given a slide show in the Midwest, the woman driving me to the airport asked, "Does Tibet really look like your pictures?"

I said yes, summarized my photo philosophy, and asked why she had questioned my work.

"I used to work at the Smithsonian," she said. "A *National Geographic* photographer documented my department and the magazine ran a picture of our art restoration work. It had all sorts of rising vapors and strange colors, but that's not how it really looks. He set it up to make an interesting picture. Ever since, I haven't been able to look at that magazine the same way."

I assured her that *National Geographic* had the strictest standards of image manipulation of any magazine I had ever worked for. That tidbit only served to broaden the range of her doubt. If things she knew were altered there, what publication could she trust?

What's at stake here is far more than the credibility of my work and some current publications. The long-term dignity and viability of nature photography as art and a source of information about our planet is becoming as endangered as a rare species. Nothing intrinsic about a photograph gives it credibility. Nature photographs are credible only because for a brief one hundred and fifty years nature photographers, on the whole, have been credible.

The perceptual world of photographic images, like the natural world, is finite and fragile. Up to a point, our belief in images with minor discrepancies is as self-renewing as a healthy environment that heals its own problems without our putting out any extra effort. Beyond a certain level of carelessness and neglect, the existence of both the system and its parts as we know them become threatened. Abstracting oneself from concern about the degradation of photographic integrity by labeling it as merely a cultural perception doesn't work if you value how future generations will see the world we live in through our photography. The entire process of seeing and perceiving a photograph, both in the making and in the beholding, depends on cultural perceptions that have grown noticeably weaker during my lifetime. Imagine a hundred more years of evolution of the kind of thinking that stopped a poster buyer from marketing my Tibetan rainbow because he perceived this straight photograph as somehow phony.

Photographs: Pages 44–45,
54, 154, 161, 264–65

The Rhythms of Nature

*" Even though failures are
certain to outnumber
successes, the idea of
pursuing a dream image
in my imagination and
going out to find the place
where it actually happens
before my eyes is what
keeps my creative juices
flowing year after year."*

When I singled out nature photography as a career, I realized that it didn't fit all those neat little compartments contrived long ago by photography schools, clubs, and business analysts. Take, for example, the mountain sunrise I shot last week on a personal trip. Is the shot editorial, commercial, or fine art? The image might sell for one, all, or none of these uses. Equally dubious is the distinction between professional and amateur. What if the shot never sells? How about the image of the same peak or sunrise I made back when I was an amateur? If it sells now, does it undergo some mystical transformation into "professional" work?

The very sight of a beautiful nature image is enough to make most critics wince or flounder. How should the work be judged? Susan Sontag, one of the wisest critics, objectively described in her book *On Photography* how "the convention has arisen that photographic seeing is clearest in offbeat or trivial subject matter," but gave away her own bias when she added, "because we are indifferent to them, they best show up the ability of the camera to see."

I have considerably more faith in human visual perception. It takes conscious effort to deny the emotional power of fine nature imagery in favor of subjects "chosen because they are boring or banal," as Sontag says, citing Irving Penn's close-ups of cigarette butts that were exhibited at the Museum of Modern Art in New York. To judge photography by the expediency of banal subject matter makes a critic's task far easier. Ethical concerns about altering content become moot when the inherent power of the natural world is dismissed as too obvious.

I have long felt that landscape photography needs a structure to make its artistry better understood, not only by critics and the public, but also by photographers themselves. I have given a lot of thought about

how best to classify the most important creative, emotional, and ethical concerns of landscape photography into a simple scale.

Ethics always trail a few steps behind the social and scientific advances of an era, and to understand their place in photography we need to view them in a historical sense. The great conservationist Aldo Leopold used to relate the story about how the ancient Greek hero Odysseus returned from war and hanged a dozen of his slave girls on a single rope because he suspected them of misbehavior. No one questioned the propriety of the act because the girls belonged to him. Leopold concluded that "disposal of property was then, as now, a matter of expediency, not of right and wrong." He used the story to make a powerful case for a new land ethic based on respect for nature rather than just expediency. Thus the seeds were sown for land reforms, such as the Wilderness Act and environmental assessments.

Every new endeavor begins in an ethical vacuum. Heart transplants and genetic engineering, being life-and-death matters, are receiving prompt public attention, while nature photography, like slavery in ancient Greece, never receives hard enough scrutiny to truly separate the good from the bad, the right from the wrong, or the meaningful from the banal.

Photojournalists have devised an informal scale of ethics that rates images as *manipulated, contrived, controlled,* or *found.* This scale is of only limited use for landscape photographers because it ignores creative and emotional vision. Nevertheless, it is worth examining before going further.

Manipulated images that change editorial content without disclosure are taboo in responsible publications. *TV Guide* provoked national outrage by running a cover with Oprah Winfrey's head grafted onto Ann-Margret's half-clad, retoned body. Certain mass-market travel and photography publications cling to this bottom rung of the ladder by repeatedly foregoing

natural images in favor of double-exposed moons, color-grad sunsets, and much worse. The eye is drawn to artificial input rather than to true editorial content.

Manipulations are not intrinsically bad. Anything goes in the world of commercial illustration, but not in editorial work that implies representation of the world as it is. My basic rule for nature photography is never to purposely alter an image away from what either the eye or the film sees. Use of flash or a graduated neutral-density filter is acceptable to bring out details that the eye really sees, but not to create artificial colors for effect.

Contrived implies a manipulation of the setting rather than of the image itself. Disclosure can be all-important. When it was revealed that the prize-winning World War II image of soldiers raising the American flag over Iwo Jima was actually shot at a second flag raising well after the battle had ended, both the photographer and the soldiers lost face.

Controlled means an uncontrived change in an otherwise undisturbed setting. Had the photographer really been there when the soldiers first raised the flag and cried "Hold that pose!" the resulting image would have been universally accepted, for it indeed would have contained the true visual elements of the original flag raising.

The highest level, *found,* means that a scene is recorded exactly as it would have been at that moment without the presence of the camera. Here in one simple word is the basic starting point for all fine nature photography.

In a realm where all images are presumed to be found, internal events begin to take precedence over external ones. In other words, a photo that records an intimate, emotional connection with some element of nature rises a level above the most perfect spectator's image that impartially records external subject matter. Personal vision is what counts, and it succeeds only when it is communicated visually to the viewer.

My proposed four-level scale begins with *snapped* images (none in this book). Although auto-everything cameras allow images of high technical quality to be made without much forethought, I believe that not even one in a million snapshots of nature communicate a strong emotional response to their subject as well as a fine preconceived image.

The next level, *previsualized* (page 44, above), describes passively preconceived images. These are discovered with normal vision and then mentally translated into the language of film. Guided by some understanding of how film sees the world differently than the human eye, previsualization allows photographers to fine-tune and correct a scene that is already before them. This is as far as your camera's instruction manual takes you.

The third level, *preconceptualized* (page 44, below), applies to actively preconceived images. Here the content, composition, and exposure have been rethought based upon an active visualization of the finished photograph, rather than a passive one of what happens to be visible through the viewfinder at the time. The photographer might scout the scene and return when the light is different or seek a different foreground for the same landscape. This is your basic nature calendar level: dramatic, technically perfect, well composed, but only rarely inspired.

The highest level, *created* (pages 45, 54, 161, 264–65), applies only to images that were imagined as true visualizations of their finished appearance on film *before* they were seen in real life. They are revealed by a process of discovery that, to me, is by far the most satisfying aspect of nature photography. Even though failures are certain to outnumber successes, the idea of pursuing a dream image in my imagination and going out to find the place where it actually happens before my eyes is what keeps my creative juices flowing year after year.

Instead of altering or contriving a scene to fit human needs, this highest level of nature photography, like Leopold's land ethic, urges humans to adapt to conditions as they are and focuses on keeping in tune with the existing rhythms of the earth. Of course a snapshot can sometimes be more evocative than a created image that utilizes so much more of the conceptual power of the human mind. These exceptions to the general rule do not negate the four levels I propose any more than the presence of many tall and strong women negates the general rule that men are taller and stronger. We can argue for the power of a candid snapshot in a way that makes perfect sense, but when it comes down to it, the nature photographs we recognize as great were almost entirely conceived in level three or four rather than one or even two. We intuitively recognize when a photographer has presented us with a deep emotional connection to a landscape instead of merely snapping the shutter. Contemplating the four levels helps us understand the process necessary to communicate our inner visions.

Photographs: Pages 4, 44, 55, 107, 154, 161, 224, 269–70

" I can't wait to go out in the field and search for examples of chaos in clouds, trees, and turbulent waters to juxtapose against the more predictable and immutable patterns of nature."

Of Chaos and Composition

I am constantly on the lookout in seemingly unrelated fields for new ways to think about photography. The novel science called chaos began to shed light on classic problems of mathematics and physics during its ancient history about two decades ago. More recently chaos has affected virtually every hard science plus medicine, economics, and weather forecasting.

As I started reading James Gleick's 1987 book, *Chaos: Making a New Science*, I was intrigued, though I saw no direct connection with photography. The idea of visual enlightenment of complex numerical problems had never occurred to me. Before the computer age, scientists simply gave up when they couldn't solve a problem by conventional equations. Textbooks aimed math students toward problems that could be solved and simply ignored the apparent disorder of nonlinear phenomena that couldn't. More recently, however, scientists in unrelated fields all over the world have discovered hidden patterns behind millions of computer calculations they apply to apparently unsolvable problems. They found that a state called chaos often lurks behind a facade of order, and deep inside that chaos may be another, more mysterious type of order. Many previously unsolvable problems proved to have internal, cyclical patterns with upper and lower limits that are never exceeded.

The father of this new science was a meteorologist named Edward Lorenz who discovered what is now called the Butterfly Effect in 1961. His inadvertent rounding off of decimals in a computer program to model weather produced a drastically different pattern for the next week's weather. Gleick describes this effect as "the notion that a butterfly stirring in the air today in Peking can transform storm systems next month in New York." It accounts for why computer forecasting is speculative for more than a couple of days and next to worthless for more than a week. But Lorenz didn't stop here. He found that

the patterns were anything but random. They had limitations and form.

Computer graphics enable chaos to be observed as a visual pattern, rather than a set of numbers. Any long series of numbers is hard to observe in its entirety, but when plotted with computer graphics, strikingly similar patterns are being seen, as no generation before us has seen them—except in the natural world. Outside the realm of controlled experimentation, the same patterns of chaos have long been observable but unrecognized. We didn't have a name for them because we didn't know what we were looking at. Patterns of chaos blending order and disorder have always been around us in nature. We have seen them and intuitively appreciated them. We include them in our photographs for reasons that we can't clearly explain.

What is chaos and what is not? An expert physicist who can predict the moment a spacecraft will land on Mars is at a loss to predict the pattern that the smoke from his pipe will make as it wafts to the ceiling of his quiet office. Yet the patterns in the rising smoke are easily recognized by any visitor as something more than random, something to be expected in that particular situation. If that visitor were a photographer coming to make a portrait of the physicist, he or she might intuitively decide to include that patch of smoky chaos in some sort of juxtaposition with the man's features.

Author James Gleick ties the new science to aesthetics with the following quote from physicist Gert Eilenberger:

Why is it that the silhouette of a storm-bent leafless tree against an evening sky in winter is perceived as beautiful, but the corresponding silhouette of any multi-purpose university building is not, in spite of all efforts of the architect? The answer seems to me, even if somewhat speculative, to follow from the new

insights into dynamical systems. Our feeling for beauty is inspired by the harmonious arrangement of order and disorder as it occurs in natural objects—in clouds, trees, mountain ranges, or snow crystals. The shapes of all these are dynamical processes jelled into physical forms, and particular combinations of order and disorder are typical for them.

The random, chaotic curve of the storm-bent tree reads real to us, whereas the building's shape fails to "resonate with the way nature organizes itself or with the way human perception sees the world," as Gleick puts it.

He further explains how chaos mathematician Benoit Mandelbrot began to discover an internal order to fluctuations in many kinds of data while working for IBM. Mandelbrot also saw that irregular patterns of chaos in nature often retain a constancy over different scales and that he could model this effect on a computer, much as he had done with other kinds of data. Mandelbrot coined the name "fractals" for these invisible building blocks of the universe. At first, Mandelbrot was consider-ed something of a charlatan by other scientists, who refused to take his new way of looking at the world seriously. Now, science after science has begrudg-ingly accepted his findings. Gleick mentions how the characteristic irregularity of clouds "describable in terms of fractal dimension—changes not at all as they are observed on different scales. That is why air travelers lose all perspective on how far away a cloud is. Without help from cues such as haziness, a cloud twenty feet away can be indistinguishable from one two thousand feet away." Gleick concludes, "In terms of aesthetic values, the new mathematics of fractal geometry brought hard sciences in tune with the peculiarly modern feeling for untamed, uncivilized, undomesticated nature."

The new ways of thought I have gained from learning about chaos will not instantly make me a better photographer. I have always known that when I am out in the field with my camera, I am not making completely original creations. Instead, I am discover-ing existing natural forms, patterns, and relationships to please both myself and my photographic audience. Knowing about chaos helps me clarify my purpose and narrow the search.

After my first visit to the Himalaya in 1975, I wrote a book, *In the Throne Room of the Mountain Gods*. My editor marked the following quote for deletion:

> Life forms shaped by adversity in the rugged mountain environments seem to show recog-nizable brush strokes of the same grand artist. I saw a hidden sameness in the curl of an ibex horn, the twisting grain of a timberline juniper, the lines in an old Balti face, and the giant arcs in the path of a living glacier.

The editor wanted to cut the passage because it sounded too speculative and mystical. Readers might not trust my other, potentially more valid observa-tions. I fought successfully to leave the words in. I could state no firm rationale other than that I was expressing my valid feelings at the time.

Secretly, I suspected some sort of deeper truth, but I could not express it. Now, I would be able to quote Gleick about chaos, fractal geometry, and "forms in nature—not visible forms, but shapes imbedded in the fabric of motion—waiting to be revealed." I can't wait to go out in the field and search for examples of chaos in clouds, trees, and turbulent waters (pages 4, 44, and 55, respectively) to juxtapose against the more predictable and immutable patterns of nature. I also understand why many of my images I have called "dynamic landscapes" gain so much visual power from the inclusion of something that displays the seemingly random yet internally ordered patterns of chaos.

Circles from the Sky

"Natural circles seem to hold a special fascination for us. Our eyes are drawn to the full curl of the horns of an old wild ram, the perfect orb of the sun coming through haze or cloud, and the concentric ripples from fish jumping in a still pond."

Ever see a rainbow with no end? I did over the coast of Mexico as Barbara flew our small plane to Patagonia at the tip of South America. I scrambled for my 16mm lens and Barbara lifted the wing so I could get as much of the 360-degree rainbow (page 52) as possible. As with all other rainbows, the area within was more than one exposure stop lighter than the area without. Just outside this bright circle was a second full circle of a double rainbow, less vivid and harder to see without its own edge of changing light values.

I had been on the lookout for unusual optical phenomena, and the 360-degree double rainbow did not come as a total surprise. We had also seen one from our plane five years earlier in a rainstorm over British Columbia. Conditions for forming rainbows always follow the same basic rule. Arcs with a radius of 42 degrees around the antisolar point appear directly opposite the sun. From normal observation points a full circle is never visible because the ground interferes, but it can be seen from the air when a broad curtain of rain is sunlit. In this case, we were flying directly away from the sun with our eyes on the airport where we were going to land within minutes. I never would have seen the rainbow except by looking to the sides where I knew it should be after noticing the right conditions for its formation. Only by turning off course and lifting the wing were we able to see it in its entirety.

This was the first major light show of one of the greatest adventures of our lives. Barbara and I left California on November 30, 1990. She piloted our Cessna T206 in tandem with a similar airplane flown by our friend, Doug Tompkins. After going down the Pacific coast all the way to Patagonia, she headed back up the Atlantic coast of South America after we had partaken in several land adventures, including climbing, hiking, and river running. I stayed down with Doug to go climbing after Barbara had left to fly home.

Our first twelve days were spent en route to Santiago, Chile, landing in nine countries with miles of red tape. I never got bored. The view out the window when we flew as low as 75 feet over beaches or as high as 19,500 feet over the Andes was many orders of magnitude more interesting than what you see out the porthole of a commercial jet. Photographically, the difference is simply that between publishable and nonpublishable opportunities. Not only does everything have a bluish cast at the heights where commercial jets travel, but a photographer has considerably more trouble convincing the pilot to circle something, open the window, and change altitude for a better perspective.

One of the more unusual photographs of our journey came from going up for a better look instead of going down. In Ecuador we circled Cotopaxi, climbed, and flew just over the summit of the 19,348-foot volcano so that we could peer down into its periodically active crater (page 52). I opened our plane's special photo window, gave my camera an extra stop of exposure to compensate for the bright snow, and then bracketed half-stops each way as we passed over the top.

A couple of weeks later, I saw a full circle of colors that many people confuse with a rainbow. I was high up in the sky, but with my feet on the ground on the summit of a previously unclimbed peak in Patagonia. Doug was beside me. The much smaller 22-degree solar halo (page 53) is formed from refractions in ice crystals rather than raindrops. I found a position just below the summit where I could use my 24mm lens at a very low angle to include Doug's silhouette and the complete halo.

Later on, Doug and I were flying back from the island of Tierra del Fuego when yet another circle of colors appeared that was not a rainbow. This one (page 52) had the full range of prism colors with the shadow of our airplane dead in the center. I

immediately recognized the Specter of the Brocken, a phenomenon first described on a mountain by that name in Germany, where, under the right conditions, you can look from the top into a bank of clouds just below the summit as low-angle rays of sunlight come from behind. The specter is a vivid circular glory of colors formed in the small vapor droplets of cloud, rather than in the larger water droplets of rain that generate true rainbows with a much broader arc. Whereas the solar halo is seen around the sun, both the Specter of the Brocken and the rainbow occur opposite the sun. From a mountain, the specter is especially ominous because clouds offer no perspective of size and your shadow often appears huge. In the Middle Ages, religious significance was attached to sightings of giants dancing in the clouds, but today's common observer sees an airplane in the specter and is more likely to be concerned about frequent-flier miles.

After I returned home, I realized I had singled out four unusual, yet wholly natural, circular phenomena. Natural circles seem to hold a special fascination for us. Our eyes are drawn to the full curl of the horns of an old wild ram, the perfect orb of the sun coming through haze or cloud, and the concentric ripples from fish jumping in a still pond. Circles touch our soul differently than do straight lines or flat horizons. There are many perfect circles in nature, but virtually no perfect squares or rectangles except at the close-up level of crystals and cleavages of minerals.

When a photograph of nature works for me, I always try to analyze why, both before and after. What is it about the photograph that makes me or someone else respond? I am convinced that the best nature photographs always borrow their artistry from the earth itself. In other words, they depend on our clear selection of naturally occurring forms that we respond to positively.

The same principle holds true for photographs of people. The best images are those that capture the natural character of the subject's behavior rather than a gimmick or situation contrived by the photographer. When we have prior knowledge about the personality of a person in a photograph, the way he or she looks connects at a deeper, emotional level if it reflects some aspect of how we like to think about the person rather than a random moment of life. Similarly, when we know something intimate about a particular environment, selected forms speak to us with special eloquence. The task of an aerial nature photographer is to separate out recurring natural rhythms and patterns of the earth for all to see, whether they be part of the land or of the light and the sky.

*"All of us are guilty at one
time or another of working
a roadside scene with signs,
buildings, and power lines
just so, until it looks like
pristine wilderness. This
is acceptable so long as the
process stops here."*

In Quiet Desperation

Soon after I began outdoor photography, I joked that Ansel Adams had it easy. Whenever I tracked down the location of one of his great pristine images and veritably stood in his footprints, I found myself facing at least one of the following: power lines, jet contrails, smog, or graffiti. Now I am having the same experiences when I revisit the locations of my own favorite photographs. Out of eighty images published in 1986 in my book *Mountain Light*, I have already found sixteen whose situation has so physically changed that a similar photograph cannot be taken, even if lighting and atmospheric conditions somehow repeated themselves.

For example, the book's opening shot of a tree beneath the peak of Machapuchare in Nepal (page 45) was made in 1977 from the outskirts of the town of Pokhara. A decade later I found the simple scene cluttered with squatter's trash and some of the aesthetic tree limbs hacked off.

Closer to home, a stark scene of Badwater in Death Valley, the lowest point in the United States, now has a National Park Service "Don't" sign square in the middle of my old composition.

New power lines have ruined several other scenes. Among the most improbable is my 1975 image, *Porters at Concordia* (pages 48-49), which shows a line of people trekking through the inner sanctum of the Karakoram Himalaya a hundred miles from the nearest road. In 1989 I walked for ten days to the same spot only to find military phone wires (page 46). Pakistan's Siachen Glacier War with India was still being fought at the highest altitudes in history.

The message is clear. Humans are altering the natural world at an ever accelerating rate. It is becoming ever more difficult to photograph natural landscapes that are not obviously marred by human activity. But there is another side to the problem, an ethical dilemma for photographers.

All of us are guilty at one time or another of working a roadside scene with signs, buildings, and power lines just so, until it looks like pristine wilderness. This is acceptable so long as the process stops here. One example of this ethical dilemma came when an environmental organization discovered a power line in one of my transparencies selected for use in a calendar of wilderness scenes without human artifacts. They asked if I would consent to digital retouching to eliminate the wires. When I declined, they showed me an image printed in a previous calendar in which wires were removed. Unlike the photographer who had consented to this manipulation, I stood my ground and lost the sale.

I firmly believe that any photograph that purports to represent the natural world must not be manipulated away from its natural appearance or in a way that changes its basic information without clear disclosure in the caption. This rule allows for selective use of special photographic techniques to bring an image more in line with what the eye sees. For example, a polarizer separates clouds and colors much like our own visual perception. An 81A warming filter kills the midday blues just as our brain's automatic color balancing does for our eyes. Burning and dodging black-and-white prints or using graduated neutral-density filters with color slides can bring an image more in line with the broad tonal range that we normally see.

Whenever we change an image of the natural world away from our normal perception for effect by double exposures, extreme colors, or gimmick filters we chip away at the basic message of photography: evidence of the way something looked at a particular time and place. Photographs with manipulated content may satisfy a commercial client in the short run or a full month in a wilderness calendar, but they lose greater relevance as documents of time and

place. Each abuse figuratively removes a grain of sand from the great 150-year-old bastion of photographic integrity that continues to allow our brains to initially see a photograph as a representation of reality. The assumption of truth we make when we see a wilderness photo is more a cultural habit than an innate response to a two-dimensional image. If this philosophical conceit were to weaken, studio photographers could go on endlessly manipulating content to create commercial illustrations for ads, but we photographers of the outdoor world would begin to lose our audience. Our images would no longer have that instant credibility that people now accord to a bunch of colored dots on paper.

The changes I see in the natural scenes of many of my favorite images serve as both a warning of a rapidly deteriorating world environment and a more healthy natural progression that begins with photographic statements about persons or places and slowly evolves into icons of eras that have passed.

Photographs that endure most always take on a much broader meaning than the photographer's original intentions. A Civil War portrait is no longer just a picture of a particular person. It comes to represent a whole era. Following a similar progression, the visions of pristine wilderness that Ansel Adams made in this century are well on their way to becoming icons of an era now slipping into the past, when a man with a camera could stop by the side of the road, stand on the roof of his station wagon, and repeatedly produce stunning images of American landscapes that appeared totally wild.

Right:
Essay pages 16–17, 146–49
Alpenglow gets its name from a vivid glow frequently seen high in the Alps around sunrise and sunset. I traveled there to get this image on the Mont Blanc massif high in the French Alps, but I have photographed equally fine displays in my home mountains in California. I have learned that my internal perceptions are far more likely to lead me to great images than any guidebook to an exotic place.

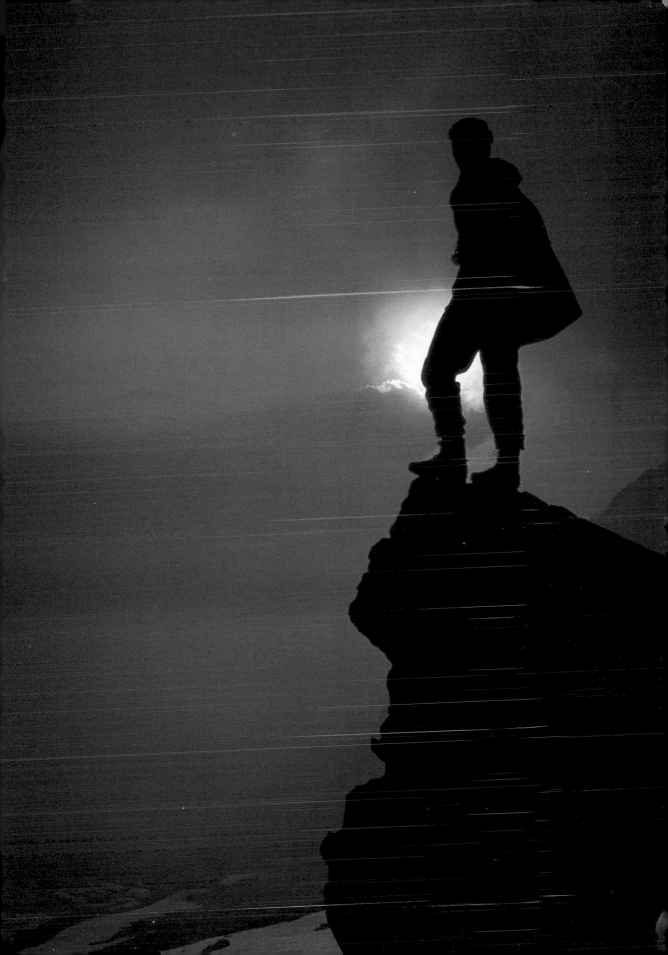

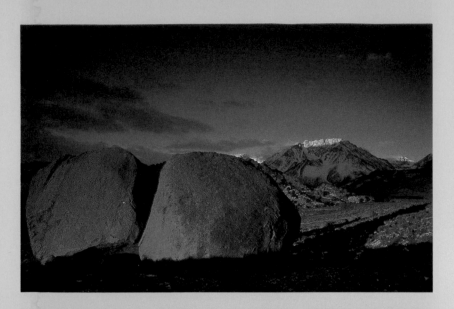

Left and below:
Essay pages 14–15
At a photo workshop in the Eastern Sierra, my wife, Barbara Cushman Rowell, isolated two rocks and a mountain peak at dawn (left). Meanwhile, I framed a different peak behind two other rocks (below), unaware of the picture she was taking out of my sight. Even with the similarities, differences in our personal styles are evident. Naturally, we each prefer our own image!

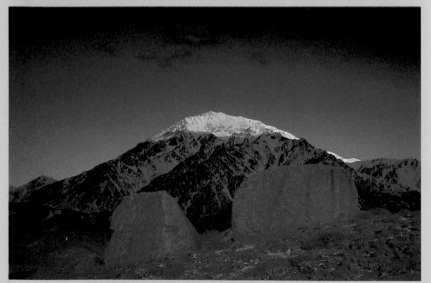

Right:
Essay pages 18–19, 128, 244–48
Mount Kailas in western Tibet is considered the center of the universe by Tibetan Buddhists and all Hindus. I never would have made this image without visualizing Kailas that way and imagining it beneath a great arc of stars streaking through the night sky. I used Kodachrome 25 and a 15-minute exposure through a 24mm lens.

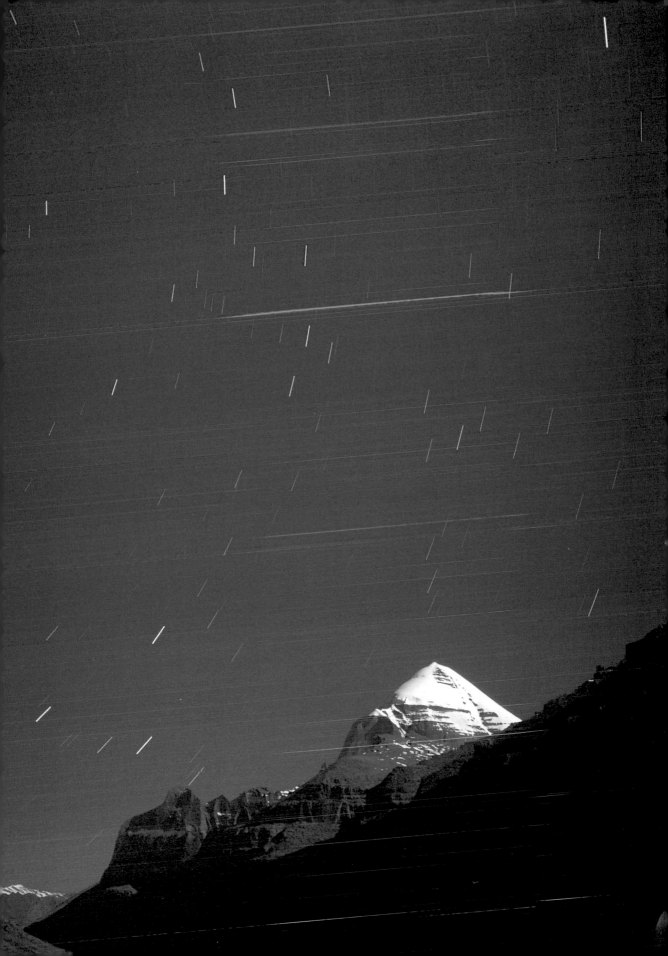

Left and below:
Essay pages 20–21
The image at left "looks" without "seeing" at a bristlecone pine with a wonderfully twisted limb. Even though I made a technically good photograph of the tree, my vision of the limb does not communicate well until I react to the scene (below) and figure out how to de-emphasize the trunk of the tree, yet show the limb attached to the earth in an open forest.

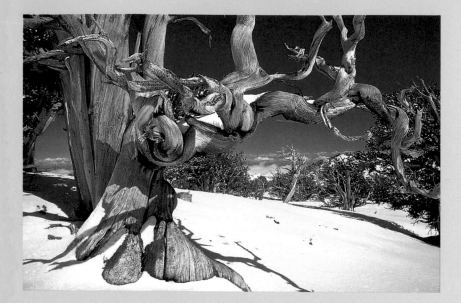

Right: Essay pages 26–28
I made this photograph of Machapuchare at dawn in the Annapurna Range of Nepal by scouting a location the previous day where I could catch the peak in warm light with another singular form below it in blue shadow. I waited until just before the sun hit the top of the tree to take this image in 1977. When I revisited the same spot ten years later, I found squatter's trash and some of the limbs hacked off the tree.

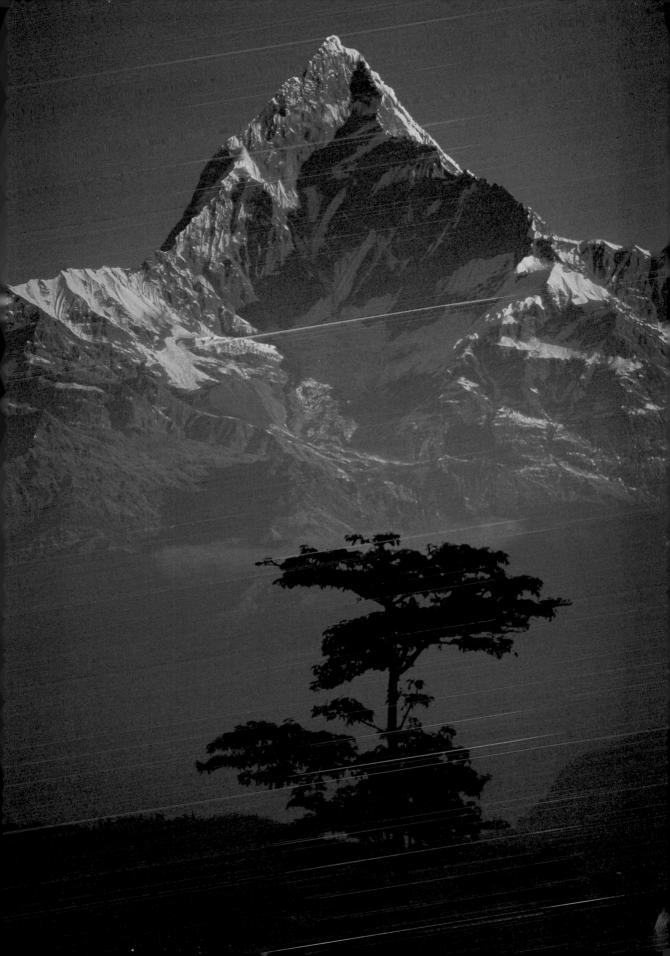

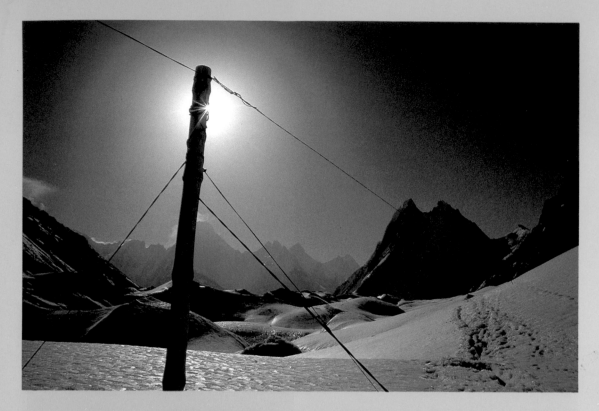

Above and following pages:
Essay pages 39–40, 128
When I revisited Concordia on the Baltoro Glacier in the Karakoram Himalaya of Pakistan, I was shocked to find phone wires (above) running through one of the wildest and most pristine scenes (following pages) I had photographed fourteen years earlier on a 1975 expedition to K2. Since I published my book Mountain Light *in 1986, I have already found sixteen of the eighty locations of the book's photographs so marred by human activity that a similar image cannot be taken.*

Right and far right:
Essay pages 26–28
The ramshackle teahouse (right) photographed in 1987, sits exactly where I shot one of my favorite images of the Annapurna Range over an open meadow in 1977 (far right). I brought along a copy of the 1977 image and lined up my feet precisely on the same spot by matching the perspective of trees on foreground ridges against features on the peak.

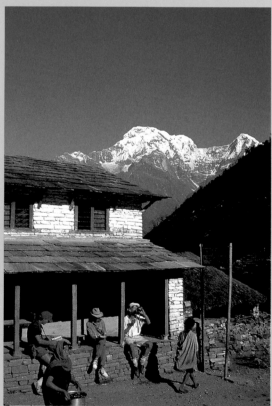

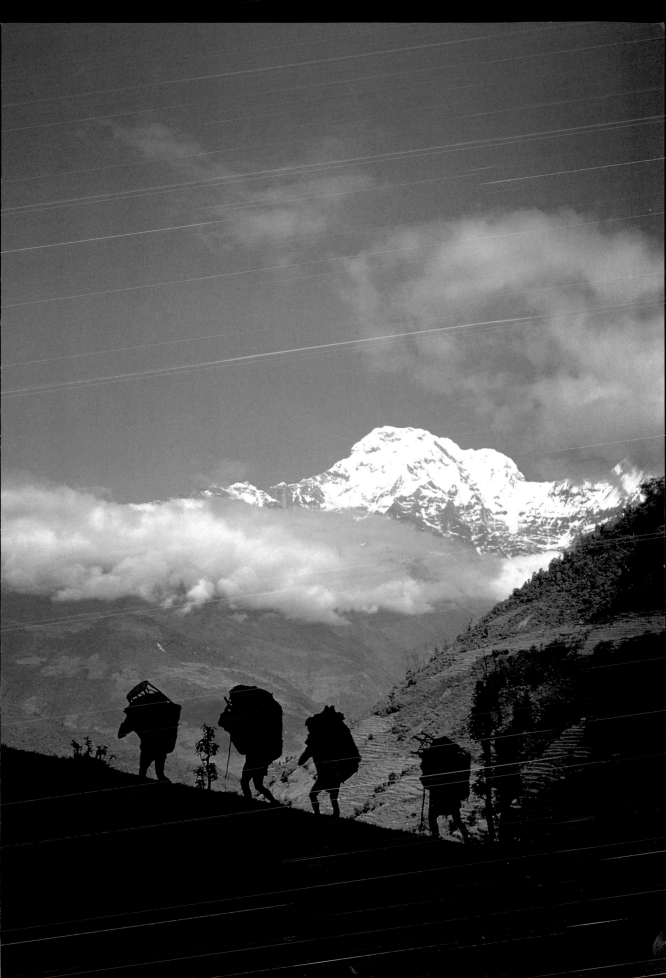

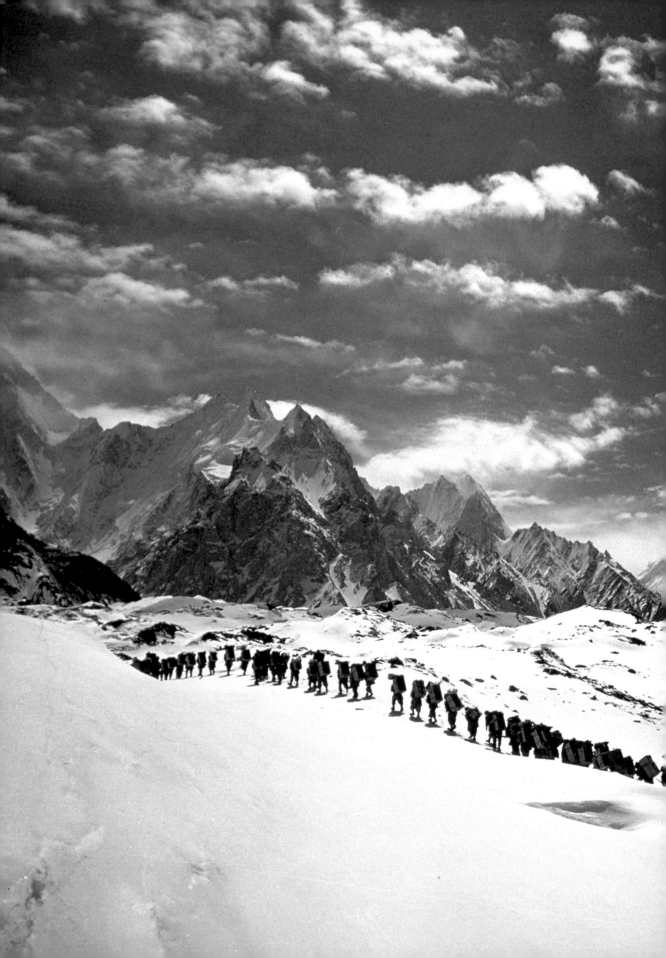

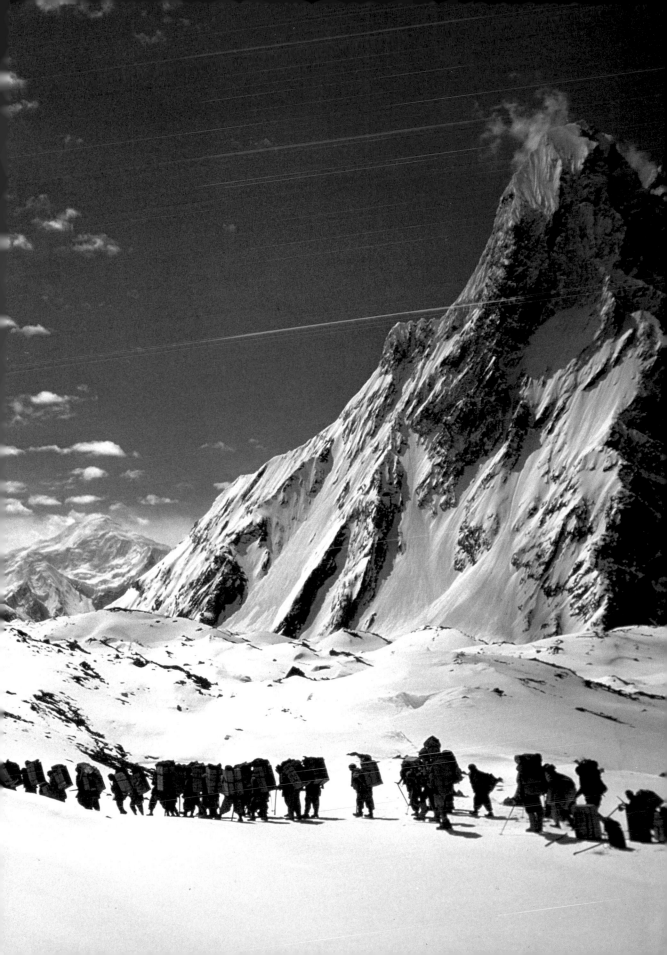

Right and below:
Essay pages 24–25
A photograph I made in the seventies of a Sherpa standing in front of Mount Everest is no longer used in trekking brochures. At the time I took the photograph, adventure travel was an "immature" subject that required direct imagery such as we often find in children's textbooks. Today, another image from the same trek (below) continues to be published because it is a "mature" image. It suggests the idea of a trek by showing a peak, a yak, and a lunch spread out on the ground. Only when we already know a subject can our minds fill in the gaps.

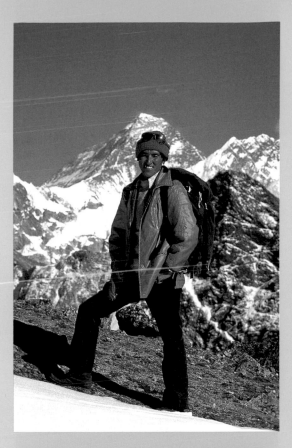

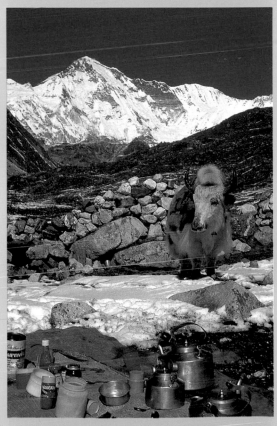

Left: Essay pages 22–23
What appears to be a typical section of the John Muir Trail in the California High Sierra is really an uncommon, highly selective vision. I walked miles to find a scene along the trail with this visual simplicity. We often search out the unusual to reveal the norm of our personal experiences through photography.

Above and right:
Essay pages 37–38
*When my wife, Barbara,
flew her single-engine Cessna
to Patagonia, I was able to
photograph four natural
circular phenomena, including
the extremely rare 360-degree
double rainbow (above) that
appeared in a sunlit rainstorm
along the coast of Mexico.
Atmospheric physicist Craig
F. Bohren says in his 1987
book,* Clouds in a Glass of
Beer, *"to the best of my*
knowledge, one has never
been photographed." He
continues with "a suggestion
for anyone who would like
a bit of fame and fortune:
photograph a complete
rainbow. You will need an
airplane . . . You will also
have to persuade the pilot to
fly in stormy weather. If you
survive your flight you will
have acquired something rare
indeed." The much narrower
22-degree solar halo (facing
page) greeted Doug
Tompkins and me at the
summit of a virgin Patagonian
peak. The Specter of the
Brocken (upper left) appeared
as we flew near a patch of mist
hovering over the ocean with
the sun at just the right angle.
We flew to 20,000 feet in
Ecuador (upper right) to peer
into the periodically active
crater of Cotopaxi volcano.

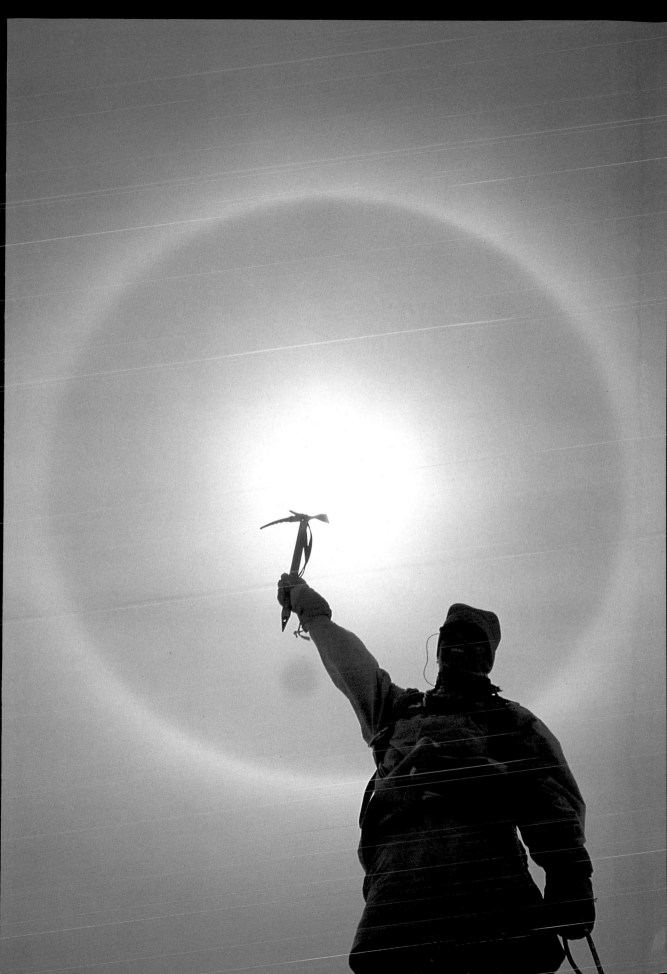

Above: Essay pages 32–34
I consider this a created image because I didn't just happen across the scene in the Yosemite high country. I imagined an ideal moonset through a single row of trees, then scouted a location that needed a complex set of factors: an open area at the precise distance and angle from the trees to hold depth-of-field at f32 for moon and foreground with a 560mm lens (actually a Nikon 400mm f5.6 with a 1.4X teleconverter). *When I returned at dawn, I let the moon touch the horizon and go behind the limbs so the image would not be mistaken for a double exposure. The lens and camera were held solid by two tripods. The image was revealed only during the last moments of the creative process.*

Above: Essay pages 35–36
The new science of chaos has helped me understand and seek out elements in images that I have long called "dynamic landscapes" that convey a sense of the power and mystery of nature. Cascading water is a classic example of chaotic behavior of a natural substance with a clearly recognizable and somewhat predictable outer form. Photography shows this form better than the naked eye when either very slow or very fast shutter speeds are used.

For this image of Eagle Falls cascading into Lake Tahoe at dawn, I used 1/15th of a second with a 24mm lens to create a silky texture and Fuji Pro 50 film to bring out the green in the water.

Following page:
Essay pages 29–31
I completely changed the photographic result of what began as a mundane scene of a man under fluorescent lights in the corner of a concrete building at the Tibetan Medical Institute in Dharamsala, India. He was sealing "Precious Pills" with ingredients such as ground yak bladder stones in silk with the wax of a candle. I tuned into the feeling of that light source from a flame by turning off the room lights

and using a Nikon SB-24 flash, a colored gel, and a 12-inch Litedisc reflector to bounce the light from behind the candle. I matched the light to the candle, believing that manipulation toward what the eye would see at the scene is valid, but that creating weird colors or other special effects that were not at the scene to draw the eye to artificial input is wrong in editorial photography that purports to show the world as it is.

Photographs: Pages 73, 76, 253, 267

The Photo-Friendly Nineties

" The question made me feel as if my work was somehow important rather than frivolous and self-centered, as I often thought when I woke up in the middle of the night before another day at my small automotive business."

I recently came across an old file from the sixties. I had been a part-time photographer then, and my receipts for sending unsolicited photos and story proposals by registered mail had exceeded my income. The rejection slips reminded me that my chief limiting factor had not been a lack of knowledge, ability, or experience, but the meager marketplace. There had been no color magazines on outdoor photography or adventure. Gallery owners and makers of calendars and greeting cards had generally avoided color nature photography, considering it less than true art. At the time, getting published in *National Geographic* had seemed as much a pie in the sky as a passing 747 to a person lost in the desert.

I wandered through the wilds with my camera for eleven years before I was lucky enough to land a *Geographic* assignment in 1973, my first year as a full-time pro. That success has forever colored the way others look at my early years. Articles describing my career are often oversimplified to say only that I became a pro in 1972 and soon landed that assignment.

One of the best analogies of how early success in an outdoor pursuit can color future perceptions comes from my friend Nick Clinch, who led the only American first ascent of an 8,000-meter peak in the Himalaya. Before that 1958 triumph, most of his friends had thought his team would fail. Two years later, Nick returned to a lower but more difficult mountain. The same pundits now predicted success, even though the real odds were lower and his team barely made it.

My old file, like Nick's first team, is untainted by success. It presents a very different picture than the one people have in their minds when they try to tell me how lucky I was to have started out before there was so much competition. I try to tell them how lucky they are to be operating in the photo-friendly nineties. In the old days, even the most noble lone wolves of our profession were on the edge of hunger. In today's world, there is more room for success and less for envy. And more reason for hope than ever before.

Those Stone Age years of the sixties also remind me how rapidly outdoor photography is evolving. Hope is based on using past events to help predict a better future. As photography critic Robert Adams put it, "A photographer can describe a better world only by better seeing the world as it is in front of him." Once a photograph is made, the moment that is recorded moves into the past to be viewed only in the future. Too much romanticizing of the past tends to dull the present, while objectively viewing it often opens up previously hidden creative pathways for the present.

I recall that the earth was in better shape back then and somewhat easier to photograph. There weren't so many scars across the land or contrails in the sky. There also wasn't much of a market for pictures urging us to save the earth or even to celebrate its natural beauty. My outlet for environmental work was restricted to the black-and-white publications of organizations that thanked me profusely and paid me in pocket change.

My sense of hope for both environmental photography and my own career is based on knowing where that photography has come from and where it may be heading. A century ago, only a rugged few went to the effort to pack glass plates and a portable darkroom onto the back of a reluctant mule before heading out on a wilderness adventure. Then, photography was a cumbersome intrusion, but by 1962, when I effortlessly carried a small rangefinder on a climbing trip, the two pursuits had become compatible. Amateur outdoor photographers were common, while pros were as rare as wolverines. No one took much notice of my rangefinder, but after I bought a Nikon FTn in 1968, I was often asked, "Are you a *professional* photographer?"

The question made me feel as if my work was somehow important rather than frivolous and

self-centered, as I often thought when I woke up in the middle of the night before another day at my small automotive business. I am quite sure that it was my uncommon camera, not my appearance, that moved people to ask the question. I remember all too well how I must have looked rounding the corner of a trail with a top-of-the-line black camera body, an extra lens, and a mop of long hair draped over clothing selected for price and durability, not for style, from a thrift store where the clerks called me by my first name.

Today, no one asks if I am a pro unless I am caught with three bodies, twelve lenses, and a couple of tripods on the rare occasions when I use that much gear. I don't rate a second glance carrying a Nikon F4 with a couple of extra lenses and a tripod, because quality camera gear has become a predictable part of outdoor apparel like fancy running shoes and designer sunglasses.

A high percentage of outdoor enthusiasts of every sort now carry cameras. Thus the combined total of outdoor photographers is now greater than that of backpackers, fishermen, hunters, climbers, skiers, bird-watchers, Boy Scouts, Girl Scouts, or rangers taken individually. Photography has now become the common denominator of these formerly separate fields of outdoor endeavor. Human beings can become hooked on any pleasurable experience, and the relaxed joy of modern photography is addictive. I've met many wildlife photographers who started out as hunters and mountain photographers who began as climbers. I know a former boatman on the Colorado River who passed through outdoor photography on his way to success as a corporate photographer. Like John Wesley Powell, he boarded his raft without knowing where he would emerge and kept his hopes up.

Another reason for the proliferation of photographers who aspire beyond point-and-shoot snapshots is the result of a bold marketing decision. In the late seventies, several camera manufacturers foresaw a future in red instead of black if they focused on their core market of enthusiasts who already had closets full of gear. Therefore, they risked all on a strategy designed not so much to increase market share as to expand the basic market itself. These companies began to make, promote, and sell entry-level SLR cameras at very low prices in order to lure new photographers into their interchangeable systems of professional-quality lenses and bodies. The Nikon FTn I carried in 1968 was indeed the tool of a serious pro or advanced amateur at the time, which explains the questions I received on the trail. But the Nikon EM of 1981 and the Nikon 8008s of 1991 are often in the hands of average shooters, even though these cameras are capable of taking just as fine photographs through the very same interchangeable lenses. Even top-of-the-line pro models with four-digit price tags are owned by many beginning photographers these days.

The underlying reason that the marketing strategy worked and so many outdoor enthusiasts are willing to add the weight and expense of cameras to their travels is that off chance for a miracle image. Even the most experienced photographers find their images always hold something of a visual surprise. I know of no seasoned pros who are so sure of their results that they would skip a chance to review their work on a light box before seeing it published. There is a constant disparity between how we think our photo will depict reality and what we get. Knowledge and experience help, but the more factors we learn to control, the more we desire to master. I have yet to make a "perfect" photograph, but I am going to keep trying. I have hope.

And there is always that larger gamble of an unexpected event happening before your eyes. With your camera along, you have at least lottery odds of winning big. A mountain lion may leap out of nowhere and pounce onto that deer you're watching or a funny cloud may curl up and turn crimson against that mountaintop. By comparison, painters and sculptors have no realistic hope that their work will be instantly transformed into something other than the form they themselves impart to it. Being ready for chance events in photography is part of the game. As Louis Pasteur said long ago, "Chance favors the prepared mind." Or as *National Geographic* photographer Bob Madden said not so long ago in a caption that accompanied his photo of a small plane crashing into a pickup truck and the startled driver frozen midair in a lifesaving leap, "If you carry a camera every day of your life—or almost every day— you're going to come across something like this every few years."

And next year there will be more of us.

Photographs: Pages 76–77, 253

"Some pro cameras of the eighties and nineties are destined to be the historical counterparts of the 1958 Buick and the bullet-proof hiking boot."

Future Crave

In my *National Geographic* story on the John Muir Trail (April 1989), I was able to include several photographs taken by my aunt of my mother's 1924 adventure along the same 211 miles of the High Sierra before the trail was completed. After Aunt Marion died in her nineties and bequeathed her vast photo collection to me, I gained not only the historical images for that article, but also some forgotten insight into my own beginnings as an outdoor photographer. Between the frames she had taken of me in my youth, I saw more clearly than ever why I instinctively revert to the simplest equipment when the going gets rough, even when I am on assignment with bags filled with the latest gear.

When I was twelve, Aunt Marion taught me the basics of how to use the 120 Brownie I won for selling newspaper subscriptions. I took lots of funny portraits of my dog and a few murky landscapes before I got my driver's license, souped up my first Chevy, and then promptly dropped photography for several years, with one exception.

While driving one of my hot rods late at night toward Yosemite to go rock climbing, I had a blow-out. The freeway had no turnouts, so I pulled to the side and left my parking lights on. Traffic was thin, but suddenly a semi-truck bore down on me at full speed, even after I blinked my brake lights. I jumped out of my car just before the impact catapulted it over an embankment. My car was totaled, but that was only the beginning of my troubles. A highway patrolman cited me for blocking the roadway, claiming I should have driven two miles to the nearest exit. He didn't like my explanation that to do so would have ruined one of my mag wheels (which cost more than my first Nikon a few years later).

I had no collision insurance, but I had a plan. I returned the next day with my old Brownie and took carefully aligned photos of the tired trucker's short skid marks, which showed no attempt to avoid the crash by turning into one of the other lanes. Additional shots depicted the trucker's unrestricted view in both directions.

Remembering the jargon Aunt Marion had taught me, I ordered 8-by-10 glossies at a custom lab. When I picked them up, the printer said, "These are really sharp. What did you take them with, a Rollei?"

"A what?" I cautiously asked, not wanting to admit I had no idea what a Rollei was.

"A Rollei twin-lens."

"No, another brand," I hedged, reaching for the door.

Later, in court, the judge commended me on the photos and found me not guilty. The trucking company paid for my car, and I was on my way to becoming a true believer in simple cameras.

That same year I had an accident with the beautiful Swiss mountain boots Aunt Marion had given me. After every mountain trip, I had lovingly cleaned and polished them, but after a winter climb in Yosemite, I set them by the camp fire to dry while I took a shower. Someone stoked the fire, and the whole campground smelled like a tire factory by the time I returned. As I mourned over the remains, a fellow climber told me not to buy another pair of such clunky boots but to try the bizarre-looking low-top athletic shoes he was wearing. They were made for cross-country running by some obscure company I had never heard of called Adidas. After I returned home I bought a pair. Because the term "running shoes" would not enter the American vernacular for another decade, I had to endure endless questions in public about what sport I played with my little leather shoes as well as beratings on the trail from men limping in big boots leading Boy Scouts limping in similar footwear. Meanwhile, I never got a blister.

Big hiking boots, muscle cars, and twin-lens cameras are today's anachronisms, predictable victims of a simple rule of all human endeavors: the more

known, the less needed. As Antoine de Saint-Exupéry wrote in *Wind, Sand, and Stars:*

> Have you ever thought … that all man's industrial efforts … invariably culminate in the production of a thing whose sole and guiding principle is the ultimate principle of simplicity? It is as if there were a natural law which ordained that to achieve this end, to refine the curve of a piece of furniture, or ship keel, or the fuselage of an airplane, until gradually it partakes of the elemental purity of the curve of a human breast or shoulder, there must be the experimentation of several generations of craftsmen. In anything at all, perfection is finally attained not when there is no longer anything to add, but when there is no longer anything to take away, when a body has been stripped down to its nakedness.

Unfortunately, professional 35mm camera bodies have now broken away from the natural trend that brought us the original Nikon F and the Olympus OM1. It is no easy task to walk through the wilderness with an auto-focus, data-backed, motor-driven, multimetered creation with a dozen buttons and knobs that you can so easily turn the wrong way. Many innovations on new cameras are too good to ignore, but not good enough to remain above criticism. The certitude I once felt with a 35mm camera in my hand has ebbed in recent years. I have gotten many images I never would have made in the past, but I have lost others to new problems with battery-operated shutters, auto-focus, twisting filters, and far too many settings to think about at the decisive moment. Some pro cameras of the eighties and nineties are destined to be the historical counterparts of the 1958 Buick and the bullet-proof hiking boot.

At the other end of the scale are point-and-shoot rangefinders without interchangeable lenses that make good snapshots but not selectively exposed and focused images. As we near the twenty-first century, weeds are growing in the middle lane once occupied by my Schneider-lensed Kodak Instamatic 500 in the sixties, my Nikkormat FTN in the seventies, and my Nikon F3 in the eighties.

I have reason to suspect that outdoor photographers may soon lead the industry out of the current blind alley. During my lifetime I have watched separate markets for outdoor enthusiasts merge with the mainstream in many other areas. People in line at the supermarket now wear the same shoes I chose for mountain trails in the sixties. *People* magazine featured George Bush wearing a Patagonia jacket originally designed for the rugged outdoors by one of my old climbing partners. Today's small, quick-handling vehicles evolved from yesterday's country sports cars rather than from the Detroit dinosaurs of my youth.

When cameras are built for the outdoor market, as they inevitably will be, we will have compact units with interchangeable lenses that preserve the best innovations and discard the rest. The eventual product may be as hard to predict as was the Sony Walkman after decades of 20-pound, bedside "portable" radios. In the short term, I see a camera smaller than an Olympus OM1, with a detachable motor-drive that has auto-balanced fill-flash electronically coupled to compact manual lenses. Auto-focus will be an option for the minority of photographers who suffer from impaired vision, laziness, or incurable gadgetiphobia. Manual lenses will have identically sized filter threads that don't turn your polarizer or graduated filter off center each time you focus. These lighter cameras will also work on lighter tripods and fit in smaller camera bags.

When I think about Aunt Marion, my Brownie, and my old Chevy, I know in my heart that today's camera designers are as far from producing what the public really needs as were Detroit's fifties futurists, who were smugly certain that they were doing the best they could to balance design with engineering, economics, and personal choice. If we want to hasten change, we outdoor photographers need to constantly remind the industry that the guy with the biggest pack is rarely the happiest camper.

Traveling Light and Not-So-Light

"I chose 35mm as my sole means of photographic expression because I wanted to be relatively unencumbered. I tried larger cameras, but the bottom line is that my imagination more directly connects with the final image in 35mm."

I have yet to give a lecture or seminar at which someone hasn't asked me the deceptively simple question "What kind of camera do you use?" Sometimes I am lucky enough to quickly say, "Nikon," and move on. More often, I am not so lucky and have instead opened a Pandora's box of general misconceptions about photography.

"Which Nikon?" comes next. The questioner usually assumes that a decisive factor in the quality of my photographs must be the difference between Brand X camera and Brand Y camera. Answering this question leads to an unfounded conclusion. It's like asking what kind of clothes I wear. I wear clothes most of the time and I dress to suit the occasion. I carry cameras much of the time and I chose them to suit the occasion, too.

My current wardrobe as of 1993 includes a Nikon F4, a Nikon N90, and sometimes a Nikon FM2. If I dangled all of them around my neck at once, I would not enjoy taking pictures, would not have consistent results, and would have given up photography long ago. I chose 35mm as my sole means of photographic expression because I wanted to be relatively unencumbered. I tried larger cameras, but the bottom line is that my imagination more directly connects with the final image in 35mm.

While all these things are running through my mind, someone asks the third most commonly asked question: "What equipment do you take with you on an expedition?" If I say that I usually head out into the field with forty to fifty pounds of gear including three camera bodies, a dozen lenses, and lots of other gadgetry, then I wrongly give the impression that I am always lugging that stuff around to make good photographs. To the contrary, I have made many of my favorite pictures when I was carrying only one camera with a couple of lenses.

When I travel, I carry a bag of clothes to fit the various occasions I'll encounter and a bag of cameras.

I don't head into the field on foot carrying my whole wardrobe, nor do I try to carry all my camera gear. I tailor my photo equipment to each occasion, but not before asking myself one simple question: Who's going to be carrying this stuff?

Pros with assistants and big expense accounts can travel with twenty cases of photographic gear that they themselves will never lift. What's inside their cases has little relevance for amateurs who travel to the same places and have to lug their own equipment through a myriad of airports, hotels, and shooting locations.

When I go on a foreign assignment for a book or magazine, the bulk of my equipment is usually carried in vehicles, on pack animals, or on the backs of porters or hired assistants. At this stage, I can easily afford to take about fifty pounds of gear. But when I'm out in the field on that assignment, I'll personally select what I might need for each situation and carry only that myself. For example, on a Himalayan expedition all my gear is carried by pack animal or porter to the base camp. During the long trek in I have access to everything in the morning and evening when the light is best. While on the trail and above base camp on a climb, I often carry only one camera body with one wide-angle and one short telephoto lens. I add to this basic gear as necessary. For example, if I am passing through an area where I expect to see wildlife, I might carry my 300mm that day. But overall, my outdoor photography kit stays much the same.

Before I list the contents, I would like to emphasize once again how most of this equipment has little to do with my best photographs. I would estimate that 90 percent of my top images were taken, or could have been taken, with a single camera accompanied by two lenses, a 24mm and an 85mm. The extra gear gives me backups in case of equipment failure, the convenience of having different films in separate camera bodies, and more lens options than are usually necessary. If you're

strictly a nature photographer who isn't trying to document people in low light or architecture, then you can cut ten pounds from my kit by deleting the perspective-control lens and all flash paraphernalia. You can cut even more by limiting yourself to cameras without auto-focus or auto-exposure.

Camera bodies: One Nikon F4 and one Nikon N90. I use the smaller four-battery MB-20 motor-drive on the F4 when backpacking unless temperatures go below zero. If I want to go fast and light with one camera, I usually take the N90, because it weighs less. I take the Nikon FM2 for backup on major assignments, but rarely use it these days.

Lenses (all Nikon brands): Choice of 15mm f3.5 (rectilinear with no curved lines) or 16mm f2.8 (mild fish-eye effect), 20mm f4 (lightweight, 52mm filter threads), 20mm f2.8 (heavier but better for available light), 24mm f2.8 AF (my most-used lens—lighter and with less flare shooting near the sun than the more expensive 24mm f2), 28mm f2.8 PC (perspective-control lens for correcting parallax in buildings or trees), 35mm f2 (a medium-fast, standard, wide-angle—my favorite for aerials and night landscapes), 35–70mm f2.8 AF zoom (for auto-focus and auto-flash capability—I leave it behind if I'm tight on weight), 55mm f2.8 Micro-Nikkor (a close-up lens that works fine as a normal lens), 80–200mm f2.8 AF zoom (tack-sharp and fast, but heavy), 85mm f2 (my standard telephoto—just right for low-light candid portraits on slow film without a tripod or for light day trips), 300mm f2.8 EDIF (the classic photojournalist's telephoto optic; when f2.8 lens speed won't be necessary I often substitute the much lighter 400mm f5.6 EDIF to carry on my back any distance), TC-14A teleconverter (a tack-sharp teleconverter that multiplies focal length 1.4 times to make the 300mm into a 420mm f4 or the 400mm into a 560mm f8), TC-301 (a fine 2X teleconverter that makes the 300mm into a 600mm f5.6 or the 400mm into an 800mm f11).

Camera bag: Photoflex MFP ("Galen Rowell" Modular Fanny Pack that I helped design and patent) with detachable backpack. The MFP holds one motor-driven body with up to six lenses and a flash. Side pockets hold filters, film, and other gadgets. The backpack stows my 300mm lens, three-pound Gitzo tripod, second camera body, extra lenses if necessary, plus more film, jacket, and lunch. For some rugged trips I use only a Photoflex chest pouch with two additional lens pouches on the belt.

Chest and lens pouches: Photoflex (patented "Galen Rowell" design to carry body and lenses for instant use in rugged travel).

Tripods: Gitzo 226 with Slik Pro ball-head (six pounds) or Gitzo 106 with Slik Standard ball-head and center column removed (three pounds) or Gitzo 001 with Slik Standard ball-head and center column removed (two pounds).

Tripod quick-releases: Kirk Enterprises (plus special Kirk tripod mount for f2.8 80–200mm lens).

Filters: Nikon 52mm, 62mm, and 77mm polarizers with a 77-to-72 adaptor for my PC lens. Nikon 52mm, 62mm, 72mm, and 77mm skylight 1B and 81A (warms tones in shadows or overcast light—sort of a double-strength skylight filter); four Singh-Ray 84 x 120mm graduated neutral-density filters made in special "Galen Rowell" configurations (see essay pages 82–83), Cokin P filter holder with 52mm, 62mm, 72mm, and 77mm adaptor rings.

Flash: Nikon SB-25 with SC-17 remote cord.

Meter: Minolta Flashmeter IV (optional for tricky flash work only).

Soft box: Chimera Super-Pro, small (one and a half pounds); Photoflex On-Camera XTC, inflatable (two ounces).

Reflector: Photoflex Litedisc 38" gold/white; 12" gold/white; 12" white/white (great for bouncing sunlight into shadows for portraits).

Photographs: Pages 5, 74–75, 132, 186–87, 192–95

"Removing an F4 from the box and trying to take pictures with it is something like walking into your corner grocery for a quart of milk and a loaf of bread and finding it transformed into a supermarket. At first the old, familiar act of grabbing what you want is slower."

Around-the-World F4 Shakedown

In December 1988, a few days after I received an early-production Nikon F4, I embarked on an informal around-the-world shoot-out against my faithful old F3. My principal stops were two dream locations for nature photographers: the Galápagos Islands and the Himalayan kingdom of Bhutan.

When Charles Darwin sailed to the Galápagos in 1835, he found wildlife fearless of human beings and observed differences in species from island to island. He took voluminous scientific notes, but didn't fully recognize a larger meaning until years later. His theory of evolution came after he had realized that the strange animals of the Galápagos were all descendants of mainland creatures, transformed by new habitats.

On my Ecuatoriana Airlines flight from Los Angeles to Quito, I read both the manual for the Nikon F4 and Darwin's journal, *The Voyage of the Beagle*. I sensed a hidden sameness in these extremely disparate publications. Both present essential facts, while refraining from making the sort of larger judgments that come after long reflection and that define their subject's place in the universe. Then and there I decided to look at the F4 in an evolutionary and philosophical sense, as well as to review its technical performance. It had broken ground in all three areas.

Biological evolution rarely proceeds with clear forward steps. New species evolve after a rugged real-world trial Darwin called the "survival of the fittest." In the photographic world, too, there is no substitute for a rugged field test to see if the latest product of evolution is the greatest. Most magazine "test reports" provide a shopping list of features with bench tests that give little inkling whether a camera really delivers visibly better pictures than its competition.

Because the F4 is not the first evolutionary experiment in professional auto-focus cameras, let's look first at an earlier entry in the same marketplace. Minolta tried to win over the Nikon-armed battalions of pros with its high-tech Maxxum 9000, which utilizes some of the F4's basic features in a less user-friendly fashion. For example, Minolta engineers dropped familiar knobs and numbered dials in favor of digital readouts. Many pros felt uncomfortable with the camera because they sensed a loss of control at the height of the action when they needed to keep their eye to the viewfinder. No mass conversion occurred, although the Maxxum line continues to sell briskly, especially to amateurs. I tested a 9000 against an F3 several years ago and found that I didn't get as many top images with it, although the number of technically publishable images did increase. I want qualitative success, not quantitative files of less-inspired work.

The hasty introduction of professional auto cameras created a negative image among most pros. "Auto is a four-letter word and auto-focusing is a twelve-letter word," a top shooter told me in 1986 when we compared notes while working on *A Day in the Life of America*.

Minolta, like General Motors, fell into the trap of letting executives and technicians assume they knew their markets. Nikon, on the other hand, didn't rush into the marketplace with the F4. Design concepts began seven years earlier. Meetings and mailings among Nikon's vast network of pro users kept the project on course. Ads for the F4 rang especially true for me, because I was one the "thousands of professionals" consulted for "their suggestions. Their musings. Their concerns. Their wish lists in photography." Virtually every problem I had with the F3 has been addressed on the F4—and much more.

As a result, the F4 is designed with auto-focus as an integrated option instead of a controlling mode with manual focus a clumsy afterthought. Another thing pros demanded was to be able to see all necessary settings through the viewfinder, especially the frame number so that film changes could be more easily anticipated. Where the F3 shows only aperture and shutter speed, the F4 displays full information:

exposure compensation value (if any); frame number; four focus indicator lights (that also work with manual lenses); exposure compensation warning; flash ready-light; metering symbol for either Matrix, TTL, or Spot modes; shutter speed; auto-exposure lock warning; aperture; four-stop manual exposure display; and auto-exposure mode (choice of two Program, two Auto, or one Manual mode). Outside the finder, there's even a little window that lets you read the film type and speed directly off the back of the cassette.

Removing an F4 from the box and trying to take pictures with it is something like walking into your corner grocery for a quart of milk and a loaf of bread and finding it transformed into a supermarket. At first the old, familiar act of grabbing what you want is slower. But after a few visits to the supermarket, you begin to figure out what you want before you walk in, where it is, and how to quick-step down the long aisles of options about as fast as you did in the older, smaller store. Yet something about the whole process of entering the supermarket for a quart of milk and a loaf of bread is stressful and overwhelming. The glitter of the big store begins to wear off, and you find yourself stopping at the Seven-Eleven when you need only a couple of things.

But few of us choose to shop exclusively at a Seven-Eleven, so allow me now to jump ahead to my most important conclusion: For rugged fieldwork, I won't go with just the F4, but I won't go without it either. Nikon has me hooked. At the time I decided that my complete traveling kit would always include at least one F4 and one F3, but evolution has continued since 1988 and I now carry an N90 plus an F4.

Why did I still want a camera like the F3? Most important, I could take the motor off the F3 to lighten it, but the F4 won't operate without one when I need to go as light as possible, on rock climbs, ski tours, or intense hikes. In other situations, especially close-ups with people and wildlife, I'm hooked on the F4's ability to meter TTL flash synched at 1/250th and natural light simultaneously. I also like the option of being able to manually set the fill ratio to deliver an amazingly natural look. Because the newer Nikon N90 combines the F3's lightness with most of the F4's technical benefits plus some new ones of its own, it has become not only my second camera of choice, but also one to which much of my experience with the F4 applies. For a further comparison of the F4 and the N90 in the field, see "No Latitude for Error," pages 144–45.

Now let's return to 1988 and move directly into the field with the F3 and the F4. I've landed on Hood Island in the Galápagos with a group of eleven people. Our sailboat is waiting, and I've got just two hours to capture scenes that will pass just once before my eyes. Wildlife is everywhere. I walk up to within two feet of a marine iguana and a blue-footed booby eyeing each other on top of a rock (page 74). As I compose the scene with the F4, a sea lion appears in the background. Instinctively, I pull back to include it, and as my finger sinks the shutter release my heart sinks, too. I was in Single-Servo auto-focus mode with my finger slightly depressed to hold focus on the booby after I recomposed outside the bull's-eyed focusing zone. Thus, when I pulled back, my focus was still locked to a shorter distance.

This isn't an isolated incident. In the beginning, the F4 repeatedly made me feel stupid. I often forget to set some "automatic" feature the way it should be. I'm reminded of how many mistakes I used to make with my first word-processor in 1981. Dealing with a computer that is difficult but always right is as trying as dealing with a person of the same ilk. But after a short learning period with that computer, I never reverted to serious writing by hand. I'm having the same feeling of positive adjustment, for the first time, about a fully automated camera.

Back on Hood Island again, I encounter a pair of chocolate brown Galápagos hawks perched against a cloudy sky. I doubt that either the F4's five-segment Matrix or Center-Weighted TTL metering options will handle the contrast ratio, and I worry that the third option, a spot meter in a 5mm circle, might still pick up the white clouds behind the birds and cause underexposure. To further complicate things, a bright white albatross, one of the few left after the breeding season, struts in front of the hawks. Now I've got three immediate picture situations: one of dark birds, one of white birds, and one of both together.

For this one, the F3 stays in the bag, because its ability to deal simultaneously with auto and manual exposures is paleolithic. Whereas the F3 requires the releasing of a lock and the twisting of a dial to locate and meter a manual shutter speed, the F4 allows you to set and leave set a manual exposure while you switch to auto-exposure mode. In manual mode a superb viewfinder display shows overexposure or underexposure in third-stop increments two full stops in either direction.

I quickly aim the F4 with 180mm f2.8 AF lens at a dark rock in manual mode, set the speed for two-thirds of a stop underexposure to render the dark birds dark, flick my finger to return to auto-exposure, and go into action. Within seconds I catch the albatross with the hawks as background silhouettes, then catch the huge white bird nearly full frame at its nearest approach, still on auto. I quickly switch to my preset manual exposure and catch the dark hawks seconds before they fly off as the albatross nears them. (The results of all three fast-moving situations are technically perfect, a feat beyond the realm of my F3.)

As I walk back to the boat, I spot a male frigatebird with seven-foot wings on final for a short landing nearby. With manual focusing, I would have little hope of getting more than one sharp image in a motor-driven blast of exposures, but I try out the F4's Focus Tracking feature. With the focus mode set in Continuous Servo, and film advance set to Continuous Low Speed, the F4's eight-bit computer takes auto-focus one giant step forward. When a subject moves at a reasonably constant speed, the computer advances the focus ahead, predicting the subject's position the instant the shutter releases. If the subject's speed suddenly changes, Focus Tracking ceases, and normal auto-focus takes over.

With enough warning, a photographer can lock Focus Tracking on the moving subject by keeping it centered in the finder for a few seconds before taking a picture, just like Tom Cruise getting ready to launch a missile in *Top Gun*. But whereas a million-dollar missile fires only once, wide of the mark without a preparatory step such as this, forty-cent slides keep firing 3.5 times per second. My blast of six frames at the frigatebird shows Focus Tracking working true to form. The first two frames are a little soft, just as I would expect from a fast-moving subject with a standard auto-focus camera. The next four are all tack-sharp. Doing my best with manual focus, I have found my experience is usually the opposite: While the bird is distant, I get off a couple of sharp frames, but as it looms larger in the frame, I get key images that are soft.

When I later view the results on a light table, I feel a new sense of freedom in my photography. In the past, I used up lots of film on birds in flight, but frames for publication were more often chosen because they happened to be sharp rather than because they satisfied my creative intentions. Now I have many sharp images from which to choose.

If the Galápagos Islands are a wildlife photographer's Eden, the dense jungles of southern Bhutan are purgatory. Nothing is easy. A hundred years ago, people who roamed through the forest dreaded coming face to face with a tiger. Today's visitors lust for a glimpse of a tiger or the other

dangerous animals that live in Bhutan's new Manas National Park, which I came to document for the World Wildlife Fund.

In the Galápagos, where I could walk right up to animals that were unafraid and wouldn't hurt me, my choice of lens, tripod, and camera angle was wide open. In Bhutan, as I head out in darkness at 5:00 A.M. on the back of an elephant, I realize my options are limited. I've got the F4 around my neck with a 180mm f2.8 AF lens, SB-24 flash, and Kodachrome 200 pushed to 500. If a tiger appears right in front of me, I have a chance to make a fine image. The lens is set on f2.8 in aperture-preferred auto-mode. The dedicated strobe not only "knows" the aperture and ISO, but also zooms its head to match the focal length and auto-focuses the lens by infrared sensor. The strobe has a bright display, and with the view-finder light switched on, the F4's readings also stay lit for about sixteen seconds after the shutter release is lightly depressed. After I test the infrared sensor in the jungle and find that it works up to thirty feet, I do two hypothetical dry runs. First, the tiger appears at fifty feet and I switch from AF to M, then man-ually focus the lens. Second, the tiger appears at twenty feet, and as I imagine a broadside, full-frame image, I wonder if the focus beam in the middle of the finder will deliver a critically sharp image of the animal's face off to the side.

Before dawn, I catch a fleeting glimpse of wild boar and two kinds of deer, but they are never close enough for photos. Then I hear a loud crashing far ahead, as a herd of wild buffalo thunder through tall grass. I don't take a single shot. Even if I were close enough to use my strobe, it would put harsh light on the grass and very little on the dark creatures.

Asian wild buffalo combine the size and square-ness of a minivan with the coarse, hairy unpredictability of a Hell's Angel. With great caution, I ask the elephant mahout to let me down to stalk on foot,

where I can make sharp, slow exposures. On the ground I feel instantly vulnerable. Besides tiger and buffalo, the tall grass hides wild elephant, one-horned rhino, and wild boar.

With great care I track the buffalo to a fine photo-op. The first rays of light come from behind me onto a herd of sixteen animals. I leave my bag and F3 behind as I crawl to the edge of a clearing. I begin shooting about two hundred feet from the animals, keeping the sun directly behind me for camouflage. I use the F4 in Continuous Silent mode, which is quieter with motor advance than an F3 without a motor. For twenty minutes I go unnoticed, using my 400mm f5.6 manual-focus lens flat on the ground. It focuses just as easily as on the F3, and only when in doubt do I look beyond the ground glass for confirmation from the green focus indicator light. Then I decide to climb a tree for a better vantage point and risk being seen. As I quickly ascend into the branches, a huge buffalo faces me off in a very threatening manner. I brace, focus, shoot, and nothing happens. The viewfinder display flickers and goes out. The F4 is dead.

With my F3 I would have had the option of a mechanical film advance, a mechanical shutter speed, plus the silver-oxide cells in the body to independently power the electronics. The F4 runs only on AA batteries with no backups. The telltale warning sound of a slowly advancing motor-drive is disguised in the Continuous Silent mode, because film transport is purposely slowed and muted. Because I had put in a fresh set of AAs within the last ten rolls I had not heeded the F4's single light on the battery check the previous night. I carefully read the manual to see what one dot showing meant instead of two. Although the manual suggested replacing batteries when only one dot showed, I was hesitant to change after just ten rolls. I thought perfectly good batteries might show just one light on a cold morning in the Himalaya when their output was lower than normal.

When I pull out the dead batteries, I see printed on them, "Union Carbide, Bhopal, India." Even though I just bought them, I have no idea of their age or quality. The F4 previously used three sets of U.S. alkaline batteries for ninety rolls of film in warm temperatures without use of auto-focus. The next night, I awake from a nightmare about a world in which everything runs on AA batteries—cars, cameras, computers, air conditioners, electric lights, and television sets. People spend a good part of their lives replacing AAs and trying to get them all installed the proper way.

The lack of a backup is the only design flaw I have found in the F4, and it is not a serious drawback. Very few F4 users are going to have their camera go dead when they get treed by wild buffalo after the word gets around that they should always carry an extra set of AAs. However, this extra weight adds to the F4's existing weight problem, which, like that of human beings, is not as noticeable in the city as it is on those remote excursions that outdoor photographers like to make. An F4 body with the MB-21 motor weighs in empty at forty-five ounces and at fifty-four ounces with two sets of six AAs. An F3 without motor nudges the scale at just twenty-five ounces; the manual FM-2 at only nineteen ounces; the newer N90 at twenty-seven ounces.

After coming back from my round-the-world jaunt with a splendid set of images, but a tired shoulder from lugging a huge bag of mixed AF and manual lenses, I decide on a final test that a biologist would call a deprivation experiment. I venture on my next journey, a week's shoot in Guatemala, without the F4.

As I try to focus on moving figures in murky market scenes, and to fuss with the ISO to fool my F3 into the proper fill-flash ratio while fighting its low 1/80th synch speed, I long for the F4. I imagine all sorts of creative situations in which I can use it. I also figure out that I can take nearly full advantage of the F4's potential by carrying just two AF lenses in addition to my manual ones. I plan to use an AF 24mm $f2.8$ and the fine AF $f2.8$ 80–120mm zoom.

In the final analysis, what I envisioned as a shootout between the F4 and the F3 ends up like the Russians and the Americans at the end of the Cold War. Neither one blows the other away. There's room for both in this world—and in my camera bag, where I carried an F4 and an F3 until the newer N90 came out with some of the best attributes of both. There is no question in my mind that the F4 is the parent of a race of cameras that will continue to survive and evolve further. Its offspring, like the creatures of the Galápagos compared to those of the mainland, may have an outwardly different appearance while preserving a hidden sameness within. Lenses that interchange with a 1959 Nikon F fit my F4, which in turn has a Matrix metering system that has gained a true third dimension of electronic distance information in the new N90. Who knows what the twenty-first century will bring? I do know that I can't afford *not* to be using the emerging technology.

Photographs: Pages 5, 74–75,
132, 186–87, 192–95

"Do automatic cameras therefore require more, rather than less, expertise to operate than manual ones? I am convinced the answer is yes with complex pro cameras such as the F4."

Embracing the New Technology

Using the Nikon F4 has made me think more about the creative potential of automation. In the past, I shelved a number of auto-focus SLR cameras because they delivered the worst of both worlds. In slow-moving situations I didn't need auto-focus, and in fast-moving ones the system either bombed (due to low light or lack of subject pattern) or led me down the boring path of centering all moving subjects.

Using the F4 in the Galápagos Islands, I was forced to bull's-eye distant moving subjects when shooting with auto-focus, but up closer I was able to work out creative compositions, partly because the auto-focus was so dependable that I felt comfortable experimenting with it. One afternoon a pod of dolphins swarmed the bow of our sailboat, jumping out of the water at random intervals. Because I put the dolphin's nose in the center of the frame, my images had just the right composition for a fast-moving animal: lots of open space in front of the subject with very little space behind. Similarly, I focused my close-ups of birds in flight on their eyes so as to keep the bird nicely off center in the image. I also began to break out of typical vertical/horizontal thinking in which objects are framed so that their motion is parallel to the base or side of an image. Moving subjects took on a wonderful look of visual tension when I composed them diagonally so that their motion cut a line from a corner of the frame into the centered rangefinder.

Even something as mundane as a direct shoot-out between the F4's auto Matrix metering and the F3's manual exposure mode opened my creative eye. Before the test, I was confident that my fine-tuned ability to use the F3's Center-Weighted TTL metering would beat the F4 hands down (given plenty of time to contemplate manual settings). I know what I like in an image. On transparency film, I want correct exposure for the most important highlights, a choice that had always seemed very subjective to me. In Matrix mode the F4 analyzes exposure data from five separate segments of the scene. Because bright skies are the most common cause of incorrect auto-exposure, the F4's computer senses whether the camera is being held vertically or horizontally as it "recognizes" a myriad of lighting and contrast situations. It will favor an exposure for a large, darker area in the lower part of the frame as important foreground, or drop out a very bright small area such as direct sunlight or a bright reflection.

When I put the first pair of test rolls on the light table, I thought that I must have switched them. The F4 exposures looked too good. My score card read: F4—eleven wins; F3—seven wins; plus eighteen ties. On my next test I tried to confound the F4 with weird situations of mixed light with subjects in different parts of the frame, and the score came out dead even.

The more tests I made, the more I realized that I was glimpsing a potential far beyond the simple automation of tasks I had already mastered manually. To utilize the F4's full potential, a photographer must first accept the basic difference in philosophy between the F3 and the F4. Despite the F3's LCD display of shutter speeds, it remains a hands-on camera. The operator has a sense of direct feedback from its settings. Manually metered subjects "feel" perfectly exposed; manually focused moving subjects "feel" sharp when they are and soft when they aren't.

The F4, however, views the outside world through far more indirect readouts. Although nothing is "right" or "wrong" with this approach, it is normally foreign and disquieting to those who have been conditioned by decades of hands-on photography. Once I worked through these feelings, I became absolutely convinced that the future of still photography lies in the direction of the F4, not the old F3.

Aviation provides a useful metaphor here. The differences between a basic airplane being flown by hands-on visual flight rules (VFR) and a more advanced craft being flown by instrument flight rules

(IFR) may not be apparent when the planes are viewed from afar in good weather. In bad weather, however, the VFR plane either stays on the ground or flies at great risk, while the IFR plane cruises along by means of indirect readouts. The F3 is a VFR camera, while the F4 can be either VFR or IFR.

As I made this comparison while flying from the Galápagos Islands to Bhutan via Quito, Miami, Frankfurt, and Delhi in just over one day, I realized that it would be virtually impossible to schedule connections through the bad weather that invariably is encountered somewhere along this great distance without IFR flight.

When I extend the aviation metaphor further, I confront a reality quite different from what I have been led to believe over the years in ads for "IFR" automatic cameras. Hands-on VFR pilots require far less training than specially licensed IFR pilots. Do automatic cameras therefore require more, rather than less, expertise to operate than manual ones? I am convinced the answer is yes with complex pro cameras such as the F4. The marketing premise that auto cameras are easier to use than manual cameras holds true only for simple cameras and simple expectations. In the pro world, a viewfinder full of instrument readouts is far harder to master than manual settings matched by hand and eye.

Once I let this realization sink in, the F4 beside me no longer makes me feel stupid. When I goof an "automatic" picture by ignoring a wrong setting that was staring me in the eye as a symbol in the viewfinder, I know I should have taken the time to scan the readouts before pushing the shutter release. My wife, an IFR pilot, took months to master the art of scanning a panel of gauges and dials to form a continuous picture in her mind of what was outside her window, hidden in the clouds. The feeling is quite unnatural at first. Even after a great deal of practice, a few moments of inattention may put the craft into an unforeseen spin. Similarly, to use all the F4's sophisticated instrumentation is to distance yourself from the primary experience of allowing the camera to become a mechanical extension of your senses—and artistic intentions. Gone are those almost unconscious acts of moving shutter speeds, apertures, and focus in tune with the scene before your eyes in much the same way that an experienced walker's feet follow rugged terrain without having to think.

To edit a set of these "manual" images is to relive precise moments when everything came together, but to edit images made in "IFR" with an F4 is to discover something previously unseen with clarity: to trust those instruments until you emerge from the clouds just where you hoped to be with a perfect vision before you.

Flights of fancy with the F4 are as yet unregulated by the Federal Aviation Administration or the American Society of Media Photographers. No license is required. It is up to each user to define his or her medium. Indeed, the F4 can be operated with AF lenses in Program mode in as foolproof a fashion as any point-and-shoot auto-rangefinder, but very few users are going to pay over $2,000 to lug around four pounds of ultimate idiot camera. Once people taste the fruits of the F4's Garden of Eden, they will partake of all those options again and again.

While riding elephant-back in Bhutan, I found that I couldn't make the F4 perform the same trick I use with my F3's metering system. When I am shooting wildlife that goes in and out of shadows and sometimes can be profiled against an overly bright sky, I set up an auto-exposure at the maximum speed (1/2000th) for the animal in the sun. If the animal goes into shade, the shutter speed automatically drops; if it stands against the clouds, the shutter speed tops out at 1/2000th so the exposure stays right on. The F4's 1/8000th speed is unworkable for this trick, especially with the slower color films I like to use.

Instead of scoring points for my F3, I considered that the trick hadn't been obvious when I first bought that camera. Only after years of field use did I figure it out. The F4 with its far more computerized functions must have plenty of unrevealed creative potential. Just as avid Macintosh users get together to share shortcuts and clever ideas, F4 users are going to spend many a happy field day and social evening exploring the fresh potential within their cameras and themselves.

"As auto-everything cameras gain market share, cottage industries have sprung up to make trick gadgets for people who really care about how their equipment performs."

Back to the Future

When I saw the movie *Back to the Future,* the audience roared at the gas station scene in which eager attendants rush around washing windows and checking oil, tires, and battery while pumping gas. I overheard a kid ask if there really was a time when Daddy didn't have to do it all.

In college in the late fifties, I worked in just such a station and later owned an auto shop. We fixed many cars that really needed repairs, but the most interesting were the cars that customers wanted to perform better than they did when new. We did a lot of modifying of original parts until the growing "aftermarket" offered a full range of ready-made parts that outperformed original equipment. By the time I sold out to pursue photography, Detroit had gotten the message and offered many of the "trick" gadgets hot rodders had developed as factory options. The result was not at all what I expected.

Personal involvement with equipment declined as people stopped thinking about their cars in the same active way. If their vehicle didn't perform well enough, why bother fixing it up when a down payment could put them into the driver's seat of the latest and greatest? It was unpatriotic to hint that Detroit didn't really know what was best for us. And our president was the choice of the people, wasn't he? Of course he wasn't a she, because at only 54 percent of the population, women qualify as our nation's largest minority group, except for consumers, who don't really count because at a mere 100 percent there's no room for increase in market share. This was the American way, and, sad to say, the ideology lives on today.

Photography is now experiencing a parallel evolution. As auto-everything cameras gain market share, cottage industries have sprung up to make trick gadgets for people who really care about how their equipment performs. Pros moan about top brands not addressing their real needs and top models only coming with unwanted froufrou.

The connection between photography and the movie *Back to the Future* came to mind when I was using lots of nonstandard photo gear in surroundings that reminded me of California in the fifties. Gas jockeys washed the windows and checked the oil of the tired Avis car I had rented in Punta Arenas. On the front seat was my bag full of cameras and gadgets made by cottage industries that have sprung up to improve on the likes of Gitzo, Nikon, and Duracell. I was bound for Torres del Paine (Towers of Paine) National Park in Chilean Patagonia.

I had grown frustrated with the constant looseness and wobble in the center columns of my smaller Gitzo tripods and had come up with my own fifties-style solution (see "Tripod Tricks," page 81). I had thrown the column in the garbage and bolted the ballhead of my choice directly to the best pair of slender legs in the business. Now there's a product that allows you to keep your extendable column and have it firm. Mike Kirk of Kirk Enterprises in Angola, Indiana, produces not only a special replacement column for popular Gitzos, but also a more solid main cluster to which you can bolt those great legs.

Kirk has also designed a slick, simple, and strong quick-release system. A man after my own heart, he tested one for strength by using it to pick up his son's 454 Chevy engine. He cautioned me that he had used 3/8" tripod threads rather than the 1/4" I use for my 35mm work. Mine might hold only a Honda engine.

In Torres del Paine I was eager to test a special Kirk gadget that attaches to this quick release. I was headed for Lago Pehoe, where on my first visit in 1985 I had shot the cover of my book *The Art of Adventure.* My second visit in 1990 was disappointing because most of my images made with a fine Nikon 80–200 f2.8 zoom lens were not sharp. I had just begun using a zoom again after years of abstinence because I had noticed a distinct loss of quality, as compared to fixed lenses. I had recently tested the 80–200 f2.8 in bright

light and found it to produce images that I couldn't distinguish, with a loupe, from ones made at the same time with 85mm and 200mm prime lenses. I later discovered that at slow shutter speeds or in wind like that in Patagonia my results were quite blurred from camera shake. In designing the hefty optic to be compact, Nikon didn't leave room for a tripod socket.

My new Kirk bracket attached in about thirty seconds with a ring that fits around the lens barrel and a bracket that screws into the camera body. The quick release can lock it at the exact balance point of my chosen camera/lens combo, which varies and becomes especially critical when using a 1.4X or 2X teleconverter. I was like a kid on Christmas morning as I set up fifty feet from a herd of guanacos on a green hillside below ice-draped granite spires in billowing clouds. Several condors circled above and flocks of ibis flew through my frame.

I give Torres del Paine the highest marks of any national park in the world for combined landscape and wildlife photography as well as for more general reasons. Visitors are few, animals have no fear of reasonable human approach, and photographers have no fear of unreasonable human authority. I could stop my car where I wanted without a power line or a contrail in sight and feel as if I had traveled back to the fifties with my nineties cameras and worldview.

Never mind that a skittish fox stopped in the shade. I shot frame after frame with my 300mm $f2.8$ lens and fill-flash with fast recycle yet no auxiliary battery pack. My Super Cell rechargeable AAs made in Saint Louis, Missouri, deliver far more flashes far more quickly than big-name nicads and recharge in just an hour.

Never mind that the plastic base of my Nikon N90 wobbles on small tripod heads. My special Kirk release plate makes it as firm as an old die-cast Nikon F. Never mind that I can't adjust the drop-in polarizer on my long Nikon telephotos. My Kirk gear-driven circular 39mm polarizer adjusts from the outside. Never mind handling my equipment while standing in a marsh in gum boots shooting black-necked swans. My Photoflex MFP ("Galen Rowell" Modular Fanny Pack) clings to my waist, ready as a coin changer with fifteen pounds of everything I need, except my tripod and big lens for wildlife, for spontaneous photography of the natural world. To carry more becomes counter-productive except in special situations.

Mike Kirk's down-home technology first passes what he calls the "gumption test" of whether people out in the field will really go to the trouble to use it. I agree with him fully that features we are told we can't pass up often cause us more trouble than help, because of added clutter and weight or unfriendly design. We always need to keep thinking our way back to the future.

Right: Essay pages 58–59
I began reading about the physics of light before I became a professional photographer in 1972. The following year I spotted a perfect situation in which to photograph a diffraction fringe with the shadows naturally filled by light bouncing off a snowfield below. I scaled the unclimbed spire near Mount Whitney and posed while my partner, Jeff Campbell, tripped the shutter. This straight, unmanipulated image was rarely published during the seventies, but has been used much more often during the "photo-friendly" eighties and nineties.

Above, left:
Essay pages 69–70
Using auto-focus and auto-exposure on a Nikon F4 enabled me to quickly make an impeccably sharp photograph of a Darwin's finch landing on a cactus flower in the Galápagos Islands.

Above, right and facing page:
Essay pages 64–68, 69–70, 92–93
Another marine iguana virtually disappears into the underexposed dark rock with an exposure for the turquoise tropical sea. I solved the problem by using a Nikon SB-24 flash set at -1.7 to fill in the shadows (right) with light on the reptile balanced so perfectly that it appears entirely natural until compared to the photograph above.

Above: Essay pages 64–68
While I was testing the Nikon F4 in the Galápagos Islands, my wife, Barbara Cushman Rowell, caught me photographing a marine iguana and a blue-footed booby at close range. About half of my published work is handheld without a tripod.

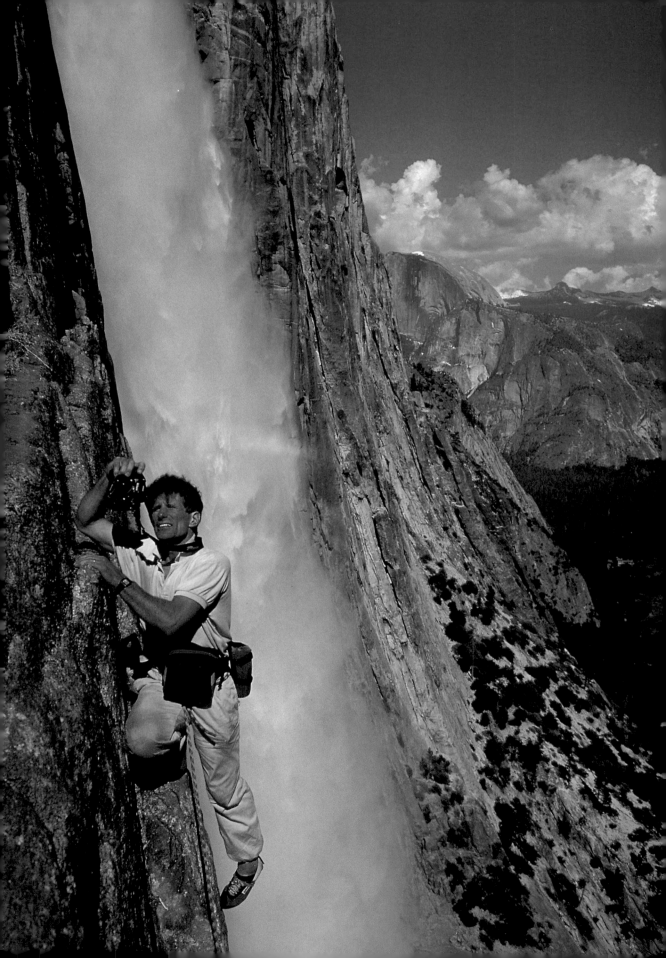

Left:
Essay pages 62–63, 103–4
I choose my camera gear, like the clothes I wear, to fit the occasion. Here beside Upper Yosemite Fall I am carrying one camera and lens in a Photoflex chest pouch that I designed for outdoor activities. In this case, however, I left a backup camera in another bag on a ledge some distance away while I worked with Ron Kauk, one of the world's finest climbers, to make photos of him climbing beneath the rainbow in the spray (see photo, page 105; text pages 103–4). Ron, who is not a photographer, shot this cover image of me at my request. I set my Nikon 8008s with a 24mm lens for auto-focus and auto-exposure.

Above: Essay pages 81, 94–95, 98–100
While I was scouting a photo workshop location in the Berkeley Hills on a run with a two-pound converted Gitzo tripod, Rob Mackinlay photographed me making a wildflower photo, while my dog, Khumbu, bounded through the grass nearby after being sternly ordered out of the picture.

Left and right:
Essay pages 82–83

When the sun began to set in Oak Creek Canyon near Sedona, Arizona, the deep shadows were five stops darker than the sunlit sandstone in the distance, a range beyond the ability of transparency films to record with acceptable detail. Exposing for the highlights (left) lost virtually all shadow detail. When I put on a special three-stop, soft-edged Singh-Ray graduated neutral-density filter (right), the range was cut to two stops and the detail in the shadows resembled what I saw with my eyes.

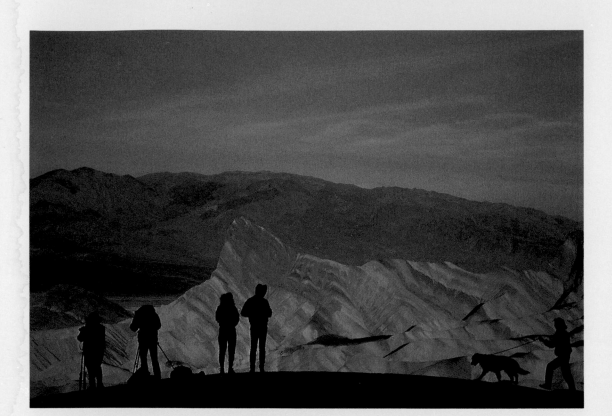

Above:
Essay pages 81, 98–100
Years of teaching photo workshops have taught me that people who are in the same place at the same time never make the same photographs, unless they deliberately copy someone else's exact composition and equipment at the scene. Here in Death Valley, two *photographers are using tripods and two are taking photos without tripods, while Barbara is running Khumbu after making pictures in better light several minutes earlier. I've moved back—still on a tripod—to include the silhouettes of these photographers with different visions into my own way of seeing.*

*"It is hard to believe the
sense of liberation that
comes from debunking
the notion that serious
photography requires a
seriously large tripod."*

Tripod Tricks

Some photographers never use a lightweight tripod. Stung early in their career by some $39.95 plastic-jointed toy, they go through life burdened like Sisyphus with the weight of a big tripod. Yes, they are guaranteed sharp pictures, but only at the expense of considerable personal mobility and loss of some of the best photo opportunities. I have found two viable alternatives to carrying big tripods. The first allows me to make sharp long exposures with four pounds of Nikon F4 on less than two pounds of tripod.

The center column is the weakest link in most tripods, and the lighter it gets the worse it is. A center column on a lightweight tripod does little except allow the manufacturer to advertise that a tripod stands taller than its real functional height. I can count the times on one hand that I have actually used the center column of a lightweight tripod in the last twenty years, but I would be well into four-digit numbers if I had kept track of all the times that unextended center columns have loosened, wobbled, and otherwise inhibited my ability to get sharp pictures.

I came up with a ridiculously easy solution. Buy a quality lightweight tripod with firm legs and a separate light ball-head. Go home, unscrew the center column, and junk it. Go to the hardware store and find a single case-hardened bolt with a few washers that will attach the ball-head directly to the tripod. You'll gain both stability and the ability to get the tripod lower to the ground without the center column interfering. You'll lose only extra frustration and several ounces of tripod weight.

For the best results, begin with a quality tripod that will cost you over $100. My choice is the Gitzo 001, which weighs in at two pounds with a new ball-head after its center column is thrown in the trash can. Barbara likes the slightly heavier and more versatile Gitzo 026, with legs designed to do the full splits, which weighs in at two and a half pounds after conversion. The original center columns of these Gitzo tripods are inadequate because of their internal looseness and inability to stay tightly fixed to the head. However, the little Gitzo legs are by far the sturdiest for their size in the industry.

The second alternative also focuses on center-column wobble. The idea is to stabilize the tripod by adding inertia to this flimsy part, which fiendishly connects directly to the tripod head. "Jim's Steady-Hook" is a beautifully tooled stainless-steel hook that can be locked into the base of the center column by means of a rubber grommet that expands by tightening a nut. I learned of it at a workshop, where a student named Jim Brick from Sunnyvale, California, presented me with his invention. Once the hook is in place, you attach a weight to it. I use a light nylon stuff bag that I fill on location with rocks, gravel, or sand.

When I tried almost the same idea long ago, I attached the bag directly to the tripod's legs instead of to its column, but didn't have as much success. Connecting the weight directly to the base of the center column is far more stabilizing, because the center column, in turn, is what directly connects to the camera body.

It is hard to believe the sense of liberation that comes from debunking the notion that serious photography requires a seriously large tripod. The image that appears on page 162 wouldn't exist without my baby tripod. It has full sharpness and depth-of-field from infinity to two feet in front of the lens, even though it was shot at f22 at 1/4 second on a Gitzo weighing two pounds.

A light tripod that can really work opens up many new horizons. I remember hearing from the owners of the Galápagos Hotel on Santa Cruz Island that the morning light was wonderful at Tortuga Bay. Camping by the bay and in most areas of the Galápagos is forbidden. You can reach the bay only by boat or by three miles of hiking trail from the town. In the past I would have either hiked there without a tripod or not arrived until it was too late to photograph dawn if I did carry one. But on this occasion, I went out for a morning run with enough predawn light to see and reached the bay in time to make several fine images as the sun's first rays touched the land. I took one camera body and a 24mm lens in a prototype of the Photoflex chest pouch I had designed, easily carrying the light Gitzo 001 in one hand.

Photographs: Pages 6, 55,
78–79, 106–9, 130–31,
154–56, 160–62, 164, 192–
94, 197, 200, 263, 268, 272

*" The position of the gradation
over the lens can give a false
impression. The percentage of
shading over the front element
does not necessarily equate to
your slide. At f 22 on certain
lenses an apparent one-third
gradation may not show at
all on the final image."*

Graduated Neutral-Density Filters

Few photographers who own graduated neutral-density filters (ND grads) know how to use them properly. These seemingly simple gadgets shift across their field from clear to neutral density, but often fail to deliver the desired exposure control in a color slide. The results are virtually irreversible. It is a lot riskier to alter density on an original color slide before the shutter is released than to experiment later by burning and dodging prints in the darkroom, as black-and-white photographers have been doing for generations.

The brief design history of ND grads reminds me of the barriers that kept computers out of the home and small office before 1980. The raw computing power for writers to move words around existed, but hardly anyone bothered with it until a better interface between human and invention was worked out. The original ND grads were about as user-friendly as a 1960 IBM card. Accessing their potential was so fraught with hassles that most early users gave up.

My success rate has gone up at least a thousand percent since I first bought an ND grad in the seventies to record more closely the colors and tones I naturally saw. The range of usable detail on fine-grained Kodak or Fuji slide films is about a stop and a half of exposure in either direction. These three stops equate to a brightness range of about 8 to 1 that can be increased to 64 to 1 with a three-stop ND grad. Although this technique opens whole new possibilities in color photography, it pales beside the eye's eleven-stop range of about 2,000 to 1.

As with all good things in life, there is no free lunch. That twenty-dollar screw-in grad from a popular aftermarket filter company is likely to give you garish off-color, a split down the middle where you don't want it, and vignetting of the corners with that 20mm lens you like to use to get full depth-of-field from shadowed flowers to sunlit mountains—a typical situation that calls for a graduated filter. ND grads are normally sold in only one- or two-stop

shifts, but three stops are often necessary to balance deep shadow with sunlight.

Let's say you've solved all these technical problems and now hold the perfect filter in your hand. It won't help you unless you can previsualize exactly where the shift will fall. You expect to see the gradation clearly through the viewfinder, but when you put it over your lens, only the barest hint appears. This is also due to your eyes seeing a greater dynamic range than your film can record.

The position of the gradation over the lens can give a false impression. The percentage of shading over the front element does not necessarily equate to your slide. At f 22 on certain lenses an apparent one-third gradation may not show at all on the final image. What counts is only the part of the filter in line with the image coming through the diaphragm opening. Original designers of screw-in grads gave them a 50–50 split so they would work to some degree with any focal length or aperture.

A further complication is that when you hold these filters up, they appear to be split at the light side of the gradation, but the edge you see on your film is near the dark side. What looks like a 50–50 split in the hand might well be a 40–60 or even a 35–65 split on your slide. This has dire consequences where the gradation is intended to hold down a bright background with a sharp boundary above your subject. If the edge ends above where you thought you put it, you'll have an unnaturally bright band that draws attention away from the intended subject.

Whether you are using the set gradation of a screw-in filter that can be turned sideways but not adjusted up and down, or the more adjustable edge of a square filter in a special holder, the position of the gradation and its effect can be best visualized through an SLR camera with a depth-of-field preview control (missing on cheaper SLRs these days). Here's my method:

Set your aperture for your final exposure if it is $f8$ or higher (as is normally the case for landscapes to achieve good depth-of-field as well as lens sharpness). Hold the depth-of-field preview button down while turning the filter slightly back and forth on the lens with your other hand. With motion the gradation will become far more visible. If you still can't see it well, aim the camera temporarily at a continuous tone area such as grass or sky. In the rare event that you want to use a grad with a wide aperture below $f8$ (a moving wild animal or human figure, for example), first stop down the lens to where you clearly see the gradation, then slowly open the aperture and watch how the line of gradation recedes rapidly. You'll see where it falls far more easily as it changes position. On a typical wide-angle lens, a setting for a 50–50 split at $f16$ darkens less than 10 percent of the frame at $f2.8$.

Color fidelity is poor on the most commonly used, lower-priced filters. Many are not even labeled as true ND filters. Sold as graduated gray, they have a magenta or brown shift that becomes especially severe with high-saturation films such as Fuji Velvia. Every one of the dozen brands of gray or ND grads I have tried in the price range below $50 is simply not acceptable for my work in terms of color fidelity. Many of the higher-priced grads are color-neutral, but their configurations have never been satisfactory for me.

After trying a number of expensive filters with carefully controlled spectral response, I chose Singh-Ray grads because they not only had true color and fine optical quality, but also were available in custom configurations. Most major companies offer only the few filters listed in their catalogs, but Bob Singh told me on my first call to his Venice, Florida, shop, "Just tell me what you want and we'll make it for you. We do that for anyone. You photographers know what your needs are better than we do." For me, this made the key difference over other quality grads in the same $100 range as Singh-Ray. I worked with Bob for over two years to come up with just the right set of filters to match the most common high-contrast situations in nature. I doubt I could have succeeded in making the tricky photo that appears on page 79 with any off-the-shelf filter.

I no longer carry any screw-in grads. They're far too limiting. I pack what Bob now markets as "Galen Rowell" sets of either two or four Singh-Ray rectangular ND grads. They are custom-sized 84mm by 120mm to fit a Cokin P holder. The extra length permits unusual 90–10 or 10–90 situations, such as a field of wildflowers with only an edge of brightly lit mountains in the background, or a range of mountains with a vital subject in a narrow strip of shadow.

Each of my four filters serves a different purpose. When I go light and carry just two, I choose one that has a soft, gradual shift from clear to a two-stop gradation (especially useful where the boundary between light and dark is not straight, as in the increased sky detail above a meadow on a cloudy day on page 164). My second filter abruptly changes from zero to three stops across only 5 percent of its area for use in sunrise or sunset situations with hard-edged shadows (page 6). Unlike a soft-edged filter, this filter adjusts light values between discrete zones without an unnatural shift across an even sky.

On serious photo assignments or personal expeditions I feel naked without the full set of four grads. A three-stop filter with a soft gradation is harder to use without the edge being noticeable than a two-stop, but invaluable where strong shadows fall alongside rough lines of rocks or trees (page 79). The fourth filter is a two-stop hard edge for sharply defined but more open shadows where the lighting contrast is less than three stops (page 160). Pound for pound and dollar for dollar, these four one-ounce filters have given me a greater return in both dollars and otherwise impossible images than any other equipment I own.

Photographs: Pages 118, 154

" It sounded like good advice the first couple of times I heard it. Then it ran the gamut from sounding repetitive, absurd, very absurd, and funny to sounding clever and, ultimately, very effective."

Crash Course to Perfect Exposures

I learned how to ski the same way I learned how to photograph: by going out and making lots of mistakes. The two skills have much in common. Both require a triple mastery of mind/body/machine coordination. Instructors in both fields, whether teaching or writing, tend to confuse their adult readers and students with unnecessarily complex explanations of basic maneuvers that children, on the other hand, can learn quite naturally. There's an insider's joke that ski magazines keep recycling a hundred different descriptions of how to make the same turn. Photography has a similar problem. Writers and manufacturers overload us with at least a hundred ways to make the same exposure determination.

The danger here is that you'll stifle your creativity by getting locked into one particular method that is unnecessarily technical, especially if you consider it as gospel and use it all the time. One photographer may always go out in the field with a gray card, while another always uses a $600 handheld spot meter; yet both use cameras with built-in meters.

A few years ago, I dropped in for one day at a week-long clinic held on the steep slopes of Squaw Valley, the ski equivalent of an advanced photo workshop. I expected to hear a litany of complex jargon during critiques of each skier's technique. Instead the instructor surprised me with a disarmingly simple approach. For the entire day he gave only one piece of advice to us advanced skiers. For every situation, no matter how different it appeared, he told us, "Face down the hill!"

It sounded like good advice the first couple of times I heard it. Then it ran the gamut from sounding repetitive, absurd, very absurd, and funny to sounding clever and, ultimately, very effective. No matter what skiers in the clinic were technically doing wrong, they improved immensely by simply disciplining themselves to keep their torso aimed down the fall line.

I began to wonder if there wasn't some similarly simple message for photographers to help them make proper exposures with color transparency film. The ski instructor's advice was successful because he knew enough not to give it to rank beginners. Everyone in the advanced class was capable of facing down the hill all the time, but no one had ever been forced to do it all the time. But ask beginners to do the same thing on a steep slope and they would almost certainly fall on their face. This idea led me toward a simple and unoriginal phrase that would be wholly inappropriate as a single entry on the exposure page of a camera instruction manual: *Expose for your most important highlight!*

State-of-the-art computer-assisted automatic exposure systems try to do this, but often fail because they can't assess your personal, subjective decision about the most important value. Once you make that decision, you need to be able not only to expose your image correctly for that highlight value, but also to compose it intelligently with the knowledge of where surrounding values will fall. In the example at the bottom of page 118, an exposure for the climber and the foreground rock makes the bright sky and snow peaks turn out unacceptedly overexposed. I solved the problem by recomposing to include very little of the background. At the top of the same page is an image made during the same minute by changing my idea of what was my "most important highlight" and rethinking both my exposure and composition, although I still had the same climber on the same rock in the frame. Recomposing to make the background highlights dominant solves the problem.

When I describe getting different pictures like this out of the same situation, some photographers mistakenly say, "That's the Zone System in color." But there's a major difference here. Ansel Adams's black-and-white Zone System depends on the ability to compress or expand tonal range through printing and development. With color transparencies the tonal range is fixed and the exposure method can be stated far more simply. My method does resemble the Zone System in the way that it forces a photographer to previsualize the relationship of tones in an image before pressing the shutter button, which is the exact opposite of the purpose of auto-exposure systems designed to avoid further consideration of tonal relationships once a composition has been initially selected. Although this exposure method adds an extra step in the creative process, I find it absolutely vital to much of my best work.

To go through this process every time you make an image isn't practical, and there are some useful corollaries to the basic rule. If the most important highlight is also the brightest highlight, any through-the-lens meter will give you an accurate reading so long as the subject is reasonably large in the frame. On the other hand, if your chosen highlight is not the brightest highlight, then a red flag should go up in your mind. First, you need to get a special exposure reading for your manually selected highlight or from a sophisticated automatic exposure system that you are sure will favor your chosen area. Second, you should consider whether your image needs to be composed differently in order to draw your viewer's attention into a less bright area of the image, as I did with the example on the bottom of page 118. Third, you need to consider how far overexposed those brighter areas will be. If it's just a little bit—say a stop or so—then you may be able to get away with having more open bright space around your subject than if the background is several stops brighter than your chosen highlight.

When properly used, the expose-for-the-most-important-highlight method gives you the best of both worlds. When your chosen highlight is also the brightest, you can casually fire away on automatic, just like any point-and-shooter. But when you recognize that your chosen highlight is not the brightest (or is too small or out of position for your camera's auto-exposure system), slow down and think out your image in detail. You'll be well on the road to attaining the consistency and variety of results that separate artists and working pros from snapshooters.

Fine-Tuning the Film Palette

On the twentieth anniversary of my first purchase of a single lens reflex camera in 1968, two memories rose above all others. I remember how seeing through the lens seemed like a miracle to me and how I never questioned making all my outdoor photographs on one film. I used ISO 25 Kodachrome II (KII) for wildlife, people, scenics, night photography, and sports. The combination of using a single film and actually looking through the lens led me to the decisive exercise of teaching myself to see like film (in the visual language of KII, of course).

In 1974 my vision was temporarily impaired when KII was discontinued. Two new emulsions, Kodachrome 25 (K25) and Kodachrome 64 (K64), offered slightly greater tonal range and a bit less color saturation. Ernst Haas bought a thousand rolls of the old KII to store in his freezer.

For the next decade the two Kodachromes ruled the 35mm outdoor photography market, but when Fuji Pro 50 and Fuji Pro 100 hit the U.S. market at the 1984 Olympics, long-standing assumptions about Kodachrome's innate superiority were challenged. According to the common wisdom, any E6 film such as Ektachrome or Fujichrome had a more grainy appearance, because the dye couplers must be incorporated into each grain instead of being introduced in the lab as in clever, complex-to-process Kodachrome. Fuji Pro 50's sharpness is on the order of K64, though one drawback is less archival stability (roughly half of Kodachrome's one hundred year's dark storage). Both Fuji films offer greater saturation than Kodachrome, with similar exposure latitude and visible grain.

My quadfocal film vision was just up and running when along came test samples of Kodachrome 200 (K200) in 1986, further blurring the Kodachrome/E6 Divide with better color saturation than K64 but with more grain than Fuji Pro 100. K200's high contrast is fatal at high noon, but the film comes into its own in

soft, low light, where it makes details pop with snappy contrast in the highlights.

In 1988, Fuji discontinued old Pro 50 and Pro 100 in favor of new emulsions with the same names designed for better push-processing. In adding this ability to the chemistry, Fuji slightly subdued the film's high saturation and fine tonal separation, making them a bit less suited for landscapes. I mirrored Ernst Haas's rush for the freezer with a stash of old Fuji Pro 50, but not Fuji Pro 100, after making exhaustive comparisons against ISO 100 Ektachrome Plus Professional (EPP) as part of a Kodak prerelease trade test. At first glance, the images I made with EPP looked very close to those shot on Fuji, but the differences were significant. EPP had the cleanest whites of any transparency film I had ever seen. Grain and sharpness looked identical to Fuji Pro 100. Color saturation was less extreme in the greens. I would have made EPP my single film of choice if only Kodak had offered it in a fine-grained slower version with an ISO of 25 or 50. It is a fact of film design that film grains get larger as ISO ratings go up because they need to have greater light-gathering ability. But Kodak chose to stay at ISO 100 to maximize sales rather than quality.

I began to experiment with EPP. When I needed a faster film I tried having EPP push-processed to ISO 200 and discovered that I liked it better than K200, especially in aerial photography. EPP's higher saturation, combined with the increased contrast that results from a one-stop push, produces a snappy look in soft light beyond anything I've ever seen on any Kodachrome. I gave up using K200 except when I wanted a grainy documentary feel, which I liken to Tri-X in color.

In my search for renewed simplicity the score was two films down, four left. My next logical elimination surprised me. K64 had been my journalistic standby, yet in my tests, I preferred the look of EPP over K64 in virtually every one of these situations.

I continued to use K25 in perfect light where neither extra speed nor saturation was a major factor. K25 holds a slight edge over K64 in sharpness and latitude, delivering the sharpest and most archival image of all the films I've mentioned so far. When I needed more color saturation for a landscape image, I used Fuji Pro 50, often shooting the same scene with it and K25 loaded in separate cameras.

From 1985 to 1990 I was faced with Solomonic choices between stronger colors with slightly more grain on films that would fade sooner and less intense tones on sharper, more archival Kodachrome. I disliked having to delay my decisions from the field to the light box, where I usually ended up with a Fuji or Ektachrome to publish and a less vibrant Kodachrome to keep for posterity. As one frustrated top pro put it, "Who wants dull, boring pictures that last forever!" I endured going on outdoor assignments with three cameras loaded with EPP, K25, and Fuji Pro 50 and trying to limit myself to the three separate visual languages of these films.

I fondly recalled my singular KII visions of twenty years before and began speculating about films of the future. I saw a chasm to be filled in terms of a sharper high-saturation slide film. Throughout my travels and through my column in *Outdoor Photographer*, I had heard from both amateurs and professionals interested in photographing the natural world who were profoundly unhappy with films that continued to favor the Fotomat fare of faces and flesh tones over vivid renditions of nature. As a consultant to Kodak's Professional Products Division, I communicated this pressing need over and over again to every tech rep and manager with whom I dealt. Some of them took my appraisal of Fuji's superiority in many areas as a sign of disloyalty. I tried to give Kodak every benefit of the doubt when, in 1988, I ended a column in *Outdoor Photographer* with these words:

> I dream of a Kodachrome with the color palette of EPP 100 and the ultrafine "T-grain" technology of modern B & W films. With this addition, Kodak would unquestionably be king again. Other films might sell better and be more suited for specialized applications, but photographers would know which way to turn when they needed an ultimate fine-grained, archival, state-of-the-art, high-saturation transparency on 35mm format. A lesser dream, perhaps more quickly attainable, is for a finer-grained, slower E6 film that can deliver the saturation of EPP or Fuji 50 combined with sharpness equal to or better than K25.

*"When I went out to shoot
more Velvia after my first
test, I felt as if I were
behind the wheel of a new
sports car on an empty
road on a clear morning.
I was excited right down
to my bones."*

Velvet Media

After driving Chevrolets for twenty-five years I remember the eerie, disconcerting feeling I had driving out of the showroom with my first Japanese car. It simply drove much better than comparable American models of the time. I switched to a Japanese car after General Motors had spent its dollars trying to market image, rather than conducting research and developing new products more suited to the needs of its customers.

Kodachrome was once the Cadillac of color slide film. Twenty-five years ago it was the finest money could buy, but perhaps no other technology that recorded light or sound for mass market had stood still for so long and remained on the market. Quantum leaps in technology were frequent in audio, video, color negative films, black-and-white, and faster color positive films, but not in the realm of slow, fine-grained emulsions that 35mm outdoor photographers really need. The images I made on ISO 25 Kodachrome II between 1965 and 1975 are in most cases technically superior to any other work I did between 1975 and early 1990, especially when blown up to poster or exhibit print size.

After twenty-five years of using Kodachrome whenever sharpness was of the utmost importance, I abruptly gave up on it in February 1990 after seeing tests of an amazing new slide film from Japan. Fuji's introduction of ISO 50 Velvia at the Photo Marketing Association show in Las Vegas was kept so secret that even the company's own sales reps had no inkling of the new product at meetings held a few weeks earlier. The samples I saw on a light box fulfilled my dream of having just one slide film with great sharpness and saturation that could be reliably processed in a day.

After I returned home, I ran controlled comparisons of Velvia against Kodachrome 25 (K25), Kodachrome 64 (K64), and Fuji Pro 50. On my own light table the next morning, I clearly saw the end of an era (page 108). Velvia was the best of all existing

worlds. Its resolution exceeded that of K25 and the other test films in high-contrast tests simulating daylight and equaled K25 in soft light. Its color saturation and separation of tones exceeded those of Fuji Pro 50 and the other films. I was aware that many photographers would prefer Kodachrome's relatively muted colors, but I believed much of this was due to a conditioned constancy illusion that Kodachrome slides accurately represented the natural world. I knew better and fully expected Velvia to establish a new constancy illusion with picture editors and the public.

The exposure latitude of Velvia equals that of the other films, yet it produced far richer blacks (page 115). Its granularity rating of nine equals that of K25, and exceeds K64's ten, Fuji Pro 50's eleven, and K200's sixteen. The grain often looks tighter than that of K25 because it doesn't build up as much in dark, continuous toned areas such as blue skies or facial shadows.

When I went out to shoot more Velvia after my first test, I felt as if I were behind the wheel of a new sports car on an empty road on a clear morning. I was excited right down to my bones. I wanted to see the world freshly through this new tool and to push it to the limit to see what it would do.

Over the years, the limitations of other films had caused me to consider certain kinds of subject matter and lighting as impossible. Murky renditions of greens in shadow under a blue sky on Kodachrome become vivid on Velvia. Fuji Pro 50 renditions of delicate foliage have very strong color, but also a lack of resolution that calls attention to itself, especially when compared with K25. Velvia holds both color and sharpness, living up to its strange name, a contraction of "velvet media," a bit too close to Velveeta to suit American ears.

I soon began asking, "Is anything wrong with this film?" not only to myself but to other users. The few negative answers have to do with too strong colors and a slower film speed than the advertised ISO 50. I have found it to be a bit slower than older films. Instead of shooting it at ISO 64 as I do with Fuji Pro 50 to get richer tones from slight underexposure, I set my camera right on ISO 50 for rich colors and on ISO 40 for more open shadows. Only part of my change in settings is due to actual loss of film speed. I no longer need to underexpose because of the film's ability to produce rich blacks and saturated colors at normal exposures. Although I love the saturated color, I admit to a nagging feeling that Velvia makes things too easy. Did I waste all those years learning how to tweak Kodachrome colors with a polarizer, a different ISO setting, and a curfew on sunny scenics from 9:00 A.M. to 4:00 P.M.?

Looking back, I can clearly see what led me away from shooting just one film. My favored Kodachrome II was replaced in 1974 by two less saturated new films with lower silver content: K25 and K64. I used them almost exclusively for the next ten years until Fuji Pro 50 appeared with richer color, but slightly less sharpness. By 1987 I was shooting a confusing medley of five films that were not as good as my old Kodachrome II for fine landscapes that needed high saturation and ultimate sharpness.

Since Velvia arrived, I have been shooting major assignments with just one film again. If I need something faster than ISO 50, Velvia pushed one stop holds better sharpness than any normal 100-speed film. When pushed to at ISO 200, a two-stop push that Fuji does not recommend, Velvia shows an increase in warmth and contrast that, although not accurate, is highly pleasing in the kind of cool, flat light wildlife photographers often encounter before dawn or after dusk. The results look much sharper than those from any normal ISO 200 film. (See my dog, Khumbu, in the ivy on page 114.)

Will I use Velvia for the next quarter century? All I can say is that I am loyal not to any particular brand, but to products that work for me. I loved that Japanese car, but I later bought a Chevrolet Suburban truck for my work because it suited my needs. No other company had a comparable model at the time. My secret wish is for a full-on film war of fine-grained emulsions between Fuji and Kodak. If it happens, we'll all have more of those splendid days when the world seems young again as seen through the fresh visual language of a newly born film.

Photographs: Pages 108–9, 160–61, 196, 251

"We get into trouble when we assume those clean colors we see will come out on film. Unless a film can saturate colors beyond the range of degradation of the cast that is present, it will fail to give us tones anything like what we see."

Seeing Saturation

No film delivers color exactly as we see it, especially in the outdoors. Early in my career, I realized the sense of power and clarity that comes from seeing strong, saturated colors. I began to pursue them in the natural world with a personal ethic: I would manipulate color only to tune into my real perceptions of it. In other words, I might darken the blue of the sky to separate out a cloud with a polarizer, but never simulate a sunset that wasn't there by putting an amber filter over my lens. I would either accept the way film inherently produces different colors in many situations as a valid visual foreign language and make no color adjustments, or change the color only in the direction of what I was seeing.

The new high-saturation films have made my work easier. I use a polarizer with Velvia about a tenth as much as I did a decade ago with Kodachrome. Films with increased color saturation have not been universally accepted, however. Photographers need to choose the film that best suits their particular use.

When Velvia was introduced some photographers began to ask me if Fuji might have taken a good thing too far. "Aren't Kodachrome colors more accurate?" was a quite common question. I had no easy answer. At least four separate realities come into play here: the chemistry of color films, the physiology of color response, personal preference, and the conditioned acceptance of the fixed color palette of existing films.

The fact that outdoor photographers compare Kodachrome and Fujichrome exposes an important aspect of the problem. Neither of these films are color accurate. A studio photographer shooting a clothing catalog with controlled lighting will usually choose Ektachrome 100, which produces hues more closely almost every time. Note, however, that I've used the word hue, which has an entirely different meaning than saturation. Hue is the tint of a color, defined as a precise range of spectral response. Saturation also has a clear definition, but one that gets murky, so to speak, in outdoor situations. Saturation is the degree of intensity of a color as measured by its freedom from mixture with other colors.

Take Ektachrome 100 out of the studio and into the wilderness, and the results become flat and listless in natural lighting that is less than ideal. Although the film has quite accurate hues, it has much lower saturation than either Kodachrome or Fujichrome Velvia, and it literally pales beside them in distant scenes without close foregrounds.

High-saturation films that can exaggerate colors in studio situations often render natural landscapes closer to real perceptions. Take, for example, an early fall scene with a mixture of green, yellow, and red leaves. In a close-up of the forest floor taken under a cloudy-bright sky, the colors appear vivid and well separated, both on film and to the eye. The trouble comes when we try to photograph the leaves, still hanging from the trees, as part of a broad and more distant landscape. Their color and tonal separation suffer more than mere size reduction can account for. Why? Because at a distance through the atmosphere, actual saturation has decreased. Particles of dust and moisture in the air weaken the purity of the preceived color. Also, refraction of sunlight in the sky creates a bluish cast that especially alters yellows and greens. We usually make our favorite scenics during the hour around sunrise or sunset, when colors gain saturation because the darker sky refracts a lesser percentage of blue light compared with direct sunlight.

Individuals vary considerably in the way they perceive color, especially the 8 percent of the male population that suffers some degree of color blindness. But even those of us blessed with "normal" vision do not see things as our cameras do.

True seeing includes perception. All too often we look without seeing. We look when we turn our eyes in a direction, but we only see when we perceive and interpret what our eyes are looking at. Perception

allows us to single out parts of a scene while ignoring those distracting backgrounds that our cameras so religiously record. But perception also includes color constancy illusions that alter our impressions of hue and saturation. As we stand there in that fall forest, we perceive the leaves on the distant trees to have the same color saturation as those on the ground beside us.

Perception attains color constancy by an automatic balancing system that adjusts each situation anew. Film records color in a fixed manner. Outdoor film used under artificial light has a strong yellow cast that degrades the saturation of every color except yellow. Our eyes "auto-balance" this cast away in the real scene, but not in a photograph. In a similar way, shifts in the color temperature of light in the natural world are constantly degrading the saturation of the colors we perceive there with our eyes. We get into trouble when we assume those clean colors we see will come out on film. Unless a film can saturate colors beyond the range of degradation of the cast that is present, it will fail to give us tones anything like what we see.

I began to understand this process after many failures with early color landscapes. Through experimentation, I taught myself tricks to increase both actual saturation and apparent saturation. The former is a measurable increase of a given color stimulus on the film, while the latter has no such increase except in the way the color is perceived.

A low angle of natural lighting is important in maximizing actual saturation. A polarizer, used correctly, aids saturation by cutting surface reflections and blue from the sky that would otherwise mix with a color source to lessen its intensity. Dark backgrounds create an apparent increase in saturation without any actual change in the color source. Quality camera lenses maximize saturation by precise color transmission and control of flare that would otherwise add a random mix of light to an image.

In workshop critique sessions I often see the painfully obvious difference between images shot by different students in the same place at the same time on the same film where one image has been taken with a bargain zoom lens and the other with a quality fixed lens. The visual difference looks suspiciously similar to a comparison of images made on higher- and lower-saturation films. In both cases, weakened colors appear to merge together because of saturation loss. The effect is cumulative. A poor lens, a film with low saturation, and a distant subject under a blue sky at midday add up to a disappointing photograph. A high-saturation film mitigates some of the other negative effects, thus giving an outdoor photographer more usable hours of the day and more leeway with murky air and distance.

Another complication is that we photographers take on a color constancy illusion about the particular film we use. We rarely judge photos of the natural world directly against that world. Instead, we compare them to a mental image based on our earlier photographic renditions. Thus a high-saturation film like Fuji Velvia is first judged more by how it compares to the illusory standard of Kodachrome rather than by how well it matches the perceptual reality, so hard to define, that we set out to record when we started taking photographs. I don't have to explain why I'm now fielding questions about whether Kodachrome colors have gotten weaker.

Photographs: Pages 56, 74–75, 116–17, 129, 165, 187, 189–91, 218–19, 260

" If your artificially lit shadows are as bright as your naturally lit highlights, the resulting image will always appear overlit."

The New Fill Shooters

A quiet revolution transformed editorial photography in the late eighties. You saw it on the pages of every news magazine, if you knew what to look for. Color photojournalism used to reflect two polar opposites, neither with much relevance for the outdoor photographer who wished to portray the natural world with a blend of artistry, quality, and authenticity. One style, from the heyday of black-and-white, caught the height of the action in gritty, grainy, harsh tones on fast film with available light. The other, the eighties photo-op, used big lights, gels, and assistants "on location" to contrive a situation that otherwise would not have happened.

Now, thanks to auto-balanced fill-flash, we are seeing an ever increasing number of authentic "found" images made at the height of the action on fine-grained, slow films with perfect fill light. The revolution came because of "smart flash" that not only creates auto-balanced fill light while shooting happily away on automatic, but also allows the creative control of adjusting the fill ratio.

One reason the use of flash combined with natural light in outdoor work has lagged far behind its ubiquitous presence in photojournalism is that the faster turnover of news images has sped up the pace of the evolutionary transition. Outdoor photographers shoot for next year's calendars or next fall's magazine stories and don't get feedback on their work for some time, while newsies receive instant gratification or rejection from their editors. They realize more quickly if their work is behind the times.

In the leisurely world of outdoor photography we almost never think of using flash when we have the beautiful glow of warm, natural light. We go about shooting from every possible angle with different lenses and exposures, but we rarely tinker with the light itself. In editing, our shots that don't work are simply passed over. The process has created loopholes in outdoor coverage that are only now, if you'll pardon the pun, beginning to be filled.

When natural light is ideal for landscapes, close-ups of people or wildlife don't always work because shadows and contrast are too strong. If we pick out our very top images of dramatic light in nature with people, we usually wind up with the Sierra Club calendar look in which figures are distant, poorly lit, virtually unrecognizable silhouettes that serve as icons of human presence. Close-ups of the same, poorly lit, unrecognizable figures are simply poor photographs.

The two images on pages 116-17 illustrate the problem and its solution. At a distance, the figure of the climber becomes a graphic element of the composition that doesn't require shadow detail. A close-up of the same climber in the same light doesn't work until the shadows are filled, as in the second frame. I made the first image in Matrix mode on automatic with a Nikon F4 and an on-camera Nikon SB-24 flash, the unit that began the smart-flash revolution in 1988.

Automatically metered through-the-lens flash has been with us for a long time, but manufacturers used to take it for granted that most photographers wanted fully lit scenes of their family or friends and would prefer more automation over more controls to adjust. Mixing on-camera flash with daylight was about as user-friendly as a tax return. Years ago I stopped using auto-flash in daylight except for emergencies, because I got hideously overlit, blue-white highlights glaring out of those dull scenes. Out of desperation I had used a flash to avoid these highlights in the first place. My rare successes were accidents in which my flash didn't fire at full power or my subjects were slightly out of range.

The Nikon SB-24 allows not only simultaneous metering through the lens of both flash and ambient light, but also the ratio between the two types of light to be manually set. This last item is crucial. If your artificially lit shadows are as bright as your naturally lit highlights, the resulting image will always appear overlit. Because slower transparency films show some detail in the shadows up to about two stops under proper highlight exposure, a fill ratio of about minus 1.7 is a good starting point to create the proper subtle balance for flash in outdoor landscapes. Except for critical professional work, the -1.7 ratio can be plugged in and left alone.

By making some extra manual settings you can simulate the effect of auto-balanced fill-flash with any camera that has manual ISO and shutter speed settings combined with any automatic flash (page 129, below). Begin by setting a manual exposure for the ambient light. Make sure that your shutter speed doesn't exceed the flash synch capability of your camera. Also check that your chosen aperture isn't too small for the power of your flash unit, but before doing this, jump ahead one step and set your film speed two stops higher (directly on the camera with a dedicated unit or on the back of the flash with an automatic but nondedicated unit). Now you've gained more effective power and distance because you've asked your flash to fill in less light than normal. Your manual exposure has been set by the proper film speed, so resist the urge to fiddle with it.

Let's run through a hypothetical situation. Suppose you've finished shooting a sunset over the ocean when you notice great color in the clouds above a shore bird that tolerates a close approach. You put your camera on a tripod, make a manual exposure setting for the clouds of f5.6 at one second to hold depth-of-field, then you switch film speed from 100 to 320 to fool your dedicated flash into delivering 1.7 stops less light. You are ready to shoot away after considering a possible exception: If you're using Kodachrome with a long exposure of one second or over, you may have to use a higher fill ratio to compensate for slower exposure due to film reciprocity failure. Fuji Velvia loses less than half as much speed on long exposures. Once you get the hang of how to do smart-flash manually, you'll lust for a camera that will do it all automatically for you.

*"Even if I don't end up
with a publishable photo
or two, I've still gotten
some healthy exercise
and exploration of a
trail. I know if I want
to come back at a slower
pace with a backpack
full of cameras."*

Photography on the Run

For years I kept photography and running separate. If I saw remarkable light and form on a trail run, I would say, "If only I had my camera," knowing in my heart that I never would have reached that place at that time had I been carrying a backpack and my camera gear. Since then I have found a way to carry a full-sized Nikon SLR while running in comfort. The secret involves a combination of the right chest pouch and the right neck strap.

When I first experimented with making photographs during runs, I went for the lightest possible camera. I used a Minox 35 that weighed 6.6 ounces and was barely larger than a pack of cigarettes. It took fine full-frame 35mm slides, but not being able to use my favorite 24mm and 85mm focal lengths and not having through-the-lens viewing meant quite a low percentage of quality results. I gave up my idea of running with a camera as a lost cause.

A few years later—in 1978 to be exact—I wrote about a fine camera pack in a magazine column and received a visit from the bag's designer, Dana Gleason, of Bozeman, Montana. As he demonstrated several of his designs, I didn't give a second thought to the elastic neck strap he left for me to try. Just before he left he said, "You'll be surprised how much weight this will take off your neck."

It sounded too gimmicky to me. I couldn't see how elastic could take weight off my neck, but as soon as I tried it I noticed right away that the normal shock of my camera bouncing up and down virtually disappeared. I thought out loud, "I could even run with this!" And so I set off on my usual six-mile run through the Berkeley Hills with a Nikon FM and 24mm lens attached to one of Dana's neck straps and prototype chest pouches. To my surprise the camera clung to me like part of my body. At an easy running pace I hardly felt the camera, but when I later tried to wear it at close to race pace, I learned it had some limitations after all. Normal six-minute miles

would drop to 6:20 or 6:30, and I had to hold onto the case with one hand. However, on cruising runs at a slower pace I almost forgot I was wearing my camera.

The camera chest and lens pouch system I use today is based on my own design ideas after years of frustration with what was on the market. When my new F4 simply wouldn't fit into my old chest pouch, I decided to see if I could work with a company that would listen to my design ideas and develop a line of camera bags suited for adventure photographers who were outdoor participants rather than spectators. Photoflex was interested, and I worked together with its designer, Hans Wain, to invent a chest pouch system for running and action photography with compression straps and modular components. By adding a special lens pouch on my chest strap I can bring an extra lens or two plus film and filters and still keep the weight to five pounds. We also produced a modular fanny pack-shoulder bag-backpack system for carrying more gear in the wilds.

I don't run every day with a camera strapped to me, but whenever I anticipate great light or scenery, especially in wilderness areas, I strap on my camera, plan to cut back my speed 5 or 10 percent, and try to time my runs to be in the right place at the right time for the best photography.

One morning in the Canadian Rockies, I set out to do a mountain run up Mount Temple from Moraine Lake, 5,500 vertical feet below. When I left the lake in predawn twilight, I debated whether to take my camera because the sky was mostly overcast. At the last minute I strapped it on, and an hour later I made one of my all-time favorite photos of alpenglow across a meadow below Sentinel Pass. I braced my camera on a rock beside a stream crossing in order to get enough depth-of-field to hold sharpness in both the foreground and the background (page 106).

I did not use my running rig to take what has become my best-known photograph, but I would

never have made that image of a rainbow over the Potala Palace in Lhasa, Tibet (pages 264–65), unless I had developed the discipline of running with a camera. When I saw the rainbow in a field well to the side of the palace, I began to run with my shoulder bag of camera equipment to try to line up the rainbow with the palace roofs. After a few hundred yards at 12,000 feet, I realized that the rainbow would likely be gone before I could get to where it was in line with the palace. I ditched my camera bag in some bushes, grabbed a Nikon F3 with a motor-drive, a 75–150mm zoom, two rolls of film, and began running. The Op/TECH strap took the shock of the camera off my neck as I held it against my chest with one hand. I could see that direct sunlight was hitting a broad curtain of raindrops, so I knew that the rainbow was quite likely to continue moving with me as I rushed across the fields. When I got to the perfect place where the rainbow seemed to be emanating from the golden rooftops, yet another factor came into play to make the photograph even more extraordinary. A beam of light came through the clouds and onto the palace for a brief moment while I had my camera solidly braced against a post with focus and composition set exactly where I wanted them.

These days I often integrate my photography and running with careful advance planning. When I worked on a book that matched the text of John Muir's *The Yosemite* with my images, I wanted to do more than put his flowery words beneath a modern set of rock and tree photographs. I wanted my selection of Yosemite photographs to be uniquely tied to his visions. When I read about his first exploration of what was later named Muir Gorge in the Grand Canyon of the Tuolomne River, I figured out a novel way to photograph it. Muir Gorge goes years at a time without a single human passage. It is impenetrable except late in the summer of very low water years and even then you have to rock climb, scramble down waterfalls, and swim in glacier-fed waters. On an August morning of one of the lowest water years of the century, I set out in my running gear with my camera and two friends. This time I brought six plastic Ziploc bags. We ran sixteen miles of trail through the canyon and began scrambling through the gorge until we were forced to swim a series of long pools. I used three of the bags to triple-seal my camera and the other three to triple-seal my

extra zoom lens. I climbed out on the rocks several times, undid my camera, and took pictures of my companions as we duplicated Muir's traverse through the gorge 115 years later in much the same fashion. At the end, however, we regained the trail and continued running eighteen more miles to reach a roadhead beyond the canyon. Such a one-day adventure is obviously not for everyone, but anyone who is in shape to run a marathon and enjoys photography can devise a similar adventure, instead of merely pounding the pavement near home.

Running with a camera is now a standard practice on almost every one of my professional wilderness assignments. When I go to a new national park or wilderness area, I often take exploratory runs to locate future picture sites. Sometimes I get my best images on that first run, rather than on later visits with more camera gear when the weather has changed or some subject is no longer there. Even if I don't end up with a publishable photo or two, I've still gotten some healthy exercise and exploration of a trail. I know if I want to come back at a slower pace with a backpack full of cameras. And if I do come back, I know exactly what equipment to bring.

The running-with-a-camera theme has many variations. The rig I helped design for Photoflex works great for cross-country and downhill skiing. It also functions for all but the most extreme level of rock climbing. When the chest pouch begins to get in the way, I simply put one arm through the neck loop and switch the camera onto one side, where it is no more bothersome than a few extra pieces of hardware. The chest and lens pouch rig is highly compatible with almost all self-propelled outdoor sports, including bike touring, mountain biking, and even river running if a waterproofed camera is used.

Conventional sports are not so compatible with participatory photography. It is hard to imagine a tennis, football, or baseball player photographing a game while playing it. But it is this very difference that makes outdoor photography so unique and the possibilities opened up by a functional camera pouch so significant: The images are not taken by an observer at a physical and philosophical distance, but by a knowledgeable participant. Any time that photography moves from an external view of a subject to an internal one, the results are bound to be more intriguing.

Field Wise

"Instructions for equipment and film are designed to keep you within safe boundaries of operation. If you follow those instructions to the letter, the pictures you get will look good, but many better ones will get away."

I'll let you in on a secret. Pros have even more trouble with equipment than amateurs, and the blame is more often on us. We rarely stick just to the trusty camera bodies we know. We're more likely to be rushing or to be switching gadgets on the very latest model without having read the instructions. At best, we've scanned how to turn the thing on, load it, and get it out of auto-mode. We skip right over those lists of precautions every outdoor pro is going to violate anyway. How could we do our jobs and not subject our camera to heat, cold, dust, water, shock, and vibrations?

Those of us who stay in the business atone for our sins by having a clear plan of action for screwups. I advocate field testing new equipment before using it for serious work, but I've even messed up my own field tests. Before going to Alaska one winter, I took a brand-new Nikon 8008s to Yosemite in freezing conditions. Just as I was congratulating myself for having loaded and shot four rolls of film without ever taking off my gloves, I happened to push the ISO button. As 200 appeared in the display, my pulse surged to equal it. I was shooting ISO 50 Fuji Velvia. Somehow my big gloved finger had accidentally switched the setting. But when?

All my other Nikon F series bodies have locking, visible ISO dials, but the 8008 series only displays ISO with a special ISO button depressed. To reset the ISO, a universal "command dial" is twisted with the button down. As soon as I realized my mistake, I knew instantly that if I ever so much as felt my finger slide to the edge of an adjoining button while switching exposure or drive modes with the command dial, I would check my ISO on the spot. But that wouldn't save my Yosemite shoot.

If I gambled on normal processing, I'd better hope the mistake happened only on the last few frames. If I had the film push-processed by a custom lab to ISO 200, I would be gambling not only on an

early mistake, but also on the quality of my images. A two-stop push is not recommended by Fuji because of added grain, contrast, and a reddish color shift. I know from my own tests that two stops would be okay for wildlife and action shots in soft, low light, but unacceptable for the landscape and forest shots I had been doing.

I asked The New Lab in San Francisco to do "snip" tests pushed one stop to ISO 100. They snipped and processed four frames from the start of each roll, then waited for my instructions. My hope was that because I had bracketed a half-stop both directions from my meter, I would get some publishable frames of each important situation shot at either ISO 50 or 200 as well as find out which rolls had the problem.

Snips from three rolls looked a bit dark, but the fourth looked overly bright for two frames, then very dark for the other two. I recognized the first situation I had shot. By luck, I had found where I had made my mistake, and it was at the beginning. I now knew to push-process all four rolls, but how much?

I dreaded the harsh look of a full two-stop push, so I split the difference and asked for 1.5 stops. I got slightly dark but quite publishable slides, including the image on page 114 of pines, firs, and cedars growing together on the edge of a clearing. It holds the whiteness of the snow on an overcast day with fine enough grain to make an exhibit print.

Both the 8008s and my fingers gave a flawless performance in Alaska, but the point of recounting my "save" is less to celebrate a specific solution to a problem than to talk about an attitude that goes far beyond the nuts and bolts of technical fix-its. Instructions for equipment and film are designed to keep you within safe boundaries of operation. If you follow those instructions to the letter, the pictures you get will look good, but many better ones will get away.

Say, for example, you are standing in a meadow with wildflowers when a mountain lion walks through the shadows just fifty feet away. A rare moment, but you've got ISO 50 film in your camera. Your tripod is in your pack, and your 80–200 zoom will put you at a low shutter speed guaranteed to deliver blur from both camera and subject motion. By the time you stop to change film or take out your tripod, the animal will probably be gone. If you shoot with your wide-angle meadow lens, you can describe that tiny brown splotch as a lion to friends and family over the hum of your projector in your very own living room. Editors won't care. Nor will their pulse quicken at that out-of-focus telephoto you got of the creature's back end as it disappeared.

I would use my telephoto unless the animal was unusually close. If I could brace it on a log or a rock, I could shoot at a very low shutter speed, perhaps 1/15th or 1/30th, depending on the support. If not, I would need to shoot a 200mm lens at 1/250th or above to get a publishably sharp result. If I was underexposed shooting at this minimum speed, I would check to see if I was within a couple of stops. If I was, I would go for it without further thought except to note what frame number I was shooting. I wouldn't want to lose my concentration on the photo opportunity by trying to finesse on the spot what to do with my film. Only after the animal was gone would I recheck the light reading on the meadow and think about what to do. If I had been within a stop, I would process the film normally and know I could make lightened repro dupes or good exhibit prints from the slightly underexposed slides. But if the difference was a full stop or more, I would have the film snipped at the proper frame number and push only the tail of the roll. If I thought one of the very first frames might be the best, I would hedge my bet and ask for the snip a couple of frames early. Only if the animal was still hanging around after finishing the roll in the camera (or if the situation was more than two stops below my ability to handhold), would I risk trying to set up my tripod or changing to faster film.

You can't learn to make these sorts of decisions from studying a camera manual or a book any more than you can learn to drive a car from studying the operator's manual. Quick decisions in the field come from testing your own limits beforehand and having a clear vision of what to do when you accidentally underexpose a forest or have a once-in-a-lifetime event happen before your eyes.

Photographs: Pages 2–3, 77,
80, 110–13

*"The heart of the workshop
learning process is when
students experiment with
their own visions and
quickly see not only how
these visions translate to
film, but also how they
stack up alongside those
of other photographers."*

The Consummate Workshop

Today's myriad of workshops are a normal outgrowth of the unstructured nature of photography itself. Anyone can hang out a shingle and call themselves a photographer. Anyone can advertise a photo workshop. The marketplace decides who succeeds.

Before I began teaching workshops, I naively assumed that the chief difference between them was simply the ability of the instructor. I accepted positions from anyone who met my fee. After all, the success or the failure of the workshop was in my hands, wasn't it? After a look behind the scenes at dozens of operations, I have changed my mind. Besides a good instructor and adequate facilities, the success of a workshop clearly depends on matching students with their objectives.

Photographers attend workshops for three basic reasons: to learn, to make images in the field, and to socialize with people of like interest. Although some people attend for all three reasons, many others have more narrowly focused goals. Before selecting a workshop, honestly appraise your motives and your personality. If you consider yourself a hot photographer who just needs to be in the right place to make the great images of your dreams, then select a workshop at a location that excites you. Overnight processing is desirable but not a necessity here. Your slides mean everything to you, and poor processing would ruin your trip (even though you could learn just as much in critique sessions from scratched or slightly off-color images).

If your primary goal is to learn, avoid exotic locations without standard facilities and overnight processing. That dream image of the full moon over the mountains at sunset on film processed overnight is a luxury, not an essential component of the learning process. You can learn more from a midday shoot in murky light in a city park than you can from a shoot in which the inherent splendor of the subject matter overshadows your lack of understanding of how to translate your personal vision onto film.

If you cop to being among the high percentage of photographers for whom the social atmosphere of a workshop is as important as your own personal growth, then listen closely. I understand why some groups fly across the country for one-night reunions, while others part forever with weak good-byes. A major catalyst for group bonding is communal meals and/or lodging. I can't overemphasize the difference on the third morning between a group whose members have socialized together and a group whose members have spread to the winds at the end of each day. The former feels like a family picnic, while the latter has the ambience of a slow elevator ride with strangers. Very few major workshop facilities offer in-house meals and lodging, while the most savvy, smaller ones favor group bonding by booking clients together at local inns and planning at least a few joint meals.

If you buy "greatest hits" recordings instead of straight Beatles, Beethoven, or Brooks, a workshop that rotates instructors may be your kind of thing— easy listening, low commitment, and lots of variety. But learning at such workshops inevitably suffers from a lack of continuity. At a famous workshop I was asked to critique work students shot with another instructor who had motivated them, given them special advice, and worked with them in the field the previous day. Unfortunately for the students, the same instructor was not there to view their results. They lost on both ends, as did the frustrated instructors who never got to see the photographs that showed how well students responded to their methods. I came home feeling as though I had spent a week as a substitute teacher.

The rotating-instructor format is basically a marketing ploy. If workshop promoters land a couple of big-name instructors and then hire others whose individual classes probably won't fill, they can hedge

their bets by offering every student time with the big names. The students receive a less worthwhile learning experience than with a single unknown but competent instructor.

Any class with more than twenty students is not a workshop, regardless of how it is promoted (page 112). What separates a workshop from a seminar is a high level of interaction between instructor and students that includes personal critiquing of photos made during the course. It's worth paying ten times as much per day to participate in a workshop of ten instead of a seminar of a hundred if you expect to learn by hands-on experience.

Although you may find portfolio review of existing images helpful, you will learn far more in a workshop that allows you to make photos in the field, to have them developed overnight, and to be critiqued the next day by the instructor. The longer the workshop, the more chances you have to repeat this process and fine-tune your creative eye.

Fixed-based workshops are far more likely to provide better learning environments than those that visit exotic locations or follow travel itineraries. When considering a workshop with a fixed base, always inquire about the facilities. Are there plenty of light boxes so students can edit their work easily without feeling rushed? Does the room fully darken for group projection sessions during the day? Are facilities available at flexible times so the schedule can be adjusted depending on local weather and class whims? Be sure to ask about access to quality over-night processing. You may not find very many of these features at traveling workshops, especially those that visit remote locations. I've learned the hard way. Good judgment comes from experience; experience comes from bad judgment. Against my wishes, I once accepted a situation in which an outdoor chain sponsoring a workshop had booked a conference room for critiques for a fixed two-hour time slot. The lab was late with the film. Another time, a lab that got behind didn't mount the slides and didn't think it would be a problem. Projection session canceled. The number-one complaint of field workshops according to a report published in *Outdoor Photographer* is faulty processing. This can mean anything from delays, failure to process some or all of the film, scratches, off-color, and mix-ups to film that just plain vanishes never to be seen again.

I try to plan foreign traveling workshops to include two or three days of shooting and critiquing of nonessential subjects at the beginning of the trip. Participants are then free to take their prime film to a lab they know to be reliable upon their return.

I have often found a chasm between well-planned facilities offered by full-time workshop companies or photography schools and those organized as a single event by a club, college, or retail store. Expect to pay more for the use of real estate permanently set aside for photography, and think twice about a good deal on a workshop with questionable facilities.

The role of instructors in the field is not clear-cut. Should they put down their camera to work with each student and spend their time peering through students' viewfinders and giving advice? Or should they shoot with the class and present their work along with the students' work during the critique session? At first glance, it may seem that instructors who refrain from shooting but impart their way of seeing to students do the most to further learning. From long experience in the field, however, I have come to favor the opposite approach. Instructors aren't truly tuned into the realities of a field session unless they, too, shoot and see their own results before critiquing their students' work.

The goal of a photo workshop is to enable students to translate independently what they see and what they want to see onto film, which sees the world in a different visual language. When an instructor

"translates" for a student in the field, suggesting to do this or that to "improve" the photograph, they short-circuit the learning process. You will learn a foreign language faster by actively trying to speak it in that country than by hoping someday to wake up speaking it after you have been relying on an interpreter.

The heart of the workshop learning process is when students experiment with their own visions and quickly see not only how these visions translate to film, but also how they stack up alongside those of other photographers—including the instructor—who were at the same place at the same time.

Many instructors are secretly intimidated to shoot beside their students. We know that the photos people admire represent only a tiny percentage of our most inspired work. We can't expect to produce on demand in a couple of hours, surrounded by a group of students asking questions. On the other hand, one of the most important realizations for developing photographers is seeing the validity of their own work. So imagine the joy and boost in self-confidence in the amateur student who brings back a fine image of something the esteemed instructor walked right past. Or imagine the lesson the student learns from having walked right past something the instructor made come alive on film. Instructors owe it to their students to put themselves out there in the mix rather than merely preach from the pulpit.

I believe the pictures that come back from the field need to be entirely composed and executed by the student, even if they could have been improved by the instructor coming over and making a few adjustments. The student is unlikely to remember all the reasons for the instructor's improvements and how they were made when the workshop is over. Of course, technical assistance is another matter. Students benefit from seeing how to set depth-of-field or meter a complex lighting situation so long as they get to make all their own creative choices.

Workshops are addictive because no single one can deliver it all. You can't sign up for a week in Alaska and expect fresh Kodachromes with your morning coffee, but you can expect to see and photograph a stunning part of the world. You won't get a personal portfolio critique out of that $40 one-day "workshop" with a big-name pro that's almost sold-out at your local auditorium, but you might gain valuable insight into how that individual turned personal passion into a commercially viable style.

I have narrowed down my own involvement to three types of situations, although I occasionally make exceptions. The first are large, relatively inexpensive one-day seminars with lectures and discussions. The second are the small, relatively expensive three-day Mountain Light Photo Workshops I give out of my offices in Albany on San Francisco Bay for fifteen people in the spring and the fall. The third are special tours that merge a few days of workshop lectures at the beginning of the trip with logistics planned to optimize field photography in exotic locations such as Antarctica, the Galápagos Islands, or Nepal. But if learning is your primary goal, a scenic pilgrimage is a luxury rather than a necessity. Interaction, not location, is the key. The longer and smaller the workshop, the better your odds to receive that special balance of formal instruction and unstructured personal attention that will guide you toward your own chosen path.

" Whenever I find a scene that's really working for me, I shoot anywhere from three to ten in-camera duplicates."

The Duplicate Dilemma

An old proverb states that when people succeed, they credit noble personal qualities such as intelligence and ingenuity, but when a similar effort brings failure, the situation is to blame. Thus, a well-reproduced photograph in a book or a magazine is seen as the product of a fine artist, while a poor reproduction cries out for a convenient situation to blame. If a duplicate transparency is involved, we instantly have a case of guilt by association, usually without due cause.

For years I have made extensive use of duplicates in my stock photography business, despite certain trials and tribulations. My last six books have all been printed from enlarged duplicate transparencies made from the original 35mm chromes. Some of my oldest, most treasured images were involved here, and I chose duplicates for two reasons. First, I didn't want to risk loss or damage of prime images. Second, in many cases I thought I could get better reproduction from duplicates especially if the originals showed slight fading, scratching, or color shifts due to film and processing variables that could be corrected. Several times I have had publishers initially reject certain transparencies as "bad dupes," when the same defects showed up in the original as well. I have even had publishers who assured me that scratches made during the publication of past works using original images would not cause a future problem reject a duplicate of the same image for a future use because it was considered defective.

If this were an ideal world, where every use of my work involved a "closed system" (such as a book, for which the images are preselected and all my own and the deadlines are comfortably long), I would always chose 4-by-5 reproduction-grade duplicates instead of original 35mm. Problems arise when competitive selection of images for publication is made by someone who has a bias against dupes, a poor understanding of them, or both.

I remember a representative from a publisher rushing into our office to tell us, "All the dupes for our calendar are no good." An hour later our visitor left happy, but only after comparing dupes with originals and hearing us explain that, no, there actually is not any more grain in the enlarged duplicates than in the originals, and no, they are not fuzzy just because the already enlarged dupes look far less sharp under the same magnification used to view a 35mm original. Given an "open system" situation with the same editor competitively judging submissions for a calendar or magazine, the enlarged dupes might well have been rejected out of hand.

Because of the "blame-the-dupe-first" bias and the expense of duping, I find myself using five different types. The first is the 4-by-5, usually made on Ektachrome duplicating film by a custom lab for a price between $20 and $50 each, depending on quality, quantity, and precision of size and color matching. As mentioned, these are perfect for personal projects, but horrendously expensive and difficult to market in competitive situations.

The second type is 70mm. These are the mainstay for major sales of my top images. At 2 1/4-by-3 1/4 inches, they are plenty large enough to hold all the information contained in a Kodachrome 25 or Fuji Velvia original with no visible loss of sharpness. Yet they are small enough to look sharper under a loupe than 4-by-5s and do not suffer such a high rate of rejection. The New Lab of San Francisco makes the ones I currently use.

When you feel you have a great photo story, but are unwilling to risk sending your top originals to a publication who might lose, scratch, or hold them for months (or years), then a few hundred dollars spent in advance on 70mm dupes is a good investment. They are especially useful for foreign sales that might not otherwise be undertaken.

The third type is a basic, same-size 35mm duplicate, usually made on Ektachrome #5071 duplicating stock or its equivalent. It is possible to make just as close a color and contrast match to the original as with a 4-by-5 dupe, but always with a loss of sharpness because duplicating film is grainier than any slow transparency film. I make my own 35mm dupes with a ChromaPro duplicator that has dial-in color filtration. I always use these for projection, because they look perfectly sharp from a normal viewing distance and fade more slowly than Kodachrome. (Kodachrome, of course, has better *dark* storage stability.) These dupes reproduce well up to about half-page size, but in full-page or cover use an enlarged dupe will give noticeably sharper results. The difference isn't always obvious to people other than the photographer, however. Once, by mistake, a high-quality art poster was printed from one of my 35mm dupes. I was asked to keep quiet, the poster sold briskly, and no one seemed to know the difference.

The fourth type breaks all the rules. Common wisdom has it that daylight films make unspeakably harsh-looking dupes. In other ways, however, the idea of a Kodachrome duplicate is a photographer's dream. Imagine having a 35mm dupe in a Kodachrome mount that has virtually all the sharpness of an original plus archival stability. A friend of mine has developed a system of preflashing Kodachrome and using black-and-white contrast masks especially made for each image to reproduce original tonal values with excellent sharpness and color fidelity. The drawback is that each duplicate requires almost the same degree of hand labor as a masked Cibachrome exhibition print. Each Kodachrome dupe costs me $12, but for a submission request by a publisher used to dealing only with originals, quality same-size duplicates can often make or break a sale.

The fifth type sounds like a miracle. Imagine a dupe, 35mm in size, that is absolutely indistinguishable from an original at a cost of 40¢ with overnight service. The secret? It really is an original. In-camera multiple originals of situations that hold still enough to make more than one identical image are always the best and cheapest way to go. Whenever I find a scene that's really working for me, I shoot anywhere from three to ten in-camera duplicates. I bracket exposures half a stop each way so that I have some fully saturated images with complete highlight details that work best for careful book reproduction as well as more open exposures that are more likely to be chosen by editors of mass-production magazines who try to avoid dark transparencies. Every time I think about all the hassles involved in making duplicates from my best work and marketing them, I make firm my resolve to produce as many of these perfect duplicates in advance as possible.

One last little-known secret is that even when you send originals to the publisher and have them selected for use, the actual magazine or brochure could be printed from duplicates. One custom lab manager tells me that his biggest market for enlarged reproduction-grade transparencies consists of publishers saving money by making duplicates exactly to size for color separations, so that they can be ganged up together and separated all at once.

If you cover up the caption on page 107, it is hard to tell which one of the two identical images is printed from a dupe. Both are. One is printed from a 70mm Ektachrome and the other from a masked and pre-flashed Kodachrome. You won't catch me sending out my top originals these days whenever I can help it!

A Digital Sky

"If National Geographic could move the pyramids of Egypt on its February 1982 cover and if TV Guide could stick Oprah Winfrey's head on Ann-Margret's retoned body, then putting a splash of water back into a real water-fall shouldn't be a problem."

When Hoya introduced a 4X loupe that shows the full area of a 35mm slide in sharp focus edge to edge, I tested one alongside the quite similar 4X Schneider loupe I had been using for twenty years. I couldn't see a difference. Because the Hoya was more convenient to use and considerably cheaper, I carried one around in my briefcase.

I learned the hard way that both brands should carry a product warning for outdoor use. The situation had never come up with the Schneider. I had deemed it too valuable for use outdoors. Back in the seventies, however, I took my Schneider to meetings with photo editors. Quality loupes were so rare then that I often made sales to people who were as wowed by the crisp full-frame image on their light box as by the subject matter. On subsequent visits, I found that most publications had purchased their own Schneider loupes. I often saw Schneiders chained to light boxes to keep them from disappearing. I never saw anyone use either a Schneider or a Hoya loupe outdoors until that fateful day in 1991 in Yosemite Valley when I learned a hard lesson.

For years, Ron Kauk and I had been talking about the ultimate Yosemite climbing photograph. If you're on El Capitan or Half Dome, you're at the wrong vantage point to capture the classic contours of these rock icons at the same time. Ron had cased out a situation on the face of Yosemite Falls where, at the right time on a spring day, a climber could be depicted on the sheer cliff with a rainbow, Yosemite Falls, and Half Dome in the background. As we climbed on the face together, the rainbow didn't stay still for us. Normally, it is an indistinct band in the falls, but that day, as the wind whipped the spray toward us, the rainbow virtually surrounded Ron moments before we got drenched. I set my Nikon 8008s on auto, held it in one hand (cover and page 76), and shot several rolls of film as the falls blew back and forth over us.

I rushed to San Francisco to process the slides at The New Lab, and when I returned to Yosemite Valley the next day, Ron and I looked at the selects over an outdoor lunch. Using my new loupe, he exclaimed, "Look at *this* one!" and chose one frame as the ultimate because it caught him in the middle of a reach with a double rainbow at full intensity. No other select was quite like it, although Nikon later used another frame from the same take in an ad. A climbing friend wanted to see what Ron was so excited about, so Ron held the slide with the loupe pressed against it in his outstretched hand for ten or fifteen seconds until his friend finished a bite of his sandwich. Looking through the loupe, he said, "It's a real nice picture, but what's that big spot in the waterfall?"

A bright circle curled at the edges and grew larger until it dawned on me that without an eye to the loupe for those ten or fifteen seconds, the sun's rays had been perfectly focused on the emulsion of one of my all-time favorite climbing shots (page 105). Ten years ago, the slide would have been a total loss for quality stock sales. A hand-retouched duplicate might have worked for small use, but not for full-page enlargements.

In today's world, the image seemed a natural for digital retouching. If *National Geographic* could move the pyramids of Egypt on its February 1982 cover and if *TV Guide* could stick Oprah Winfrey's head on Ann-Margret's retoned body, then putting a splash of water back into a real waterfall shouldn't be a problem.

The first company we tried patched the sky so that the damage was unnoticeable, but the resulting image had the quality of a poor slide dupe. Excessive contrast burned out detail in Ron's white pants and blackened shadow detail. The color balance was off, and data stored at high resolution had been outputted onto a 35mm color negative that had far lower resolution than the Velvia original.

Queries about who could output the digital information onto a 4-by-5 transparency led us to Thurston Productions of San Francisco. Chuck Thurston's main business is outputting data files of graphics or photos onto film. He also uses his Mac IIfx computer, Nikon LS 3500 scanner, and other gadgetry to digitize photos, rework data as necessary, and return the information to film. With an 8,000-line field and 68 megabytes of information he could output virtually all the sharpness of the original onto a 4-by-5 transparency. Chuck told us that sampling the digital pattern from another part of the waterfall and painting it into the hole would be the easy part. The technology won't automatically produce a perfect replication of a transparency. Just as an automated print from your local one-hour photo shop rarely does justice to your original slide or negative, output from a digital scanner onto transparency film may require the electronic counterparts of burning and dodging, color filtration, and contrast masking before it matches the original.

Chuck used an isolation mask to restore detail to Ron Kauk's white pants, as well as other tricks to selectively correct color balance and increase sharpness. Increase sharpness? Yes. Although resolution is a measured quantity, sharpness is a perceived quality. The 24-million-pixel image would hold the high resolution a fine lens records on 35mm film, but by using Adobe Photoshop software, Chuck could selectively increase edge definition along outlines of key subjects, thus creating a sharper appearance.

Like all good things in life, digital salvation doesn't come cheaply. It normally costs between $350 and $650 to repair a slide and output it to a 4-by-5 transparency, depending on the kind of damage. A decade ago, it was possible to repair damage with a million-dollar Scitex machine for reproduction in books and magazines, but not to regenerate transparencies that resembled the original at a price the individual photographer would be likely to pay to salvage top images. Now the ball is in our court to use this handy tool ethically to preserve or enhance what is really in our original photos rather than to create what was never there.

Right and below:
Essay pages 103–04
*After the sun had burned a
hole through my prime
original slide of Ron Kauk
climbing beneath a rainbow
in the spray of Upper
Yosemite Fall, the image was
digitized, repaired, and
outputted back to film again
(below) by Thurston
Productions of San Francisco.*

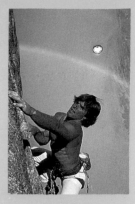

Right and below:
Essay pages 101–2
Which photo has been printed from a duplicate transparency? The bristlecone pine in winter was originally shot in 1974 on old Kodachrome II 35mm slide film. The photography in my 1986 book, Mountain Light, *was printed from a 70mm enlarged duplicate (right). The same image (below) was also duped, after masking and preflashing, onto Kodachrome 25 film that is much sharper than 35mm duplicating film. Differences in the colors of these reproductions may be due to variations in printer's dyes, but can you detect any difference in sharpness?*

Left:
Essay pages 82–83, 94–95
During a dawn run up Mount Temple in the Canadian Rockies in 1981, I stopped to brace my camera on a rock as alpenglow turned the peaks crimson. I used a two-stop graduated neutral-density filter to open the shadows. Now that I've designed my own filters for Singh-Ray, I would choose a three-stop, hard-edged model to add further detail to the foreground.

Left and below:
Essay pages 86–89, 90–91
Kodachrome 25 renders a purple flower blue and the shadows murky (left). Kodachrome's 50-year reign as the sharpest color slide film ended in 1990 when Fuji Velvia (below) was introduced with better resolution and saturation as well as richer blacks. Within its dynamic range of usable detail, Velvia remarkably holds no more contrast than Kodachrome. Beyond that range, however, shadows drop quickly to black, giving the film its name, a contraction of "velvet media."

Right: Essay pages 82–83, 90–91, 201–5
The powerful color saturation of the diverse subjects in this image of Reflection Pond at dawn in Alaska's Denali National Park is due to several factors coming together. The foliage is wet, close to the lens, and in soft light. The grass is lit by the sun's first rays. The far brighter pink cloud is held back by a two-stop, soft-edged graduated neutral-density filter.

Following pages:
Essay pages 98–100
Just hours before I made this photograph of a fog bank lifting over the Berkeley Hills at sunset, a workshop student voiced disappointment over our proposed shooting location because it lacked the scenic grandeur of Yosemite or Big Sur. Another student in the same workshop was not disappointed. He entered a different personal vision of the same moment when the fog bank touched the trees in a National Geographic Traveler photo contest and won a trip to the Caribbean for two plus cash. Great locations do not make great photographs. People do.

Above: Essay pages 98–100
*Any photo class with more
than twenty students is not a
workshop, regardless of how it
is promoted.*

Above: Essay pages 98–100
At Mono Lake a workshop of fifteen students pursue personal visions on film to be processed for a group projection/critique session the next day.

Above: Essay pages 96–97
I "saved" this image of a
Yosemite forest mistakenly shot
at ISO 200 on ISO 50 Fuji
Velvia by having the film
pushed 1.5 stops to ISO 140
and choosing a frame that I had
bracketed one-half stop lighter
than my meter reading. In this
way I saved the transparency
as an exhibit-quality image
without the slightly objec-
tionable increase in grain and
contrast I would have gotten
by going a full stop beyond
Fuji's maximum recom-
mended one-stop push. For
wildlife rather than scenics,
however, the full two-stop push
often works out fine where big
enlargements are not going to
be made (left).

Right: Essay pages 88–89
I made this image of pine
shadows on granite in Joshua
Tree National Monument on
the first roll of Fuji Velvia I
ever shot the day after the film
was introduced. I was testing
Velvia's ability to hold fine
detail in bright highlights while
rendering shadows rich black.

Above:
Essay pages 88–89, 96–97
In this portrait of my dog,
Khumbu, taken on a foggy
morning, ISO 50 Fuji
Velvia has been pushed to
ISO 200 with special
processing. Fuji does not
recommend this two-stop
push, but the added contrast

and warmth are actually
desirable in many wildlife
situations, where the lighting
is soft and cool. Velvia is my
film of choice here because,
even after pushing, it has
far better color (except for
flesh tones) and sharpness
than any normal ISO 200
slide film.

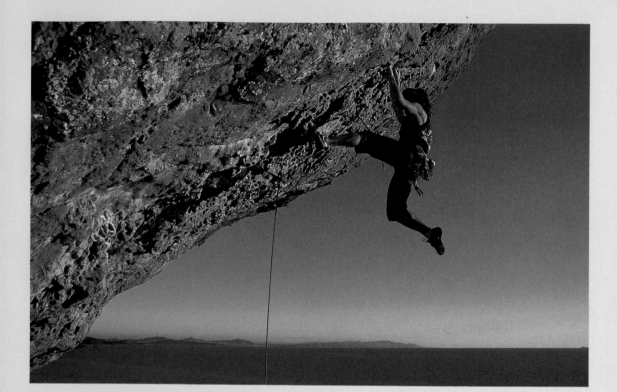

Above and right:
Essay pages 92–93
Fill-flash is unnecessary in the above scene of climbing Endless Bummer, a 5.13 overhang on the California coast. Ron Kauk is simply a distant graphic element. When Ron is photographed larger in the frame (right), the same strong shadows would have ruined the image for publication without fill light. In the past, either Ron would have fallen or I would have missed the shot by the time I computed flash-to-ambient ratios and made manual settings. Nikon's SB-24 "smart flash" revolutionized photojournalism by doing this automatically.

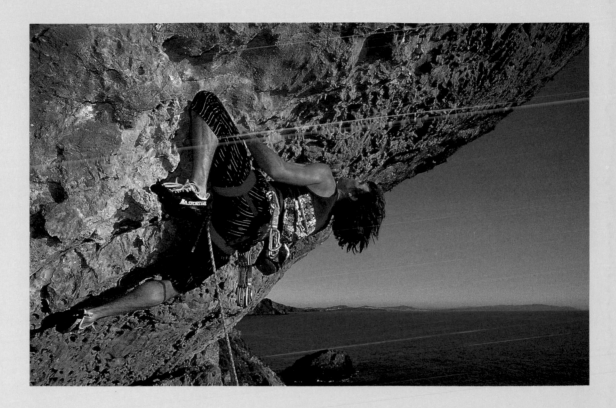

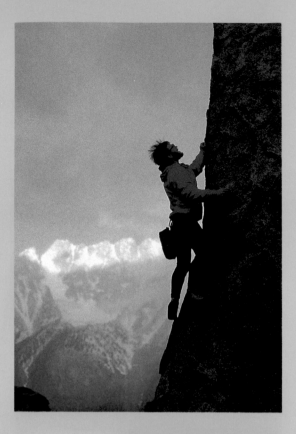

Left and below:
Essay pages 84–85
The image at left was made within seconds of the very different image below. The changes involved choosing and exposing for a different highlight and recomposing the scene based on those decisions. The image at left would appear unacceptably burned-out with the same exposure as in the image below. The climber has become almost a silhouette with an exposure for highlights in the clouds and snow. In high-contrast lighting, exposure and composition are inextricably linked because film does not see like the eye.

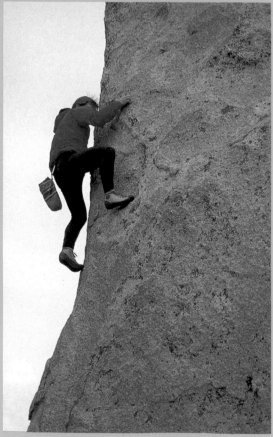

Right:
Essay pages 273–74, 275–79
Although this long exposure of a winter ski camp on the John Muir Trail in the Yosemite high country was used on the cover of Outdoor Photographer, *I did not select it for my book of Yosemite photos matched to John Muir's words because the image is obviously too contemporary. During a long automatic exposure of about one minute on Fuji Pro 100, I walked up to the tent and set off a flash into the door. Thinking my exposure was over, one of my companions stepped out holding a weak flashlight, causing the blur beside the tree.*

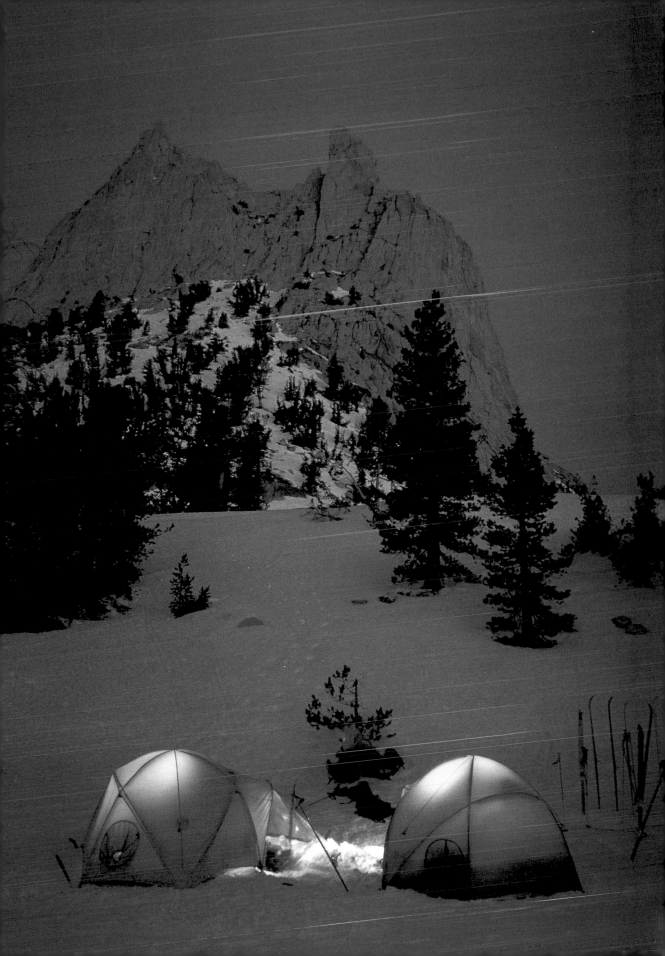

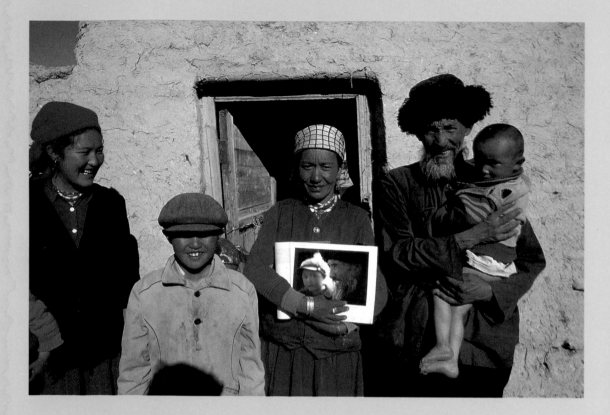

Above: Essay pages 122–23
*Members of a Kirghiz nomad
family in the Pamirs of western
China hold a book I gave them
turned to a photograph of the
father and son I had made six
years earlier. I found them by
chance many miles away from
where they had been camped
with their herd when I made the
previous photograph. Naturally,
they opened up to my
photography more than ever
after I showed them the book
and drank fermented mare's
milk with them before taking
out my camera.*

PART THREE JOURNEYS:
Merging visions with realities

Photographs: Pages 8, 56,
120, 249, 262–63

*"I find it much easier to
create meaningful photos
in an adventurous setting
than to try to make images
where cameras and tourists
don't rate either a second
glance or a hello."*

The Hello Factor

What defines adventure travel these days? Certainly not risk of life or limb. A recent survey about the health hazards of Himalayan trekking showed only fifteen deaths per hundred thousand—a statistic that proves the activity to be no more dangerous than staying home and watching television. Physical effort doesn't necessarily lead to adventure, either. A 26-mile marathon is a grueling affair, but at any time you want, you can simply step to the side of the road and quit. A marathon on a paved road is less adventurous than a far easier off-trail walk in a wild area. No one denies the adventures of Columbus in a sail-powered boat or those of Marco Polo riding in his uncle's caravan over the Silk Road.

In the comfort of one's living room it seems easy to separate real adventure from ordinary travel, but in the field there is an overlap that can be both confusing and disheartening. Photographers may set out for an exotic place and imagine that they are going on an adventure. But once they get there they find the local people wearing Western clothes, sullen expressions, and a quick-draw response to pictures that enables them to ask for money in English faster than you can push a shutter button. Guidebooks never really tell the true degree of adventure, because it can vary from season to season, village to village. Arriving by plane in Lhasa, Tibet, in midsummer is no longer an adventure. Yet pedaling on a mountain bike into the same city in November is certainly a great adventure. These modes of travel are obviously different, but you might rightly ask what's different once travelers arrive in the same city.

What I call the hello factor cleanly separates adventure from the mundane. A pair of summer travelers who fly to Lhasa are not greeted by their fellow passengers on the airplane. They ride a bus into town with other tourists who usually don't acknowledge their presence or talk to them unless they already know them. They check into a modern Western-style hotel, where guests say hello about as often as people in Holiday Inn elevators.

The mountain-bike riders, however, arrive out of season by somewhat unusual conveyances. With panniers loaded and the dust of the road on their clothing, almost any traveler they see is bound to say, "Hello! Where have you come from?"

In a remote valley in the Andes it would be almost unthinkable to pass someone, either native or foreigner, without at least saying hello. Our national parks give an even more clear-cut demonstration of the hello factor. On the boardwalk to Old Faithful people rarely if ever say hello to a stranger. But twenty miles away in the backcountry in the off-season, everyone acknowledges everyone else. "Hellos" are symbolic of the enjoyment of exotic travel. "Aloha" in Hawaii. "Jambo" in East Africa. "Salaam" in Islamic countries. All these words conjure up an image of adventure and mystery. People stop saying hello to one another when their human contacts are wholly expected rather than random or adventurous.

Kathmandu in the seventies had an air of mystery. When I walked through the bazaar I could go blocks without seeing another Westerner. If I did meet a foreign traveler, we invariably greeted each other with "Namaste," which roughly translates to "I greet your soul." Today, Westerners are everywhere in Kathmandu. Strangers rarely greet one another. The mystery and adventure have begun to seep away.

How does all this relate to photography? I find it much easier to create meaningful photos in an adventurous setting than to try to make images where cameras and tourists don't rate either a second glance or a hello. Mutual curiosity goes a long way toward providing photo situations that make it to the pages of *National Geographic* or the travel section of your local newspaper. You cannot pay people to

look spontaneous and curious. It has got to come from the heart. Theirs and yours. The hello factor is an accurate measure of spontaneity and curiosity. Once it is gone, it rarely comes back.

Even Hollywood relies on the hello factor to separate ordinary travel from adventure in movies. When the main character is just traveling, he or she doesn't shout hellos or strike up conversations. Faceless crowds rush by. But when an adventure is about to happen, the camera shows us more about the people surrounding our main character. They strike up conversations and talk to one another while we eavesdrop. Intuitively, we know we are about to witness an adventure.

I would not have spent such a long time introducing the hello factor were it not of such great use to a traveling photographer. Besides telling you whether you are having an adventure or not, it is also a good indicator of your potential to have subjects go out of their way to help you make good photographs. Many nature photographers are very reticent to ask local people or foreigners for permission to take their photograph or, harder yet, to go out of their way to do something special. I use the hello factor as a rule of thumb. If the locals aren't saying hello to you in a village, it's almost certain that you'll need some sort of introduction to be invited into someone's home. On the other hand, if they cheerfully greet you in either their language or yours, chances are they'll be more than willing to show you their home, their family, and other aspects of their lives. You can return the favor by sending them a print as both a gift and a reminder the next time a photographer asks them for a favor.

Some photographers give away Polaroids for this purpose, but I never do. I don't believe that instant gratification is healthy. A few quality prints, photographed with precision and given to those who made a difference, are much more meaningful and also more telling of what we outdoor photographers are about when we ask people in foreign countries to pose for us. Giving Polaroids merely engenders giving more Polaroids. Instead of saying hello, Polaroid-wise societies see my camera and ask the international question: "Ah-toe-mah-teek?" If I don't have an "automatic" camera, they often refuse to pose for me. To them the sole purpose of a camera is to make a quick and dirty instant snapshot. My style of photography is simply not understood.

The hello factor works just as well at home as abroad. On a Sunday afternoon a mile from the trailhead, crowds may rush by without even raising their eyes to see you. Ask them to pose for a photo, and it's highly unlikely that their response will be any more pleasant than what a New York cabbie would tell you if you asked for a free ride. But when hikers round a corner in a remote area near sunset with a cheery hello, the odds are pretty good that if you stop and talk about the beauty of that sunset, they will be glad to walk out on that point for you to put their silhouettes into your photograph.

To expect the unexpected is a motto of adventure travel. If you travel with this attitude, you'll find yourself saying hello and meeting many interesting people. If you go out expecting a predictable journey, chances are very good you'll get it, both in person and in your photographs.

Photographs: Pages 43,
48–49, 129–33

Ten Zones to Paradise

*"For a period of months,
or a few years at best, a
glimpse of the world in
a primitive state exists
alongside the ease of access
that has made the rest of
the world what it is today.
The two cannot remain
wholly apart for long."*

The Seven Wonders of the World have been revered since biblical times. The Hanging Gardens of Babylon are long gone, but they live on almost as if they had been photographed, because they are one of the seven places every schoolchild for numerous generations has learned to see in the mind's eye.

Seven is the lucky number of old, but ten has become the modern favorite among those who use supercomputers as well as those who count on their fingers. In the otherwise forgettable movie *10*, Hollywood made tens of millions of dollars by having a rather silly man give a vacuously beautiful woman a visual rating of ten.

Rating scales of ten are now rampant in our society, from the ten worst-dressed women to the ten visual tones of Ansel Adams's Zone System. I have never been one to take ratings too seriously, and you have every right not to take the scale I am about to propose here seriously. My modest proposal is a rating of ten wild wonders of the world that are destined to change rapidly during our lifetime and may live on only in photographs or in the mind's eye of future schoolchildren. I dreamed it up in the spirit of fun, based on a humorous incident relating to the Zone System that I witnessed three decades ago, before I became a photographer.

During the early sixties, I climbed mountains and rock faces with a wonderfully irreverent fellow named Warren Harding. In 1958, he had spent forty-seven days making the first ascent of the face of Yosemite's El Capitan. Many people thought he was crazy. Ansel Adams wrote an indignant letter to the editor in the *San Francisco Chronicle* decrying the desecration of El Capitan by piton. Warren's reaction was, "Could it be that virtuosity in the field of photography does actually qualify one as an expert in judging another person's climbing efforts? It sure as hell doesn't work the other way around."

Ansel's criticism of technical rock climbing actually went back decades earlier to a 1931 Sierra Club adventure where California climbers learned proper rope and piton techniques brought over from the Alps. Ansel was a recognized mountaineer who had made a number of first ascents of remote but easy peaks. In the Sierra Club's annual bulletin of 1932 he wrote about the "ascendancy of acrobatics over esthetics" and how "mountains are more to us than a mere proving-ground for strength and alert skill."

One day in 1964 Warren and I spotted Ansel teaching a workshop on the glacier-polished slabs above Lake Tenaya in Yosemite. He stood profiled against the sky like a vision of Moses as he delivered what we called a sermon on the Zone System. I had no desire to become a photographer as I watched the group take notes on how to equate numbers with nature and light meters. When one man walked over and held his meter against Ansel's face, Warren burst out laughing. Surprised, the group looked our way as we darted through the trees to our camp. When we caught our breath, I asked Warren what he found so funny.

"Those people! They were treating Ansel Adams as another great wonder of Yosemite to be photographed. He just stood there, craggy as a cliff, while that guy metered him and wrote down the numbers."

Soon thereafter, Warren came up with his own modification of the Zone System to rate people he knew. At one end were those who figuratively wore white hats, the saints on Warren's scale. At the other end were black-hatted characters with sinister intentions, Warren's favorite people. His heart went out to those in Zone 5, the poor gray drones who lacked sufficient character and conviction to be interesting. I had a good laugh when I found myself listed in the appendix of Warren's autobiographical farce, *Downward Bound,* as a Zone 9 out of 10 (Ansel Adams's Zone System for photography actually uses Zone 0 to 9). Warren thusly explained why he gave me an almost black hat: "Potentially a Zone 2 or even a Zone 1, Rowell's frequent articles on conservation have a rather impassioned sincere ring, but they lack the fine narrow-mindedness invariably exhibited by the true zealot."

My rating scale for wild wonders owes its heritage to the Seven Wonders, Dudley Moore, and both Ansel's and Warren's Zone Systems. It focuses on the degree that natural and cultural experiences have been synthesized into theme park atmospheres where derivative situations created expressly for tourism are passed off to the public as authentic.

After I moved on from twenty-dollar weekend climbing trips during the sixties to international travel for photojournalism, I found that most travelers shared my fascination and disdain over the degree of commercial encroachment on their intended wild destination. Those who spend thousands of dollars to see and photograph exotic wildness are less concerned with whether they get to see all the things in the travel brochure than with how much of the original ambience of the wild and the exotic still remains.

My photo assignments have led me to many places around the world that seem exotically wild in the mind's eye of the public. People often tell me that I have been very lucky to visit so many places on the verge of evanescence, but I know that lucky is not the right word. I have deliberately sought out such places, knowing that in today's world the times when a person can fly or drive into the past only last for an instant of history. For a period of months, or a few years at best, a glimpse of the world in a primitive state exists alongside the ease of access that has made the rest of the world what it is today. The two cannot remain wholly apart for long.

When a previously inaccessible place is suddenly thrust open to the public by politics or by new transportation access, the first visitors are usually adventurous souls. Then come commercial adventure groups, followed by the general public in increasingly elaborate transport and comfort. The experience becomes ever more like everywhere else where tourists go rather than like the special qualities of the place that were the original attraction.

Travel articles rarely convey the true degree of ambience that remains in an area. Text and photos are purposely edited to emphasize the exotic and de-emphasize the number of travelers who go there and the extent of urbanization. Journalists and photographers who are given free trips often fail to mention the adventure travel group they joined, because they want to create the aura of an adventurer in control of his or her destiny rather than present the real picture of a passive participant on a prepackaged tour.

In my Wild Wonders Zone System, I rate ten fabled destinations spread over the major continents that I have had the good fortune to visit and photograph, mostly with Barbara. I have rated them using Ansel's Zone 0 to Zone 9. My two guiding principles are the condition of the original resource that first attracted tourists and the overall degree to which our experience was impacted by other visitors. A "9" is a virgin place of great beauty and charm, while a "0" is one small step above Miami. The scale from zero to nine is intended not only to be humorous and informative, but also to provide an unmistakable index of the effect of mass tourism on the most fabled and exotic places remaining on the planet, which has lost most of its Seven Wonders and a whole lot more. I have tried to select single photos that match our overall experience.

Zone 0—Puerto Vallarta, Mexico (page 129): Land, air, and water are saturated with winter sun worshipers in this view through my toes from a parasail. Inland from the wide crescent of white sands dotted with thousands of multicolored bodies is a broader arc of modern hotels with U.S. prices and Mexican service. Across the road, trucks without mufflers drone day and night pouring goods into a tourist trap that used to be a quaint town. Main Street is a solid row of businesses that cater strictly to the tourist trade. A good place to tan and party that's about as wild and cultural as Malibu.

Zone 1—Northern Japan Alps, Japan (page 130): High in the Japan Alps hikers end their days not by erecting tents, but by stepping into five-star mountain huts equipped with television, hot baths, sushi, and sleeping mats. Service and comfort are fantastic, but the prices make the real Alps seem like a bargain. As I walked a remote trail between Mount Tsurugi and Mount Tateyama, my "wilderness" experience was interrupted by many low passes of a helicopter with a fully loaded sling. No one was in trouble. The chopper was stocking huts with the two staples of Japanese mountain living: rice and beer.

Zone 2—Kathmandu, Nepal (page 133): Swayambhu stupa is a major spiritual center for both Hindus and Buddhists in Nepal. Lamas and monks circumambulate the shrine, spinning prayers simultaneously with their bodies and the rotating wheels in their hands. Photographing them without a tourist in the frame is becoming increasingly difficult. Foreigners often outnumber worshipers, especially when a tour bus arrives and more cameras than prayer wheels orbit the ever watching eyes on the face of the temple. Cheap facsimile souvenirs dominate shops that sold genuine Tibetan handicrafts just a decade ago. "Very Old Tibetan" is the Kathmandu equivalent of buying the Brooklyn Bridge. The situation is unlikely to change, since the

government has stated its desire to attract a million foreign visitors a year by the turn of the century.

Zone 3—Basque Country, Northern Spain (page 131): If it seems surprising to rate a little village in Spain above Kathmandu, consider that I saw no foreign visitors in Ceanuri, while in Kathmandu even the back alleys of the bazaars are haunted by money changers and peddlers who prey on tourists. The Basque people maintain a sense of proportion about their land and their personal lives. They have cars and television, but they also hold dearly to meaningful old ways of living in 500-year-old farmhouses on land where nonmechanized chores are a matter of tradition and pride. Basque sports are based on these daily tasks rather than contrived games like football or baseball. The farmer in my photo has a neighbor who is the national champion at both scything grass and lifting 200-pound grain bags. Few people on earth have entered the twentieth century so gracefully.

Zone 4—Lake Baikal, Siberia (page 129): Lake Baikal has more geographical superlatives than any national park in the United States. The world's deepest and purest freshwater lake is also the largest by volume, containing 22 percent of the earth's fresh water with twelve hundred animal species unique to the lake's environs. Life around its shoreline is a pioneer mishmash of culture, not unlike that found in Alaska. This photograph shows the mayor of Baikal's major town standing on an ice floe during spring breakup. His features reflect pure native Siberian ancestry, but his urban dress and degree in computer engineering highlight the clash in values that continues to make the lake Russia's premier environmental cause.

On the day I left the lake in 1987, front-page headlines in Moscow told of the firing of a cabinet-level minister because of scandal. A pulp mill on the shores of the lake had consistently exceeded national pollution standards that were established after a nationwide grass-roots outcry over the possible pollution of Lake Baikal. Much of Baikal's shoreline remains extremely wild. At the time of my visit, access to remote areas was politically and practically more difficult than reaching the heart of the Himalaya. Since the breakup of the Soviet Union, Baikal is both easier to visit and more endangered than ever.

Zone 5—Ancient Silk Road, Pamir Mountains, China (page 131): Ever since Marco Polo became the first adventure travel writer, generations of armchair travelers have longed to follow his overland route into China. He described green meadows in the deep valleys of the Pamirs where glaciers float on high and merge into the clouds. The Karakoram Highway from Pakistan was opened to foreign travelers in 1986, providing the first permitted road access to the Silk Road from a foreign country. There I found Kirghiz people carrying on with their traditional ways beside the Chinese road. I have no doubt that these seminomadic people will ride from the Middle Ages into the twenty-first century in motorized vehicles rather than on their traditional horses and camels, as roads are improved and tourism increases.

Zone 6—Galápagos Islands, Ecuador (page 132): One hundred and fifty years ago, a young ship's naturalist in his twenties named Charles Darwin explored these islands. Wild birds and reptiles had no fear of him. He could reach out and touch them. Darwin gained a vision that would change the way the human race saw itself. He observed the variation in species from island to island and connected a positive life force to the struggle for existence in the natural world that other naturalists had viewed as merely bestial. Where they saw death and extinction, he saw a creative process that he called evolution.

Today's visitors can still approach animals closely enough to photograph them with wide-angle lenses (instead of the extreme telephotos needed in so

many other places where human interaction has made creatures rightfully fear human approach), but they cannot do so alone or off-trail. The sheer numbers of visitors—thirty thousand each year—necessitate strict rules for staying on trails, traveling with a guide, and leaving the islands by dark. Touching animals is forbidden by law. Fittingly, most modern visitors use the same combination of sail and foot travel as Darwin did on his memorable visit long ago. Barbara made this photograph of an iguana, a man, and a blowhole with a 24mm wide-angle lens on a Nikon F4.

Zone 7—Fitz Roy Range, Patagonia, Argentina (page 132): The wild granite spires of Fitz Roy and Cerro Torre are the most spectacular I have seen on earth. These peaks lie in a small national park reached by a dirt road across the arid pampas. Lonely sheep *estancias* dot the plains, overseen by gauchos who roam on horseback. The weather on the peaks is some of the worst in the world, but the sun often comes underneath banks of contorted clouds at dawn or dusk to provide some of the wildest alpenglow imaginable. Trails lead from park headquarters to base camps for the peaks, to lakes filled with icebergs, or to the edge of the Patagonian Ice Cap that extends for two hundred miles along the crest of the southern Andes. Barbara made this photograph of our vehicle on the dirt road beneath the peaks.

Zone 8—Concordia, Karakoram Himalaya, Pakistan (pages 46, 48–49): When I visited Concordia on an expedition to climb K2 in 1975, the place was unquestionably a Zone 9. The second highest mountain in the world came suddenly into view after days of trekking over trailless glacier. On the last days we had seen six of the world's seventeen highest peaks pierce the sky above a totally uninhibited land. Concordia is the junction of several glaciers in a deep basin below the mountain walls. Here I chose to release my 90-year-old

father's ashes after my mother had sent them by ordinary air mail and a special expedition mail runner had carried the parcel up the ice to me. But when I returned to make this image in 1986, the situation had changed. I arrived by helicopter as a photojournalist. Near the site of this image was a year-round military camp of the Siachen Glacier War. I found litter, excrement, and telephone wires. Up the glacier toward K2 were the base camps of many simultaneous K2 expeditions. Twelve climbers died on the peak in 1986 within a few weeks of my visit, the greatest tragedy in the mountain's history. Concordia is still wild, wonderful, and far away from the living world, but a bit too close to death by bullet or ice.

Zone 9—Mount Kailas, Western Tibet (page 43): Mount Kailas represents the center of the universe for both Hindus and Buddhists. Even non-believers feel the power of the place. Four of Asia's great rivers have their headwaters nearby, spiraling out to cut through the Himalaya and reach the ocean fifteen hundred miles apart from one another. Mount Kailas appears to rise out of the plains, sheer on all sides, shimmering in the waters of the holy lake, Manasarovar. Interlocking valleys, some of them veritable Yosemites, provide a 32-mile holy pilgrimage route around the mountain. Circling any auspicious object is a form of prayer for Buddhists, whether it be spinning a prayer wheel or walking around a shrine. To circle the peak at the center of the universe is thus an ultimate pilgrimage. On my two journeys around the mountain I never encountered another foreigner. One circle took three days, but the most memorable was a single-day affair beginning under the full moon with three Tibetan companions. I was drawn completely out of my Western shell into a spiritual connection with the land.

Right: Essay pages 124–28 *Puerto Vallarta, Mexico, occupies last place in my whimsical "Zone System" for rating the degree that commercial tourism has destroyed the original mystique of exotic destinations. To get this image, I put some distance between the Zone 0 seawall of hotels and me by riding a parasail and photographing the crowded beach through my feet with a 20mm lens.*

Right:

Essay pages 124–28, 137–41 *Lake Baikal in Siberia rates a mediocre Zone 4. Like Lake Tahoe in my home state of California, it juxtaposes pristine waters with shocking human encroachments. When the native Siberian mayor of the lake's major town showed up in a business suit to meet me, I thought it fitting to pose him standing confidently on a patch of thin lake ice.*

Above: Essay pages 124–28
The ancient Silk Road in the
Chinese Pamirs rates a mid-
dling Zone 5. Communism
and tourism have impacted the
traditional ways of life of the
Kirghiz nomads who live near
the Karakoram Highway,
which opened the remote region
to the outside world in 1986.

Left: Essay pages 124–28
The Japan Alps rate a lowly
Zone 1, even though I was
able to single out an ancient
Shinto shrine at dawn on the
top of Mount Tateyama from
the huts, hot baths, helicopters,
and hordes of people that
disrupt the sanctity of these
mountains. Shot on assign-
ment for A Day in the Life
of Japan, this photo was
conceived as representing
the first moments of the day
and was later chosen as the
book's frontispiece.

Above: Essay on pages
124–28
The Basque Country of
northern Spain rates a
Zone 3, quite high for a
nonwilderness scene in
Europe, because old
traditions are relatively
intact, despite modern roads
and cities. I never saw
another foreign visitor in the
little town of Ceanuri, where
I took this photograph of a
farmer using a donkey cart
in his field.

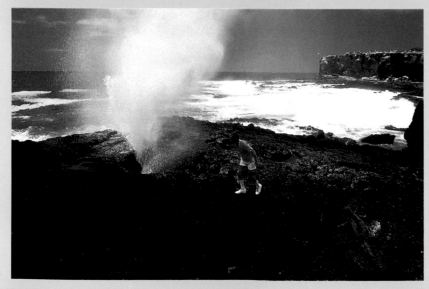

Above: Essay pages 64–70, 124–28
The Galápagos Islands of Ecuador rate a Zone 6 despite thirty thousand visitors per year. The wildlife remains unafraid of human approach because of sound environmental regulations. Barbara took this photo of an iguana, a man, and a blowhole at close range with a 24mm lens.

Above: Essay pages 124–28
The Fitz Roy Range in the southern Andes of Patagonia rates a Zone 7 for the normal tourist or trekker, although for a climber on the high peaks the experience is definitely a Zone 9. Barbara took this photo near the entrance to Los Glaciares national park, where an ugly little village was built inside the park in 1985 in direct violation of the park's charter.

Right: Essay pages 124–28
Kathmandu, Nepal, rates only a Zone 2 because so much of its old ambience is gone. Westerners are everywhere. Many shops now cater strictly to tourists instead of to the local people. At Swayambhu stupa I had trouble keeping tourists and street merchants out of my frame long enough to grab this photograph while on a dawn run.

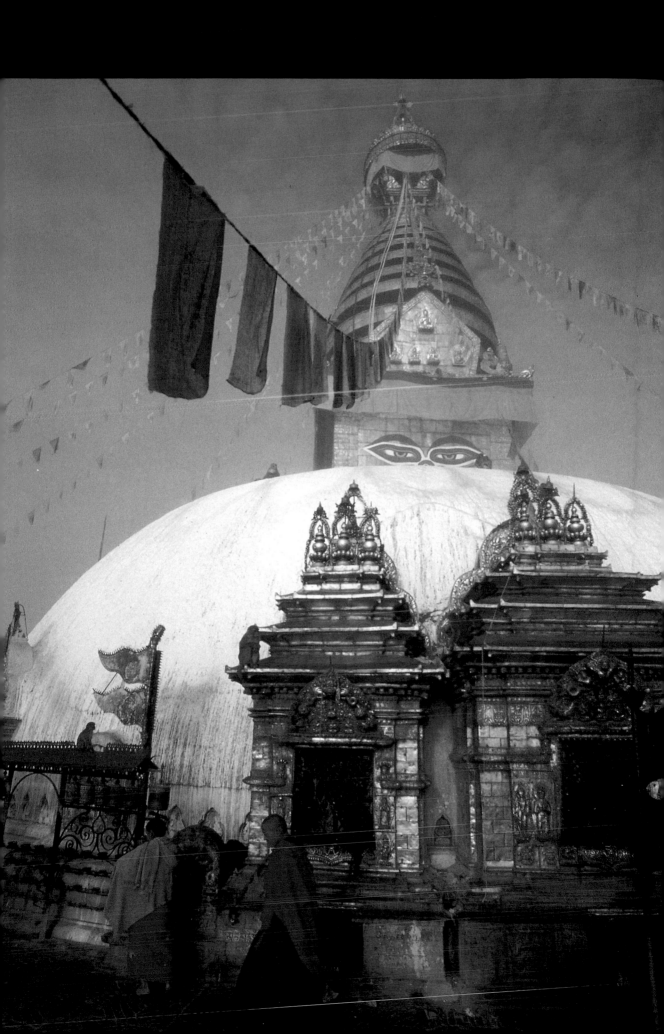

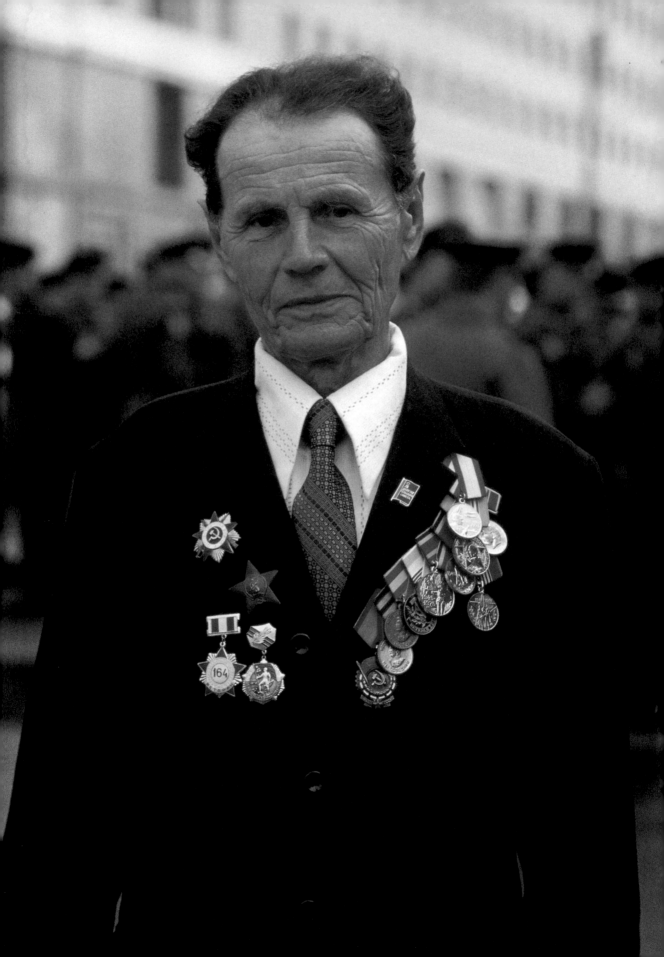

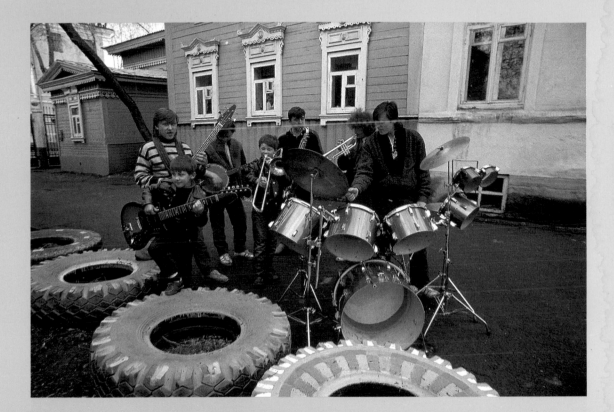

Left: Essay pages 137–39
While walking through Moscow's Red Square in 1987 with an informal group of photojournalists, I photographed a World War II veteran sequined with medals. When he found out that we were from the United States, he made an impassioned plea for peace.

Above: Essay pages 140–41
My photograph of the Seven Simians Dixieland band playing in an alley in Irkutsk, Siberia, never made it into A Day in the Life of the Soviet Union, *but the photograph's meaning was forever changed a few months later. The band of seven brothers hijacked a jet to seek asylum in the United States. Several of them died in a shoot-out.*

Following page:
Essay pages 140–41
Also in Red Square, Saint Basil's Cathedral in Moscow may be the most recognized example of Russian architecture in the world because of how often it is seen in photographs. The building has an even more auspicious appearance as you walk up the cobblestoned incline into the square. It is fully revealed only at the last moment over a sea of people. Then, as in this photograph, the giant scale becomes apparent as human figures can be seen walking past the base.

Photographs: Pages 129,
134, 136

A Day in the Life of the Soviet Union

*"Now we were no longer
strangers pointing
cameras at him, but
people with whom he
was involved, people who
preserved his dignity by
asking questions about
his life and permission
to take his picture."*

In May 1987, I flew to Moscow on the same plane with forty-nine other photographers on assignment to shoot the book *A Day in the Life of the Soviet Union* for Collins Publishers. We talked about our concern over restrictions on our photography in a country without a bill of rights.

A German photographer who had previously worked in the Soviet Union said he had been assured that the Russians wouldn't get to censor or even edit the final picture selection. "But you'll only be able to shoot what they let you shoot," a French photographer proclaimed.

"That's right," the German said.

"And they'll follow you everywhere," a *Time* contract photographer added. "They'll have a least one KGB agent for each of us."

"How about if I go on a morning run with my camera?" I asked.

"They'll be there, but you may not see them," the *Time* photographer said as our French and German comrades nodded in agreement.

Our arrival at the Moscow airport seemed to confirm our worst suspicions. Two hours of forms, permits, and declarations preceded a bus ride to the Intourist Hotel. At our first group meeting I received the good news that I got my requested assignment to cover Lake Baikal in Siberia, a natural treasure comparable to Yosemite or Yellowstone. The bad news was that I would have just two days in Siberia, one to scout, the other to shoot. The other six would be in Moscow.

I shared those days in Moscow with other photographers and went out on the town with them to take photos for our personal stock. I had no official sanction to photograph in Moscow, and thus I learned much more about what a normal tourist with a camera could do in the country than on my actual assignment at Lake Baikal with a special guide and interpreter.

I got up at five on the first morning and went for a run with my camera. No shadows moved in the empty streets, not even in Red Square. (I wish I had been in the square just a few days later, when a German teenager thoroughly humiliated Russian air defenses by landing his Cessna there.)

Ten miles and five rolls later, I returned to the hotel, where I delighted in telling my experience to my roommate, Matthew Naythons, the same *Time* photographer who had assured me that I would be followed everywhere by the KGB. An old friend, he took my riposte in stride. He said that the freedom I experienced on my run and the very presence of the American book project were due to *glasnost*, Mikhail Gorbachev's new policy of openness. The effect of *glasnost* was obviously greater than Matthew had imagined, and with a grin he expressed interest in learning its limits.

Most of the photographers who set out to walk the streets were drawn like magnets to Red Square, one of the most auspicious urban landscapes on earth. From a distance only the tops of buildings are in view. The striking spires of Saint Basil's Cathedral and the ominous walls of the Kremlin gradually revealed themselves over a sea of people as we took each step up a broad swell of cobblestones that crest onto the giant square (page 136).

There on a Sunday afternoon I saw crowds waiting to see Lenin's body and the changing of the guard. As the trio of soldiers goose-stepped toward the Lenin Mausoleum, they passed through a gauntlet of tourists armed with cameras. Inside the mausoleum itself, cameras are not allowed. The reason has more to do with keeping thousands of people moving quickly past Lenin's body than with restricting photography.

In the square I met a dozen other *Day in the Life* photographers standing near a larger group of old men sequined with war medals. The photographers

were having a heated discussion over whether these men had actually earned all the medals they were wearing, or whether, as one suggested, "they picked them up in Goodwill stores."

The difference between being with a group of amateur photographers on a foreign tour and being with a group of top pros quickly became apparent. Instead of continuing the argument over a beer in the hotel and never knowing the real answer, as amateurs would do, this group took direct journalistic action. Matthew Naythons said, "Let's pick the guy with the most medals and have an interpreter ask him where each of his medals came from."

The old man's eyes lit up and his chest swelled as he agreed to tell us about his medals and to let us take his picture. Now we were no longer strangers pointing cameras at him, but people with whom he was involved, people who preserved his dignity by asking questions about his life and permission to take his picture. He proudly identified his medals one by one: bravery in Stalingrad, wounds on the Polish front. When he came to one on the bottom row, he was so choked up with emotion that he stopped to regain his composure. Speaking slowly with great compassion, he looked us each in the eye and said, "This one is for the campaign in northern Italy. We met the Americans there. We fought together, drank together, and you were our friends then." Tears came to his eyes, and his voice became ever more firm. "Now you want to bring us war. War is terrible. We know that better than any people in the world. We don't want war. Tell your president that. Our people want peace."

I was so moved by the old man's plea that I put my camera down even before his words were translated. He didn't seem to mind as other photographers shot the key moments of his emotion. Each of us shook his hand before he merged back into the crowd (page 134).

Back in the lobby of the hotel, the old man's message was driven home again when I picked up the proceedings of the Icelandic summit conference of 1986, available in several languages. Just before leaving the United States I had read an editorial about how our government stopped both public and private printing of the same material in the interests of national security. Now, it pained me to read Gorbachev's statement that after making a sweeping nuclear disarmament proposal exactly along the lines requested by the United States, he "did not see even the slightest desire on the American side to respond in kind or meet us halfway."

My point here is not to get sidetracked in a debate over the politics of world peace, but to show how a dozen of the world's top photojournalists witnessed and photographed a poignant, topical human event that did not appear anywhere in our "free press" until I mentioned it six months later in a photography column. There is an unwritten law among press photographers not to write or disclose the sensitive things they observe in the course of photographing world events and personalities. I even questioned whether I should mention what I've just written here because I did not want to breach their confidence. I decided to relate some of what transpired without giving names or revealing any privileged information.

Photojournalists normally work elbow to elbow with other members of the press vying for a story. They quickly learn to keep their eyes open and their mouths shut. The *Day in the Life* project provided one of the rare situations in which a large group of top photographers were together in one place without the rest of the press corps. They could talk freely without fear that what they said would be published or attributed to them. I heard things from them that could easily have changed the course of U.S. politics. In Madrid, on the night before we left for

Moscow, I dined with some press photographers who related what they had observed while covering the 1988 presidential candidates. Many published rumors were confirmed, and then some. I don't dare say more.

The conversation turned toward a *Life* photographer, now retired, who wrote seventy-eight diaries of intimate observations of the lives of men and women who shaped the last half-century. Unpublished, of course. The tidbits we heard would have altered history had they become public knowledge at the time. Suffice it to say that it was not lost upon us that we were now engaged in making a book about the Soviet Union for editors who would chose and publish only our photographs, with no text except captions. The real story of our experiences would never be told.

The difference between the freedom to photograph in the former Soviet Union and the freedom to photograph in the United States is nowhere near as different as most people imagine, because of *glasnost* in the Soviet Union and the phobia of lawsuits that now strangles so many professions in our own country on either end of the lens. I regularly used my camera on runs beside the Moscow River, on tours through the grounds of the Kremlin, and on forays inside the giant Gum department store without meeting any more objections than if I were doing the same kind of shooting in Manhattan.

On our last day in Moscow, Matthew and I decided to push the limits. With the *Day in the Life* already shot, our actions would no longer jeopardize the project. We took a cab to the new U.S. embassy, an empty hulk of a building never completed because of a scandal over bugging devices found imbedded in the walls. Russian guards gave us dirty looks, but never stopped us from taking photographs. Then we turned our lenses toward the active U.S. embassy, also the focus of international attention at the time because of the recent arrest of U.S. Marine guards for espionage. We began taking street shots of armed Russian soldiers standing underneath the seal of the United States as U.S. diplomats stepped through the doorway.

Almost immediately a soldier motioned to me to come to him. Around my neck was a press pass that said I was part of a book project approved by the government of the Soviet Union. The *Day in the Life* staff had emphasized that these passes had no official status whatsoever, but that they might help us if we got in a pinch. I walked up confidently and held the pass to the soldier's face. He read it, looked me in the eye, and saluted me. Matthew motioned him to pose for us while we shot to our heart's content.

A few minutes later, I had trouble keeping a straight face when a blue-suited American came through the door and, with shocked coolness, looked up into my lens and then at the soldier. "CIA," Matthew said knowingly. The Russian soldier nodded and smiled.

Photographs: Pages 129,
135–36

*"Snapshots made a century
ago have evolved into
priceless windows into the
past. But the process of
change can be far more
sudden, as in the case of
the Seven Simians, when
destiny reshuffles the deck."*

When Fate Is the Editor

When I saw the TV documentary on the making of *A Day in the Life of the Soviet Union,* I was vaguely disturbed. At first I didn't know why. I knew the photo coverage for the book was accurate because I had been there. When I did put my finger on the problem, it seemed so unintentional and universal that I nearly shrugged it off until I realized its relevance to all photography, and especially to one remarkable situation that I had photographed in Siberia.

What bothered me was the juxtaposition of the narrator's voice proclaiming great success and unprecedented access while the photographers on the screen were still in Moscow. I remembered that we all had grave doubts about what we would be allowed to shoot when those TV cameras were on us. My Moscow briefing with the Russians had been suspiciously short. I was told that every effort would be made to allow me to shoot all the things that I had proposed. I knew that was impossible. My assignment was Lake Baikal, the world's largest, deepest, and purest freshwater lake, which contains 22 percent of the earth's fresh water and over twelve hundred species not found elsewhere in the world. I had only two days in the region; one to scout, the other to photograph.

My first day in Siberia was disappointing. My promised lakeshore accommodation turned out to be two hours away in the big city of Irkutsk. Most of my proposed shots were nixed. There was too much ice on the lake to travel by boat to an island where the native Buryat Siberians live or to find the rare fresh-water seals. The Siberian tigers were all gone around Baikal, and not even one could be found in the zoo in Irkutsk. The lake itself? Instead of walking the wild shores, I visited a pulp mill where scientists laboriously presented every detail of what was touted as the world's most advanced water purification process, which returns treated mill water to the extremely pure lake.

On the day of my shoot, every picture situation proved different than my expectations. My hosts dug up a Buryat native for me to photograph, but he turned out to be a computer engineer in a business suit (page 129).

All too soon I was back in bleak Irkutsk on a drizzly day caught between winter and summer with no sun, no grass, and no snow. I toured a mono-chrome warehouse that distributed Barghuzin sable, used for $300,000 fur coats, and made a valiant effort to photograph a dozen pale, plump women sorting furs on a dusty table lit by low fluorescent lamps with a poster of a fashion model in furs on the wall behind them. Even though I set up lights, I knew the image wouldn't make the book. The situation was entirely too cluttered for American editors. That experience made me accept an invitation I had previously refused.

Irkutsk was home to a Dixieland band called the Seven Simians, composed of seven brothers aged eleven to twenty-four. I had first thought it unwise to single out the rare signs of Western influence from the greater whole in Siberia. The idea of photographing the seven brothers became increas-ingly attractive as my other options all fell through.

The oldest boy in the band told me how much he and his brothers wanted to tour the Western world. After I rejected a possible indoor location as too cluttered, the band agreed to play for me in an alley between 200-year-old homes where old truck tires had been gaily painted to create an informal playground for children (page 135). The brothers apologized for leaving behind their double bass, saying that it was too heavy to lug through the streets. Soon a hundred decibels of drums, cymbals, guitar, banjo, trumpet, saxophone, and trombone split the quiet Siberian air. I shot two rolls for the project and moved on to other subjects.

On the day I returned to Moscow, the nation's major paper, *Pravda,* ran a front-page story on the Lake Baikal pulp mill. Several cabinet-level ministers were fired over mismanagement of the water puri-fication process. At certain times, raw effluents had been allowed to flow directly into the lake, bypassing all the high technology I had been shown.

My pulp mill shots were published in the book, but the Seven Simians didn't make it. A few months after the book came out, however, headlines around the world described how the Seven Simians hijack-ed a jet from Irkutsk with their mother on board and demanded to be flown to the free world. They boarded the plane with their double bass case, which they claimed was too fragile to go in the cargo hold. The case was also too large to pass through the X-ray machine, and, apparently, no one checked it with a metal detector. Once under way, the boys pulled out sawed-off weapons and explosives. The flight crew tricked them by landing in Leningrad, where a SWAT team attacked the plane, a bomb went off, and the four oldest boys plus their mother lay dead on the tarmac.

Thus the meaning of my unused band photo-graphs was forever changed by events that occurred after the photos were taken. Similarly, the initial doubts we photographers had about the Soviet pro-ject in general were overwhelmed by the success of the book and glossed over in the TV documentary.

In a larger sense, time always changes the mean-ing of photography. Snapshots made a century ago have evolved into priceless windows into the past. But the process of change can be far more sudden, as in the case of the Seven Simians, when destiny reshuffles the deck. Then we are forced to look at the role that luck plays in the importance of all photo-graphs. I used to think that the only elements of luck in a photograph had to do with getting the best moment on film in the best way. Now I understand that the luck of draw continues to evolve the mean-ing of an image forever.

"Imagine floating at over twenty thousand feet in the wildest part of the Himalaya after a flood greater than the one reported in the Bible raised the oceans. This was our view, day after day."

Icebreaker to Antarctica

In December 1991, I had the unique opportunity to be on the last voyage a Soviet icebreaker would ever make to Antarctica. We sailed across the rugged Drake Passage, pulled into a bay in the South Shetland Islands, brought out the vodka, and had quite a party while the Russian crew chiseled off the hammer and sickle from the stern, took down the red flag of the Soviet Union forever, and put up a handmade Russian one.

The *Professor Molchanov* was built in 1983 as a scientific research vessel to explore the icy waters of the Soviet Arctic. Because the Soviet Union was in dire economic straits, an Australian travel company had been able to book the ship as a tourist vessel to take passengers to Antarctica. There had been a shortage of ships, as well as aircraft, capable of Antarctic work.

Barbara and I came aboard the *Professor Molchanov* after Adventure Network, a struggling Canadian firm that pioneered adventure travel by air to Antarctica, left our photography tour group high and dry. The company had canceled flights booked a year in advance after the great Japanese mountain photographer, Shirakawa, paid far more money to hire one of its few aircraft for the entire season. InnerAsia Travel saved the day by rebooking our sold-out adventure photography trip by sea. The group withered to a tiny party of four who were willing to merge our itinerary with that of the Soviet ship instead of flying to remote camps on the mainland.

At first I was disappointed to be aboard a ship instead of out on the ice with a solid tripod perch. It was soon apparent, however, that the icebreaker provided far better and more reliable opportunities for photography of the wild coastline. My friend Reinhold Messner related horror stories of how his carefully planned land traverse of the Antarctic continent had been compromised and cut short by Adventure Network's broken promises, which caused long flight delays and prevented critical supply caches from

being placed according to plan. We could well have ended up stranded somewhere on the ice for weeks without access to the daily fare of penguins and icebergs to photograph that we had from the sea.

Every day we took Zodiac rafts to various destinations. The biggest surprise was a mountain landscape far more rugged and wild than I expected to find based on the photographs I had see. The Antarctic Peninsula is actually a continuation of the Andes. On the map it resembles a pig's tail attached to the bulky body of the continent. In person, it conjured up a far grander comparison in my mind. Imagine floating at over twenty thousand feet in the wildest part of the Himalaya after a flood greater than the one reported in the Bible raised the oceans. This was our view, day after day.

Now imagine that the flood had been around for millions of years and that ships had been sailing past the pristine terrain for the last century or so. The coast would no longer be pristine. This is precisely what has happened to the Antarctic Peninsula. Wherever a raft or larger boat can be landed, signs of human intrusion stand out as clearly as cockroaches at a White House banquet.

The historic qualities of an abandoned national base littered with rusting oil drums and toxic chemicals are lost on me. By its very nature, Antarctica creates the expectation that it will be pristine and primeval, yet I found myself constantly having to recompose scenics to avoid including signs of human passage such as graffiti, old buildings, and all sorts of other abandoned paraphernalia from airplanes to whaling stations. To be out in a bay with five killer whales surfacing all around was worth the price of the entire journey, but to see a rainbow in diesel oil flowing over ice at a Chilean base gave me a chilling specter of Antarctica's future.

Antarctica is such a powerful landscape that even more powerful photographs are necessary to

communicate its essence. If you expect this environment to trigger your photography without putting yourself emotionally out there, your results are likely to display your passivity. You actively need to visualize the feelings that a personal encounter with Antarctica evokes in you.

I deliberately chose icebergs as an ideal subject for influencing my results through personal visualization. A photographer who had been to Antarctica many times mentioned how he had never made an image that really communicated the danger of icebergs. He felt many of his images failed because he saw icebergs as beautiful and tried to photograph them that way. I began by purposely thinking about the danger of icebergs and the kind of image that would convey that feeling. Most photographs take into consideration only the part of an iceberg above the surface of the water. We know theoretically that 90 percent of an iceberg is beneath the surface, but we can't see that ominous part, so we normally don't respond to its unseen presence. I decided to suggest the presence of the invisible hulk below by purposely including an unusually large foreground of open water (page 155). I also chose a period of bad weather when I otherwise would not have taken a photograph so that the iceberg would appear indistinct in an ocean that already looked threatening.

An even more difficult thing to communicate about an iceberg in a purely natural photograph is its size. Without a familiar object in the frame at a similar distance, an iceberg becomes a two-dimensional abstract expression. When I saw a flock of cape petrels fly past our ship toward a nearby iceberg, I visualized an image with size cues that would be completely natural to the environment, rather than introduced, as in the case of a person or a boat. Using a 200mm lens wide open at 1/1000th of a second, I panned the black-and-white birds and froze their motion against the turquoise berg (page 155).

My favorite image of the beauty of an iceberg surprised me because it was not one that I had carefully framed on a tripod. I hastily snapped a rather small but hauntingly beautiful berg at $f2$ with an 85mm lens as it passed by the side of our moving boat (page 154). Anyone watching me take the photo would have doubted I visualized it in a conceptual manner. In classic snapshot fashion, I lifted my camera suddenly to my eye and clicked the shutter. Most photographers tend to believe that the photographs they shoot this way are made without conceptual thought.

What is really happening is that personal perceptual activity has become wired into our motor nerves as surely as a dance routine, which does not lose its artistic or personal content when it is done with less conscious thought after much practice. In any human pursuit, even something as mundane as driving a car, conscious thought gradually disappears from a complex sequence of actions. Thus my hasty image of an iceberg retains all the components of my more deliberate work, rather than those of the amateur snapshots I made thirty years ago. I had just enough time to make an intuitive composition and exposure choice.

The true benefit of the modern electronic camera is not so much that an amateur can pick one up and make great pictures. No camera can shortcut true conceptual thought. Sophisticated equipment can, however, speed up the creative process after it is ready to be expressed by the nervous system of the photographer. Thus the creative photographer has everything to gain from taking advantage of new technology, so long as it isn't allowed to shortcut personal vision. Imagine the kind of pictures of icebergs that might have resulted from mindless motor-driving in Program mode. There is no mechanical or electronic substitute for active involvement with the subject at hand.

My electronic Nikons worked fine in December on the Antarctic Peninsula where temperatures at sea level were in the high twenties and thirties. I carried a manual Nikon FM2 for backup and never used it. I wasn't so sure how my equipment would hold up the following October on another journey I was planning deep into the continent where the conditions are far colder. I knew my experience as an insider at a U.S. base was bound to be very different from being with forty international passengers and twenty-five Russian crew members on the wildest seas of our planet.

Photographs: Pages 153, 156–59

" 'Winterizing' new cameras with special lubricants is no longer necessary, as it was years ago. The common fear of subjecting electronic cameras to cold seems to be unwarranted."

No Latitude for Error

I am scrawling these notes in a blizzard just below the crater rim of Mount Erebus, the world's most southerly active volcano. To see a lava lake, eternal ice, and a caustic atmosphere merge in physical and visual chaos flips my brain between visualizing either the end of the world or its beginning. Here at twelve thousand feet high over Antarctica scientists have found a Mars analogue.

For several weeks now, I've been documenting Antarctica on an artist and writer's grant from the National Science Foundation (NSF). It takes conscious effort to photograph in a realm clearly beyond the normal performance envelope of both humans and cameras. Yesterday I circled the crater at midnight, followed by the unsetting sun and Tim Cully, a field safety guide assigned to accompany me. On that windless evening I shot six rolls of film with my Nikon F4. Nicad battery packs last for a dozen rolls in these -20°F conditions so long as I turn off the autofocus and hand-rewind the film—a good idea anyway to minimize static marks and sprocket tearing.

I carry extra nicad battery packs that slip in quickly plus a backup remote pack that will be in general use next week at the colder South Pole, where -40°F temperatures with nasty little winds quickly cold-soak exposed cameras and fingers alike. I am pleasantly surprised that the shutter keeps right on clicking on my new Nikon N90 with a remote DB-5 lithium pack wired from my breast pocket, even when the liquid crystal display blanks out somewhere below zero (a roll shot blind on Aperture Priority mode with a plus .7 compensation to whiten the snow came out well, even though I couldn't know it at the time). Tim's old mechanical Pentax has also been doing fine with far less out-of-chest-pouch time.

I planned to climb Mount Erebus to photograph Dante descending into the inferno. But Dante broke his legs in Pittsburgh. He is a robot designed by the Carnegie-Mellon Institute to gather science data from the inner crater as a test for a future Mars landing. His injuries happened last week during his first shakedown. Now his arrival has been postponed. I came up anyway to photograph this violent landscape topped by sulphur clouds that turn the sun crimson and six-story ice towers that form around fumaroles (pages 158–59).

Today we did a 75-foot free rappel down one steaming hole filled with giant ice crystals. After I came out of that misty hole into the freezing air, I had my only true camera failure. As I shot more images on the crater rim, I began to wonder why the light was so low even though the sun was still up. My meter coupling ring had frozen in place.

My problem was a variation of the most common subzero camera ailment: sudden transport of cold equipment into warmth and then back into cold again. Condensation forms in the more humid warmth and locks up functions when the camera reenters the cold. This, rather than actual low temperature, is the primary cause of problems that don't involve batteries. The cure is to rewarm cold equipment in a Ziploc bag with as much air as possible removed to prevent condensation. The problem is cold-to-warm. A warm, dry camera thrust suddenly into the cold works fine.

Today the windchill factor is around -100°F. We are in a small Quonset hut below the rim erected for NSF scientists. With a stove going and plenty of food, the temptation to lie around and not take photos is enormous. I saw the rare opportunity to capture human experience in extreme conditions, so I talked Tim into donning all his gear and heading into the swirling clouds of snow while I shot several rolls. Quick releases are essential for serious tripod work in these conditions. Kirk Enterprises releases come into their own here for quickly attaching bodies and lenses to tripods with gloves on.

I have come to believe that the limiting factor of cold-weather photography is more biological than technological (I believe this is true for normal temperate photography, as well). My cameras continue to perform after my body has gone down quicker than a K-Mart flashlight. It's another story when my fingers stop working. Photography becomes limited to blind stabs at the shutter release. If a roll runs out in these conditions, it's all over until your fingers are rewarmed enough to do the switch.

The Nikon N90 (and 8008s) allow rapid film change with thin gloves, but a Nikon F4 holds onto each motor-driven, spring-clipped cassette like the teeth of a leopard seal tugging a penguin into the sea, and I have to use bare or nearly bare fingers for a few seconds. My tips are numb and my nails are broken, but I would have given up ultracold work in my youth were it not for a miracle innovation: chemical hand-warmer packs.

Grabber disposable dry packs have never failed me, but other brands of reusable liquid packs have left me cold, so to speak, numerous times (they are fragile, useless if they tear, and hard to reliquefy in rugged field conditions). For deep cold I use wool mitts that have a flap that pulls back to expose a fingerless glove underneath. These were sold by REI and some yuppie gadget stores, but I haven't seen them for sale lately. I put a seven-hour Grabber pack into each mitt flap so that the moment my bare tips are done with a short task they touch warmth. Windproof overmitts add greater warmth, but greatly slow down shooting.

The bottom line is that no glove by itself works well enough for photography in extreme cold. Down to zero or perhaps -20°F in still air for brief periods, neoprene Glacier Gloves from Orvis fly-fishing shops are the best call. They have slits that allow a thumb and a forefinger out when needed and a high degree of tactile sensation, but they don't breathe and soon get damp and icy.

I have also been using Grabber toe warmers in my mountaineering boots up here (although not in the superwarm but clumsy Bunny Boots I also have to wear in easier terrain). In the snowless Dry Valleys the toe warmers work so well that they allow me to walk, run, and photograph in my New Balance running shoes while covering twenty miles in a day.

My techniques for cold-weather photography are far from original. I learned some from partners on twenty-odd Himalayan treks and climbs, but even more during a 1980 assignment to cover the Lake Placid Winter Olympics where Nikon Professional Services tech people gave me sound advice. I have relied on them ever since, especially for tricks about new models. Ron Taniwaki of the California office is especially cold knowledgeable. He clued me in on using AF lenses focused manually when ultracold locks up the barrels of manual units. He advised using moleskin on my cameras where my hand or face might touch them, a $1.19 paintbrush to de-snow lenses and bodies, and the F4's Continuous Silent advance mode (designed to slowly whoosh film forward in sound-sensitive places) to prevent static or tearing.

"Winterizing" new cameras with special lubricants is no longer necessary, as it was years ago. The common fear of subjecting electronic cameras to cold seems to be unwarranted. Fewer moving parts with advanced lubricants make techniques for cold-weather shooting about the same for two months in Antarctica or a winter weekend in Yellowstone. In Antarctica, I shot 220 rolls without ever using my backup mechanical FM2, and I'm planning to leave it home on my next polar journey.

"I was reasonably certain that some atmospheric effect was to blame, but I couldn't figure out what was going on. It looked as if the sun was rising too late or daybreak was coming too soon."

The Alpenglow Enigma

For years I have touted the Eastern Sierra as my favorite place on earth. I have made many of my best photographs there, not only because of the wonderful physical setting and my emotional connection to the landscape since childhood, but also because of the fine warm light at sunrise. It was here that I learned to look for light first, then find subjects to match with it.

Over the years the Eastern Sierra has delivered me a wild variety of unusual outdoor optical phenomena. My favorite shots often combine vivid alpenglow that I have come to take for granted with rainbows, halos, full moons, lenticular clouds, and snowcapped peaks. In March 1992, however, I spent a week on a commercial shoot without alpenglow ever materializing. Every morning the sun rose with a colorless flatness. The dramatic colors of dawn were extremely muted. Instead of a crimson searchlight on the highest ramparts of granite and snow set against a deep blue sky and dark shadows, a soft pink murk would descend over the summits well after the general light level was bright.

I was reasonably certain that some atmospheric effect was to blame, but I couldn't figure out what was going on. It looked as if the sun was rising too late or daybreak was coming too soon. I would sit there watching the landscape grow light without the sun coming up, and when it did, the light would be disappointing.

Although the blue sky seemed pale, the air didn't look a tenth as hazy as on a smoggy day in Los Angeles, when sunsets can still be vivid. I reasoned that something other than sheer quantity of particulate matter was shutting off my magic light, but I didn't have an answer for what was wrong.

The winds that normally blow from the west had a strong southerly component, and I wondered if perhaps muted air was blowing up already dirty from Los Angeles and picking up something strange from the alkali dust around Owens Lake near Lone Pine. The lake is nearly dry because Los Angeles' thirst diverted the Owens River into an aqueduct. I began to doubt this scenario because I had frequently seen conditions that look less hazy continue to deliver wonderful alpenglow at dawn and dusk.

I hoped that I wasn't witnessing the end of an era. To mourn the loss of fine natural light at the hand of humankind was certainly not new. At the turn of the last century, the Dutch optical scientist Professor Minnaert noted in *The Nature of Light and Color in the Open Air* that "the original beauty of the hues in the landscape, more and more spoiled in our parts by the effects of industrial development, can still be enjoyed in full splendor in the mountains." The work of Minnaert and other atmospheric scientists originally led me to pursue fine light through a scientific understanding of its source. The title of my 1986 book, *Mountain Light*, was directly related to that search.

After a second and then a third commercial assignment in the Sierra failed to produce a single morning of vivid alpenglow, I sensed something big had happened, but I remained confident that my understanding of alpenglow would lead me to it in more remote locations elsewhere.

Some of my assumptions proved quite erroneous, but I was on the right track to seek answers in the atmosphere rather than in my photography or bad luck with sunrises. Before I explain the cause of the alpenglow problem, we need to know what causes alpenglow in the first place. There is a distinct difference between particles in the air that intensify the colors of sunsets and sunrises compared with those that weaken them. "Warm" red light is literally warmer than "cool" blue light. Red light contains more heat radiation that can be measured as higher color temperature and thus penetrates certain kinds of haze more easily than blue light. Beyond visible red is infrared, which has a much greater ability to penetrate haze.

Light turns noticeably warm when the sun shines through disturbed air near the horizon as particles in the air stop more cool rays than warm ones. Given enough space for considerable sorting to occur, light transmitted from the sun becomes warmer as the cool waves are scattered away. The scattered light doesn't vanish. It gives atmosphere without a direct light source the color of the shorter wavelengths, and thus we have blue sky.

Up to a point, the more disturbed the air, the more vivid the warm color of the sky in the direction of the sun as well as the color of objects that reflect the sun. However, for the warming of light to occur, the particles that cause the interference must have a distinct size relationship to the wavelength of light. Only then will some shorter blue waves scatter while more red waves pass through. Water vapor does not have this size relationship, and thus fog and clouds do not color the light of the sun. Smoke at any time of day will turn sunlight distinctly reddish.

Alpenglow was first described as a wild red glow on snow peaks in the Alps that occurred when the sun wasn't shining in the villages below. Several additional factors contribute to the intensity of alpenglow on high mountains that rise well above the normal surface of the earth or clouds that can range far higher. Light that strikes them at dawn and sunset is making what amounts to a double-length journey through the disturbed layer of air close to the earth. The last light rays mountains and clouds receive skim the horizon of the curved globe quite some distance away before continuing in a straight line through the atmospheric filter a second time toward the heights.

The two examples on pages 160–61 show how a cloud at well over thirty thousand feet above the Eastern Sierra has taken on a much richer red than the alpenglow on the upper ramparts of 14,496-foot Mount Whitney, the highest peak in the contiguous forty-eight states. In both cases saturation has been increased by warm light reflecting off light colored subjects—clouds and granite cliffs. Darker landscapes without snow don't show anywhere near as pronounced colors.

The snow peaks of the Alps are both high in altitude and light in color. Historically, both sides of the range were heavily forested. Photosynthesis helps create the kind of haze that warms light. Today, much of what has been lost in Alpine forest cover has been more than compensated for by Europe's particulate gifts to heaven. When I spent two weeks in the Alps in 1990, I was rewarded with splendid textbook alpenglow in situations very similar to those in the Sierra.

After the sun sets on peaks and clouds, a highly photogenic variation of alpenglow continues. The deep blue twilight wedge, also called "the earth shadow," rises into pink atmosphere lit directly by the sun. The intensity of saturation of this meeting place of colored light also has to do with high altitude, but for a different reason. When the earth shadow appears the most vivid a few minutes after sunset, the juncture of blue against red occurs along a curving plane high in the sky that is roughly parallel with the earth's surface. From sea level we look through the blue layer into the red, and thus the juncture is somewhat diffuse. When we view the scene from high altitude, our angle of vision is more in line with the juncture.

Why, then, did alpenglow and the earth shadow dramatically weaken in the Eastern Sierra in the winter of 1991–92?

"Across most of the world, exceptional displays of alpenglow were rare if not wholly absent during 1992 and 1993. They have begun to return to normal at about 50 percent a year, since 1992."

Requiem for Alpenglow

During the spring of 1992, when muted alpenglow frustrated my photography in the Eastern Sierra, I later found equally poor light in the deserts of the Southwest, the Colorado Rockies, and western Canada. Other photographers told me similar accounts of flat light at dawn and dusk all across the Northern Hemisphere from the Alps to the Himalaya, Siberia, and my home on San Francisco Bay. Strangely, I could find no mention of the problem in the media or in scientific journals. People to whom I mentioned it would acknowledge, oh yes, come to think of it they hadn't seen a good sunset or sunrise in a while. I didn't want to think the problem was global and I held out hope for the Southern Hemisphere because, based on my own experience there in late 1991, alpenglow was alive and well in Patagonia.

I originally discounted the possibility that the eruption of Mount Pinatubo in the Philippines during the summer of 1991 could have had anything to do with my local problem in the Sierra. Unlike my recent observations of flat light, the eruption's positive effect on warming sunset colors had been well documented in the media. During the months after the eruption, I too had seen far brighter, rather than weaker, sky colors in the Sierra as well as in many other parts of the world. My favorite textbook on light and color mentions how the 1883 eruption of Krakatoa caused vivid sunsets around the world for more than a year, but says nothing of atmospheric colors weakening long after the eruption.

I guessed that some other form of particulate matter must be affecting the Rayleigh's scattering of different wavelengths of light in the atmosphere that causes alpenglow. For example, vapor particles near the sun do not turn the sky red in the middle of the day, while particles in forest fire smoke do shift the color we perceive. I knew that Sierra sunsets go flat in the final minutes when the sun begins to drop into water vapor

in the air above the coast on certain days. Alpenglow is most vivid on clear, cold days right after storms.

I expressed my overall bewilderment at what was going on and began contacting some atmospheric scientists to see what they thought. Answers from the University of California at Davis and the National Oceanic and Atmospheric Administration in Boulder were identical. The news is not good for outdoor photography in the near future. Volcanic aerosols from Mount Pinatubo are the culprit. Across most of the world, exceptional displays of alpenglow were rare if not wholly absent during 1992 and 1993. They have begun to return to normal at about 50 percent a year, since 1992. It could be as long as five years after the summer 1991 eruption before we have as vivid and frequent alpenglow as in the past.

When Mount Pinatubo spewed twenty million tons of ash into the sky, the excess particulate matter first favored rich sunsets. After the larger particles settled to earth, a stratospheric blanket of sulfuric acid molecules began to bond to water molecules over the entire Northern Hemisphere and much of the Southern Hemisphere. Within the year, Patagonia and Antarctica were also affected.

The scattering by this layer is so intense that the sky within a broad area around the sun appeared more white than blue all across the United States throughout late 1991 and 1992. This greater scattering naturally puts more indirect light on the landscape. The effect is especially noticeable at times the sky would normally be quite dark, as at dawn or dusk. When the first rays of warm light hit the highest peaks at dawn, the scene is one or two *f* stops brighter than it used to be. Rich colors are washed out as if the house lights were left on during a slide show. No matter how saturated the colors may be in an especially fine slide, they won't come across with ambient light shining on the screen.

Sunset and sunrise colors looking toward the sun should begin to appear reasonably normal on good days after 1993. Unlike alpenglow, which is seen in the opposite direction from the sun, these situations depend on the direct color of the transmitted light. They are not so affected by the exaggerated amount of scattered light.

Most of my best alpenglow photos from late 1991 and 1992 look as if I overslept. A few, however, look nearly normal from what would otherwise have been truly exceptional natural light shows. Some photographers have shown me quite nice photos to prove that there is still alpenglow, but so far the ones I have seen only make me think how much better the situation would have photographed if that angry volcano hadn't blown its top.

Some early scientific reports confined the sulfuric acid layer mainly to the Northern Hemisphere and equatorial latitudes, but by early 1992 dispersion was evident over much of the Southern Hemisphere as well. To my surprise, no atmospheric scientists were able to tell me if Antarctica had enough aerosols to alter sky colors for photography before my October 1992 visit there under the auspices of the National Science Foundation. The moment I stepped off the plane, I saw the telltale salmon-colored circle around a diffuse sun and knew the aerosols were there in force. The natural clarity of the air combined with clean white snow did give me more alpenglow colors than I had expected, but old Antarctic hands told me how much softer the light, how much paler the sky, and how much weaker the crimson glow of the past had become.

I had only a brief two weeks to capture alpenglow on the edge of the Antarctic continent before the sun began to stay above the horizon all day after October 23. After that date I got some surprisingly good photos by placing the salmon-colored circle of haze around the sun on the horizon behind a chosen subject (pages 158–59). In tight telephotos it resembled the pastel pinks and blues of twilight.

I have learned the hard way over the years to tune into natural light rather than to try to fight it. During the summer of 1992, I headed for the Canadian North into an area where my best photo opportunities in the past had been under cloudy-bright skies that gave clear, even light to meadows, flowers, streams, and wildly sculptured peaks. The coming years are not a time to put my cameras away, but to rethink my creative strategies. I'll continue shooting some long-term projects for myself, but in some cases I'll delay book publication plans for a few years until I know the light will be more advantageous for some key images that need intense saturation at sunrise and sunset. And maybe I'll even sleep in once in a while.

Photographs: Pages 162–67

The Cirque of the Unclimbables

"I wanted to let my photography seek its natural level rather than be guided by an editorial formula brewed in advance. If a story resulted, I'd try to sell it afterward based on what really happened."

Success in outdoor photography holds a paradox. That great early feeling of escaping modern "hypertime" when you're out in the wilds with your camera gives way to the establishment engulfing you with ringing phones, whirring faxes, preconceived assignments, deadlines, and exotic travels that begin to look the same through the windows of taxis, hotels, and airports. I've learned that dream assignments that pay fat fees plus tickets to some far end of the earth are rarely as personally satisfying as the early trips I made on my own before I became a professional. I came home from those trips feeling really great with few good pictures and less money.

I'm more certain of that than ever after revisiting the location of the last major trip I took before becoming a pro in 1972. That summer I went on a small climbing expedition to the Cirque of the Unclimbables in the Northwest Territories of Canada. At that time, probably fewer than twenty-five people had ever set foot in this paradise of alpine meadows and granite walls with names like Lotus Flower Tower. I felt a real connection between physically expressing my being on the cliffs and visually expressing myself through photographic interpretations of the landscape. In both cases, I succeeded only some of the time. The major summits and a few of the big faces had been climbed by adventurers like us who drove north and flew the final roadless miles over marsh, meadow, river, and glacier by floatplane or helicopter. Overland travel to the Cirque was wholly impractical with the gear needed to climb a big wall or do serious photography.

Even though a 10-day storm dampened our enthusiasm to climb a major face in 1972, I returned with memories of one fine first ascent and some captivating photographs. For the last decade or so I've been wondering what it might be like to revisit the Cirque in better weather with my advanced photographic knowledge. I never dreamed that I'd have a chance to upstage all my past rock climbing as well. In the summer of 1991, Todd Skinner and Paul Piana began asking me if I thought they might be able to free climb the wildest face in the Cirque. In 1988 the two Wyoming climbers had made the only free climb of the face of El Capitan in Yosemite. Ever since, they had been dreaming of doing the hardest free climb of an alpine rock face in the world. Their skill level was equal to the task, but their problem was finding the mountain to match it.

I had climbed a major face in Wyoming with Todd and Paul two years ago, but it didn't prove quite hard enough for them. Sometime later, Jim McCarthy, my old partner from my 1972 Cirque expedition told them his candidate for their ultimate alpine free climb. In 1963 he had spent several days climbing the sheerest face in the Cirque, the 2,000-foot wall of Proboscis (page 162). The route had never been repeated. His party had used many anchors in the rock for direct climbing aids instead of only to protect free climbing on natural holds, as Todd and Paul hoped to do. He recalled that the sheer granite had the right balance of enough texture for tiny finger and toe holds without easier sections to break the continuity.

When Todd and Paul asked me what I remembered about the face, I told them it had looked fantastic. We planned an expedition on the spot a year in advance. Knowing how momentary enthusiasm can fade like autumn leaves, I sent them an exhibit print of the big wall on Proboscis to ponder. Meanwhile, the two Wyoming climbers—sometimes paired, sometimes apart—took off on adventure climbs in North Korea, Vietnam, South Africa, and the jungles of Venezuela.

Once we had a firm departure date for the Canadian North, I resisted the urge to arrive too fast through the virtual-reality chambers of airports and hotels. I also wanted to put personal experience first, as I had in the seventies, and not saddle myself with an assignment from a major magazine to cover what

could be a climb of great international significance or a failure if just five feet of the cliff was too blank to free climb. I wanted to let my photography seek its natural level rather than be guided by an editorial formula brewed in advance. If a story resulted, I'd try to sell it afterward based on what really happened, unlike so much of what passes for the whole truth in many preassigned adventure sagas. Heinrich Harrer, who sold *Life* its first color cover after the fact and whom I consider to be this century's greatest adventurer, once told me, "If people say farewell to you with the band playing at the airport, it's a bad sign."

One day in July 1992, I hopped into my old Chevrolet Suburban, picked up Todd and Paul en route, and drove to the Yukon. The Far North revealed itself slowly through a progression of changes as we detoured through Glacier, Waterton Lakes, Banff, Jasper, and Mount Robson parks. Days became longer, sun angles lower, and vegetation less complex as species dropped away with each passing mile. Here was the beginning of the simplified subarctic landscape that I knew would come across on film without the selective drama of magic-hour light. Many of my best shots from the Far North had come under cloudy-bright skies when the natural order of things worked on their own without the need to find special light to drop away "busy" vegetation or dirty air. I was all too aware of the subdued light at sunrise and sunset caused by a sulphuric acid aerosol layer in the stratosphere after the 1991 eruption of Mount Pinatubo. It would be a joy to photograph where I wouldn't have to keep fighting the light.

Northern British Columbia was a shock. I had flown across it a number of times without realizing how radically it had changed since I had driven through it in the seventies. The wild sheep, goats, elk, moose, and bear I had photographed beside the roads were all but gone, as were most of the old-growth forests. The Bowron Valley clear-cut near Prince George is one of the few efforts of our species that is visible from space. If aliens have seen this 75-mile swath and haven't tried to contact us, it is because they've rightfully concluded our planet lacks intelligent life. My one concession to assignment photography was to rent a plane to document the Bowron for a friend's book on forest problems. The afternoon was clear but hazy, so I had the pilot fly below two hundred feet while I used a 16mm lens with Fuji Velvia pushed

a stop to get wonderfully crisp images. The slightly curved horizon mirrored the feeling of that infamous view of the world's largest continuous clear-cut from space.

We continued north up the Cassiar Highway, where I had driven through endless virgin forest the year it opened. Now virtually all the lower valleys were clear-cut. Only after we crossed into the Yukon did we see trees consistently standing.

Our travel by car ended abruptly at a mineral exploration camp beside a remote lake on a narrow dirt road called the Campbell Highway. From here we had arranged a 150-mile flight over trailless mountains and marshy valleys into the Cirque of the Unclimbables. We had a choice of a floatplane or a helicopter at twice the price, which would save us days of slogging heavy loads up a canyon from a lake. For the budget-conscious 35mm photographer, the fixed-wing is the way to go, but with 400 pounds of climbing gear and food to survive for several weeks that might be plundered by grizzlies before we could shuttle it to our base camp at higher altitudes, we planned to opt for the chopper.

We almost changed our minds when Warren LaFave arrived that evening in the most immaculate bush plane we'd ever seen, a restored Beaver on floats with engine and wing modifications that snapped it off the lake in twenty seconds with all our gear and several more passengers. We cruised low over grazing moose, curving rivers, and verdant forests before dropping down beside the new Inconnu Wilderness Lodge, an elegant group of log buildings surrounded by thousands of square miles of roadless wilderness. Warren was also the owner of the lodge and he invited us to spend the night before heading into the mountains, even if we decided not to fly any farther with him. The scene reminded me of a TV travel commercial, and I soon found out why. Warren played video footage from a recent ad for Canada that included the lodge, his plane, and the region from the air.

Soon a Bell Jet Ranger landed. Warren introduced us to the pilot, John Witham, and they made us an offer we couldn't refuse. Did we want to spend the next day surveying the photo and adventure potential of the region by helicopter? Warren wanted to bring in photographers, climbers, and river runners as well as his mainstay hook-and-bullet clientele. Hours of helicopter time with John are already part of Warren's lodge package price. His Kluane Air Service is officially based in Whitehorse, but when his plane is at the lodge in the summer and fall, he is able to

offer the shortest and cheapest air access to the Cirque.

John is not your average helicopter pilot. Besides making an incredible twenty thousand wilderness landings in the last year to pick up a myriad of mineral samples, he is the nearest town's justice of the peace, coroner, dogcatcher, ex-mayor, and one heck of a country-western singer. When we flew with him the next day, we chased caribou and rainbows under stormy skies over intensely green valleys en route to scout unclimbed rock walls in several ranges. I took ten rolls of rich and snappy aerials using my cloudy-day technique of pushing Velvia one stop while flying slow, shooting fast, and staying low.

After a second luxurious lodge night, John dropped us beneath the awesome wall of Proboscis and shuttled extra gear that Warren had flown to the nearest lake for us. When the face was first climbed thirty years ago, getting up by any means was a great adventure fraught with uncertainty. Today, climbing has reached the level where a competent party that can wait out bad weather is reasonably sure of success if direct aids are used. Our goal, as in climbing Mount Everest without oxygen, was to restore adventure by meeting the mountain on its own terms. We hoped to free climb it, using only natural holds for upward progress.

Todd and Paul decided against the original route in favor of a clean blade of rock projecting from the face for twelve hundred feet. They wanted to name it "The Great Canadian Knife" if they could climb it. We spent nine long days of the arctic summer preparing the route for such an extreme free climb and reveling in the wildness of the flowered valley around our camp, where every morning and evening I ventured out with my camera.

Just as a fine concert needs a rehearsal, personal limits of difficulty in climbing can't be attained by starting from below and reaching for unknown, dirty holds. Each section was first climbed with direct aid and fitted with anchors where necessary to clip safety ropes. Tiny hand and foot holds were brushed clean of dirt and lichens.

Once the critical lower half of our new route was known and practiced, we began the main performance from the bottom of the wall. So long as one climber is able to lead each section from below without falling, the free climb is considered a success, much like a relay race of shared, maximal effort. Since the first eight hundred feet were vertical, crackless, and beyond my ability to free climb on the lead, I concentrated on photography. Hanging from mechanical ascenders on the fixed ropes we had set up to prepare the lower route, I moved in with my 24mm lens as Todd and Paul alternated leads up the longest stretch of extremely difficult free climbing ever done at the time (page 163). They repaired torn fingers with Superglue and survived entirely on Powerbars and water.

After our first bivouac in narrow Porta-ledges hanging from the cliff (page 165), we moved above the highest fixed rope into terrain with natural cracks that I could lead. Snow flurries struck in the evening before we bivouacked straddling a ridge crest no wider than a chair. At dawn the skies cleared, and we reached the summit on the third day in balmy T-shirt weather (page 165). We made it down to base camp that night and called out on the radio to get picked up and to report our great success.

John Witham had a surprise for us. He landed only minutes away in Fairy Meadow (page 164), exactly where I had camped in 1972. The feeling of that era, plus the decade before it when the Cirque of the Unclimbables and its peaks and meadows had gotten their names from the first climbers to visit the area, came back to me in a rush as I got out of the helicopter in familiar surroundings. There in the grass below Lotus Flower Tower was a chef John had flown 150 miles from a mining camp to give us a victory banquet. We couldn't believe our eyes as she brought out wine, a hot soufflé, and ice cream. That night we soaked our tired bodies in the lodge hot tub before heading south with a photographic record of a 7,000-mile adventure by car, bush plane, helicopter, foot, and vertical rock.

The first general-interest magazines I approached didn't buy my photo story. Editors told me it was *Esquire* stuff, a bit macho for the mainstream public. It doesn't fit the mold of either a sporting event or a travel story about a place where normal people might want to go. I'm glad it wasn't assigned either way. I brought back photographs that please me because they match my personal passions and experiences instead of images contrived to compete with the Royal Family on newsprint at the checkout stand. This is what outdoor photography is really about, quite apart from the economic imperative of what we do for money to keep on taking photographs that are meaningful. Whether our career requires working at another job or matching photos to someone else's ideas, it's important to let it all hang out on the edge of wildness as often as possible.

Right: Essay pages 144–45
I took this self-portrait at the South Pole in -45°F temperatures with a self-timer on an electronic Nikon N90. The post by my right hand marks the 1992 official South Pole. The posts from previous years can be seen receding into the slowly moving ice cap behind me, roughly thirty feet apart.

Left, above, and right:
Essay pages 32–34, 82–83,
142–43

While on a cruise to Antarctica on a Russian icebreaker, I used conscious visualization to avoid the creative blind alley of photographing a subject with a single mind-set. These three different visions of icebergs are the result of separate mental images of beauty, scale, and danger. My visualization of beauty (left) singled out the simplicity of one berg with vivid blues and gleaming whites. Anyone watching me quickly snap this photograph as an iceberg passed off the bow would have doubted it was highly preconceptualized (page 34). I had my camera at the ready with a two-stop, soft-edged, graduated neutral-density filter on an 85mm lens to isolate a berg against a dark, cloudy background. To add a sense of scale (above) to an iceberg, I sought size cues that were natural to the environment. I wanted to avoid introduced human presence.

In countless photographs of people in rafts beside bergs, scale is evoked at the expense of the image no longer depicting a wholly natural landscape. I found a flock of cape petrels that I froze at 1/1000th of a second against a turquoise berg. To visually communicate the danger of *icebergs, I first imagined the unseen 90 percent beneath the surface, then suggested its presence (below) by including an unusually large foreground of open water in my composition. To make the berg appear indistinct and more threatening, I used a 200mm lens in bad weather.*

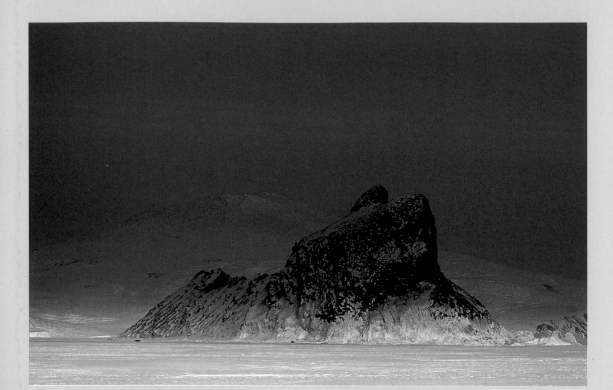

Above and right:
Essay pages 144–45, 146–49
*Alpenglow warms the upper
ramparts of Mount Erebus in
Antarctica, while the base of the
world's most southerly active
volcano remains in soft, blue
light. The peak rises 12,450
feet directly out of the Ross Sea
in Antarctica—a greater vertical
distance than Mount Everest
above its base camp. To my
surprise, my fully electronic
Nikon F4 and N90 worked
perfectly in these extreme
conditions so long as I used
remote battery packs wired
from under my parka.*

Following pages:
*Smoking ice towers up to
sixty feet high form around
steam fumaroles near the
crater rim of Mount Erebus.
To add scale and make the
image more evocative, I asked
my partner, Tim Cully, to
stand beside the largest tower
with his ice ax while I
carefully composed the sun's
rays diffracting into a star
around the tower's edge.
Note that the sun is too high
in the sky to justify the
degree of pink tones near the
horizon, which are partly
caused by the "Mount*

*Pinatubo effect" (pages
148–49) in the atmosphere
in 1992. While I framed
the image to include part of
the diffuse salmon-colored
ring that has surrounded the
sun and weakened the blue
sky since that eruption in the
Philippines, I suddenly
thought about where I was
standing: on the rim of an
active volcano!*

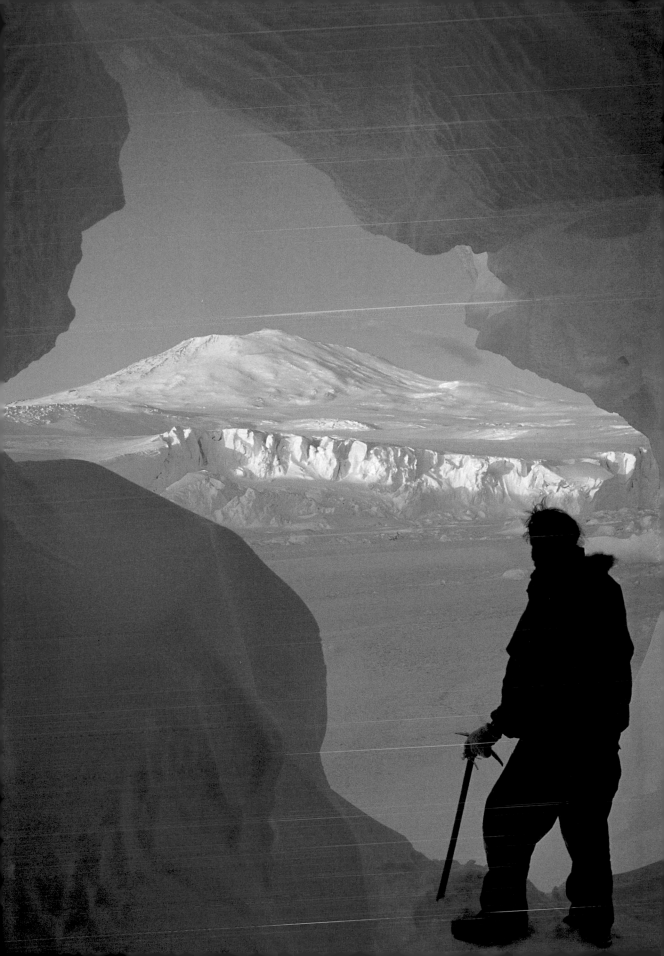

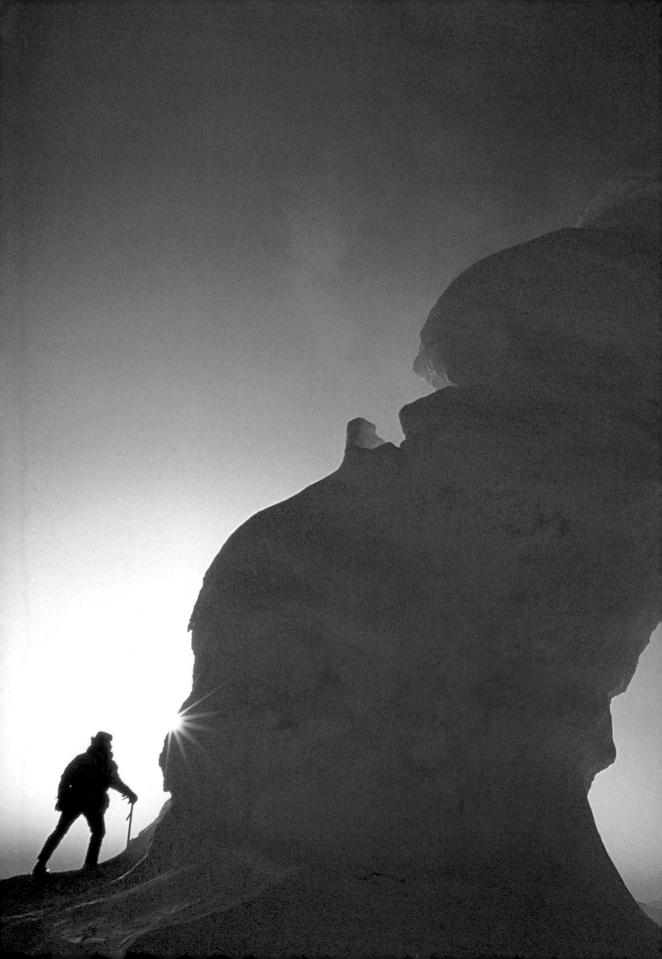

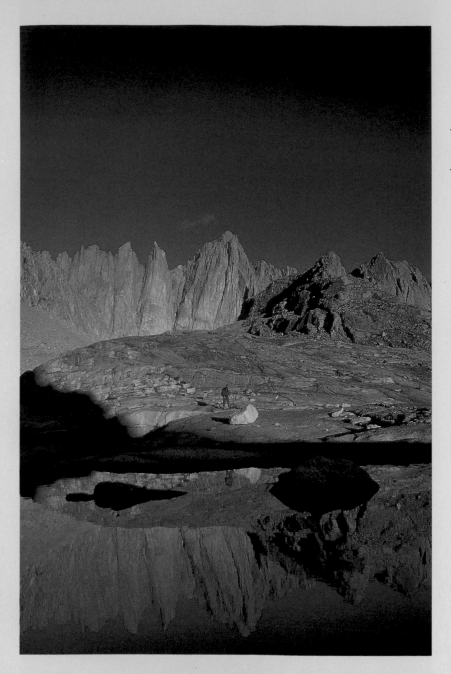

Left and right:
Essay pages 146–47, 148–49
The extremely rich colors of alpenglow are related to a subject's height above the surface of the earth and its reflectivity. The planet's curvature accounts for why high peaks and clouds receive sunlight so long before dawn and after sunset in the flatlands. The light they receive has taken a much longer path through disturbed air. So much blue light has been scattered away that vivid orange and red hues appear when the atmospheric conditions are right. Thus the color is more intense on lenticular clouds at over 30,000 feet (right) than on 14,496-foot Mount Whitney, the highest peak in the contiguous forty-eight states (left). Knowing that alpenglow after sunset on the lenticular cloud was highly likely, I searched out a situation that would complement its form and color on the ground. I discovered a bend in the Owens River that not only mimics the shape of the cloud, but also has the same color because of reflection.

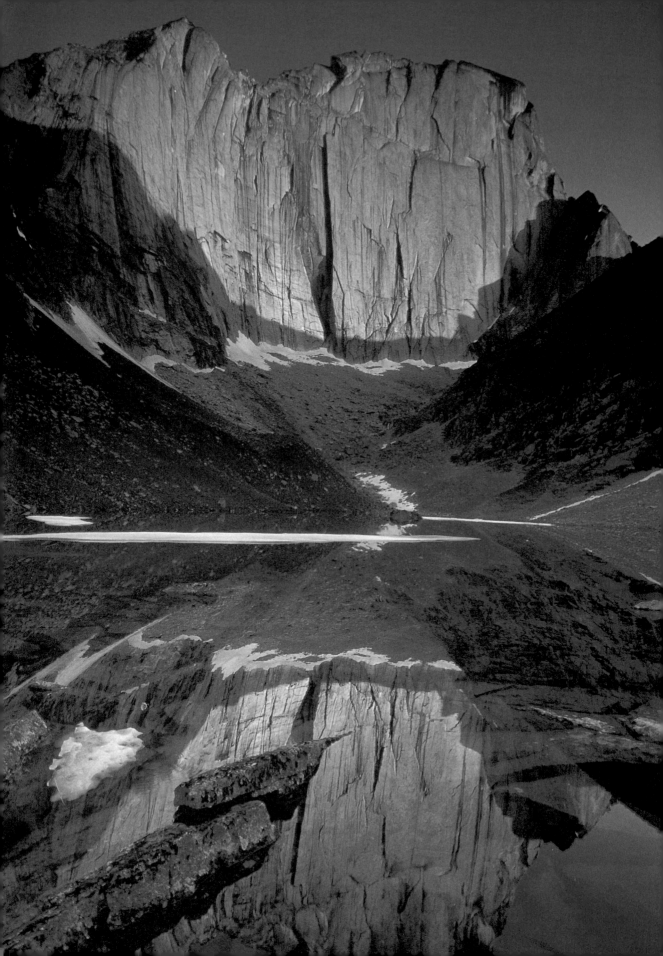

Left: Essay pages 150–52
After a helicopter dropped me below the southeast face of Mount Proboscis in the Cirque of the Unclimbables of Canada's Northwest Territories, I discovered that I had left my normal six-pound tripod behind. The tiny two-pound Gitzo I had brought along for the climb and for hiking gave me surprisingly sharp images throughout my two-week visit. Here I used my Nikon 8008s with a 20mm lens and two-stop graduated neutral-density filter very close to water level so that I didn't have to extend the Gitzo's legs.

Right:
Todd Skinner leads the fifth pitch (rated 5.13B) of "The Great Canadian Knife" route on Mount Proboscis in the Cirque of the Unclimbables. Each section of the climb was first practiced and memorized before we set off to make what turned out to be the most continuously difficult alpine free climb ever done. We left fixed ropes in place beside the most difficult early sections so that I could photograph the lead climber at critical moments. For this shot I used a 24mm lens on auto-focus while I held the rope with one hand.

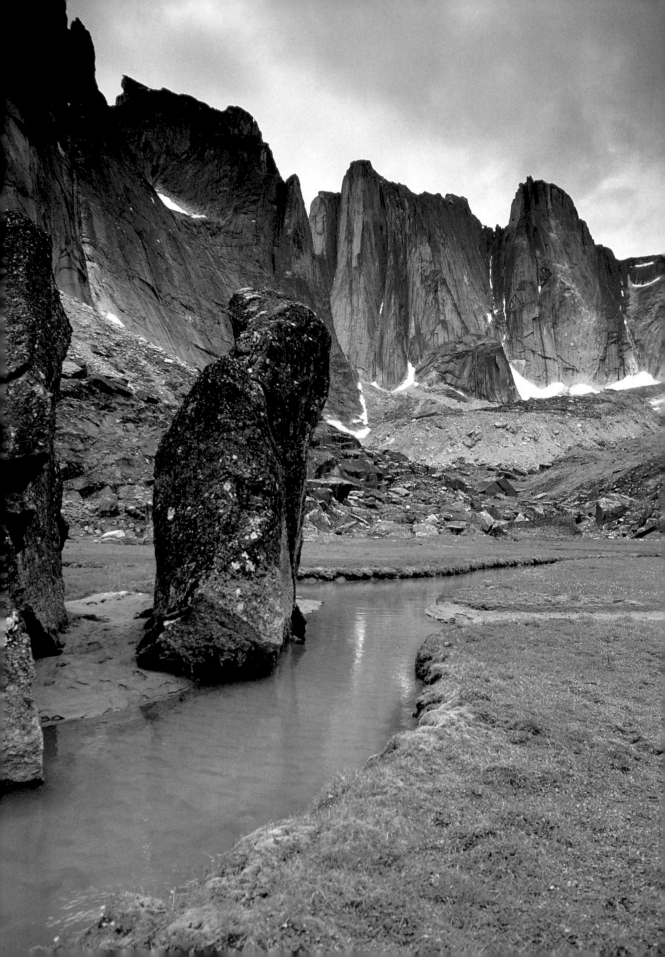

Left: Essay pages 82–83, 150–52

This seemingly straight image of Lotus Flower Tower and Fairy Meadow actually required a two-stop, soft-edged graduated neutral-density filter to hold detail in the clouds and stop the sky from becoming white.

Right, above:

To capture my own bivouac on "The Great Canadian Knife" on Mount Proboscis in the Cirque of the Unclimbables, I unhooked the rainfly of my Porta-ledge in strong winds and used a 16mm lens to include everything from the sleeping bag in which I was lying to the distant peaks. This view seemed even more dynamic than looking straight down on my companions in their Porta-ledge about fifteen feet below me.

Right, below:

Todd Skinner, Paul Piana, and I celebrate the first ascent of "The Great Canadian Knife" on the summit of Mount Proboscis. I used a Nikon 8008s with a 24mm lens and fill-flash from an SB-24 set on my little Gitzo 001 tripod. A 30-second self-timer gave me plenty of time to get in the picture.

Following pages:

Moments after sunset I caught this moonrise from Mount Proboscis with a 300mm f2.8 lens and 2X converter. To make the 600mm setup rock solid, both the end of the lens and the camera body were propped up in rock cradles. The exposure was set from a spot meter reading off the big moon with brackets one stop over and one under in half-stop increments.

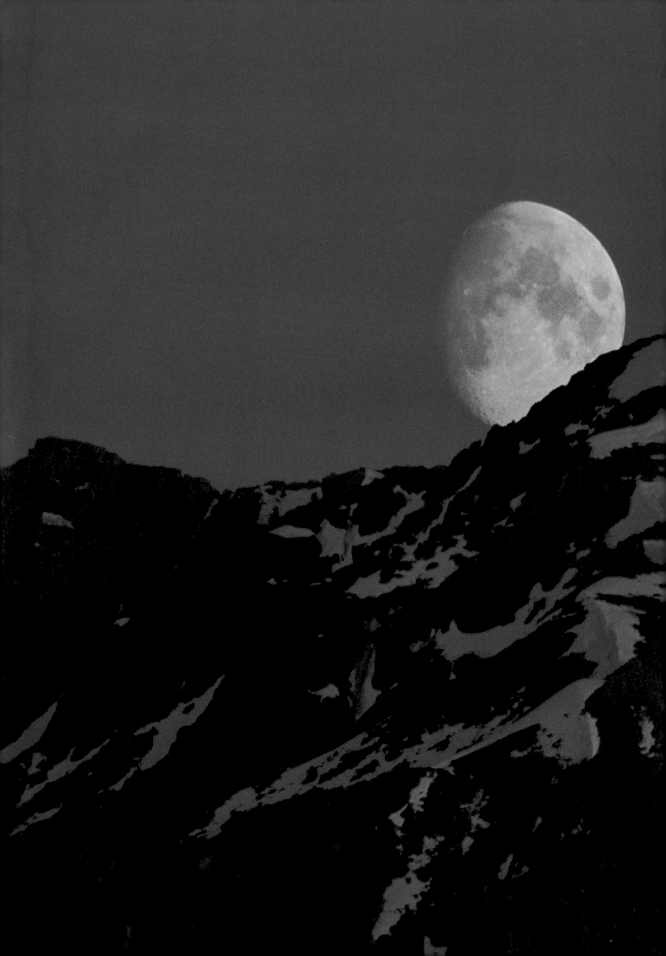

Above: Essay pages 169–71
While photographing the highest war in history for National Geographic *in the Karakoram Himalaya of Pakistan, I caught another helicopter in the Bilafond Valley profiled against an unclimbed granite face at over 18,000 feet. The area has been closed to visitors for a decade.*

Right:
I had only minutes to jump out of helicopters at extreme altitudes and photograph soldiers while the aircraft shuttled men and supplies. At 20,500-foot Conway Saddle, the highest place of year-round human habitation in history, 20 percent of the soldiers died from high-altitude pulmonary edema during the first year. As one soldier told me, "We are fighting two enemies: India and Allah. Allah is winning."

Photographs: Pages 46,
48–49, 168

The Highest War

*"After returning from the
high camp, I wrote,
'Men might as well shoot
at each other on the moon
as stand here on the
pristine heights of the
earth, gasping for breath
with weapons inhand.'"*

Once upon a time, Himalayan peoples lived in independent kingdoms, each one a Shangri-la of peace and tranquillity, isolated by the world's most rugged geography. Or so the legend goes. In truth, virtually every Himalayan region has had a long history of strife. In the eighth century, for example, Tibet controlled all of Central Asia from the present Russian border to the old Chinese capital of Chang-An. Consider what Himalayan politics were like after World War II: China had yet to go communist; Nepal was a mysterious place never opened to tourists; and British India was in the process of being split into two new nations—Pakistan and an independent India.

In 1986 a new Himalayan war jeopardized my *National Geographic* assignment to document the old kingdom of Baltistan. Access to a third of the area I wanted to photograph was summarily closed. In 1947 the British had conveniently forgotten to complete the separation of India and Pakistan all the way across the Himalaya to the Chinese border. In 1984 Indian troops suddenly occupied the 47-mile Siachen Glacier, the longest in the Himalaya, in a region Pakistan had always administered.

When I first proposed the story in 1983, I had no intention of covering a war. My proposal described Baltistan as a peaceful, Maryland-sized district of northern Pakistan. As I prepared to do my major coverage in 1986, an entire third of Baltistan was closed. The highest war in history was being fought at altitudes up to 20,500 feet. The situation was virtually unknown to the outside world because photographers and journalists were banned from the war zone by both sides.

Having been to Pakistan many times before, I could have organized my own travels, but I would have lost important time for photography and missed possible connections with high officials who might allow me to visit the closed area. I hired Nazir Sabir

Expeditions of Islamabad, Pakistan, to handle all my travels. Nazir is a native of the old mountain kingdom of Hunza who speaks perfect English. He has climbed not only K2, but also two other 8,000-meter peaks with Reinhold Messner. Months before my assignment began, I flew to Pakistan with Barbara to attend a government travel and tourism conference. There, Nazir told us, "The doors are closed to you unless somebody very high grants you permission. No one in the Tourism Department has the authority to let you visit a war zone."

As we sipped tea with Nazir at a lawn party in Peshawar, a helicopter landed nearby, dispatching an unannounced guest with a large entourage. When President Mohammed Zia-ul-Haq stepped onto the grass, Nazir whispered to me, "Now's your chance. Here's the one man who can do it."

I instantly emulated a press photographer, moving in to catch Zia greeting each important guest. After he asked Barbara for whom I was working, I mentioned my assignment and asked if I could chat with him for a minute or two sometime. His eyes widened when I described how I had been one of the few Westerners to visit the Siachen Glacier under the auspices of Pakistan. My published description of that remote 285-mile winter ski traverse of the Karakoram Himalaya in 1980 had been requested by the Pakistan Army as evidence of their nation's former control over an area it had never actually occupied. I told Zia that the *Geographic* would use only my current photographs. He quickly realized that if my coverage did not include the closed third of Baltistan, it might appear to the world as if India controlled it. He turned to his aide and said, "See that this man has an appointment with me before he leaves the country."

Six weeks later, Barbara and I flew in separate army helicopters into the inner sanctum of the Siachen Glacier War as guests of state of President Zia. Over the course of many flights we saw and photographed specifics related to national security

that we promised not to disclose. Thousands of troops were mobilized on either side. Previously remote villages had become supply depots for the military, while new roads penetrated deep into the heart of the mountains. Although I had *carte blanche* to photograph whatever I wanted, my abilities were challenged as never before. A helicopter would land me at a remote outpost with only minutes to meet officers, do interviews, figure out scenes to photograph, and then make images in subfreezing temperatures without breathing supplementary oxygen at altitudes up to 20,500 feet (page 168). The high camps looked like mountaineering expeditions that were going on forever with no peak to climb. Tents and clothing were worn out. Men's faces looked haggard. As one young captain put it, "We are fighting two enemies: India and Allah. Allah is winning."

The captain believed that it was against the will of God to try to live in these mountains, where winter temperatures drop to -60°F and summer storms can drop several feet of snow in a single day. Deaths by bullet were few. At Conway Saddle, the highest place human beings have ever lived year-round, 20 percent of the inhabitants of the military camp died from high-altitude pulmonary edema, even though evacuation by helicopter was just a radio call away if the weather was clear. Other soldiers fell into hidden crevasses on the glaciers or lost fingers and toes to frostbite as they attempted routine tasks.

After returning from the high camp, I wrote, "Men might as well shoot at each other on the moon as stand here on the pristine heights of the earth, gasping for breath with weapons in hand." The war was then and is still now being fought over virtually uninhabitable land that has little strategic value. For each nation, saving face is all-important. Thus, Indians in Swiss down suits lob Soviet SAM-7 shoulder-to-air missiles at Pakistanis in North Face suits who shoot American Stinger missiles bought from European arms dealers toward American-made

C–130 cargo planes used by the Indians to parachute men and supplies onto the glacier.

Because more than a year passed before the story ran in the October 1987 *National Geographic* with photos by both Barbara and me, I feared that the story would either be scooped by other media or that the war would be over. To my surprise, my story was still hard news. No one else had penetrated Baltistan's ban on journalists, and as soon as the story came out, *Time* magazine bought one of my images to publish with an account of the war. The magazine later claimed on the editor's page that a *Time* photographer two years later was the first to photograph the war, but declined to print a retraction even after I pointed out that my photo of the war had been previously published with an earlier story in their own pages!

President Zia was blown out of the sky in a C–130 the year after my *National Geographic* story, most probably by Afghan zealots opposing U.S. dollars and weapons moving through Pakistan. As of this writing in 1993, India continues to occupy the whole Siachen Glacier, while the two countries still skirmish over the dozen-odd mountain passes that lead from the glacier to the rest of Baltistan.

Why should I, a nature photographer, be concerned with showing the public my photos of a wildly impractical high-altitude war? My mother provided the answer in an oral history transcribed and printed by the University of California Bancroft Library when she was well into her eighties. She had been a member of a women's chamber music trio that had the first live, regularly scheduled network radio program of classical music in America. She was also deeply involved in the world peace movement. At one point, the interviewer asked her, "Is there any relationship between being an artist and pursuing world peace?"

She answered, "Of course! An artist would never try to solve problems by killing people."

Through my art, photography, I want to continue to deliver her message.

Photographs: Pages 186–87

The Last Shangri-la

"He said, 'I have seen photographs of these big cities in America with buildings that grow into the sky like mushrooms. Some of them are banks... When does a person say, 'Now I have enough and I can go on with my life?' "

Bhutan's Royal Manas National Park will never be as photographed as Yosemite or Yellowstone, or even Antarctica. His Majesty Jigme Singye Wangchuk, the young ruler of this Himalayan kingdom the size of Maryland, values the traditions of his people far too highly to allow a massive influx of foreign visitors. In an age when dozens of formerly remote regions are touted as "the last Shangri-la" in mass-market travel ads, Bhutan is the only remaining place on earth where Buddhists have self-rule of their ancestral lands. While the king of nearby Nepal has announced his intention to court a million foreigners to his nation by the year 2000, Bhutan had only 2,255 tourists in 1988, an average of just seven arrivals a day.

In 1989, I attended Bhutan's first-ever Symposium on Nature Conservation. As one of only four Westerners among sixty participants, I flew to Bhutan from Delhi in a spanking-new British Aerospace minijetliner that cruised eyeball-to-icefall with Mount Everest, Lhotse, Makalu, and Kanchenjunga—four of the world's five highest mountains. Beyond was Chomo Lhari, a lower but equally impressive peak on the Bhutan–Tibet border. The plane's windows were perfectly clear, and so were my pictures. Photographing from commercial flights isn't as hopeless as it seems if you follow the usual rules for landscape photography. Shoot early morning or late evening, underexpose slightly for increased saturation, and use slower films for finer grain and lack of excessive contrast. Also watch for reflections from the double windows. Try a rubber lens shade, or use your hand as a makeshift one. I got my best shot (page 186) moments before we dropped through the clouds to land in the village of Paro.

During the flight I chatted with a British Aerospace engineer who told me, "This is Bhutan's very first jet. When the government bought it from us, many people jumped to conclusions. 'Here comes mass tourism. They're going to have to pay for that

plane with hard currency from tourist dollars.' But that's not the case. They plan to use it for several flights to Bhutan a week and lease it to Thai and Indian airlines for the rest of the time. Clever people!"

I had been invited to attend the symposium by Dr. Bruce Bunting, vice president and director of the Asia Program for the World Wildlife Fund USA (WWF), a major supporter of the nature reserves that now protect a fifth of the country's lands. Organized by the Bhutan Forestry Department in collaboration with WWF, the symposium opened with the announcement that the wildlife sanctuary where our meeting was being held had just been designated as Royal Manas National Park.

Just before the meeting broke up for an afternoon elephant ride through the jungles of Manas, a young forest officer delivered an unscheduled paper about why Bhutan needed national parks and nature reserves. He said, "I have seen photographs of these big cities in America with buildings that grow into the sky like mushrooms. Some of them are banks full of money. Others are full of people. What I want to know is when does this stop? When does a person say, 'Now I have enough and I can go on with my life?' In Bhutan, we have just enough right now; just the right amount of natural heritage for each person. We need to keep it in the bank for the future."

Bruce also delivered a thought-provoking paper, explaining economic justifications for preserving wildlands beyond tourism. He told the assembled group, "People have always depended for their survival on animals and plants and the habitat on which they are found. Through most of history this dependence remained within sustainable levels." He explained how Bhutan's nature reserves make economic sense in terms of flood control, biodiversity, and employment for park rangers, guards, and workers to maintain buildings, roads, and trails. He suggested limited natural-history tourism, including wildlife photography, that would have minimum effect on the land, compared with other forms of adventure travel. The park will be used chiefly by Bhutanese citizens seeking solace from their everyday lives and by students from the growing number of schools in Bhutan. Foreign tourism will be far more limited than in the rest of Bhutan.

One of Bruce's graphic examples of the rewards of preservation brought both laughter and nods of recognition. In Nepal, a river flows through an area protected by a national park on one bank, but clear-cut and grazed by villagers on the opposite bank. During monsoon rains, the river doesn't abide by property lines. In what Westerners might term biblical justice, the river recently changed its course. A square kilometer of land eroded away from the village and was added to the park.

That event happened in the Nepalese lowlands, now regarded as a textbook example of foreign aid run amok in the Third World. Without regard for preserving natural conditions, international agencies have funded the clearing of forests and malarial swamps for farmland, thus destroying some of the last remaining habitat for the Bengal tiger, the wild Asian elephant and buffalo, and the greater one-horned Indian rhinoceros. The national park in Nepal is a small island of wildness surrounded by a sea of farms, villages, and poachers. All these same animals are doing quite well in Royal Manas National Park, situated in a similar but far more intact and spectacular habitat in the Himalayan foothills near the border of the Indian state of Assam.

Thus, Bhutan, once rated the poorest country in Asia by those who build tall buildings in which to store their financial harvests, is fast emerging as the richest in a quality of life that money can't buy.

Photographs: Pages 189–91

Endangered on an L.A. High Rise

"After the peregrine's abrupt decline was linked to extremely high levels of toxic contamination, the bird became a very different symbol, a veritable mine canary, that is telling us, by dying before our eyes, that the earth is being poisoned."

As I began an assignment on California's peregrine falcons that later appeared in the April 1991 *National Geographic,* I imagined glorious days in the mountains and by the sea photographing wild eyries. The Los Angeles factor took me by surprise. The bird's future, like that of the state's human residents, is inextricably tied to past and present events in a place where wildness has a very different meaning. Behind my bizarre photographs of wild falcons with urban backgrounds is an even stranger story.

One morning, as I stood on a window ledge thirty-nine floors above the city, a sudden blow to the back of my head brought me to my knees. I felt dizzy as the grid of streets below appeared to wobble. Hit for the first time by the world's fastest and fiercest bird, I suddenly understood the raw power a crow-sized falcon uses to bring home dinner on the wing by "stooping" in dives that have been clocked at 238 mph.

To a bird that nests on high cliffs, a window ledge on L.A.'s Union Bank is the real estate equivalent of a rock ledge on Yosemite's El Capitan, but peregrines now survive in both these places only after direct assistance from concerned biologists. Significantly, captive-bred falcons released in Los Angeles County have chosen their own nest sites.

Unlike most endangered species, the peregrine lacks a history of gradually sliding toward oblivion. Its rapid, global population crash was unprecedented. As late as the 1960s, the peregrine was still being described as "the world's most successful flying bird" because of its stable, near-global population and unexcelled flight characteristics. After the peregrine's abrupt decline was linked to extremely high levels of toxic contamination, the bird became a very different symbol, a veritable mine canary, that is telling us, by dying before our eyes, that the earth is being poisoned.

Peregrines, like human beings, live at the top of their respective food chain. Some of the birds they pluck from the sky have eaten fish that have eaten smaller organisms that have been exposed to toxics. These fat-soluble chemicals greatly increase in concentrations as they move up the chain by a process called biomagnification. Hundreds of artificial chemicals, many of them deadly to birds and mammals in parts per million, or even trillion, were found in the fatty tissues and eggs of peregrines. By the late sixties, scientific evidence isolated the pesticide DDT as the major culprit in eggshell thinning that was causing massive reproductive failures.

In 1972 the general use of DDT was banned in the United States. The following year the peregrine was declared internationally endangered. "By the end of the seventies," a University of California ecologist told me, "we all thought the story was over." A big surprise came in the eighties, when peregrine falcons that had been reintroduced near the California coast maintained much higher levels of toxics and lower levels of reproduction than scientists had predicted. A possible "witch's brew" effect of several toxics acting together has yet to be studied. Today, many California birds remain in dire trouble, although recovery in some inland states has progressed so well that by 1985 scientists were calling the bird "the premier example of success in single species conservation." A number of scientists and politicians have begun to urge that the peregrine be the first federally endangered species to become officially "saved" by removing it from the list. Some California falcon specialists fear that decreased public and private financing will doom, at the very least, their state's entire coastal population. Even in pristine Big Sur, many nests fail unless they are augmented with lab-hatched chicks at considerable risk and expense.

I went to Los Angeles with Brian Walton, manager of the Santa Cruz Predatory Bird Research

Group, to place a 14-day-old peregrine chick into a nest that would otherwise fail because of toxics. Surprising amounts of DDT remain in California's environment, with L.A. as the coastal epicenter. Here, during the fifties and sixties, the Montrose Chemical Company dumped an average of six hundred pounds of raw DDT a day offshore as residue from pesticide manufacturing. Extreme hot spots of over three hundred parts per million remain on the ocean floor. Peregrines up and down the California coast continue to pluck birds from the sky that have eaten contaminated marine organisms. Sources are difficult to trace. Some migratory birds winter in Latin America where DDT is still used. Large amounts of DDT also entered the food chain, both before and after the 1972 ban, through agricultural spraying in a state that uses 40 percent of the nation's pesticides. Until recently, significant amounts of DDT were still being sprayed in Kelthane, a nearly identical legal pesticide that was being incompletely processed from real DDT. High levels of PCBs, HCBs, and dioxins complicate the picture.

While Walton gathered the thin eggs to incubate in a lab facility and placed the chick in the nest, the male struck me from behind as I was peering through my F4. After I felt the lump on my head and saw bullet holes in the window, I concluded that violence just seems to be a way of life in L.A. The previous year's chick died, not from toxics, but from a bullet wound soon after its first flight.

Five thousand members of ten Los Angeles pigeon clubs are upset over the reintroduction of their bird's deadliest enemy, complete with federal protection and upbeat media coverage. Cornell Norwood, who raises prize roller pigeons and judges shows, outlined the problem for me: "A good pair of roller pigeons are worth $1,500. Typically, we'll train a kit of twenty birds by having them circle a house at least

a thousand feet above the ground for forty minutes or more. They're bred to spontaneously somersault in a trancelike state and recover after a few resolutions. If a peregrine spots them, it's all over like shooting fish in a barrel.

"Peregrines don't belong here in the city," Norwood continued. "They're so aggressive that they've even attacked their own reflections in skyscrapers and packed it in. The last wild birds in this county were sighted in 1946. We've tried everything to coexist with the falcons and negotiate with the falcon people to no avail. In the long run I believe the survivability of the peregrine in the Los Angeles area is zero. I know for a fact that fourteen peregrines have been shot here in recent years. I've seen their leg bands. What would Walton or the feds do if our pigeons were out there killing their peregrines?"

The California poet Robinson Jeffers eloquently linked Big Sur's peregrines to human destiny over half a century ago as "a symbol in which many high tragic thoughts watch their own eyes."

Photographs: Pages 43, 188, 224, 249, 260, 263

Tibet's Vanishing Wildlife

"By wild coincidence, I had run into Tsewang Tsambu, one of the pilgrims who had gone to Mount Kailas with me the previous year. His family invited us in and treated us like royalty because I had shared Tibet's most holy pilgrimage with their eldest son."

Few subjects have simultaneously challenged my photographic and physical abilities as much as the wildlife of Tibet. When I climb a Himalayan peak, my companions move roughly at the same speed and are usually tied to the same rope. On the other hand, I'm no match for a herd of Tibetan wild asses that can run thirty miles an hour for half an hour without stopping out on the treeless steppes of the Tibetan Plateau at fifteen thousand feet while I'm carrying a big lens and tripod. To further complicate the situation, most of Tibet's wildlife has disappeared in recent years.

Old explorers reported vast herds of wild asses and other hoofed animals in Tibet. "One great zoological garden," Joseph Rock wrote in a 1930 *National Geographic*. "Wherever I looked I saw wild animals grazing contentedly." In the forties, Heinrich Harrer (see essay pages 228–32) escaped a British prison camp in India and walked across Tibet to Lhasa, seeing bands of gazelle by the Tsangpo River, Tibetan blue sheep on the hills, Asiatic brown bear following his tracks, and *kiang,* the wild asses, flowing across the plains in vast herds.

After the Chinese invaded Tibet in 1951, foreign exploration ceased for thirty years. Wildlife vanished wherever roads were built and men with weapons could travel. Since 1981 I have been on five treks or expeditions in Tibet, but until I headed into remote parts of western Tibet in 1987 and 1988, I had yet to make a single, close photograph of a large mammal in the wild.

When the *National Geographic* sent me to the Tsangpo River in 1987, I helped arrange an entourage that stacked the odds in my favor. Our group had four Americans, three Tibetan drivers, two Toyota Land Cruisers, and one stake-bed truck filled with enough drums of gasoline to fuel all the vehicles a month.

My assignment was to explore the Tsangpo River to its source. The Tsangpo becomes the

Brahmaputra after it cuts through the Himalaya into India. Tradition has it that four great rivers of Asia spring from the earth near Mount Kailas, which represents the center of the universe for both Buddhists and Hindus. Indeed the Indus, Karnali, Sutlej, and Tsangpo all have their sources within sixty miles of the peak.

I planned to experience the legend of Mount Kailas by walking a sacred path around the peak, as well as to reach the true source by driving first on a road, then overland as far as we could go, and finally on foot to a glacier that gives birth to the river. I could find no record of any Westerner reaching the source in this century.

One afternoon a dust cloud appeared on the horizon. It reminded me of the wake of a bush plane taking off from a dirt strip. "*Kiang?*" I asked Pema, who was born in a black tent beside the Tsangpo before his family fled to Nepal.

Pema answered in broken English, "I pray this *kiang*, but maybe no. The driver goes very fast, but the cloud is not closer." Half an hour passed. Our driver had picked up speed to sixty kilometers per hour. We began to make out tall, slim silhouettes in the dust. As we drew alongside at a distance of a hundred yards, I counted nine *kiang* in a tight cluster. I made a vain attempt to shoot out the window of the bouncing vehicle with a 180mm lens on a motorized Nikon F3, but the herd veered abruptly as though it were a single jackrabbit, and we never caught them again.

That night I fell asleep on the plains remembering the *kiang* in full gallop, and how they looked more like some super race of horse, turbocharged for high-altitude performance, rather than the plodding, donkey-like "wild asses" I had expected. Meanwhile, the three Tibetans from Nepal invited me to join them on an especially sacred one-day pilgrimage on the 32-mile path around Mount Kailas. I packed a two-and-a-half-pound 400mm $f5.6$ Nikon ED lens and 1.4X teleconverter for wildlife, as well as 24mm and 85mm lenses with an F3 body without a motor. This, plus a two-pound Gitzo 001 tripod, put my total photo weight at just seven pounds.

The Tibetans knew just when to start. We began at two in the morning under the full moon and watched its light magically unfold in front of us as we walked up a great arcing valley beneath black-shadowed cliffs. An hour earlier start would have put us into darkness. After fifteen miles we reached the north side and finally stepped into dark shadows, but all of a sudden a blinding sliver of blue light appeared out of the night. Through a gap, a tiny bit of Kailas had come into view, snowy, moonlit, and so much brighter than I had expected. I just stood there transfixed before I thought about taking a photograph. The Tibetans bowed to the ground in reverence, and I found myself doing the same. Something about the light and the dramatic setting indeed made me feel as if I were glimpsing the center of the universe.

I let the others go ahead while I detoured to where the whole north face of Kailas was framed through a gap in the foreground cliffs. The moon set just before the rosy glow of sunlight touched the peak, and after shooting two rolls, I set off running toward the 18,600-foot highest pass on the pilgrimage path. I held a slow, even pace up the long grade, passing three men who looked up from their blankets in amazement. I recognized them as the three pilgrims our driver had smuggled in the back of the truck along with the fuel barrels. They waved and flashed broad grins as I ran past. I caught up with the others, and we completed the holy circuit by the end of the day, but saw no wildlife.

After a rest day, I repeated the route with the whole group, taking three days this time to search out the region more closely. I was able to stalk a herd of *bharal,* the Tibetan blue sheep, and make sharp photos of them using the 400mm with a 1.4X teleconverter as they climbed a sheer cliff at a dead run.

After we returned to our vehicles, we cruised overland like Rommel's army toward the true source of the Tsangpo. In the open valleys beyond the road we saw many *kiang*. I learned to have the driver cut a broad arc ahead of them, kill the motor, and let me dash out to brace my telephoto on the hood and pan the herd at full gallop (page 188). We also saw small groups of gazelle and antelope, plus an occasional fox or wolf. When we could drive no further, four of us set off on foot with supplies for four days.

Our first night's camp was beside a small lake. When the typical afternoon winds ceased around sunset, twenty *kiang* came down to the lake to drink. I fell asleep utterly content in the midst of the

Tibetan wildlife paradise I had dreamed of finding for so many years. The next morning, we continued to follow the river even after it disappeared under a mantle of winter ice. Around a corner we came face to face with a herd of seventeen wild yaks, which have also become one of Tibet's rare large mammals. They were jet black and looked to be about six feet at the shoulder. As the animals drew into a cluster, I hoarse-whispered to Targay, who was a hundred yards behind with my big lens in his pack. He arrived too late and I got no good photos. I vowed to stick to my own rule about always carrying my own equipment when it might be needed on a moment's notice. For the next two hours I stalked ahead to the exact point of the true source. There was the herd of yaks again, drinking meltwater burbling out of the tongue of the glacier. As they fled up a hillside, my light 400mm perched on a boulder gave me crisp images. I never would have been in position to get such photographs carrying a massive lens and tripod.

My success story could end here, but it had a surprise postscript in 1988, on another assignment for *National Geographic*, when I returned to a different part of western Tibet with Barbara. This time we were accompanied by Chinese officials and had no Tibetan-to-Chinese translator. At one point I almost gave up trying to tell a nomad boy who was herding sheep that we wanted to hire someone to help us find local wildlife. His father showed up and seemed quite apprehensive about helping foreigners who were traveling with Chinese. He agreed possibly to do something tomorrow and directed us to his family's black tent, where the first person to emerge broke into a broad grin and ran out to hug me. By wild coincidence, I had run into Tsewang Tsambu, one of the pilgrims who had gone to Mount Kailas with me the previous year. His family invited us in and treated us like royalty because I had shared Tibet's most holy pilgrimage with their eldest son.

Tsewang rounded up some Tibetan ponies, and Barbara and I were soon trotting across the plains in search of wildlife with him. Our opportunity to see his land through his eyes was a fitting conclusion to my discovery that parts of the wild Tibet of old still exist. For the time being, pockets of rare wildlife endure where the modern world has yet to penetrate. Unfortunately, I also discovered that the wildlife fled far more quickly from riders than from Land Cruisers, because of indiscriminate hunting by soldiers on horseback or on foot. Later, from our vehicle, I was able to get a close-up with a heavy 600mm lens of a wolf stalking water birds. The wolf appeared not to associate the vehicle's approach with danger until I opened the door. It immediately ran off at top speed without looking back.

Tibet's wildlife is at a crossroads. The next decade may make the difference between decline toward extinction for some species and return of the "great zoological garden" seen by Joseph Rock not so very long ago. Both the Dalai Lama, who lives in exile in India, and the American zoologist George Schaller, who has spent much of the last decade in the backcountry of Tibet, believe that the wildlife of Tibet can recover if changes in human attitude happen soon.

Tibet remains the last major occupied nation of the world, held in bondage by a communist system that promised prosperity to humans, but didn't deliver. Not even promises were made about its wildlife.

Photographs: Pages 185, 218–19

"Given the choice of a hotel room with a shower or an icy dawn in a sleeping bag with the chance of alpenglow, she would take the room and I would take the photograph."

A Zealot's Repose

Just before going to Alaska, I read a revealing essay about why political zealots stay in power despite their seeming irrationality and instability. Quite simply, they get things done. Normal checks, balances, morals, and comforts are bypassed in pursuit of goals. However irrational those goals may seem, the methods of attaining them are direct and effective.

Although the essay was about politicians, I couldn't help thinking how the same principle applies to photographers. Zealots get things done. They don't worry about comforts and frills as much as average people who may be in nearly the same place at nearly the same time yet don't bring back nearly as good pictures.

Without zealotry, people wouldn't lug heavy cameras and tripods into cold and remote places, sleep on the hard ground, and get up before dawn just to take a photograph. But zealotry has a flip side, too. In places like Alaska, we find it easy to take cold and hardship for granted and to think they are a necessary component of fine wilderness photography there.

Barbara is every bit as good a photographer as I am, but as she readily admits, she is not a zealot. Given the choice of a hotel room with a shower or an icy dawn in a sleeping bag with the chance of alpenglow, she would take the room and I would take the photograph. Yet in Alaska we found a place on the Kenai Peninsula so appealing to our different needs that we often talk of returning there together. If wilderness is defined as a place without roads or motor vehicles, then this place is definitely wilderness. If luxury living is defined in terms of comfort, tranquillity, cozy ambience, and personal service, this place also fits that definition.

I remember a drizzly August afternoon at Kachemak Bay Wilderness Lodge, when neither Barbara nor I would have traded places with anyone else on earth. I had just returned from a walk to a nearby eagle's nest where I had photographed a

fledgling about to make its very first flight. From a natural blind of spruce boughs, I watched the eagle make several test flights a few feet above the nest and then come back down and land. The next morning it was gone.

I used a 400mm lens plus a 1.4X teleconverter to photograph at a distance where I wouldn't disturb the nest. Because of the murky low-contrast light, I used Fujichrome Pro 100 pushed one stop (before the 1990 introduction of Velvia, which I would now use pushed to either ISO 100 or ISO 200 for low-light wildlife situations). Pushing Fuji slide films builds up contrast and adds a bit of magenta to warm up the scene from the murky blues that would otherwise be recorded in deep shade.

I arrived back at the lodge looking like a drowned rat. In a true wilderness situation I would have been pretty miserable standing in the rain, covered with wet leaves, soaked to the skin. On a point overlooking the bay, Barbara opened the door to our cabin. She had a fire going, and within minutes I felt warm enough to don my swimming trunks, grab a beach towel, and head for the nearby sauna with her. There above a cove, nestled in a clearing, was a genuine Scandinavian sauna complete with a sod roof that sprouted native wildflowers. On another day when I felt warmer, I would take a picture of the sauna surrounded by purple fireweed, but for now I was content to sit inside on the wooden benches with Barbara and pour cold water over our bodies every few minutes when we got too hot.

After the sauna and a hot shower, we dressed casually and headed out onto the pier, where the six other guests of the lodge were standing on a canopied deck sipping drinks and waiting for the evening appetizer. Out in the bay we could see colored buoys that marked the lodge's crab pots. A small Boston Whaler was making the rounds, bringing in fresh crab to be boiled and served whole with drawn butter to

each guest. This, however, was just the appetizer. The lodge's French chef was preparing a gourmet meal, soon to be served in the dining room.

Halfway through my crab, I saw the sun burst through a hole in the clouds. The zealot in me was triggered. Here I was in perfect comfort, about to be served a perfect meal, and yet I was analyzing the situation in front of my eyes to see if it had the potential for a fine photograph. Several factors made me think that if I returned to our cabin, a couple hundred yards away up on the point, I would see a rainbow over the bay.

Alaska is a great place for rainbows. First, it rains a lot. Second, it is at such a northerly latitude that the sun stays below forty-two degrees in the sky most of the time, even in summer. Rainbows don't usually occur when the sun is above forty-two degrees in the sky, because a rainbow is a halo with a 42-degree radius around the point exactly opposite the sun. If the sun is higher than forty-two degrees, then the opposite point is too far below the horizon and a rainbow is not visible (unless you happen to be in an unusual situation where you're looking down into a valley with the sun behind you).

As I rounded the corner to the cabin, I saw direct sunlight hitting an active rain cloud. There under the arc of a rainbow was the lodge's Boston Whaler heading in for the pier. I couldn't waste a second setting my camera and going through the steps I normally use to make a fine landscape photograph, so I grabbed a Nikon F3 from the cabin, put it on automatic, and shot only a couple of frames before the rainbow weakened and the boat was no longer under its arc.

Boats provide the only access to the lodge, except for the occasional floatplane that lands in the bay to pick up or deliver special guests. We arrived from the town of Homer on a regularly scheduled ferry, which resembles a typical ferry about as much

as the Alaska Highway resembles the New Jersey Turnpike. This ferry has no cars, no crowds, only a handful of passengers, and makes detours to see bird rookeries and hidden coves. We landed on a peninsula about a 10-minute walk from the lodge along a narrow forest trail. Our bags came later with lodge employees.

I first stayed in the lodge in 1979 when I led an "Alaska Wildlife Safari" for an adventure travel firm. That summer the founders of the lodge, Michael and Diane McBride, were busy working on a second lodge an hour's flight by floatplane across Cook Inlet on the opposite side of Homer. This is the Chenik Brown Bear Photography Camp, a full-service lodge in a virtually uninhabited section of the Alaska Peninsula, close to the famous McNeil River Brown Bear Sanctuary. The members of my safari did not have permits for McNeil, which are given out by annual lottery long in advance. Even so, we saw seventeen Alaskan brown bears our first evening. Once again, I became a photography zealot, ignoring many of the special touches the McBrides had arranged for us in pursuit of the perfect image.

What makes the Kachemak and Chenik experiences so special is an intangible factor that is hard to put across in photographs or factual descriptions. You may have noticed that so far I've been writing from the point of view of a zealot rather than a typical guest. While I chased eagles and maneuvered the shoreline around 30-foot tides, other guests were fishing, reading, sea kayaking, or simply enjoying the homey comforts of their cabin. Each cabin has been uniquely built and decorated with such a personal touch that you imagine that all this was done especially for you. Activities are conducted in a similar vein. Most lodges provide group experiences, but Michael and Diane have a different premise. They cater to each guest's needs and desires, making sure that the avid fisherman is taken to

a private hot spot for salmon and that yours truly, the photography zealot, is shown the best spots for wildlife viewing. Many people chose simply to kick back and enjoy themselves in a place apart from the rest of the world.

The McBrides' vision is not cheap, however. A typical five-day package at either lodge costs about $2,000 per person. Not everyone can afford such tariffs, but remember that they do include a private cabin, all meals, guide services, roundtrip by boat, and virtually every incidental.

I believe that Barbara and I saw Alaska both more intimately and more comfortably in our five days at Kachemak Bay than most Alaska tour groups see in a month of days spent crammed in buses in between the hours they are not in hotels, train stations, or airports.

I still remain a photography zealot, addicted to those icy dawns in sleeping bags, but as far as compromise goes, Kachemak Bay has the best I have ever seen, and I am not alone in that judgment. An independent survey of America's best vacation retreats, conducted incognito by people posing as paying guests, rated Kachemak Bay as the best wilderness lodge.

Photographs: Pages 192–95

"Even after getting buried under mud and ash, then shaken by more than twenty earthquakes . . . Antigua remains in far more pristine condition than other Latin American cities buried beneath uncontrolled twentieth–century sprawl."

Journey to Antigua

"Come join me. It's like Kathmandu must have been twenty years ago," Barbara said on the phone. She had been spending the month in Antigua, Guatemala, at a Spanish-language school. Her Kathmandu comparison intrigued me because she rarely exaggerates. She hadn't visited Kathmandu twenty years ago, nor had I until the midseventies, but we both had a sense of how wonderful old Nepal used to be.

"How's it like old Kathmandu?" I asked.

"It's a traditional village with cobblestone streets, no neon, no billboards, and lots of people in colorful native dress. It sits at five thousand feet in a lush valley surrounded by pine trees and volcanoes that rise right out of town to thirteen-thousand-foot peaks. But what makes it the most like what we've heard Kathmandu used to be like is the attitude of the foreigners here. There are very few tour groups. Almost everyone has a mission. One couple from Washington is donating their time to help Guatemalan orphans. Then there's Peter, the ornithologist, working to create biosphere reserves. But most of all, there are the students of more than twenty language schools here. They've come from all over the world to learn Spanish—college kids, missionaries, grandmothers, CIA agents. When you walk into a restaurant with foreigners, there's an open, laid-back feeling instead of that coldness of being around tourists who are being herded from place to place on some travel company's schedule. How about coming down for my last week? Any chance you could get here in time for my birthday on Sunday?"

"Sure! I'll bring my cameras and shoot some stock photos. See if you can reserve me a rental car from your end."

"You won't need one. You can get around town real easily on foot. If we want to take off for the weekend into the mountains, we'll rent a car for just a couple of days."

I arrived on Barbara's birthday in Guatemala City, a 40-minute drive from the village of Antigua, where she had found a quiet, clean hotel for $13 per night. At dawn Barbara and I went for a run through the cobblestone streets under a great clocked arch past Spanish ruins dating from the 1530s. We passed through a flowered town square with a fountain in the center and a palace, a cathedral, and the cones of three volcanoes encircling it. One of them was active, spewing a column of white cloud into the deep blue sky.

At first I accepted the town's seventeenth-century appearance as a natural expression of modern Guatemala (page 195), something like Kathmandu or Lhasa a generation ago. In common with those Asian towns, Antigua has a rich history as the great capital of a civilization. In 1527, the Spanish founded the town as they began to colonize the New World. Just thirteen years later Antigua was abandoned soon after a number of great cathedrals, convents, monasteries, and government buildings had been erected in the grand tradition of the Spanish empire.

Perhaps no other major city in the world has ever been situated in the path of so many natural disasters as Antigua. Within those first years of colonization, volcanoes began to erupt, spewing ash into the town. Huge earthquakes shattered the massive buildings. The final blow came when a tropical deluge provoked a great mudslide, killing the first Spanish queen of the New World and forcing the evacuation of the town.

Antigua means "old." Today's maps show Antigua, Guatemala, as a small dot twenty-five miles away from Guatemala City, the new capital, a jumble of concrete and shanty towns that makes Mexico City seem like a historical monument. Antigua's ultimate preservation is due to precisely the same forces that destroyed it. Even after getting buried under mud and ash, then shaken by more than twenty earthquakes with a magnitude of over 7, Antigua remains in far more pristine condition than other Latin American cities buried beneath uncontrolled twentieth-century sprawl. In the early seventies, with the help of foreign aid, Antigua was restored and designated as a World Heritage site. Private businesses now operate under strict zoning laws that dictate traditional architecture, no electric or inappropriate signs, no overhead powerlines, and no franchises like McDonald's or Seven-Eleven.

After a couple of days of photographing Antigua's "Earthquake Baroque" architecture, I ventured off with running shoes and camera to Volcán de Acatenango, 13,041 feet high. In the predawn twilight I stopped to capture the unusual juxtaposition of light and form in a cornfield perched on the slope of the volcano (page 194). My two-pound 001 Gitzo tripod held my Nikon FM2 steady enough for a one-second exposure with the legs at their shortest position. Higher, I simultaneously entered a cloud layer and a pine forest, sensing a timeless relationship between the two. Above the timberline, I scrambled up black pumice through the mist for two more hours. As I emerged above the clouds near the summit, I saw a rare optical phenomenon called the Specter of the Brocken, a colored glory in the mist with my shadow cast inside the circle.

From the top of Acatenango I traversed to the fuming crater of Fuego, a neighboring active volcano with a nasty habit of burying parts of Antigua every once in a while. The ground was too hot to stand on in one spot for more than a few seconds, so I headed down quickly. By now, the sun had burned off the cloud layer. The trail winding through Indian paintbrush, lupines, and open pine forest reminded me of parts of the California High Sierra.

By midafternoon I was back in Antigua, a town that bears little resemblance to any place in the United States. I spent a few more days photographing its

architecture, indigenous people in native dress, and way of life before renting a car and venturing off for the weekend with Barbara to Lago Atitlan, two hours away. Here, once again, reality surpassed expectations. I was skeptical of our guidebook, which quoted Aldous Huxley as calling Atitlan the most beautiful lake in the world. Soon after our arrival the sun broke through a layer of clouds into golden "god beams" that radiated earthward between the cones of two veritable Mount Fujis rising out of the deep blue waters. Although I recognized what scientists would call "crepuscular rays," I became an instant believer.

Up on Volcán de Acatenango I had carried just one light camera body with two lenses, a 24mm and an 85mm. Here, I had a big bag of bodies and lenses plus two tripods. As the light show over the lake progressed, a canoe rowed right through my frame to deliver what I thought was the perfect touch. The more simple scene without the canoe (pages 192–93) has been chosen more often for publication.

At the end of my brief week, I was down to counting frames on the last of my seventy-five rolls of film. Usually I don't shoot so much when I'm not on assignment, but Barbara had been right about the lure of Antigua. I found the town and its surroundings to be at least as exotic and photogenic as my memories of Kathmandu from my first visit, before the tail began to wag the dog and turn tourism into big business instead of spontaneous adventure.

Right: Essay pages 179–81
*A cabin at Alaska's Kachemak
Bay Wilderness Lodge offers a
zealot photographer, such as
myself, access to wild subjects
while other family members can
relax in comfort or follow less
rigorous outdoor pursuits.*

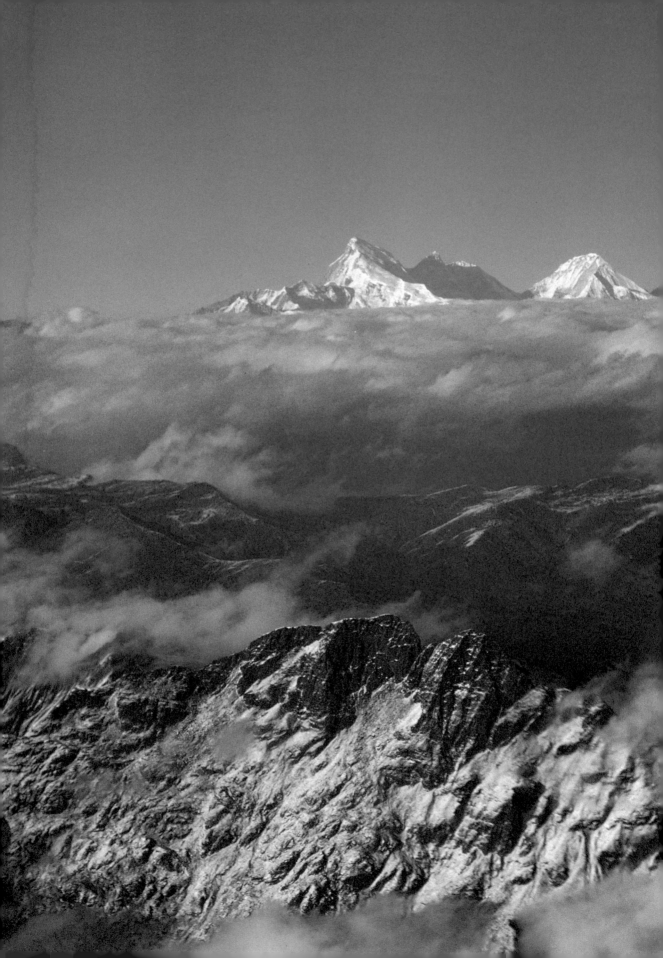

Left: Essay pages 172–73
*Chomo Lhari rose over
24,000 feet on the horizon
through a normal, double-
paned window in a com-
mercial jet as the plane
descended into Bhutan
and I shot this photograph.
Many of the keys to getting
decent photographs out of
commercial airliners are the
same as those of normal
landscape photographs: avoid
midday light, get as close
as possible to your subject,
and expose for your most
important highlight. Luck
with a clean window always
helps, but avoiding reflections
off the plexiglass with rubber
lens hoods or cupped hands is
even more important.*

Above and right:
Essay pages 172–73
*Wild elephants and tigers
roam within distant view of
the great peaks in Royal
Manas National Park in the
lowland jungles of Bhutan.
Riding a domestic elephant
(right) is the best and the
safest way to see the jungle
wildlife. I shot this photo-
graph in poor low light
with fill-flash from an
Nikon SB-24.*

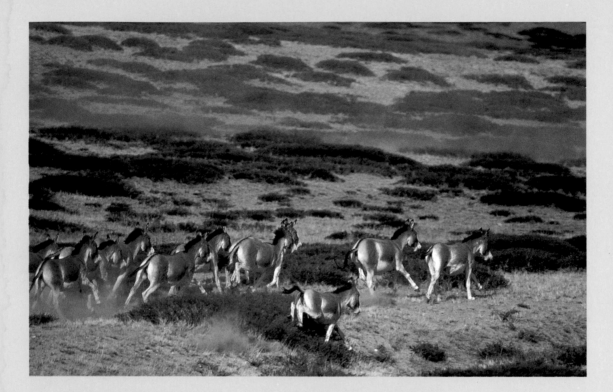

Above: Essay pages 176–78
*To freeze the motion of a herd
of* kiang *galloping across the
plains of Tibet, I used a
1/2000th shutter speed with
an* f2.8 180mm lens. Once
a common sight, these Tibetan
wild asses have disappeared
from all but the most remote
parts of Tibet since the Chinese
occupation in the fifties.*

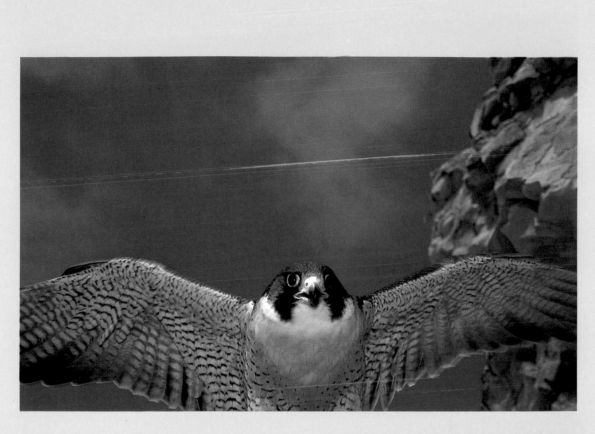

Above:
Essay pages 174–75, 233–35
An endangered peregrine falcon spreads its wings beside a sea cliff on the California coast as light from a Nikon SB-24 "smart flash" automatically fills the shadows in perfect balance with a daylight exposure.

189

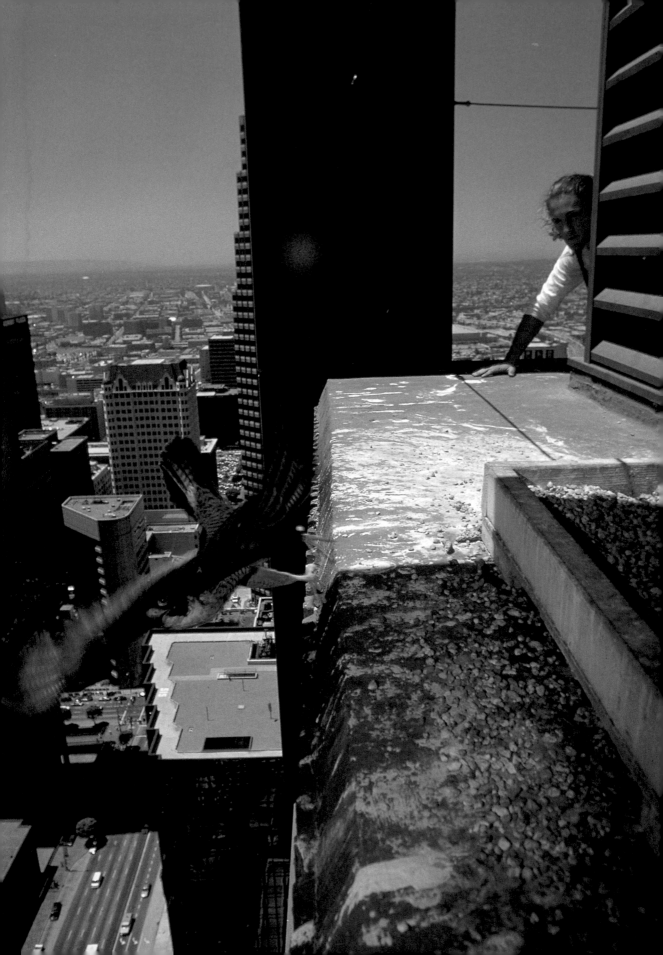

Left: Essay pages 174–75
A peregrine falcon takes off from its nest on a window ledge of the thirty-ninth floor of a Los Angeles bank. Soon after I made this photograph with a 24mm lens and SB-24 "smart flash," the falcon's mate struck me in the back of the head and brought me to my knees.

Right: Essay pages 174–75
A captive-bred chick is fed through the mouth of a puppet so that it will become imprinted to adult peregrines instead of human beings. This chick is being fed its last meal before I help place it into an active nest on the Big Sur coast.

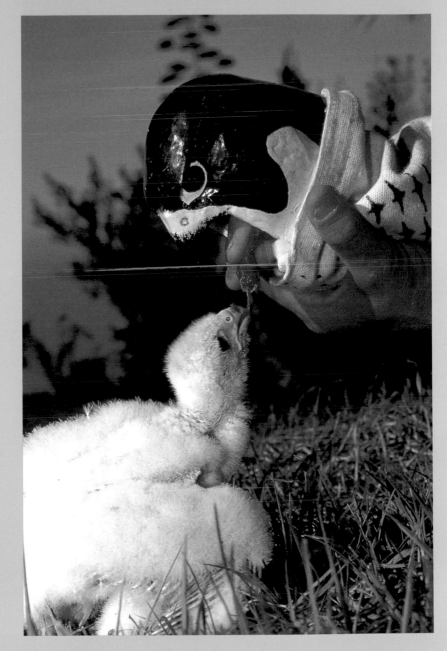

Preceding pages:
Essay pages 182–84
"God beams" (crepuscular rays) erupt from clouds over Guatemala's Lago Atitlan, which Aldous Huxley called the most beautiful lake in the world. A two-stop graduated neutral-density filter holds detail in the water, while film renders the light beams with far more contrast than our eyes would directly perceive at the scene.

Above: Essay pages 182–84
A cornfield on the slopes of Volcán de Acatenango in the highlands of Guatemala adds pattern, texture, and depth to a dawn landscape, thanks to use of a three-stop graduated neutral-density filter that balances the foreground and background lighting.

Right: Essay pages 182–84
The ancient city of Antigua retains its character because of zoning laws that forbid most overhead wires, plus lighted signs and nontraditional construction. The city, whose many indigenous people wear native dress, is a color photographer's dream.

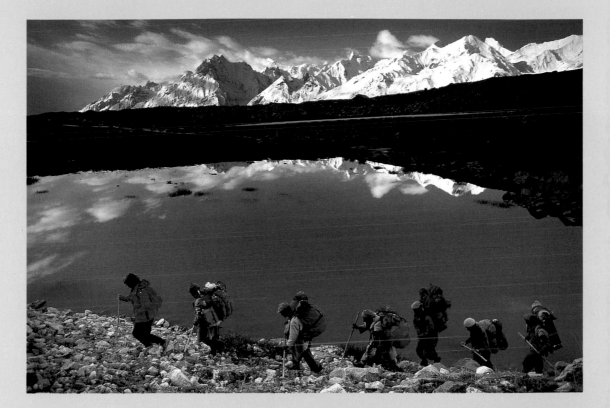

Left:
Essay pages 81, 201–5
The key to getting a large-format look out of 35mm is to pretend that your little camera gets very heavy and clumsy when you see a fine landscape. Slow down, put your camera on a tripod, and use hyperfocal distance (pages 202–3) for maximum sharpness. I made this photo with a tripod high on Buckskin Pass in the Colorado Rockies by returning to the scene the day after I had taken a few hasty shots on a run without a tripod.

Above: Essay pages 201–5
I left my tripod in my pack and handheld my camera so that I could capture the actions of Barbara leading a trek on the Biafo Glacier in the Karakoram Himalaya of Pakistan. I purposely excluded subjects close to the camera because I was shooting with much less depth-of-field than I would have had with a slow exposure on a tripod.

Above: Essay pages 206–11
In Yosemite I was fined $250 for walking along a paved park road cordoned off by a "closed" ribbon to make this photograph of a rock slide three weeks after it had happened. Assuming the danger was over, I did not get advance permission to enter the area. To this day I question why another person without a camera who was cited for walking the same road was fined only $50.

Right: Essay pages 206–11
To photograph a rock star on a Yosemite rock for an album cover, I first obtained a permit for commercial photography and posted a $1 million insurance bond. Here David Lee Roth looks up from a wild perch on Half Dome. If the same photo had been intended only for editorial use in newspapers or magazines, no permit should have been required.

Following page:
Essay pages 82–83, 201–5
A curtain of pink twilight mist over the Merced River in Yosemite Valley gains an extra measure of visual tension when juxtaposed against blue snow that reflects the color of the sky from another direction. I used a soft-edged, two-stop graduated neutral-density filter to open up the foreground exposure.

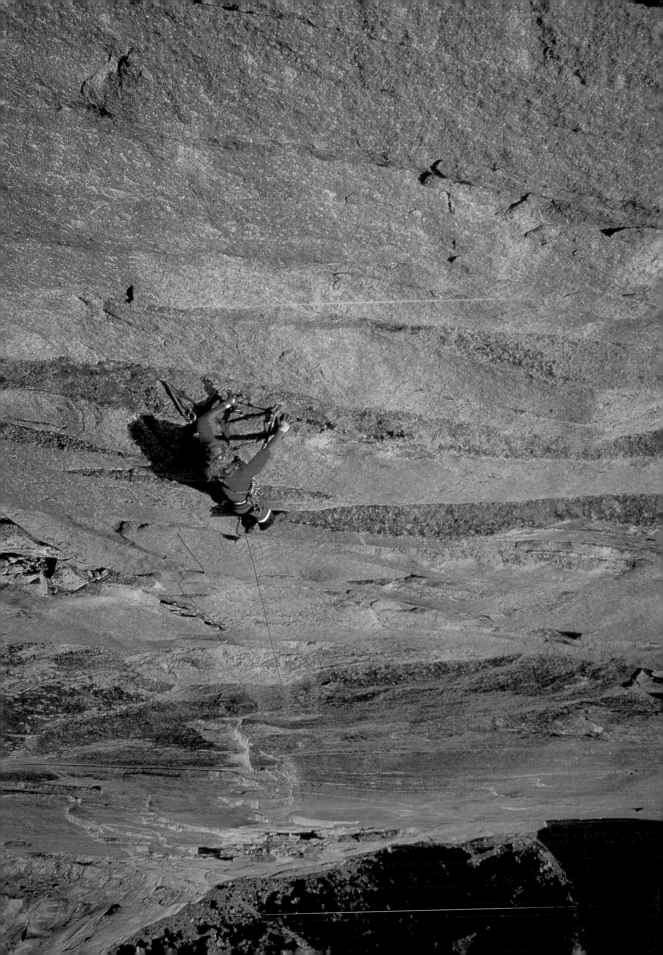

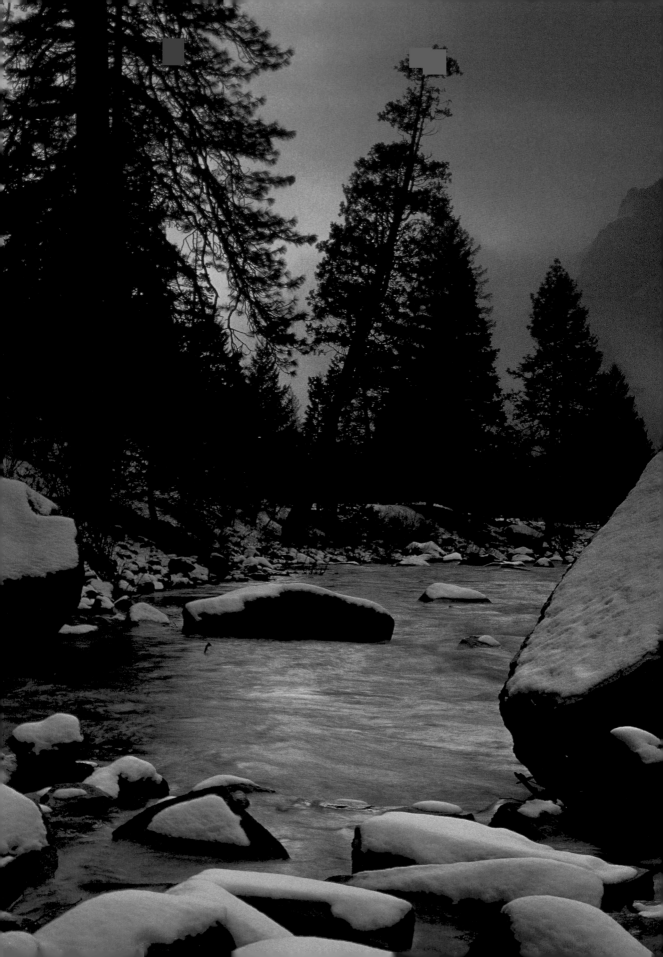

Photographs: Pages 109,
196–97, 200

Behind the Scenes

*"The red glow through
the trees looked fabulous,
but I realized that it
would be just another
image of warm light
unless I could give it
a visual edge against
cool light."*

Before I began writing a monthly column for *Outdoor Photographer,* Steve Werner asked me to do a feature that would be a continuation of my 1986 book, *Mountain Light.* In that work I expanded the captions for eighty of my favorite photographs into essays explaining in great detail how they were made. I selected four newer photographs that hadn't made it into *Mountain Light* and tried to follow Steve's instructions to tell the story of both the physical and the photographic adventure that led to the creation of each image "with inspirational insight into the logistics, timing, and picture sense necessary for success."

Twilight mist over the Merced River, Yosemite Valley; 1986 (page 200). One evening, as a storm cleared, I drove to the traditional viewpoint at the Wawona Tunnel, but couldn't decide whether to stay there until sunset. The sky was white, and mist rose from the valley floor. To this day, I don't know what the sunset would have looked like from this point as the miraculous evening progressed. I decided to leave because I didn't like the total whiteness of the sky and thought I might have a better chance working closer to my subject matter on the valley floor.

Near Bridalveil Fall, I stopped and made a telephoto of gold light on Leaning Tower with a background of snowy ridge and trees. The image later sold as an exhibition print and appeared in my book, *The Yosemite,* with text by John Muir. I continued around the corner and saw magical red light hit Sentinel Rock above a sea of mist. With minutes left at best, I grabbed a camera and tripod, rushed down to the river, shot some reflections of the scene, turned to leave, and saw a far more unearthly red glow to the west. Since the glow was in rising mist and didn't depend on direct light on the cliffs, I

had time to rush back to my car, drive a quarter mile, and run down to the river's edge to a new location.

The red glow through the trees looked fabulous, but I realized that it would be just another image of warm light unless I could give it a visual edge against cool light. I found what I wanted when I saw snow-covered boulders in the river inclined so that they reflected from the shadows and sky, which I knew would come across strongly blue on film. With my tripod in the water and a 35mm lens on my camera, I began making images as quickly as possible, knowing the glow might expire at any second. Instead, it became more intense.

When I used my through-the-lens meter to check the light readings between foreground and background, I found a three-stop difference. This told me that my snowy boulders would be in too deep shadow to give the effect I desired. I put a two-stop graduated neutral-density filter over my lens to hold back exposure in the sky and open up the foreground.

Within a minute, the light was gone and the whole scene was gray. I had made a dozen exposures at the prime time, and I felt confident that among them was a once-in-a-lifetime shot. During processing at a lab I no longer use, the film fell off its clip and was damaged. Only two exposures survived without scratches, reconfirming one good reason I always shoot multiple originals in the field when the going is good.

Wildflowers on Buckskin Pass, Aspen-Snowmass Wilderness, Colorado; 1986 (page 196). I made this image in a light drizzle during a five-day workshop I taught for several summers at Anderson Ranch, near Aspen. The previous day had been "self-assignment day," on which students went out to bring back a picture story of their choice in five photographs. I

also participated, and my subject had been an 18-mile mountain run through the eyes of my golden retriever, Khumbu. All my images of Khumbu's journey through fields, forests, flowers, snow, and running water were taken at his eye level.

When I came to this scene, I wished I had brought a tripod so that I could fill the foreground with flowers and shoot at a very slow speed to get maximum depth-of-field for sharpness from front to back. The next day, I asked my group of fifteen students if they wanted to hike part way up the steep pass to eleven thousand feet to the most beautiful wildflower field I had yet seen in the Aspen area. Some did; some didn't. I arranged the day so that those who didn't want to hike so far could photograph on the lower part of the trail near the classic Maroon Bells view of peaks rising above Crater Lake.

In the morning, it rained on and off in Aspen, while fresh snow fell on the high peaks. As we hiked up and up, some people retreated, despite my encouragement that the photography could be even better with wet flowers under a cloudy sky. Seven of us reached the site and began searching out our personal visions.

I helped people use hyperfocal distance to get the greatest possible depth-of-field. The principle of hyperfocal distance is not to focus at the nearest or farthest subject but to use the hyperfocal point exactly in between. Because focus falls off twice as fast in front of a subject as behind, this is not the numerical midpoint of the distances. It is found by focusing at the point physically midway on the lens between the close and the far subject distances. The crux is that the proper aperture must be chosen to ensure enough depth-of-field to keep those points in focus. Some

lenses have depth-of-field markings, but many newer auto-focus models don't and a table must be consulted. I use the figures for one stop numerically higher than my chosen aperture to obtain greater sharpness.

Because I wanted to photograph the flowers in relation to their mountain setting, I set up my 20mm lens just two feet from the closest flowers and aimed it low until I had just a small swatch of snowy peaks and sky in the background. Had the sky been blue I might have included more of it, but a bit of gray sky in a landscape photo goes a very long way.

Some students were concerned that they would not get vivid color, but I assured them that I had photographed my best-selling poster of wildflowers in the same kind of drizzly situation. Direct sunlight not only casts dreadfully harsh shadows among flowers, but also turns the clear sky into a big blue reflector that pollutes the rich hues. The magic hours of dawn and dusk have less blue sky pollution, but so much red that they actually weaken the color of green foliage. Given a choice, I would always photograph wildflowers under a white umbrella of cloud.

To make this image more interesting, I chose an angle where three planes of ridges intersected. My first attempt at a composition had no frame of reference, or "visual sea level" as I call it. It looked as if it might be tilted because nothing showed the true angle of the slope. By moving over and raising my tripod, I included a few young trees. My exposures were around one full second, done with the self-timer to lessen camera shake. I used Fujichrome Professional 50 because of its strong color saturation, but today I would use the even finer-grained ISO 50 Fuji Velvia.

Trekking beside the Biafo Glacier, Karakoram Himalaya; 1984 (page 197). After making the first ascent of a spire called Lukpilla Brakk in the Karakoram Himalaya, we headed down the edge of the Biafo Glacier with a string of porters. The glacier had significantly retreated during the last century, leaving an earthen moat dotted with little tarns between the ice and the valley walls. Even though the situation appeared idyllic, it was difficult to put on film because the elements were so disparate in lighting and tone: snowy peaks in sun, lakes in shadow, trekkers in undyed native woolens, and vivid red Gore-Tex on Americans.

I ran ahead of the group and found a spot with superb natural graphics. Bold layers of sky, peak, moraine, water, and rocky foreground all came together into a simple pattern without a single extraneous feature. To bring the contrast ratio closer to what I saw, I used a soft-edged, two-stop graduated neutral-density filter on a 24mm lens to hold back exposure on the peaks. I didn't bother using a tripod, because with the lens wide open at $f2.8$ I could shoot at 1/125th second on Kodachrome 64.

Barbara was in the lead as the group walked through my viewfinder. I purposely left space in front of her to give a feeling of openness in the direction the group was moving. I balanced this space with an extra wedge of dark moraine in the opposite corner of my frame.

Reflection Pond, Denali Park, Alaska; 1986 (page 109). Reflection Pond is named for its fabulous reflections of Mount McKinley at dawn and dusk on clear days. I never would have guessed that my favorite image would turn out to be one of the pond in which the mountain was not visible at all.

Just before sunrise on a fall morning, a major storm began lifting. I drove to the pond with hopes of a clear shot of the mountain, only to be disappointed.

After waiting well past the time first light would strike the top of the peak, I left the scene and drove around to look for wildlife. Half an hour later, one corner of the sky turned clear. Even though a mass of cloud blocked all view of the mountain, I had a hunch that something wonderful might happen back at the pond.

I reached the pond just as first light was about to strike the water. Stratus clouds turned pink in the sunrise and were reflected on the water beside a band of blue sky. As I set up my camera on a tripod and composed a scene to balance out the different textures of water, cloud, sky, and foliage, the grasses in the pond itself were suddenly lit by direct sunlight. This also made the wet leaves and berries glisten on the shore. I knew I had less than a minute to make an image before the rising light would wipe out the reflection and the magic would be gone.

To keep the sky from overpowering the foreground, I used a split neutral-density filter over my lens. With my lens set at $f22$ for extreme depth-of-field, I was able to make only two exposures before the reflection went suddenly flat.

One of the surprising things about this image is that I had to violate national park rules to get it, although I had driven to the pond many times before in past years. The Denali National Park management has a history of abrasiveness with photographers, and I would like to take this opportunity to explain how the best wildlife photo opportunities in North America have become fraught with the worst bureaucratic restrictions.

During the seventies, I had photographed extensively in the park. My images had appeared in magazines, calendars, and my 1981 book with John McPhee, *Alaska: Images of the Country*. I brought these, as well as recent wildlife calendars and books, to park headquarters where I asked for a photographer's travel permit so that I could drive park roads instead of ride shuttle buses that, among other things, don't take photographers to Reflection Pond before sunrise. The ranger on duty wouldn't look at my work or my letter of assignment from a national magazine. I was told that it wouldn't do me any good to try to see a higher authority.

"We give out all our travel permits by May of each year, and you have to meet this list of qualifications. Apply in January and come next year."

"How about the assignment I have now?"

"You didn't give us thirty days warning, and it has to be for a major publication." The list of qualifications I was handed would defeat most *National Geographic* photographers. It called for explicit detail about sales involving multiple publications of natural history photographs during the past year to mass-circulation magazines. After reading it, I felt that I was one of the handful of photographers who really might meet the stringent qualifications, yet I was denied a permit because of the catch-22 of not applying in advance. Everyone who does magazine assignment photography knows that very few assignments are handed out that long in advance.

I was not surprised to discover that many of the permits that year had ended up in the hands of National Park Service seasonal employees who supplement their government income through photography. This boondoggle was occurring at the expense of full-time pros. I met a very unhappy photographer on assignment for one of Europe's largest magazines who had been given a story to shoot wholly on Denali Park, but had been denied a permit.

Alternatives to the travel permit are not inspiring. Private cars are outlawed from the 90-mile park road except for driving to and from campsites. To get to Reflection Pond, I needed to have a reservation for one of the sites at the farthest campground at Wonder Lake. All sites were full when we arrived at the park, but when a storm chased out some campers, we jumped at the chance to book the first available site. Reflection Pond, however, is not directly on the road to Wonder Lake. Thus when I drove to the pond in the morning I was technically breaking park rules. I found it degrading to be appreciating the beauty of Denali at the same time I was constantly looking over my shoulder, expecting to be accosted by a ranger.

The rationale behind the limiting of vehicles is sound. Studies have shown that wildlife densities near the road are adversely affected by traffic. The method of limiting traffic I observed, however, was unsound, self-serving, and highly criticized in the Alaskan media. Park vehicles on nonessential patrols accounted for much of the traffic. Campers driving to and from sites, park shuttle buses, commercial tour buses, and those lucky souls with coveted photographer's travel permits account for the remainder.

One solution would be to have a commercially available photographer's tour vehicle for those who really want to be at certain places at certain times and need to be able to stop as long as necessary to get an image. I would have paid $200 per day for such a service, as would my friend from the European magazine. When I brought up this idea to a ranger, she told me, "You can see a lot from our park shuttle buses. I have a friend who had a photo *published* that was taken out the window. They'll stop wherever you want and let you off . . ."

The Hand That Feeds Them

"A national park ranger forced Heisler to stop photographing under threat of arrest and confiscation of his equipment. Heisler's protest that editorial photography was a legitimate use of public lands without need for a permit fell on deaf ears."

In the eighties the old adage "to leave only footprints and take home only photographs" could get a person in trouble in a national park. We outdoor photographers have always taken for granted our right to photograph on public lands for personal and editorial uses. After all, the First Amendment guarantees free communication in our society, and the courts have upheld that freedom of speech and the press apply to visual as well as written or verbal materials.

Whereas permits and proof of insurance naming a land agency for seven-digit liability have long been the norm for commercial photography (when models or the lands themselves are being used to sell a product or a service), both the editorial photojournalist and the amateur nature photographer have considered themselves exempt from such requirements. Model releases, for example, apply to commercial or potentially exploitative uses of a person's image and are not required for editorial photography. Yet in an increasing number of public places, a model release in the form of a permit is being required to take a photograph for publication.

Some recent examples of federal agencies overstepping their authority over photography may seem unbelievably startling, unless you've been accosted by officials yourself. In 1987, *Life* assigned Greg Heisler to photograph ten top American writers whose work evokes a special sense of the wilderness, each in their favorite wild place. Edward Abbey chose the desert. As the perfect sunset came in Saguaro National Monument, a national park ranger forced Heisler to stop photographing under threat of arrest and confiscation of his equipment. Heisler's protest that editorial photography was a legitimate use of public lands without need for a permit fell on deaf ears. The opportunity was lost, and rather than risk another encounter with the men in flat hats for a photograph of Abbey with neck hairs at attention, the

twosome retreated from the parkland and made the *Life* photo almost within Tucson city limits.

In the Golden Gate National Recreation Area near San Francisco, a National Park Service (NPS) ranger stopped an amateur from photographing the Golden Gate Bridge. Why? Because his 4-by-5 camera indicated his work was "obviously for commercial purposes."

In Yosemite in 1988, I walked on a paved road past a three-week-old ribbon that declared the area around a rockslide closed by order of the superintendent. I wanted to take a photograph, and I assumed the ribbon had been used to keep out cars and bystanders at the time of the slide before the road was formally barricaded. I was working on a forthcoming Sierra Club book, matching my photos to the text of John Muir's *The Yosemite* for the centennial of the park in 1990. Muir describes running out of his cabin in the night in 1872 shouting, "A noble earthquake! A noble earthquake!" as a pinnacle gave way and fell "in thousands of the great boulders I had so long been studying," reaching the valley floor almost exactly where the new slide was. Muir "ran up the valley in the moonlight and climbed upon it before the huge blocks, after their fiery flight, had come to rest." No one stopped him.

When I walked past the old ribbon, I saw no evidence of fresh activity. There was so little debris on the closed main road (page 198) out of the valley that I remember thinking to myself that if a similar slide happened on a road in Nepal, the first Toyota two-wheel-drive truck would be cruising through in minutes. It never occurred to me that pedestrians were still being prohibited. To my surprise, I was soon accosted by rangers with bullhorns and ordered to appear in front of the federal magistrate. A NPS prosecutor recommended possible custody because I had risked not only my life but also the lives of the rangers who had to come get me. The magistrate said I could either pay $100 on the spot or let him take the matter under submission. Thinking he would understand my side, I chose the latter. Four months later I was fined $250, but another intruder who went past the ribbon without a camera was fined just $50.

That same year, my experiences ran the gamut from having to fill out permits and insurance papers in Yosemite to photograph editorial assignments for the *National Geographic* and *Christmas in America,* to being initially refused permission by the U.S. Forest Service to photograph amateur mountain runners on Mount Whitney for *Sports Illustrated.* A ranger told me, "Mountain running is an exploitation of the trails."

I decided to get to the bottom of why photographers were being singled out for unfair treatment. I was able to get the U.S. Forest Service to agree to refund fees I had paid them to photograph for *Sports Illustrated* if its attorneys agreed with the reasoning in a letter I was sure I could get from the American Society of Media Photographers (ASMP), explaining the legal rights of photographers on public lands. I then talked to a lawyer on retainer for the ASMP who was quite willing to write the letter, but despite my repeated requests, the national office never authorized it. Only much later, when an ASMP officer was personally stopped from photographing in a national park, did the photographer's organization take action.

I went on to talk to Congressman Bruce Vento, who was then the chairman of the House Subcommittee on National Parks and Public Lands. He asked the director of the NPS to personally respond to me. I received a pleasant letter that began by listing many abuses by individual photographers that needed to be controlled. I did not see how any of these problems would have been stopped by selecting out tighter permit procedures. Every complaint

he mentioned already violated a park rule for nonphotographers. I imagined being born African-American and being told that my people needed to be restricted because some of them were doing things that were already illegal for everyone.

The Code of Federal Regulations is quite specific and limited about controls on still photography in national parks. The subject is addressed only in section 36CFR-5.5b, which reads in its entirety: "Still photography. The taking of photographs of any vehicle, or other articles of commerce or models for the purpose of commercial advertising without a written permit from the superintendent is prohibited." The rule makes no mention of restrictions on photographing natural features or visitors for fine art, magazines, or books. However, the director also sent me new wording for a "Superintendent's Guide to Public Affairs" that excludes permits only on photography for personal use, while urging that permits be required for "professional, commercial photographers" engaged in everything from feature movies to "art photographs sold for profit." "Newsworthy events in progress" are among the only exceptions.

Soon the good news began to pour in. I received a copy of an official internal memo written by Larry Henson, associate deputy chief of the U.S. Forest Service, instructing regional foresters not to require special use permits or fees for photographers "interested in recording images on U.S. Forest Service lands for profit through sales to publications." He added, "While photographers receive financial gain from their sales, the Forest Service also benefits, particularly from mass distribution of high-quality images of Forest scenes . . . We encourage you to take every opportunity to work with professional photographers to obtain appropriate National Forest recognition for the work they accomplish."

Long after victory on the U.S. Forest Service front, the battle for photographers' rights on NPS wildlands continued to be fought. As the NPS allowed superintendents to instigate more strict permit and insurance procedures than mandated in the Code of Federal Regulations, I urged concerned photographers, especially those who had personally experienced unfair incidents on NPS lands, to write the director in Washington, D.C., the superintendent of the particular park, and the House Subcommittee on Parks and Public Lands.

I saw restriction of photography on NPS lands as part of a larger trend of inequitable conservatorship of public lands that continues to damage the reputation of U.S. national parks worldwide. Nature photographers are casualties in a trend that could eventually threaten the very sanctuaries that the NPS is commissioned to manage. Parks were created because photographers like William Henry Jackson and Ansel Adams brought about public awareness of the value of wildlands.

Photographs: Pages 162–65,
198–99

Return of the First Amendment

*" The surprised looks on the
faces of Todd and Paul's
friends after the pair crawled
through the night to safety
were only surpassed by their
own when park rangers
interrogated them for doing
commercial photography
without a permit and
confiscated their camera."*

When I was growing up in Berkeley, the director of the regional parks in the hills behind my home was a man named William Penn Mott. When I later visited California's state parks, the director was William Penn Mott. When I wrote to the director of the National Park Service (NPS) in the late eighties to complain about the abuses of photographer's rights, Bill Mott sent me a thoughtful reply. He said the issues "are not susceptible to easy definition and regulation," and invited me to "offer suggestions as to how we can develop regulations that would properly protect those interests which are our responsibility . . . without unfairly impinging on the activities of those photographers who are attempting to uphold the highest of their profession."

I began working with the Northern California section of the American Society of Media Photographers to respond to Bill Mott with a position statement from the organization representing professional photographers. An *ad hoc* committee was formed to draft a statement to be sent to the NPS and public agencies that had caused photographers access problems of late. The committee failed to agree on wording and simply faded away. Abuses of photographers' First Amendment rights on public lands escalated, and I decided to take matters into my own hands by writing about the problem in my monthly column in *Outdoor Photographer.*

One of the more outrageous incidents in Yosemite directly related to a participant's right to record his or her own outdoor adventure in a national park. As a movie for TV, the plot would have seemed overwritten.

On the evening of June 16, 1988, two of the world's best rock climbers, Paul Piana and Todd Skinner (page 165), reached the summit of Yosemite's El Capitan. They had made history by doing the first free climb of the 3,000-foot sheer face. It had taken them forty-eight days. For the first time, every

inch of the face had been climbed with natural hand and foot holds, using ropes for safety but not for direct support, as an acrobat uses a net. They were carrying a small camera, and an old friend who was a climber and a photographer had further recorded their achievement for future slide shows and possible magazine stories by taking pictures of them from ropes fixed alongside.

Had all the networks wanted to cover their reaching the summit, the NPS would undoubtedly have complied, issuing permits to allow the news crews to use helicopters and large support staffs to bring this event, protected by the First Amendment's famous freedom-of-the-press clause, into American homes. But Todd and Paul had not contacted the media. They reached the summit alone. Their friend had gone up the fixed ropes and left after getting some key action photos of the hardest climbing near the top. They recorded the final pitch of climbing on a little Rollei 35 loaded with Kodachrome, reached the summit, and began to haul up their heavy bags of survival and climbing gear.

Todd and Paul anchored their rope to a huge rock that had been used by hundreds of previous parties without a second thought. But as they pulled up all their gear, the boulder began to move. It rolled over both of them, crushing their legs and ribs, and plunged over the cliff toward the valley floor still attached to them. By a miracle, the rolling rock severed the 4,000-pound test line at the last moment. By another miracle, the climbers were left hanging over the edge by a thin line they had tied to a day pack that they had attached to a sapling growing out of a crack. Witnesses on the Yosemite Valley floor who saw the boulder and the bags falling from a great distance thought these objects included the climbers plunging to their deaths. No rescue party was sent to the summit, and darkness postponed a body search until the next day.

The surprised looks on the faces of Todd and Paul's friends after the pair crawled through the night to safety were only surpassed by their own when park rangers interrogated them for doing commercial photography without a permit and confiscated their camera, which had survived the fall in one of the bags with the film intact. The rangers had the film processed to look for evidence of "commercial" photos of outdoor clothes and climbing gear that the climbers had been using. Presumably, a number of shots of a person in a North Face parka could be construed as intent to do commercial photography for the North Face catalog without a permit from the park bureaucrats. Their camera was eventually returned without the critical roll of film.

Six months later, I saw Todd and Paul give the keynote slide show at the annual dinner of the American Alpine Club. Their program ended abruptly without any summit photos. I learned that they had hired an attorney, but that the NPS still had not returned their film. I mentioned the incident in my *Outdoor Photographer* column, and within days after it hit the newsstand, their film was suddenly returned without explanation. The slides were competent amateur coverage of the climax of an adventure, but nothing more.

My point went well beyond this. Even if Todd and Paul had made photos of a hundred items they were wearing or using during their climb, and even if all of these situations resulted in national advertisements, they would still have had a right to take those photographs without the permit and the million-dollar insurance bond the NPS rightly requires for commercial work that affects other visitors or temporarily alters the park environment.

Partly through this experience, I became closer friends with Todd and Paul and later joined them on two major wall climbs as both a climber and

a photographer in situations with no outside media (pages 163–65; essay pages 150–52).

After my first magazine column on photography problems on public lands, the NPS in Washington, D.C., received thirty-six letters from photographers, thirty-two of which were clearly identified as written by readers of my column. All but one urged fairer procedures. The one that didn't misspelled my name and personally attacked me as a "cry-baby" who should shut up and do what the rangers say. During that same month, Stan Albright, director of the Western Region of the National Park Service, sent off a memo to all areas and offices that read, in part, "As you know, a permit is required for commercial still or motion picture photography. Unfortunately, the term 'commercial' has not always been defined in a uniform manner. The most recent draft of the National Park Service Administration Policies states that, 'The making of commercial pictures, television productions, or still photographs *involving the use of professional casts, settings, or crews* will be allowed in parks only pursuant to the terms and conditions of a permit issued by the Superintendent' [emphasis added]. We interpret this as meaning that an individual using only camera equipment and no additional props or models is not required to obtain a permit."

· The memo concluded by saying, "We realize that it may sometimes be difficult to determine exactly when filming or photography is of a commercial nature, but believe that in most instances unless props, crews, or cast is required, or disruption of normal visitor activities takes place, a permit is not necessary."

Albright's office gave me permission to quote the internal memo for *Outdoor Photographer* readers so long as I emphasized (1) it is based on draft, not final wording of a policy, and (2) it applies only to parks within the jurisdiction of the Western Regional Office.

When I later discussed the situation with Duncan Morrow, chief of Media Information for the NPS in

Washington, D.C., he said he hadn't seen Albright's memo, but was extremely pleased when I read it to him. "It's clear, concise, and consistent with the view we have long held here and have tried to instill in park managers for years. I just don't see why the typical still photographer represents any concern to park managers. In most instances, there's virtually no threat to a park resource or to other visitors' experience, and therefore, why should there be permits of bonds unless the work involves creating a situation with models, sets, or products?

"Of course we also need to be assured that professional photographers don't assume they can break normal park rules. We don't want repeats of incidents we've had where photographers have disturbed evidence at crimes, stepped on priceless antiques to photograph presidential visits to historic sites, or shot skimpy lingerie ads beside public campgrounds filled with families."

The NPS has been slow to sanction clear national policy partly because of the wide discretionary powers given to local superintendents. These powers do not include violations of the First Amendment or other parts of the Bill of Rights that have been violated in dealings with many well-meaning outdoor photographers, both amateur and professional. Now that the director of the Western Region and the chief of Media Information for the entire park system have made public statements about photographers' rights to record uninterrupted natural scenes without permits or insurance bonds in situations where resources or visitor experiences are not altered, the problems of the past may be history. If you're worried about getting hassled, bring along this book or a photocopy of the pertinent pages with the policy quotes highlighted when you want to take pictures in *your* national parks.

"Johnny sees the code as opening the door for photographers to be cited for being near animals that are simply exhibiting natural behavior: 'I have never photographed an animal in Denali that was not aware of my presence.' "

The Denali Dilemma

On a trip to Alaska in 1991, I brought a 20-year-old guidebook to Denali Park from my first visit. It advised you to "fill your tank to the brim" before driving to Wonder Lake and back beneath Mount McKinley along one of the most beautiful wilderness roads in the world: "174 miles without gasoline—and considerably more if you plan to camp in the park and drive back and forth studying wildlife or doing photography." You can't do that anymore without special permission. The park is getting too crowded, but if the superintendent gets his way, the situation will worsen. While I was there, his stated intention to "make Denali into a main-line park like the rest of the lower 48 parks" was the subject of great controversy.

After the first road travel restrictions were instituted in 1972, I praised the idea in print. Wildlife was to be protected by discouraging nonessential vehicle travel. Visitors would board free park shuttle buses that would stop anywhere. Here would be a model for the future of our national parks.

Professional nature photographers could apply for special road travel permits to go about their work. Also on the road would be park rangers, visitors to the (then) few businesses on private land beyond the park, and narrated group tours run by the park concessionaire. Guess which one of these special interest groups was most likely to end up down for the count?

By the late seventies, the special road travel permit system was being run more like a banana republic than an Arctic wilderness. Pros with major assignments were denied permits, while aspiring photographers working as seasonal rangers filled the permit quotas long in advance. By definition, they were not full-time pros, and by employment with the agency issuing the permits, they had a clear conflict of interest. Dates for visits were set months in advance—fine for off-duty rangers, but not for pros with short lead times and schedules of their own.

I found that situation to have vastly improved. I mention it here as a little window into the Alaskan mind-set against the 1980 Lands Act that instantly tripled the size of the nation's wilderness areas and doubled that of national park and wildlife refuges. In my 1981 book, *Alaska: Images of the Country*, I explained that urban conservationists had trouble understanding why Alaskans were against more parks: "Most Alaskans were not strongly opposed to land conservation; they simply dreaded the often insensitive and inequitable conservatorship practiced by federal agencies." I concluded, "The challenge of the future, both for conservationists and political leaders, is the immense task of changing the current adversary relationship between government and the governed."

Turning Denali into another Yellowstone is not likely to help current problems. A new wrench in the travel permit process makes the kind of fine wildlife images I treasure from the 1970s illegal. Johnny Johnson, one of a handful of genuine, full-time Alaskan wildlife photographers, signed his 1991 permit under protest. He and many others disputed the following provision: "Intentionally approaching on foot within one quarter mile of bears or within fifty yards (one hundred fifty feet) of the other major wildlife inhabitants (moose, caribou, sheep, wolves) is prohibited." Johnny used to be a seasonal park ranger in Denali. He wrote a letter to Chief Ranger Ken Lehrer and received a personal answer laced with bureaucratese: "One of our great challenges in Denali is to protect the park's wildlife and provide for human safety. To be effective, policies must be consistent and easy to comprehend. We cannot expect visitors to follow a policy that allows them to approach animals within different distances under different circumstances. Neither can we allow different user groups to operate under standards that differ from other user groups."

The statement smacks of crowd control tactics for the park's mainline future rather than management to preserve the environment and an individual's sense of wildness and personal freedom. In order to get his permit, Johnny signed a compulsory code of ethics that prohibits harassment. That's good, but not with a catchall definition of "any human action that causes unusual behavior, or change of behavior by an animal." Lehrer cited examples of an animal lifting its head to look at you, stamping its feet, lifting its tail, or rising from a bedded position.

Johnny sees the code as opening the door for photographers to be cited for being near animals that are simply exhibiting natural behavior: "I have never photographed an animal in Denali that was not aware of my presence, and most were photographed from less than fifty yards. . . . It is a very natural thing for a wild animal to lift its head and look around. Caribou, sheep, and moose often lift their tails when they defecate, or stamp their feet when bothered by flies. . . . What bothers me most is the attitude with regard to professional photographers in the park. Somehow we are perceived as a threat to the wildlife when we are on the same side—we all make our living from the parks and should share a role as advocates, not adversaries."

Imagine a situation in which a photographer is watching a group of animals from a distance and then that magical moment comes when the wild creatures accept human presence and move unselfconsciously closer. Instead of tuning into the rare event and making memorable photographs, the photographer will be thinking about getting up and backing away to avoid being judged in violation of park rules.

My solution? On my last trip, I booked a scenic flight with Doug Geeting Aviation out of Talkeetna on the south side of Denali. I got more intimate photographs of the mountain (page 222) than I have ever made from the park road. Wildlife? Doug can drop you in the heart of the Talkeetna Mountains on day trips or with overnight gear where you'll be just as close to the same large mammals found in Denali without the restrictions. He'll even guarantee that you'll get to see all the major wildlife on his favorite aerial tour or keep on flying you for free until you do.

Doug has been flying the mountain for fifteen years now, but he still gets really excited about photo flights. Instead of doing his normal "milk run" to land climbers on the Kahiltna Glacier, he gets to explore the interplay of mountains, light, and his moving machine. The $275 per hour may seem high at first, but it can actually be cheaper and more fun than a week of waiting in the rain on the more cloudy north side in a quagmire of bureaucratic restrictions. From the air, great views of the mountain begin immediately after takeoff. An hour-and-a-half flight split three ways costs about $135 each and can be timed for the best light. Another advantage of aerial photography of Denali is that it is not limited to the few months a year when the park road is fully open. Some of my best aerials have come during the off-season when the landscape is more snowy, the air is more clear, and the sunrises and sunsets are better timed with normal waking hours.

Photographs: Pages 217–21

Alaska Bear Safari

" Barbara and I saw thirty-six bears at once within a hundred yards of us. She felt far more at ease than in Katmai, where bears and rangers together create a double-barreled sense of paranoia for a photographer who is trying to obey the rules."

The Brooks River appeared to be a paradise for both photographers and sportfishermen on the evening Barbara and I arrived in Alaska's Katmai National Park. Last light gilded men and women in hip waders standing in turquoise waters that split a jade ocean of spruce forest. Two happy anglers were busy reeling in an arm's-length salmon and an equally big rainbow when a ranger suddenly gave an order. They pulled out their knives and cut their lines.

Had they broken a regulation? No. They were precisely following park rules. Three native residents with priority fishing rights were approaching. In the lead was a 600-pound mother, followed by two yearling cubs who swaggered with the cocky uncertainty of new members of a street gang. The three bears hardly acknowledged human presence; regulations are designed to keep things that way. If Katmai's grizzly bears connect humans as a source of fish, both sportfishing and photography will be in big trouble.

Katmai bears have a surprisingly clean record. The last visitor injury from a bear attack happened in 1967, but yesterday's regulations are unlikely to work for tomorrow. Both bear and tourist visitation to the river more than tripled during the eighties. Research shows that the more rats, monkeys, people, or grizzlies in a tight area, the more aggressive their behavior.

After the National Park Service put Katmai development and management alternatives out for public review in 1991, the *San Francisco Chronicle* quoted two Katmai rangers, three fishing guides, one outdoor journalist, and five tourists as independently using the same phrase, word for word: "An accident waiting to happen."

While heading out for pictures at dawn one morning, I startled a young ranger measuring a straight line on the forest floor. "Are you scoping out a new trail?" I asked.

"No. I'm taping fifty yards from that clearing. Bears pass through there and I want to know exactly where photographers are in violation of the park rule for close approach."

Katmai was the first and the most crowded, noisy, and dangerous of the three areas that we visited on our own personal survey of how the feds, the state, and private enterprise manage bear-watching opportunities in Alaska. I also hoped to better the photographs I'd made during the neolithic days of the seventies when both the bears and the photographers had the wilderness more to themselves. Brooks Falls, the prime Katmai real estate for both species, is now graced with a room-sized elevated platform where up to a hundred people elbow each other for a camera position.

One morning all my stars lined up and I made many of the trip's best images right on that platform. Rangers had closed the trail because of a bear sleeping within the sacred distance, but I decided to wait. Just after a couple of us were escorted through by rangers armed with radios and shotguns, the bear was sighted again and the trail re-closed.

Meanwhile, events outside the park profoundly affected my photo op. Commercial fishermen in nearby ocean waters had gone on strike as salmon prices dropped. Until the strike, both Katmai bears and sportfishermen had been catching only the "escapement," the tiny percentage allowed to get by nets strung near the mouth of the river. As I set up my tripod with only three other photographers, a surge of salmon welled upstream. Up to ten were in the air at once, jumping over the falls toward the mouths of waiting bears. I focused my 300mm $f2.8$ on a big male and shot motor-driven bursts at 1/1000th each time I saw salmon jump. Instead of the smug assurance that Katmai bears display when they pull single salmon out of the air, my favorite image (page 217) shows a bear as confounded by a surprise movable feast of four salmon coming toward him as a golden retriever thrown four tennis balls at once.

After the strike was settled the next day, the bears stood in the river as quietly as logs, while the surface remained unbroken. We moved on by floatplane to McNeil River Falls in a totally uninhabited section of the Alaska Peninsula. Here, under the auspices of the Alaska State Department of Fish and Game, we had a far wilder and more intimate experience. Warden Larry Aumiller, who had guided me back in the seventies, knows his local bears better than I know my neighbors. Each day of the summer salmon run, he or his assistants take a group of ten visitors by foot from a camp on Cook Inlet to the falls. Permits are given out by a lottery earlier in the year to less than a tenth of the applicants. Those who win get a prime, rather than a compromised, experience.

Barbara and I saw thirty-six bears at once within a hundred yards of us. She felt far more at ease than in Katmai, where bears and rangers together create a double-barreled sense of paranoia for a photographer who is trying to obey the rules. At McNeil we hiked as a team led by a bear expert, who used common sense to skirt grazing sows with cubs by more than a hundred yards on open flats, but approached other bears much closer when he thought we could observe and photograph them without incident. He carried a shotgun just in case, but had yet to kill a bear with it.

McNeil's unique permit system bats 0/0 in the bear/human casualty department and is more likely than Katmai to continue its record. Visitors to the falls stand on a natural ridgetop often within ten feet of wandering bears who display a remarkable respect for this island of human territory within their domain. The bears appear far more concerned about their colleagues than us. My favorite 1991 McNeil shot (page 220) shows a mother with two

cubs tentatively watching the scene because her cubs' lives are in danger around adult males. In contrast, I felt safer without any barriers between me and these giant carnivores than walking down the street of any major city in America.

Ten miles by boat from McNeil is the private Chenik Brown Bear Photography Camp, as personal and peaceful as Katmai is hectic and loud. The experience and rustically chic lodging pleasantly blur the border between wilderness appreciation and comfort. One afternoon as we were having tea on the deck, a lone bear approached, regarded us like the rocks and the shrubs, and began rolling in the foliage. I concentrated wholly on my photography while a staff member with a shotgun he had never used except in practice stood by. As at McNeil, our closeness of approach was a judgment call by an experienced guide who made us feel an accident was *not* waiting to happen.

Here in a wholly wild setting we shared nature walks and gourmet meals with guides who led us through a landscape that they both loved and understood. We visited a nearby fox den where two kits played at our feet without fear, and we explored tide pools as bald eagles swooped overhead. Mike and Diane McBride operate Chenik as an outreach of Kachemak Bay Wilderness Lodge, which has won national awards plus my accolades (pages 179–81) for an unbeatable combination of aesthetic design, personal attention, fine food, and grand photographic opportunity.

I would love to be able to report that Alaskan brown bears and photographers will live together happily ever after, but such may not be the case. Between McNeil Falls and Chenik, construction on a $2.6 million fish ladder began in 1991 to bypass a 35-foot waterfall on the Paint River and create a salmon run where one had never existed. An association of commercial fishermen is spending state and federal funds to increase their take of salmon, even though the present catch is too large for canneries to market. The project was undertaken without assessing the impact on the bears, either there or at McNeil, Chenik, and Katmai.

McNeil became the brown bear Olympics of salmon fishing because bears are drawn from a vast area without another waterfall in a salmon stream. Because the Paint River is outside the McNeil River State Game Sanctuary, hunters will be able to legally shoot bears that have become habituated to the close approach of photographers who intend them no harm. Unless the Alaska state legislature grants sanctuary or refuge status to the region, the greed of just sixty commercial fishermen will destroy the grandest recurring convocation of land predators on the planet. As of 1993, the bears do not have protection outside the sanctuary, despite hearings, protests, and letter-writing campaigns. The beautiful male that I photographed from the deck of Chenik Lodge (pages 218–19) disappeared that same fall. He may have walked right up to one of the Texas hunters who had been granted permits to shoot two bears in that area, only to be mounted with a growl instead of a curious glance on someone's wall. Letters to the State of Alaska resulted in a 1993 moratorium on aerial hunting of wolves, and I strongly urge those who want their children or grandchildren to be able to view wild grizzlies, as Barbara and I have done, to write to: Alaska Department of Fish and Game, Box 3-2000, Juneau, Alaska 99802.

Above: Essay pages 214–16
Four salmon leaping Katmai's Brooks Falls at the same time momentarily confound this poor Alaskan grizzly. I was reminded of the bewildered look on my golden retriever's face when someone throws him a handful of tennis balls. A 1/1000th shutter speed froze the action through a 300mm f2.8 lens. The coastal Alaskan brown bear is now considered to be a larger race of the North American grizzly.

Following pages:
Essay pages 214–16
Another Alaskan grizzly gave me the eye as he cavorted in a bed of foliage near the Chenik Brown Bear Photography Camp on the Alaska Peninsula. The eye would have been lost in shadow without fill light from a Nikon SB-24 fired on-camera from sixty feet as this photograph was made at f2.8 through a 300mm lens with Fuji Velvia pushed to ISO 100.

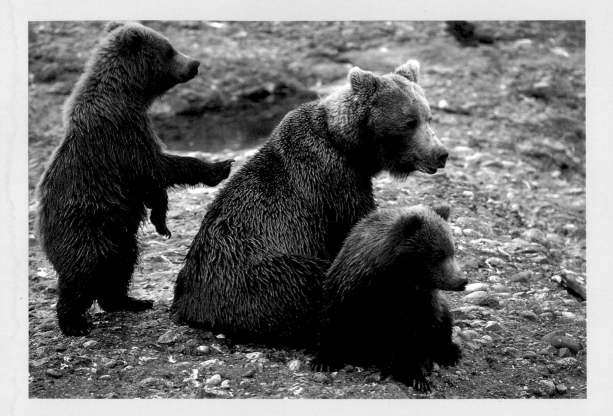

Above: Essay pages 214–16
A mother grizzly and cubs refrain from the action at McNeil Falls while the dominant males fish for salmon. Here on the Alaska Peninsula is the greatest known concentration of grizzlies in the world. I counted thirty-six at once when I made this photograph with a 600mm lens.

Right: Essay pages 214–16
Bart, a 1,400-pound male Alaskan grizzly, isn't just acting in this charge scene from the Disney film White Fang *that ended up on the cutting room floor. I was hired to shoot promotional stills on location near Haines, Alaska. While I triggered this frame from a hundred yards with a Nikon Modulite infrared remote release, Bart was chasing an off-camera meat lure in the hand of his trainer. Bart is best known for his leading role in the film* The Bear.

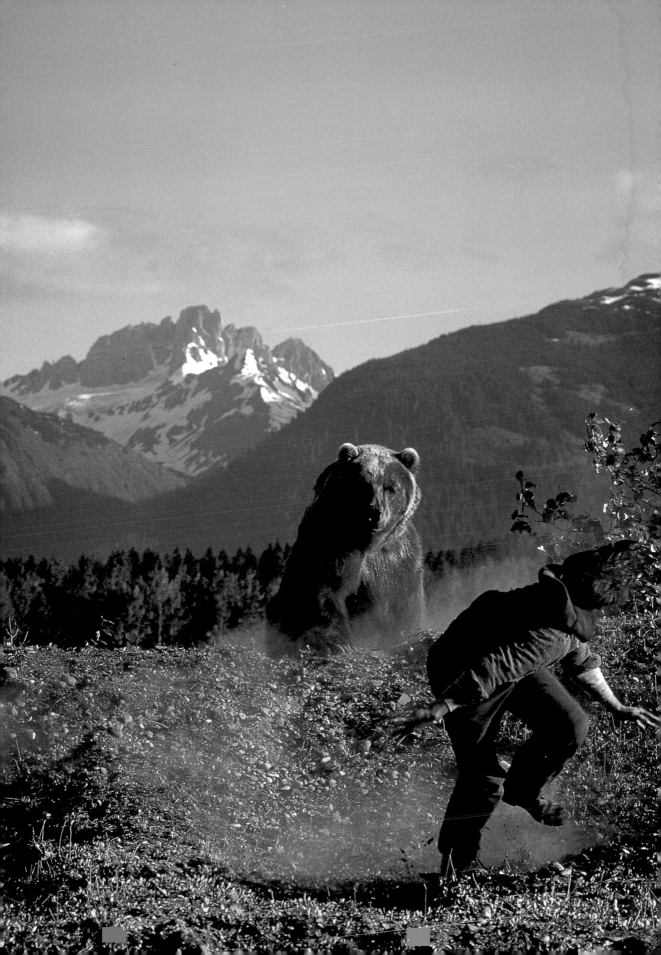

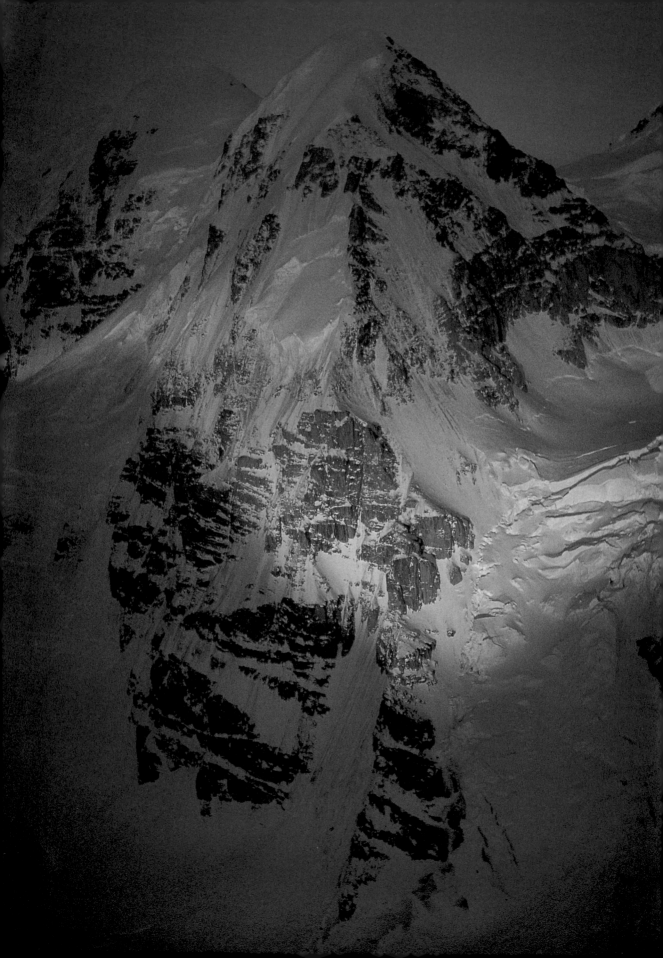

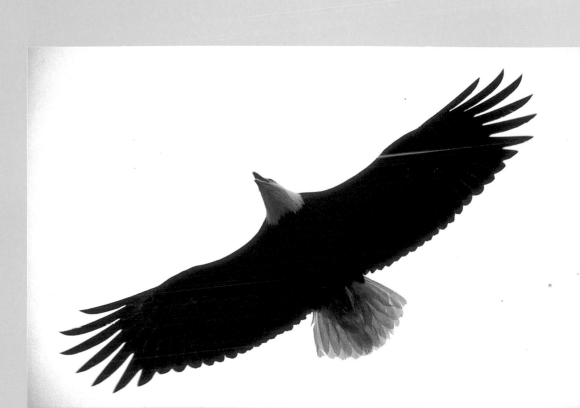

Left: Essay pages 212–13
During a week when the weather was poor on the north side of Mount McKinley in Denali National Park, I found splendid alpenglow with deep blue shadows on the south buttress of the peak during a sunset flight with bush pilot Doug Geeting of Talkeetna.

Above: Essay pages 212–13
A bald eagle spreads its wings to fill the entire frame of this 400mm telephoto I made south of Denali National Park along the Chulitna River.

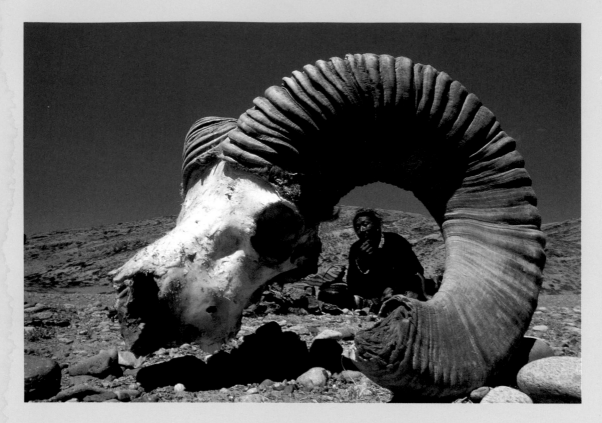

Above:
Essay pages 176–78, 244–48
When I singled out a Tibetan nomad through the horns of an endangered Tibetan argali *sheep, I had an intuitive feeling about the connection between the two subjects. The photograph became an icon of Tibet's plight and the link between human rights and the environment after Greenpeace circulated it as a cover image for the first major story on Tibet's environmental problems.*

PART FOUR REALIZATIONS:
*Communicating your worldview
through photography*

A Phantom Mentor

"The year was 1933; Brower was not yet twenty-one. He recalls seeing 'a bearded type, camera and tripod over his shoulder, coming up through the timberline forest. "You must be Ansel Adams," I said. He agreed. Neither one of us knew who I was.' "

There is no fast track to success in outdoor photography. In 1973, my first year as a pro, Bob Gilka, *National Geographic*'s legendary director of photography, told me that in reviewing portfolios, he was less concerned with technical expertise than with the kind of personality and life experience that allows a person to make interesting photographs. Earning a living as a camera operator is not at all like doing the same with a computer. The difference is software. You can insert your chosen program into your computer, but to operate your camera effectively, the software has to be all in your head. Many self-proclaimed photographers can tell us more than we ever wanted to know about equipment, but are incapable of making a living with it. Every environmental photographer should own the piece of software that I am about to describe here.

For Earth's Sake, published on Earth Day 1990 by Peregrine Smith Books, is the autobiography of David Brower. The foreword aptly describes him as "the most important environmental activist our country has produced in the twentieth century . . . an American original [who] calls us to be bold in our own lives." Between the lines of this insider's view of the environmental movement are gut feelings, passions, and opinions that give shape and form to the way that still photography has become such a powerful, positive force for the environment.

In the late fifties, Brower conceived, edited, and produced the Exhibit Format Series of outsized photo books for the Sierra Club. In *For Earth's Sake* he describes working with photographers such as Eliot Porter and Ansel Adams on books that became hallmarks of their careers. In doing so, he reinforces my impression that great photo books usually evolve apart from the normal marketplace, each one guided by unique people, events, and purposes. Brower-produced titles have a way of capturing our souls and holding them forever: *Everest: The West Ridge; Galapagos: The Flow of Wildness; Not Man Apart: The Big Sur Coast; Wake of the Whale; The Last Redwoods; Gentle Wilderness: The Sierra Nevada; The Place No One Knew: Glen Canyon on the Colorado; "In Wildness Is the Preservation of the World;"* and *This Is the American Earth,* to name a few.

Some future photo-historian may conclude that the original Exhibit Format book, Ansel Adams's *This Is the American Earth*, was a logical outgrowth of his earlier gallery exhibit by the same name. But origins of books are rarely as simplistic as they might seem. The roots of the Exhibit Format Series, like those of the aspen forests Ansel loved to photograph, are deep and interconnected. Publisher and photographer first met, not in a New York office, but in the middle of what is now, thanks to Brower's tireless efforts, both Kings Canyon National Park and an officially designated Wilderness Area. The year was 1933; Brower was not yet twenty-one. He recalls seeing "a bearded type, camera and tripod over his shoulder, coming up through the timberline forest. 'You must be Ansel Adams,' I said. He agreed. Neither one of us knew who I was. The conversation was brief."

Brower relates how Adams's concept for a book "that would reveal wilderness and the national park idea in a global context" predated the exhibit by many years. Despite Brower's modesty about his own role, it is very clear to me that the entire genre of quality large-format books about the natural world would never have come about as we know them today without his guiding hand. I interject this strong opinion because I was with Brower in 1960 for that first big book at least as much as he was with Ansel in 1933 making photos in the wilderness. It is now my turn to say, "Neither one of us knew who I was."

I was the hot-rod kid who lived a block and a half from Brower in Berkeley, disturbing the peace of

his work in his home office by frequently burning rubber up the street. I later overhead him box me up and bury me as "the crazy driver." When he produced *This Is the American Earth*, I was the same age that he had been when he first met Ansel. At the time, I was halfheartedly trying to find a major at the University of California that I could visualize as a life career. After three changes in two years, I quit, returning only for classes that interested me without ever getting a degree.

In this day of fast-paced reporting, the media love to relate how one day in my thirties I walked away from my auto repair shop to embark on a career as a wilderness photographer. It wasn't that simple, and it wouldn't have happened without David Brower's influence.

I devoted several pages of my book, *Mountain Light*, to describing my "phantom mentors." My heroes weren't particular photographers, although I borrowed ideas from some, but instead were people I had met through my family (but often had scarcely known) who had combined some conventional skill with their passion for the environment to create a unique career. A block below me lived another phantom mentor, Dick Leonard, a pioneer Yosemite climber who had used his law degree to initiate new ways of protecting wildlands.

Brower had merged his skills as a book editor, his passion for adventure and the environment, and his position as the Sierra Club's first executive director into several new fields of endeavor, each one long ahead of its time. The club grew, Cinderella-like, from printing a few regional books into publishing of the most beautiful and highly respected photography books in America. In turn, these books helped save wilderness and radically increase club membership (even though narrow-minded accountants later used their red ink on the bottom line of sales figures to help remove Brower as executive director in 1969). During Brower's tenure, the club changed from a 3,000-member California outing club into a 77,000-member global force for conservation.

In the fifties, after seeing how big business influenced public policy, Brower went to Washington, D.C., on behalf of the Sierra Club and became the nation's first environmental lobbyist. I was thirteen years old when my father told me over lunch that an important political scientist at the University of California at Berkeley had said that our neighbor was the most respected lobbyist in the country because he boldly spoke the truth. On my father's urging, I shyly approached Brower for an interview for a term paper about the battle to save Utah's Dinosaur National Monument from being flooded by a dam. It was the Sierra Club's first strong commitment on an environmental issue outside California. Both the club's stand and my term paper were successful. Although I was deeply impressed with Brower, I never pursued a personal friendship with him. I thought, at first, that I was too young and, a few years later, that his looks of disapproval of my driving were more than I wished to deal with. I settled for observing my phantom mentor's career from a distance.

Reading *For Earth's Sake* makes me realize that I know of no one else with a background as similar to my own. Brower and I were born in Berkeley (twenty-eight years apart); still live there; attended the University of California without graduating; delivered the same local newspaper; wandered through the same local park in pursuit of youthful, self-initiated scientific collections; summered in the wilderness on multi-week Sierra Club outings; learned roped climbing on Berkeley practice rocks; made dozens of first ascents of faces in Yosemite and the High Sierra; set crazy personal speed records driving to Yosemite (gotcha, Dave); and developed our abilities to write and photograph, not as ends in themselves, but as means to produce books and other bodies of work that follow in the wake of our passions.

Brower, too, began photography to record his wilderness experiences. Unlike me, he never became obsessive about it. We should all be thankful that he focused on the larger goal of saving the earth's wild places long before it was considered a fashionable, or even reasonable thing to do. Even today, thirty years after he began the Exhibit Format series, the books he published are still being imitated but rarely surpassed. David Brower, now in his eighties, continues to have the kind of personality and life experience that Bob Gilka always searched for to single out those most capable of influencing others through photography.

"He often thought he could still hear 'the wild cries of geese and cranes and the beating of their wings as they fly over Lhasa in the clear cold moonlight.' . . . the photographs he had carried across the Himalaya took on a different meaning than his original intention."

Heinrich Harrer's Lhasa

A nother of my phantom mentors was an amateur photographer who took the first color cover of *Life* magazine, but that wasn't why I admired him. I became a lifelong fan of Heinrich Harrer after I read his best-seller, *Seven Years in Tibet*, on a wilderness trip in 1955. His photos didn't do much for me because of their poor reproduction in the paperback, but I was in awe of both his adventures and his will to succeed in everything he did.

I have no memory of trying to follow Harrer's footsteps, despite strong parallels in our lives. After years of adventurous climbs in my home mountains, I was invited on a Himalayan expedition, traveled extensively through Tibet, met the Dalai Lama, took photos, and wrote books.

In 1991 I was thrilled to accept an invitation to write the introduction for a new Harrer book that blended his black-and-whites of Tibet before the Chinese invasion with fresh writings. (*Lost Lhasa* was produced by Summit Publications and published by Abrams in 1992.) I arranged for an interview when Harrer would be in New York for the opening of his first American photo exhibit. Just before my flight, I squeezed in my customary Tuesday run with my neighbor Brian Maxwell. As we ran a wild trail, I mentioned finally getting to meet one of my heroes of whom he had probably never heard.

"What's his name?" Brian asked.

"Heinrich Harrer."

"I know exactly who he is. When I was a teenager in eastern Canada, I used to carry a quote from his book *The White Spider* about willing yourself to push the limits of the possible. I read it for inspiration before every race."

Brian had gone on to become a world-class marathoner, and our mutual connection to Harrer was not as much a coincidence as it might seem. Harrer had touched millions of other souls. His legacy had influenced me in so many ways that I felt I was

seeing a long-lost friend when I was introduced to an 80-year-old man in a business suit whose blue eyes danced with the eager anticipation of a child. Our one-hour breakfast interview ended at dinner.

Harrer's compelling photographs reflect the same personal energy and attention to detail he gave to all his chosen pursuits. He mastered the radically new technique of parallel skiing so thoroughly that he competed for Austria in the 1936 Olympics. Two years later he made the first climb of the North Face of the Eiger in Switzerland, the most difficult ascent in history at that time. In 1939 he was invited on an expedition to climb Nanga Parbat in British India, where he was imprisoned as an enemy citizen when World War II broke out. He escaped with a climbing partner and finally arrived in Lhasa on an icy January day in 1946.

Having taken on the life-style of Tibetan nomads over the last two years, they had no money, weapons, cameras, or film. Their goal was not to tour, document, or plunder Tibet, but to avoid the persecution and stress of a world in chaos in the way they knew best: head for the mountains. They planned to stay in Tibet forever.

Harrer told me that his lifework "built up without intention, very organically, step by step." He quoted the Dalai Lama telling him, "You can't jump from the ground floor to the tenth floor. You have to go up all the stairs." He explained that he didn't meet the Dalai Lama until two years after he took up residence in Lhasa. "Many people say I was the Dalai Lama's tutor, but I don't. We learned English together. We were just friends and he was interested to hear from me. I had a chance, for the first time in my life, to use my training as a geography teacher."

He recalled how the teenage spiritual and temporal ruler of Tibet had been brought up by monks who had never been outside the country. "They taught him religion, meditation, and whatever was important

then to the Tibetan government. And suddenly along comes Heinrich and explains how the earth is round. How to shake hands. Science and geography . . . I was the link between his medieval world and his future life in the West."

Harrer bartered use of a Leica from a Tibetan noble who had brought it from India. His black-and-white film came from a 100-meter roll of 35mm motion picture stock left behind by a prewar expedition and preserved by the cold, dry climate. He cut it into rolls and processed a test with the help of a Mohammedan trader who did cheap portraits there. "When we looked into the chemicals, out came the shadows of the dark clouds and the white buildings [of the Potala Palace] . . . you can't imagine how happy I was!"

Harrer occasionally borrowed a bigger medium-format camera, for which both film and developing had to be procured from India after long delays because of the two crossings of the Himalaya. However, most of his work that appears in his new book came from the 35mm roll found in Lhasa.

Harrer's photography as a prisoner of war is a reminder that, in a sense, all photographers are prisoners of war. Battles have been fought for a hundred and fifty years to improve cameras and film, yet photographers are still confined by the current limitations of their craft and the current fancies of their culture. When some daring person escapes, it usually happens with the outside help of a technological advance or a personal benefactor. Midnineteenth-century photographers were condemned to slow exposures that wouldn't stop the action of people walking on a Paris street, much less the dances of a Tibetan festival. By the turn of the century, film speed had improved, but blue skies were rendered white instead of the more properly equivalent grays that panchromatic film records. Harrer used panchromatic black-and-white film, but not with the yellow and red filters

that Ansel Adams and others of the period utilized to render more dramatic tones in their skies.

Most of Harrer's photos were made with an internal motivation to record the broad experience of what he was living, rather than with the external slant so common with other photographers of the period who documented exotic cultures. The sensitivity of his style was ahead of its time, long before it became fashionable for a photographer to become immersed in a culture to show its inner values. He made no effort to focus on unusual customs with an eye for the attention they would grab from the folks back home. The implied comparison of "us" and "them" to exploit their strangeness isn't part of his work because, as he explains, "I tried to behave like a Tibetan. I avoided trying to make close-ups of the Dalai Lama, because no Tibetan would think of doing that."

According to custom, the Dalai Lama remained sequestered from all but his spiritual and political hierarchy. As the spiritual and temporal ruler of his people, the teenager was unable to walk the streets of Lhasa to see everyday life. His passage through town was always prepared in advance and accompanied by great festivity and ritual that erased the normal life-style from his view. Within the walls of the Norbulingka, his summer palace, he had a private garden filled with plants and wild animals that roamed free. The Potala, his winter palace, was considerably more bleak inside, even though it was one of the most beautiful buildings in the world from the outside. The insatiably curious teenager often sat on his roof with a telescope trying to observe everyday life in the town below. He longed to be a part of the lightness and laughter without, rather than the solemn decorum that prevailed within.

Harrer's association with the Dalai Lama might never have happened were it not for some ice skates left behind by a departing British legation. Being a great lover of fun and sport, Harrer founded a skating club with some Tibetan friends on a frozen pond not far from the Potala. The sight of monks in their robes flailing and crashing on the ice astonished and amused the populace. Monks, children, and even the Dalai Lama's older brother, Lobsang Samden, joined in the fun. When the crowd laughed uproariously, the sound drifted upward in the quiet winter air to the quarters of the Dalai Lama, who couldn't quite see the frozen pond from his roof. Had the Dalai Lama come into view, the skating would have stopped, not just for the moment, but perhaps forever.

The 13-year-old Dalai Lama heard all about the new sport from his brother and tried to figure out a way to see this "walking on knives" for himself. Protocol made it impossible for him to go there personally, so he came up with a novel plan. Out of the blue he sent Harrer, whom he had never met, a small 16mm movie camera with instructions to film the skating. The first film took two months to go to India for processing. The Dalai Lama responded to it with tremendous interest and a critical eye evident in messages asking Harrer to do more films of different subjects with precise directions about how to make the best use of light and form. Thus Harrer became the Dalai Lama's personal photographer long before the two actually met.

Harrer tried to avoid being conspicuous with the movie camera, especially at festivals and religious ceremonies. He operated on his own feelings plus the Dalai Lama's expressed desire for candid films. As it became known that Harrer was working at the request of His Holiness, the filming became less candid. Like a modern press photographer, Harrer was given special access to events and an open field of view. He discovered the power of the camera to alter its own reality through incidents such as asking the most stern and feared Tibetan guards to pose for him. Their gruff demeanor instantly faded away and "they obeyed like lambs." And wherever Harrer

took the Dalai Lama's movie camera, the little Leica went too.

The sequence of events that led up to their first meeting rightfully begins with the young Dalai Lama's uncontrollable urge to discover how the world worked by taking apart every mechanical gadget he could find. His aides stood by in consternation as he began to disassemble priceless Swiss watches and music boxes presented by the czars of Russia. They began to breathe more easily as it became apparent that the thirteen-year-old had an uncanny ability to return these things to working order. He even took apart an inoperative movie projector left behind by his past incarnation and put that into working order. He also repaired an ancient electric generator at the Norbulingka. Then he sent a message to Harrer to build a theater there.

The Inner Gardens of the Dalai Lama's summer palace were opened to Harrer as he set about transforming a house adjacent to the palace with a crew of royal workers. After he made measurements for the screen and projection platform, he constructed a separate power house to keep the noise and exhaust of the generator away from the theater. Because the well-worn generator was unreliable, he set up a method for a car engine to become an auxiliary power source. The gates of the gardens were widened to admit one of Lhasa's only vehicles.

When Harrer received an urgent summons to come to the theater at once, he thought something had gone wrong. Instead, he was formally presented to the Dalai Lama, who burst forth with a stream of unrelated questions about the outside world and life in general. Harrer understood that for years the boy "had brooded in solitude over different problems, and now that he had at last someone to talk to, wanted to know all the answers at once." That evening Harrer was asked to show a film on the surrender of Japan from the Dalai Lama's collection, but as he

began to load it into the projector, the boy "impatiently pushed me on one side, and, taking hold of the film, showed me that he was a much more practiced operator than I was."

Harrer's writings provide a rich background for understanding the motivations of his photography in Tibet, but leave direct questions unanswered. "People always want to find out about your motivation," Harrer says, "and why do I need to give them one? I just do it, whatever it is I want to do. When I read about some of these Everest climbs being done for world peace or hunger, that's a lot of nonsense. It's better to say, like my friend Heckmair who was with me on the Eiger, 'I have fun in climbing the mountains and that's all.'"

We can, however, gain deeper insight into Harrer's motivations by examining his powerful ability to achieve his dreams in many other areas besides Tibet and photography. The world is his stage, and in one way or another, he has always been building a theater and meeting a Dalai Lama.

In Tibet he kept a detailed personal diary. Even as he fled he began working on a book that would be published in 1953: *Seven Years in Tibet.* One reason he wrote text, instead of immediately assembling his photographs into a more visual book that also would have sold, was a restless urge to write promoted by the parting words of the American journalist Lowell Thomas in Lhasa, some months earlier: "If you don't do your biography soon, I will . . ."

Only during Harrer's last days in Tibet, as his idea of home changed when rumors of an advancing Chinese army reached Lhasa, did he set out to photograph with what could be called Western documentary intentions. "I knew it would be long before I saw Lhasa again, so I bade farewell to all the places I had come to love. One day I rode out with my camera and took as many photos as I could, feeling that they would revive happy memories in the future

and perhaps win the sympathy of others for this beautiful and strange land."

Before he left Tibet, his main coverage was black-and-white, but he had saved a few frames of Kodachrome from his only two rolls of color film. They had been given to him in Lhasa by Lowell Thomas, who had been invited by the Tibetan government to tell the world about its plight as the possibility of a Chinese invasion loomed on the horizon.

On January 20, 1951, a rare Associated Press story about Tibet hinted at the presence of the two Austrians alongside the Dalai Lama:

> The flight of the young Dalai Lama from his capital in Communist-invaded Tibet was one of the strangest journeys ever made by a monarch, an aide indicated today. The aide and two European technicians, who accompanied the Dalai Lama, said the Red Chinese flag already was flying over the old Chinese residency in Lhasa, the capital, when plans . . . for the Dalai Lama's dramatic trip over a perilous icy trail were made in utmost secrecy . . . Stars glowed with winter brilliance as the Dalai Lama made his way from the palace alone about 2:00 A.M. the next morning. . . . Ten miles from Lhasa the boy king descended from the palanquin (covered chair) and gazed back at the white mass of the Potala Palace lighted by the first rays of the morning sun. . . . It was apparent from questions he asked that he was uncertain where his travels would end.

After Harrer returned to war-torn Europe, he lay awake homesick for Tibet. He often thought he could still hear "the wild cries of geese and cranes and the beating of their wings as they fly over Lhasa in the clear cold moonlight." He had become a celebrity overnight and the photographs he had carried across the Himalaya took on a different meaning than his original intention.

When he processed his few Kodachrome slides, "no one would believe the colors—the film, everyone said, must be faulty and the colors were not true: no sky could be that blue, no water could sparkle that green." Harrer knew different. His eyes had seen a similar world with "these incredibly intense colors, that hard azure-blue, that eye-calming green of the grass," which his excellent exposures brought out. Anticipating that this saturated color would be absent in his black-and-whites may have influenced how much his Tibetan coverage focuses on the culture, rather than on the natural mountain landscape that was so dear to him.

Harrer had made his last photograph of his friend, the Dalai Lama, after the two of them had escaped the Chinese across the Himalaya in winter. Using one of his few remaining frames of Kodachrome, he had been thinking journalistically and seeing with the eye of a seasoned pro.

Thus the real story of how an amateur happened to shoot the first color cover of *Life* has little to do with the kind of luck that wins a lottery and everything to do with the heart, soul, risk, and focused personal energy required to make meaningful photographs with any consistency.

Photographs: Pages 189,
252–53, 267, 271

*"I secretly felt, although I
would have rather died
than admit it, that I had
a very special vision then.
The newer images that
so clearly surpass my old
work were made without
nearly so much hungry
thought about artistry."*

Return to Roots

Outdoor adventure led me into a photographic career. From the beginning, I wanted to share not only my climbs and explorations, but also visions of the wild environment I encountered. At first, specialty magazines published only my climbing images. Over the years the tables gradually turned, and the magazines published more of my nature images. By 1989 I was in a good-enough position to be very choosy about assignments. I made a New Year's resolution to focus my work as much as possible toward environmental awareness. As I neared the half-century mark, I thought I was ready to put adventure for its own sake in the backseat behind adventure for the earth's sake.

That same year, I began working on a great assignment for *National Geographic* that would combine adventure with an environmental cause. Peregrine falcons, an endangered species, were reported to be living in the middle of the face of Half Dome in Yosemite. Because of high levels of toxics in the creature's food chain, the National Park Service (NPS) had sought outside funding to remove eggs before they broke and to manipulate healthy chicks raised in captivity into the cliffside nest. I got permission to climb with the team and turned down a number of lucrative offers for the same time period, including an assignment for *A Day in the Life of Italy*, a trek through Bhutan, and an advertising shoot for Nike.

However, the original story concept about the falcons dissolved before my eyes. The species didn't breed on Half Dome that year, and the park decided to cancel all nest manipulations, even at other Yosemite sites. I considered using privileged information to write a scathing exposé of what had happened, but thought better of it at the time. It would have overshadowed the more important story of the bird's continued plight in California twenty years after DDT had been banned in the United States. I

had learned that NPS reports of breeding peregrines on the face of Half Dome were incorrect because the NPS had diverted nest observers paid by private-sector funds for the express purpose of monitoring peregrines to doing other resource work in the park. The observers simply weren't on location continually enough to confirm that peregrines were exhibiting nesting behavior at a site where they had been seen perching the previous year.

I was caught right in the middle of the intrigue not only because I was in a position to reveal to ten million *National Geographic* subscribers what I found on the face, but also because I was a member of the Project Review Committee for the Yosemite Fund that had approved the $50,000 grant at the request of the NPS. I didn't know that the site on Half Dome, visited the previous year by climbers paid $13,000 by the Fund through the NPS, was not an active peregrine nest until after I had my assignment and planned nest augmentations on Half Dome and on other cliffs in the park were abruptly canceled. I didn't believe the biological reasons that were given to me. The decision came just after a *National Geographic Explorer* film crew requested permission from the NPS to film me photographing the nest on Half Dome. The crew wanted to lower cameramen in a hot-air balloon basket from a winch placed on the summit by helicopter. I would be climbing the face with a biologist using traditional means. Of course the film crew promised not to disturb the nesting endangered species. The NPS's decision seemed to be in the best interest of preventing the filming and saving itself from public embarrassment, but not in the best interest of birds at other active nest sites in the park where eggs were still breaking.

Disappointment describes my initial emotions about as well as "loud" describes a nuclear blast. I was furious to have been deceived by both sides at once. I had initiated the *National Geographic* magazine

assignment and registered my strong objection over the proposal for a *National Geographic Explorer* film crew to cover me during the most critical minutes at the nest. I had been assured that filming would not proceed without my full knowledge and cooperation, but I was never notified that the crew was contacting the NPS. I had also been assured by park biologists that the nest site was a certainty, when in fact eggshell fragments brought back the previous year by climbers had already been examined by an outside specialist who later told me the fragments were very old and probably not from peregrines. Prairie falcons had been known to use the site in years past, and breeding peregrines had never been observed there.

As a member of the committee reviewing grants, I felt duped by the NPS. We had approved their full $50,000 request with a major portion earmarked for the Half Dome project *after* the old eggshells had been collected and were known to be suspect at best.

When I expressed my bitterness to Barbara, she quipped, "How would the Dalai Lama handle this?" We had both been working with His Holiness on a forthcoming book about Tibet, and we were deeply moved by his ability to maintain compassion and a positive outlook in any circumstance. I remembered his telling us that however negative a situation may seem, "if you look at it from another aspect, you may be able to say, 'not so bad, not so bad, is it?'" I decided not to drop the assignment but to do a story on how peregrines were still endangered in California, especially in downtown Los Angeles (pages 174–75).

This decision, however, did little to mitigate the feeling of nostalgia I had for all those years I spent climbing the walls of Yosemite strictly for their own sake. I had especially fond memories of my ascent of the 3,000-foot Salathe Wall of El Capitan. In 1967 Layton Kor of Colorado (page 253) and I became the third party ever to climb the wall (the first ascent party did it twice: once with fixed ropes, once without). Now the climb has at least three hundred ascents and has become a rite of passage for serious international alpinists. One solution to lifting my low spirits was to climb the Salathe Wall again, just for its own sake, at the time I had scheduled to be climbing on Half Dome. I invited Kike Arnal, a fine climber from Venezuela who was working in my office, to spend three days and nights on the sheer wall with me.

My choice of camera gear was considerably different than in 1967, when I carried an Instamatic 500 with a sharp Schneider lens. It took square Kodachromes that were often published during my first years of photography. Some even held up to full-page enlargements after cropping and converting to black-and-white for use in my first book, *The Vertical World of Yosemite*. For the repeat climb I decided to take a Nikon F3 without a motor-drive, plus three lenses: a tiny 20mm F4, a 35mm F2, and a 75–150mm zoom, plus a small flash. (As we go to press in 1993 my choice would be a Nikon N90 with 24mm $f2.8$, 28–70mm $f3.5D$, and SB-25 flash.)

The climb proved to be just what the Dalai Lama might have ordered to renew my spirit. Each night we reached one of the rare ledges on the cliff with an hour or two of light to spare in great weather. We spread our sleeping bags, tied ourselves to anchors, and slept a solid eight hours without interruption. I felt far more rested at the end of the climb than after a week working in my office.

Back home, I pulled out a dusty slide tray so that Kike and I could view both my old and new images. The difference, however striking, had more to do with consistency than with intrinsic quality of the top selects. Some of the old images are hits, but most are near-misses. The new images, although not perfect, have a consistent way of seeing that makes me understand more about the process of learning photography.

Problems I perceive in my new coverage are virtually all related to minor, rather than essential, aspects. I now pay special attention to what is virtually a checklist of concerns that I used to let slide before I became a pro. These include basic photographic techniques, such as bracketing several exposures in splotchy light or using depth-of-field to hold foregrounds sharp, as well as ways of seeing more specifically related to climbing, such as including a profile of the cliff at the proper angle in the frame to give the viewer the right perspective of up and down. Climbing shots looking directly up or down are rarely successful. I often use an ultra-wide 20mm or 24mm turned to the side so that I can include a cliff profile and a whole climber at close range.

I notice now that my 1967 photographs have a certain self-consciousness about them. I was trying desperately hard to be artistic and to avoid, not always successfully, that socially-concerned-starving-artist look of so much sixties amateur photography. I secretly felt, although I would have rather died than admit it, that I had a very special vision then. The newer images that so clearly surpass my old work were made without nearly so much hungry thought about artistry. I now consider a few rules and simply let my intuition connect with my eye and shutter. I doubt I am alone in my early beliefs or my later process of working through them. We all look at the world differently. Each of us secretly thinks there is something special and unique about the way we see, and indeed there is. The expression of this is why we take photographs, but to think about it too much is to shine the light in our eyes instead of on the path we want to follow.

My two very different renditions of the same climb provide me with a sense of not only what I have learned, but also how I can communicate it to others in far less time. The chosen path for my new images simply follows a sense of organization that begins with elements I consider to be the most important. The process is very similar to that which allows experienced bird-watchers to identify a rare subspecies of peregrine falcon some time later from a picture in a book, while novices (like myself) may see the same bird from the same distance in the same clear light but fail to hold in their minds the significant information they need to differentiate it from other closely related races. Just to see the falcon and to experience it emotionally may be spiritual, but this kind of unstructured perception doesn't make for a good identification or a good photograph. Top bird-watchers organize the way they look at their subject to gather the necessary information about critical markings or colorations as quickly as possible, just as top photographers make an organized visual assessment of the scene before the lens.

My new photos have the same sort of instant appraisal of critical markings and correct colorations that usually gives me enough time to tweak the artistry before I push the shutter release. I know I'll keep doing photography for the rest of my life because I'll never solve all the minor problems or make anything close to a perfect set of pictures. And I'll keep working with the Yosemite Fund, playing park gadfly when necessary, to deliver at least as wild a place to future generations as past generations have given me.

A Sense of Place

The great playwright George Bernard Shaw tried very hard to become a respected photographer. All but a few historians had forgotten this side of the most famous nonpolitical personality at the turn of the century until *Bernard Shaw on Photography* was published in 1989. The foreword calls him "as good a photographer as he was a motorist, and considerably less dangerous."

Shaw was a feisty and contrary egotist with an opinion on everything. He believed that photographs should replicate the world exactly as we see it and that a photographer could accomplish this goal by choice. By sheer force of fame and obsession, Shaw's predictably mediocre results were exhibited, published, and placed into permanent collections.

As I thumbed the pages in a bookstore, his images took the first step toward success by creating an emotional response in me. I thought about the paper on which they were printed and how much better off it had been as part of a living forest. Minutes later, however, I bought the book. My change of heart came when I realized its value as a document of the futility of trying to make photographs exactly resemble reality. Others who have pursued this extreme simply haven't gotten their efforts published.

Shaw said a "photographer is like the cod, which produces a million eggs in order that one may reach maturity." With this attitude it is hardly surprising that he grew frustrated by his own lack of results. He began lavishing praise on the work of his personal heroes, especially that of Frederick Evans, who had a dramatic method for preserving the integrity of nature photography. Shaw described with delight "how if the negative does not give him what he saw when he set up the camera, he smashes it."

At a major gallery opening in London in 1900, Evans told the Royal Photographic Society: "Realism in the sense of true atmosphere, a feeling of space, truth of lighting, solidity and perfection of perspective (in the eye's habit of seeing it), has been my ambitious aim; and to say that I have not achieved it, but only hinted at it, would be praise enough, considering the really great difficulties in the way of a full achievement."

It would be easy to criticize both Shaw and Evans for failing to follow their own proclaimed ethic. Evans publicly hyped pursuit of a perfect reality, yet privately told his peers in the photo club that he had never achieved it. Shaw could be pegged as either a loudmouthed huckster or someone so visually challenged that he failed to notice the lack of realism that Evans had acknowledged. Before passing hasty judgment, however, we should consider that all the efforts of camera designers during the twentieth century have yet to solve the problems Evans noted. Contemporary photography still fails to replicate what Evans called "the eye's habit of seeing," yet the public continues to believe that an image on a flat sheet of film directly copies reality unless the photographer has purposely tampered with it to deceive us.

A more likely interpretation that may exonerate both Shaw and Evans comes from the cognitive sciences, which have been advancing even faster than the computer sciences. The quirks that may have honestly led Shaw and Evans astray are still with us today because they are part of the biology rather than the technology of photography. Despite recent ads for a camera with a computer "that analyzes every subtlety of motion, light and distance . . . instantaneously to record precisely what you see," the basic nature of a photograph remains unchanged from the day of its invention. If computerized cameras really could deliver photographs of what we see with such precision, wouldn't their instruction manuals use such enlightened imagery instead of hand-drawn sketches to show us how to use them? The fact remains that we are biologically incapable of interpreting a photograph in the same way that we

would see the real world. In many situations simple drawings are less ambiguous and paradoxical. Sir Richard Gregory, knighted for his lifework on perception, puts it this way, "Pictures are such artificial visual inputs that the surprising thing is . . . that we make anything of them at all."

Each of us builds a different visual construct in our brain as we view the same photograph. Our brains, unlike computers, thrive on incomplete information to shape the cognitive maps by which we interpret the world. Many cognitive scientists now believe that memory and consciousness originally evolved as tools to make visual systems perform better. Because photographs have been around for less than a hundredth of one percent of human evolution, it is hardly surprising that our visual system has not adapted to accurately perceive the information they record.

The unconscious inferences we make about the contents of a photograph are based on a myriad of stored assumptions in our minds. To make sense of an image, we subconsciously match "bottom up" information that begins directly with the lines, colors, and forms before our eyes with "top down" information previously stored in our brains.

When we watch an artist draw a pencil sketch, we have a moment of recognition when the addition of a particular line makes the hidden likeness of a face pop out at us, no matter how incomplete the sketch may be. For the artist, that likeness was present in the very first mark. A similar thing happens when different people view a landscape photograph. If they have visited the location, their brain interprets the photograph with more top-down information. If they have never visited the location, they build up a less accurate mental image based on the reduced visual information in the photograph without a direct, top-down construct from the actual scene.

Thus our first view of a place we have seen only in photos is always somewhat jarring until we reorient our visual inferences. "The pictures don't do it justice" is a cliché of world travelers, even if those images happen to have been made by some of the world's best and most conscientious photographers. This is to be expected when a real scene doesn't match the imaginary construct we have shaped in our mind.

When George Bernard Shaw looked at Evans's photographs, he built up unquestioned constructs of reality based on trust in his friend's work. When Shaw looked at his own results with his carefully honed self-critical ability, he came to the unmistakable conclusion that his photographs missed the mark. Evans, on the other hand, achieved a better balance between pursuit of an honest impression of reality and pursuit of his own personal vision. Remember that it was Shaw, not Evans, who unequivocally stated that Evans destroyed negatives that weren't perfect representations. Evans more likely destroyed only those that were obvious failures and did his best to make fine prints from the rest.

The real question is what Evans had that Shaw lacked. The thought process of photography is not obvious or wholly intuitive. Over and over again, many of the best and the brightest minds of each generation have floundered at the simple act of taking a meaningful photograph. There's a reason that companies continue to pay extremely high day rates to those special people who know how to operate these over-the-counter devices that camera ads claim will do everything for us. It's all in our heads, but not in *all* of our heads.

Making the Stand

"I'm not a pilot, and I planned to stay down with Doug to attempt an unclimbed peak in Patagonia while Barbara flew the plane across the Amazon and up the east coast of South America toward home."

In mid-1990 I got a letter from a man who wanted me to photograph a tree. I almost gave up reading when he mentioned other photographers had tried but failed. That's often a clue to a situation that won't come across on film. But I spotted the word "Chile." I was going there soon.

The letter was from Rick Klein of Ancient Forest International, an activist group located in the heart of California's last redwoods. He told how he had been drawn to Chile by tales of giant trees that resembled redwoods. After spending nine years as the only gringo warden in the forest parks of Chile, he finally saw his first live alerce tree. Wherever access is easy, the trees have been severely cut back, both for domestic use and for export to Japan. While world attention is focusing on the plight of tropical rain forests, the Japanese are systematically destroying the last old-growth temperate rain forests of the Southern Hemisphere. Two huge timber ships constantly travel back and forth between Japan and Puerto Montt, Chile, processing logs on board. One of these carrier-sized instruments of death is named *The Emerald Forest*.

Klein brought scientists who determined that alerces are the world's oldest forest trees. The age of whole groves averages two thousand years. The age of one specimen is estimated at thirty-eight hundred years, second only to the scattered bristlecone pine of the American West, which is not a forest tree. Klein said that *National Geographic* had shown interest in the alerces, but not in photographs he supplied. Would the magazine send me to photograph alerces twenty feet in diameter?

In less than ninety days I was joining Barbara on the greatest air adventure of her life. She was planning to pilot our single-engined Cessna T206 south to Patagonia in tandem with a similar plane flown by a longtime friend, Doug Tompkins. I'm not a pilot, and I planned to stay down with Doug to attempt an unclimbed peak in Patagonia while Barbara flew the plane across the Amazon and up the east coast of South America toward home.

Doug and his aircraft are both turbocharged. He had just sold his interest in Esprit, the clothing company he founded in the sixties with his wife after returning from a climb in Patagonia. Doug planned on using his personal energy and considerable resources to help preserve essential parts of the global environment and establish the principles of deep ecology as a basis for public policy. When I called him about doing the alerce trek, he instantly said yes. By coincidence, he was buying thousands of acres of Chilean forest with his close friend, Yvon Chouinard, who started his own little company called Patagonia after that same earlier climb. The purchase of the threatened lands had been proposed and arranged by Rick Klein.

After Klein sent me more background information on the trees, I made a judgment call. Scientific studies of the alerces were incomplete and the photography seemed problematic. Rather than a full *National Geographic* story, I proposed a single photo with a description of the tree's plight for the magazine's *Geographica* section. When I personally visited headquarters in Washington, D.C., I got a quick approval from the editor who was responsible for the concept and text, but not the pictures. He let the photographic department know that he wanted my images and told me to work out the details with them. The people who arrange assignments were out that day, so I left a note explaining that I planned to cover my own costs and wanted only the standard day rate for the three-to-four-day walk, or possibly for two days' coverage with a few hundred dollars for a helicopter assist that Klein might get at half price.

At first I didn't worry when no assignment letter arrived. In eighteen years, *National Geographic* had always followed through for me in time or notified me of any problems. As my departure neared, I called and

left messages. I also wanted the letter to show that we weren't drug runners, as our itinerary included Colombia, Peru, and every other suspect country in Latin America. We had already planned logistics to include the forest trek and spent $900 in telexes for permission to fly into each country on certain dates. Rick Klein, meanwhile, had booked himself a commercial flight so that he could meet us in Puerto Montt.

Just days before our departure, an editor called to confirm the details of the note I had written two months before. He then called back to say the assignment was canceled due to budgetary constraints. I thought the ax had fallen because of recent financial upheavals at the magazine, but was informed that three-day assignments for single photos in *Geographica* just aren't given.

After a sleepless night, I decided the coverage was so important environmentally that I wouldn't give up. I drafted a letter to the original text editor at *Geographica* offering to do the coverage entirely at my own expense and to offer the images as stock photos. He graciously accepted and apologized for what had happened to me.

When Barbara and Doug landed their Cessnas in Puerto Montt, Rick met us with two Chilean guides for a traverse of the rarely visited Alerce Andino National Park. It rained, the last section of the trail did not exist, our guides quit, and we soon learned why no foreigners had ever traversed the park on foot. We became intimately familiar with bamboo, leeches, moss-covered granite cliffs, and the apparition of coming face to face with a tree so large, so old, and so imposing that it made us feel that we were the renewable resource.

On the second day I spent hours photographing a cluster of alerces in thick foliage in falling rain with a spongy surface for my tripod. At first the trees radiated disturbingly as I looked through my wide-angle lens aimed upward. My Nikon 28mm perspective-control lens brought them back almost parallel with a log supporting the two uphill legs of my tripod while the downhill side was propped on a crude tripod of wood. I made four-second exposures on ISO 50 Velvia to maximize sharpness and saturation out of the drizzly scene.

After we returned, the *Geographica* editor put together a sensitive editorial to go with one of my photos for the September 1991 issue. Rick received lots of support for his cause from readers as well as from Doug, who stayed in Patagonia months after I returned. When I later got together with Doug, he told me, "Remember that forest that came right down to the coast as we flew back to Puerto Montt after the climb? Well, it was private land and I bought it. It goes from the summit of a ten-thousand-foot volcano thirty miles down a river to the sea. Now I'm working to help a Chilean environmental foundation buy a chunk of old-growth forest as big as Yosemite National Park. It's like being in the United States a century ago with today's dollars and sense of deep ecology. For fifteen dollars an acre in Chile, we're buying whole forests for much less than groups spend trying to preserve public lands here."

In 1991 and 1992 Doug bought several additional large parcels in Chile and Argentina. He donated his $5 million house in San Francisco to the Chilean foundation and moved onto the forest property we had flown over together. One person can make a difference in this world.

In case you would like to help, Ancient Forest International's address is P.O. Box 1850, Redway, California 95560.

Photographs: Pages 260–61

"As the Tibetan situation worsened, I was in a quandary. If I connected myself with the Tibetan movement, I risked losing journalistic access to China. But if I didn't use my images to help the Tibetan cause, could I live with myself?"

A Higher Calling

I am a participatory photographer. Whenever possible, I want to be directly involved instead of being a spectator. When I photograph climbing, it's obvious that I have to be a climber to get many of my images. What is not so obvious is that I use the same process in my landscape and cultural photography. Rather than wait for a scene to pass in front of my lens, I search out images that at first exist only in my imagination and make them happen through active participation.

How far should I take this involvement? Do I just sell the images and move on to the next subject? Or do I stay connected to land and people worthy of my original commitment?

These questions plagued me as protests for Tibetan independence became front-page news in late 1988 and early 1989. I had been to Tibet five times. Although I tried to avoid politics, I twice had to write letters of self-criticism to the Chinese government for such serious crimes as giving a Tibetan pilgrim a postcard of the Dalai Lama and writing that Tibet had once been an independent country. I did not recant my statement but used long Latin-based words to say I had been unwise to do these things if I expected to be able to return to the People's Republic of China as a photographer. What was really at stake here was journalistic access for others working for *National Geographic*.

Once, on the border of Xinjiang, Barbara and I had our prepaid 4WD vehicle and passports taken away. Our papers were in order, but we were interrogated and held for a day and a night before being released at fifteen thousand feet out onto the frozen ground without transportation. Other journalists had been expelled or held for months without cause.

As the Tibetan situation worsened, I was in a quandary. If I connected myself with the Tibetan movement, I risked losing journalistic access to China. But if I didn't use my images to help the Tibetan cause, could I live with myself?

One choice came when I was offered an assignment to shoot for the book *A Day in the Life of China*. I turned it down with an excuse of a tight schedule, but my real concern was that I could not, in good conscience, put my images into a book that presented Tibet as part of China as required by the communist government. Our press has long been censored by China almost as effectively as their own as far as the truth about Tibet is concerned.

Tibet was a free country with its own language, religion, currency, government, and postal system until Mao's armies seized it on the tenuous claim that treaties had been signed with old Chinese dynasties. By this reasoning, Britain could reclaim its empire and Russia could reclaim the former Soviet Union and Afghanistan. I carefully subtitled *Mountains of the Middle Kingdom*, my own 1983 book, *Exploring the High Peaks of China and Tibet*.

My decision not to work on the China book was a personal one, and I respected the right of other photographers, who do not have an emotional connection with Tibet, to make the opposite decision. Another choice for me came when Tenzin Tethong, then the Dalai Lama's personal representative in Washington, D.C., asked if he could show my Tibet slides at a meeting on Capitol Hill in the offices of the House of Representatives. It was to happen on the thirtieth anniversary of the March 10, 1959, Tibetan uprising against Chinese occupation that had caused the Dalai Lama to flee into exile in India. I said yes and went a big step further by hopping a flight from California to narrate the slides myself to a large group of Tibetan travelers, refugees, journalists, and legislative staffers.

As I spoke in Washington, D.C., simultaneous pro-Tibet demonstrations were happening around the world. Protests were staged at the United Nations

and Chinese mission in New York. Demonstrators marched in San Francisco, Boston, Los Angeles, and Vancouver. In London, a crowd staged a night-long vigil and beamed flashlights into the windows of the Chinese embassy. Other events occurred in Australia, Japan, West Germany, Switzerland, and in Dharmasala, India, where His Holiness Tenzin Gyatso, the Dalai Lama of Tibet, issued a statement that read in part, "Ours is a non-violent struggle and it must remain so. Imprisonment, torture and killings of peaceful demonstrators or persons who express unsanctioned opinions are morally reprehensible and a violation of human rights. It can never be justified, no matter where in the world it occurs."

Foreign journalists and photographers had been denied regular, unsupervised access to Tibet for two years after September 1987, when a group of monks rebelled against Chinese police who had interfered with their religious rites. The story wouldn't have had any world impact if it weren't for a set of pictures taken by a mountain-loving amateur photographer. It was no coincidence that this photographer also attended the Washington meeting.

After John Ackerly, a young attorney, photographed monks throwing stones into a burning Chinese police station, his life took a new turn. The Chinese jailed him for two days, but he managed to smuggle out his film. His photos were widely published in national and international magazines and newspapers. Ackerly became the full-time legal counsel and projects director for the International Campaign for Tibet.

After my talk on Capitol Hill, I joined a few hundred friends of Tibet in a peaceful demonstration in front of the Chinese embassy. One hundred and eight windsock-prayer flags emblazoned with the flag of Tibet were held high as Tenzin Tethong read a letter over a loudspeaker. It urged an end to martial law, restoration of human rights, and environmental integrity for the land and all living things. An attempt was made to deliver a copy to the embassy, but the Chinese would not answer the door. After a long wait the letter was slipped through the crack, but minutes later the door opened slightly, a hand emerged, and the crumpled letter landed on the frozen ground.

The more pressure the Chinese exert to stop news from Tibet, the more travelers appear out of the woodwork with poignant stories to tell in the international press. Notably, not one of these travelers-turned-journalist has supported Chinese actions in Tibet or the Chinese claim of sovereignty. The same cannot be said about the government of the United States. As of early 1993, no U.S. president has ever formally supported Tibet's right to independence, partly because our diplomatic policy was to turn a blind eye on the issue of human rights in China after relations between our countries were "normalized" in 1972. Only after the violence at Tiananmen Square, a few months after my visit to Washington, D.C., did the U.S. government begin to pressure the Chinese about human rights abuses, which have caused more deaths than those of World War II, the Korean War, and the Vietnam War lumped together. In late 1990, Congress finally passed a joint resolution declaring Tibet an occupied nation with a right to independence. The State Department, however, steadfastly refused to reconsider its nonrecognition of Tibet. As the Dalai Lama says, "We have no oil."

The Whole Truth

"Whether or not you agree with Messner, the implications of two sets of photographs by the same photographer with the same captions having completely opposite meanings go well beyond environmental concerns."

Before I spent almost $4,000 on a computerized Slidetyper machine to print captions directly onto slide mounts, I asked a lot of questions of photographers who owned them. After all, you can buy a running BMW for less. Mike Yamashita cinched it by simply saying, "It changed my life." Instead of spending hours writing on slide mounts by hand or trying to stick on gummed labels, he could have whole stacks imprinted by machine in seconds. He freed himself from considerable tedium, and if he had bought that BMW instead of a funky photo gadget, he could have gone cruising.

I have owned my Slidetyper for six years, and I have found I can save even more time by creating general captions that cover many images from the same location. After I hiked the Tour du Mont Blanc around the great Alpine peak through parts of France, Italy, and Switzerland, I had to make more than the usual number of categories to accommodate the three nations and seven valleys of Mont Blanc. Finding an elegant solution with a reasonably precise yet general enough caption can feel very satisfying. The reward is not having to type in new lines and load stacks of slides as frequently.

There is, however, a profound difference between my handwritten captions of old and my modern abstracted ones. Whereas I previously might think to write "Overcrowded trail beneath the Aiguille du Chardonnet" on one slide and something different on the next, I am now able to mass-caption about fifty selects from the same area with "Beneath the Aiguille du Chardonnet."

As I began looking through my Mont Blanc take, I realized that I could select two separate photo essays with similar captions but opposite meanings. To make my point even clearer here, I have rewritten captions for both essays to be exactly the same, although their visual content leads to opposite conclusions. On the one hand, we see the Tour du Mont Blanc running through the Alps as a wilderness trail like something out of *The Sound of Music*. On the other, we confront the overuse, unnecessary overdevelopment, and destruction of the same Alpine environment. Both essays tell the truth, but only part of the truth, and a half-truth might as well be a lie.

When the great Alpine and Himalayan climber Reinhold Messner was asked why the Alps are in such bad shape while the mountains of North America have remained relatively pristine, he shrugged and said, "You had John Muir." The Alps had no strong wilderness movement to save them in time. Messner advocates what he calls "White Wilderness" for the remaining pristine mountain regions of the world. He grew up in the Alps and believes that they should be used as an example of what *not* to do to other areas. He thinks places shown on maps as white or blank without roads, trails, power lines, tramways, huts, or other human artifacts should stay that way.

Whether or not you agree with Messner, the implications of two sets of photographs by the same photographer with the same captions having completely opposite meanings go well beyond environmental concerns. Professional photographers learn the hard way that much of what is published in major magazines in the United States does not reflect their intentions so much as an editorial point of view imposed in the selection process. In general, European magazines have done far greater justice to the visual habit of truth of my overall coverages. If I object too much to a proposed layout in the United States after a magazine has paid me, I am perceived as having "an attitude." If I do the same with a layout for a European magazine, I have "an ethic." One of the American exceptions is *Outdoor Photographer*, where these parallel photo essays first appeared.

Books remain the medium of choice for photographers to communicate their visual messages in line with their original intentions. To produce one requires considerably more effort and dedication for less initial hourly compensation than magazine or newspaper work. To publish one and feel the relative permanence of its message—your message—in your own hands when it comes off the press is as great a high as standing on a Himalayan summit.

Photographs: Pages 8, 43,
188, 224, 249, 258–65

Tibetan Pilgrimage

"The success of this project rested far less on all our efforts than on how His Holiness responded to photographs of a homeland he had not seen with his own eyes for three decades."

I remember my nervousness, long ago, when I gave a slide show for a roomful of people for the first time. I agonized over how they would respond. As my home slide shows evolved into professional lectures, that early nervousness disappeared. I had nearly forgotten the giddy feeling when it returned on a spring day in 1989. Once again, I was to give a simple home slide show. This one, however, was in the old British hill station of Dharamsala in the foothills of the Indian Himalaya, where the word *audience* had a different meaning. I was about to have an audience with His Holiness, the Fourteenth Dalai Lama of Tibet. The fate of an idea for a book upon which I was ready to commit my heart and soul depended on his singular response. The success of this project rested far less on all our efforts than on how His Holiness responded to photographs of a homeland he had not seen with his own eyes for three decades.

Dharamsala became the seat of the Tibetan government-in-exile when His Holiness resettled here in 1960, but it has become much more than that. His Holiness says: "If it were not for our community in exile, so generously sheltered and supported by the government and people of India and helped by organizations and individuals from many parts of the world, our nation would today be little more than a shattered remnant of a people."

Barbara and I were ushered into a quiet meeting room with a mixture of Tibetan and Western decor. It could have been a guesthouse lobby, except for the presence of a throne and an altar. With no warning, His Holiness simply walked in dressed in the robes of a Buddhist monk. We stood up and nervously prepared ourselves for the solemn pomp and circumstance of meeting a great religious and political leader. An aide passed each of us a *kata,* a prayer scarf of white silk that we were to present with both hands in a time-honored tradition. As His Holiness neared, he bowed slightly toward us, clasping his hands together

in front of his face. I instinctively began to return the greeting, conditioned by countless meetings with Buddhists. I realized too late that the two actions didn't go together. As I raised my hands, the *kata* came up over my face. I dropped them, hoping no one would notice, but His Holiness had already begun to laugh. Within seconds, his low chuckle swelled into an all-consuming bass rumble that communicated joy and openness without a hint of derision. To this day, I don't know if he saw my fumbling, but his laughter completely defused my nervousness. He greeted each one of us as one human being to another, and I felt ready to begin the show. Before he reached me, he stopped beside Barbara, took both her hands in his, and broke out into a broad grin as he saw her lapel pin: a miniature flag of Tibet.

Until 1950, the Tibetan flag flew over an independent country that had its own government, religion, postal system, and currency. Like the mythical kingdom of Shangri-La, Tibet sought isolation from the rest of the world. Diplomatic relations were shunned, as was membership in the United Nations. Thus when Chinese communist armies occupied Tibet by force in late 1950, no international framework existed to support the Tibetan cause. His Holiness, Tenzin Gyatso, a 15-year-old boy, fled across the Himalaya in winter to seek political assistance for his country. He was dismayed to find his cause rejected both by the United Nations and world's great powers. Whatever the merit of China's claims of treaties and agreements between Tibet and old Chinese dynasties, the very concept of holding a nation in bondage is untenable in today's world.

My personal experiences confirm the ongoing Chinese political deception. On my first visit to Lhasa in 1981, a Chinese tour guide pointed out an inscription in front of the ancient Jokhang temple as evidence of a treaty made in the year 822 in which Tibet first acknowledged Chinese sovereignty. I later learned the true translation of the Tibetan inscription: "Tibetans will live happily in the great land of Tibet. Chinese will live happily in the great land of China."

Barbara and I had not come to Dharamsala to discuss politics with His Holiness. Our goal was to produce a book that would focus on the more enduring meaning of Tibet. We believe that ancient Buddhist philosophy and the modern environmental ethic merge where the future of Tibet's vast natural landscape and ancient cultural heritage are at stake. Both ways of thought underscore the idea that no person or nation has the right to destroy the birthright of other citizens of the world.

I knew from conversations with his aides that His Holiness not only felt strongly about protecting Tibet's natural environment, but also had a special place in his heart for wild animals and natural history. They had suggested putting my images of wildlife early in the show to spark his interest. In the book, I was planning to use a mixture of quotations selected from His Holiness' published work and his response to the slide show, so I began with a couple of examples to show him what I wanted from him. He calmly nodded his approval. The first image for which I had no quote was a herd of *kiang*, the Tibetan wild ass (page 188). The instant the animals appeared on the screen, he leapt off his chair with boyish delight.

The *kiang* in my photograph were running at full speed across an open plain. With an expression of sheer joy, His Holiness began pouring out his feelings: "We have always considered our wild animals a symbol of freedom. Nothing holds them back. They run free. So, you see, without them, something is missing from even the most beautiful landscape. The land becomes empty, and only with the presence of wild living things can it gain full beauty. Nature and wild animals are complementary. People who live

among wildlife without harming it are in harmony with the environment. Some of that harmony remains in Tibet, and because we had this in the past, we have some genuine hope for the future. If we make an attempt, we will have all this again."

As His Holiness spoke I thought about his 1987 proposal to "transform Tibet into our planet's largest natural preserve." I had overheard several U.S. environmental activists quickly dismiss the idea as too impractical and idealistic. They thought he should think smaller and begin with a national park or two and hope that more might be established someday, as we have done in the United States.

As I sat in the presence of His Holiness, listening to him speak about the old Tibet he had ruled, I found myself coming to some radical conclusions. Not only does Tibet's history of environmental thought and protection far predate our own, but also Tibet's form of environmental protection was the most successful of any civilized nation in the modern world. His Holiness was simply calling for official designation for what Tibetans had taken for granted until the Chinese invasion. All of Tibet was environmentally protected for thirteen hundred continuous years of Buddhist rule because respect for the natural world had been instilled in every individual at a very young age. Until after the Chinese invasion, a national park would have been redundant. Tibet is one of those remaining legendary wild places, such as the Serengeti Plains, the Galápagos Islands, or Yosemite Valley, that must be preserved for its own sake for everyone instead of being altered for the short-term benefit of a few. So, too, should its culture be allowed to endure in its natural habitat.

The following are the stories behind some of the selected images from my extensive photo experiences in this land of mystery that so easily captures the imagination and fires the creative passions of any photographer.

Nomad child of Pekhu Tso, Western Tibet; 1987 (page 8). During a portrait session in a yak-hair nomad tent, I noticed this little boy standing at the sidelines beside the hearth, staring intensely through the flames. Without his knowing it, I switched from a 20mm to an 85mm lens, turned my camera on the tripod, and got off one frame before he realized what had happened and became self-conscious. The automatic exposure was very slow, perhaps a full second, creating a soft orange veil of flame around his face. I wanted to avoid the cliché of native children smiling into the camera lens.

Tibetan nomad and argali *sheep skull on the Maryum La, Western Tibet; 1987* (page 224). On the way to Mount Kailas, Tsewang Tsambu became very comfortable with my photography, especially after I asked him through an interpreter to pretend that I didn't exist when I aimed the camera at him. It came naturally to a Tibetan Buddhist who has spent his life practicing the belief that all external phenomena are empty of inherent existence.

At a lunch stop, I found this skull of an *argali*, the heaviest-horned wild sheep in the world, while Tsewang sat down to boil a tasty cup of salted, yak-butter tea. As I saw the juxtaposition of his contemplative look and the skull of one of Asia's most endangered species, I conceived a way to bring them together by framing him slightly off-center through the arc of a horn with a 20mm lens stopped down to $f22$ for maximum depth-of-field. Working next to the ground I had no room for a tripod, but plenty of light, so I was able to handhold the shot at 1/30th on Fuji Pro 50.

Nomad family in yak-hair tent at Pekhu Tso, Western Tibet; 1988 (page 249). Here is a different rendition of the same nomad family in the same tent as shown in the photograph on page 260. The light source for that image was an off-camera flash with a portable soft box and amber gelatin filter to match the fire light

from the hearth. The light source here was sunlight coming through the smoke hole bounced onto the family with a portable reflector. I used a 20mm lens with my camera on a tripod with a slow exposure around 1/4th of a second.

Evening on the Tingri Plain below Cho Oyu (26,750 feet); 1988 (pages 258–59). As a mother led her horse and child home from the fields, I set up a tripod with an 85mm lens on my Nikon F3 to frame a classic tableau of Tibet. The mountains that seem so close are actually seen through thirty miles of clear Tibetan air. Because there wasn't any haze to cut with a polarizer, I didn't use one, but that wasn't the only reason. The sky has a polarized look because I was at high altitude where its color is already deep blue. An exposure for the white horse and snow with a polarizer would have turned the sky virtually black on Fujichrome Pro 50, which has almost no response to ultraviolet that many other films record as blue.

Nomad elder of Pekhu Tso receiving blessings from a photograph of the Dalai Lama, Western Tibet; 1988 (page 260). The scene in this photograph got me into big trouble with the Chinese government. I was traveling for *National Geographic* a few months after Tibetan demonstrations for independence in Lhasa in 1987. On previous trips I had frequently given out photos of the Dalai Lama to Tibetans as gifts. I knew that the Chinese had become very sensitive about this practice, but I decided to make an exception when I wasn't being watched at a chance meeting with the family of a nomad who had joined me the previous year on a pilgrimage around Mount Kailas. I gave them a commercially reproduced photo of the Dalai Lama that was readily available for pennies in the Lhasa bazaar. One by one, family members closed their eyes and held the photo to their foreheads to receive blessings, as my friend's father is doing here. A Chinese jeep driver observed me taking this photograph sometime later when the father spontaneously pulled

out the Dalai Lama picture in an act of reverence.

After my return to the United States, I was notified that I had been tried *in absentia* in Beijing and found guilty of sedition. I wrote a carefully worded letter of self-criticism to the Chinese ambassador in Washington, D.C. This apology got *National Geographic* off the hook so it could send other photographers to China and Tibet, but afterward, I felt humiliated and ineffectual. I vowed to free myself from Chinese censorship. On further reflection, I became most intrigued by the implied power of that single photograph of the Dalai Lama. Why did the Chinese feel so threatened? What would happen if I tuned into the positive power of that photo to make it work, not only for me, but also for the future of Tibet? Thus came the idea for a book of my photos with the Dalai Lama's words.

Festival beneath a giant silk thangka *beside the Kumbum, Gyantse; 1981* (page 262). While traveling in the open bed of a Chinese truck to Mount Everest, we happened by chance to stop in Gyantse during a festival. The big silk tapestry is unveiled only at special occasions. I wanted to show it in context with the crowds and the temple, but I had no space to back up because of a road and some ugly commune buildings. I handheld a Nikon F3 with Kodachrome 25, using a 20mm lens and a polarizer as I walked through the crowd to capture the immediacy of the event. I have always thought of this as my Tibetan "Fourth of July" picture.

Khampa mother and daughter of Derge, Kham; 1987 (page 262). These women were visiting Lhasa for both trading and pilgrimage. An Australian woman who worked in Lhasa and spoke Tibetan told me she had befriended some wonderful people and offered to make introductions for photographs. Over the years, my best cultural photography has come from situations where I have established a rapport with people before pulling out my camera. In this case, the two

women held their stomachs and belly-laughed when they were introduced to me. They recognized me from the previous day, when they had hounded me until I bought an expensive turquoise and coral necklace from them. Through our mutual friend, I was able to do much more than just take a snapshot in the bazaar at high noon. In my pack, I had a gold Photoflex Litedisc reflector, which I used at a distance to bounce just enough soft, warm light into their faces to cut the shadows and add a catchlight in their eyes.

Pilgrim praying at a mani *wall beside the Tsangpo River in Western Tibet; 1987* (page 263). According to the Dalai Lama, "No one can understand Tibet without some understanding of our religion." Building *mani* walls of stones carved with prayers is something like banking spiritual merit for the benefit of all. People with good fortune hire stone carvers and those who walk around the piles of stones waft the prayers skyward. The Chinese destroyed every wall they found after the communist invasion, often building toilets from the stones to further their ill-conceived Cultural Revolution.

Rainbow over the Potala Palace, Lhasa; 1981 (pages 264–65). This is by far my best-known image of Tibet. In Dharamsala, I was repeatedly introduced as the man who took the Potala rainbow photograph. None of them ever doubted that it was a single photograph, while Americans frequently ask me if I somehow sandwiched or double-exposed the rainbow into the scene.

I was with a group of fifteen trekkers when I first saw a dim rainbow arcing over a pasture to the left of the palace. The others accepted the scene as they saw it and made snapshots, while I visualized the rainbow appearing to emanate from the golden roofs of the palace and set out to make it happen. As I began to walk fast, the rainbow moved ever so slowly—too slowly—toward the palace. I ditched my bag in a bush and grabbed two rolls of Kodachrome 64 plus a Nikon F3 with a 75–150mm zoom that I knew was especially sharp. I began running at twelve thousand feet and continued for nearly a mile before the rainbow lined up with my dream. After I began shooting with the camera solidly braced on a fence post, a hole opened up in the clouds and a spot of light poured down upon the palace. I was nearly out of film and caught only a couple of frames of this scene. The rare event shows the meeting point of three kinds of light: the rainbow, the direct sunlight on the palace, and the deep gray shadows of the thunderstorm.

When Barbara and I showed the image to the Dalai Lama eight years later, we knew that he had seen it many times before in posters, magazines, and prints. We expected him to say something spiritual and profound, but instead he uttered a simple memory guaranteed to bring tears of laughter, not only to everyone in the room at the time, but also to readers of our book for years to come: "That's the hill where my cars broke down. The steep road up to the palace stopped all three of them—two Austins and a Dodge."

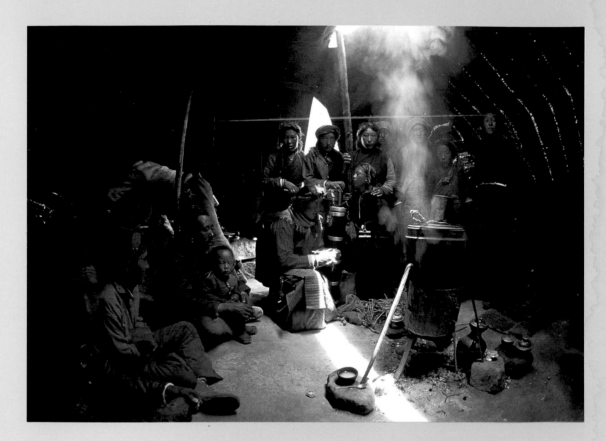

Above:
Essay pages 228–32, 244–48
*To make a photograph of an
extended family of Tibetan
nomads in their yak-hair tent,
I asked them to gather around
the hearth while I used a
gold Litedisc reflector to bounce
light from the smoke hole in
the ceiling. Heinrich Harrer
(following page, above)
lived with the nomads in this
area and practiced their life-style
during his epic crossing of Tibet
in the forties.*

Left and above:
Essay pages 226–27,
228–32
Both David Brower (left)
and Heinrich Harrer (above)
*were among the "phantom
mentors" of my youth—
people who did not directly
advise me, but showed by
personal example how they
had merged their passions
for adventure, writing,
photography, and the
environment into unique
careers. Brower holds two
globes: one political and the
other natural, as the earth
appears from space. Harrer is
telling me about his seven
years in Tibet in this
photograph Barbara took
during an interview to help
me write an introduction for
his 1992 photographic book,*
Lost Lhasa. *Harrer also
took the first color cover
for* Life.

Right: Essay pages 238–39
*Like our redwoods, the giant
alerce trees of southern Chile
are ancient, huge, and
endangered. Making this
photograph that ran in*
National Geographic *became
a physical, photographic, and
editorial adventure. I made this
image during a drizzle with a
28mm perspective-control lens
to minimize the convergence
of the 200-foot trees, which
are a full day's walk into the
Southern Hemisphere's largest
temperate rain forest.*

Left, right, and above:
Essay pages 233–35
The Salathe Wall of El Capitan is one of the classic big-wall rock climbs in the world. When I made the third ascent of the face in 1967, I used a Kodak Instamatic 500 to make a square Kodachrome of my partner, Layton Kor, *reaching the summit (right). When I repeated the climb in 1990 on what was at least the 300th ascent, I made extensive use of a 20mm lens on my Nikon F3. I took the self-portrait (above) by holding the camera overhead with one hand while leading above a wild ledge where we had spent the night.*

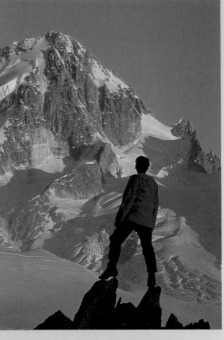

Above (4):
Essay pages 242–43
*After a photographer completes an
assignment for a magazine, the
visual message that reaches the
public is profoundly affected by the
editorial selection process. A
different conclusion is drawn from
seeing the four photographs of the
Tour du Mont Blanc in the Alps*
*on this page than from seeing
the four photographs made on
the same hike that appear on
the following page. Both sets of
photos have identical captions.*
Top, left: *A curve in the Tour
du Mont Blanc on the Swiss side
of the mountain.* Top, right:
*Beneath the Aiguille du
Chardonnet high on the French*
side of Mont Blanc. Bottom,
left: *Alpine meadow below a
pass on the Swiss-Italian
border.* Bottom, right:
*Looking down from over
13,000 feet on the Aiguille
du Midi above Chamonix.*

Above (4):
Essay pages 242–43
*Photographers whose intentions
have been repeatedly distorted in
magazine work often turn to doing
personal books that rarely earn
them as good a living. The set
of photographs on this page
communicates the opposite message
about the condition of the Alps.*

*Both sets of photographs are
accurately described by identical
captions.* Top, left: *A curve in
the Tour du Mont Blanc on
the Swiss side of the mountain.*
Top, right: *Beneath the Aiguille
du Chardonnet high on the French
side of Mont Blanc.* Bottom,
left: *Alpine meadow below a pass
on the Swiss-Italian border.*

Bottom, right: *Looking
down from over 13,000 feet
on the Aiguille du Midi
above Chamonix.*

Right:
Essay pages 273–74
This photograph of Ron Kauk climbing beside Yosemite Falls has been chosen for use in many books because it conveys a strong sense of place and satisfies the reader's "need to know" about both rock climbing and Yosemite Valley.

Left: Essay pages 273–74
Another photograph of Ron Kauk on an even more difficult Yosemite climb has yet to be selected for use in a book (until now). It focuses tightly on the sport and lacks the sense of place that comes across in the first photograph (left).

Following pages:
Essay pages 244–48
While walking with a Tibetan villager on the outskirts of the town of Tingri, I spotted a woman leading a horse and a child. By the time I rushed into a clearing with my camera, I was too late. The man laughed and said, "That's my wife. I'll ask her to walk past here again." I set my camera firmly on a tripod, and everything came together the second time. The Dalai Lama later selected this photograph for the title page of our book, My Tibet.

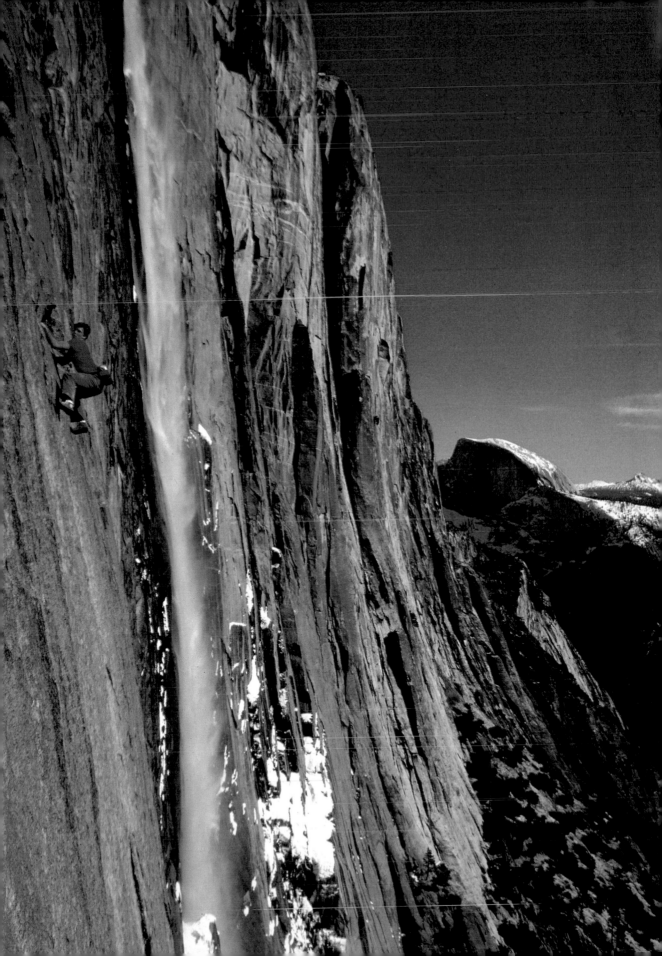

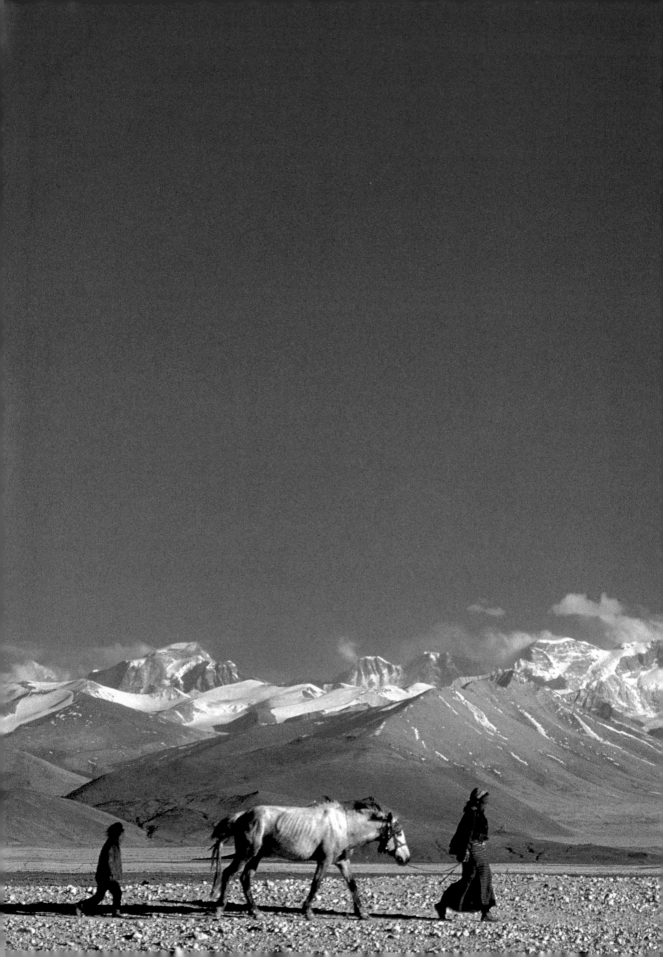

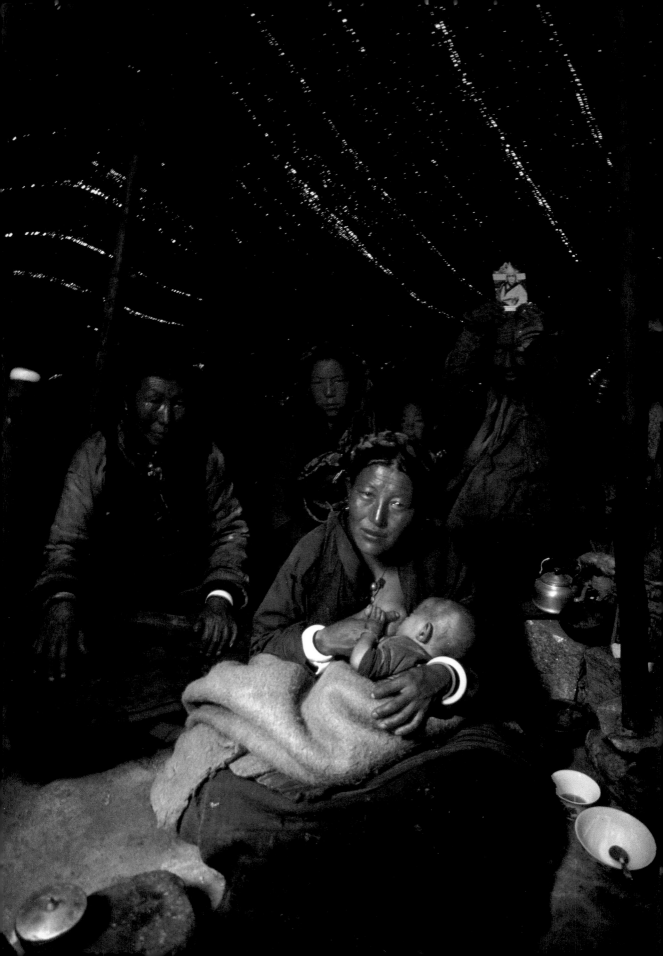

Left: Essay pages 176–78, 240–41, 244–48

A year after I did a pilgrimage around Mount Kailas with a Tibetan nomad I met on the road (see photo, page 224), Barbara and I had a chance meeting with·him 800 miles away. His extended family greeted us like long-lost relatives. After I set up a portable soft box to give warm fill light that would match the color of the flames, my friend's father spontaneously held a photograph of the Dalai Lama that I had given him to his forehead to receive a blessing. My active participation in this photograph not only got me in trouble with the Chinese government for giving a Dalai Lama picture to this Tibetan nomad, but also firmed my resolve to speak out for human rights and the environment in Tibet, regardless of whether I lost future journalistic access.

Above and right: Essay pages 240–41, 244–48

In Lhasa in 1988 I photographed Tibetans sitting in a courtyard quietly spinning prayer wheels for the release of more than 1,500 political prisoners held by the Chinese communist regime. I composed the worshipers into a strong diagonal and focused on the face of one woman whose expression of compassion spoke for the whole movement. On the thirtieth anniversary of the March 10, 1959, Tibetan uprising that led to the Dalai Lama fleeing for his life, a Tibetan refugee (right) holds a placard in front of the Chinese embassy in Washington, D.C.

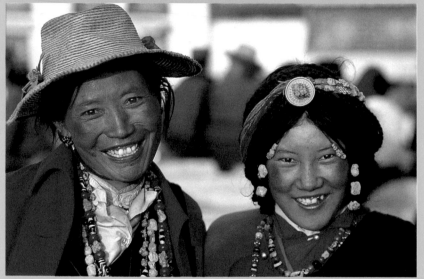

Right: Essay pages 244–48
While walking beside the Tsangpo River with a Tibetan pilgrim, we stumbled upon this intact mani wall. Devout Buddhists used to commission carvers to cut prayers in stone whenever they had good fortune. In old Tibet, building mani walls was something like banking spiritual merit. After the Chinese invasion, almost all the mani walls were destroyed. This Tibetan, who lived in exile in India, was returning to do a pilgrimage around Mount Kailas. He rode with us in our truck for several days and we became fast friends. After we found this wall, he lifted his arms in prayer with his long sleeves shielding his hands from the morning cold. I set up my camera on a tripod to use an f22 aperture that would optimize depth-of-field. Even at that, I knew the shot couldn't be tack-sharp from mani stones to mountains, so I opted to emphasize the stones and let the mountains go slightly soft. Wide-angle lenses like the 24mm are good for including a lot of information into a single picture, especially in situations like this one where the foreground and the background work together to complement each other. The most common mistake photographers make with wide-angles is to underestimate the dominance of the foreground, even after carefully looking through the viewfinder.

Above, top:
Essay pages 244–48
In 1981 we happened on a festival at the huge Kumbum temple in the Tibetan town of Gyantse. This 20mm wide-angle view shows the circular Kumbum, a giant silk thangka, and a crowd of Tibetans during a time of transition when they were discarding compulsory clothing dictated by Chairman Mao in favor of traditional dress.

Above, bottom:
Essay pages 244–48
To light the faces of these two Khampa women of eastern Tibet, I used a gold 32-inch Litedisc reflector held overhead by a friend. Otherwise the harsh high-altitude sun would have cast dark shadows over their faces.

Following pages:
Essay pages 29–31, 94–95, 244–48
When a weak rainbow appeared over a field outside Lhasa, I began running to line it up with the Dalai Lama's Potala Palace. Having a photograph match an image in the mind's eye through my own active participation is the consummation of the personal visions I pursue through adventure.

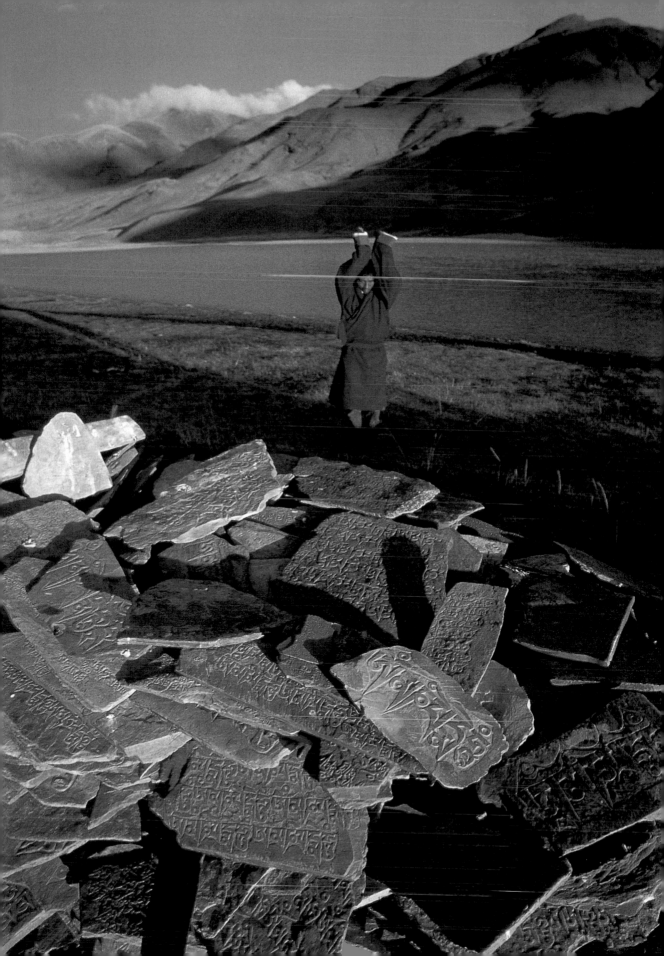

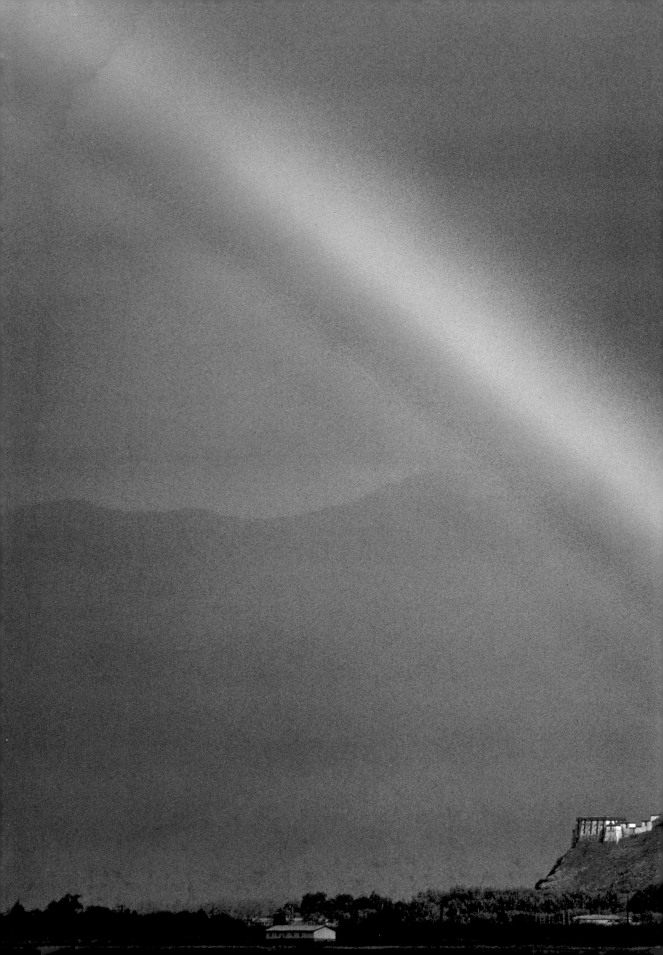

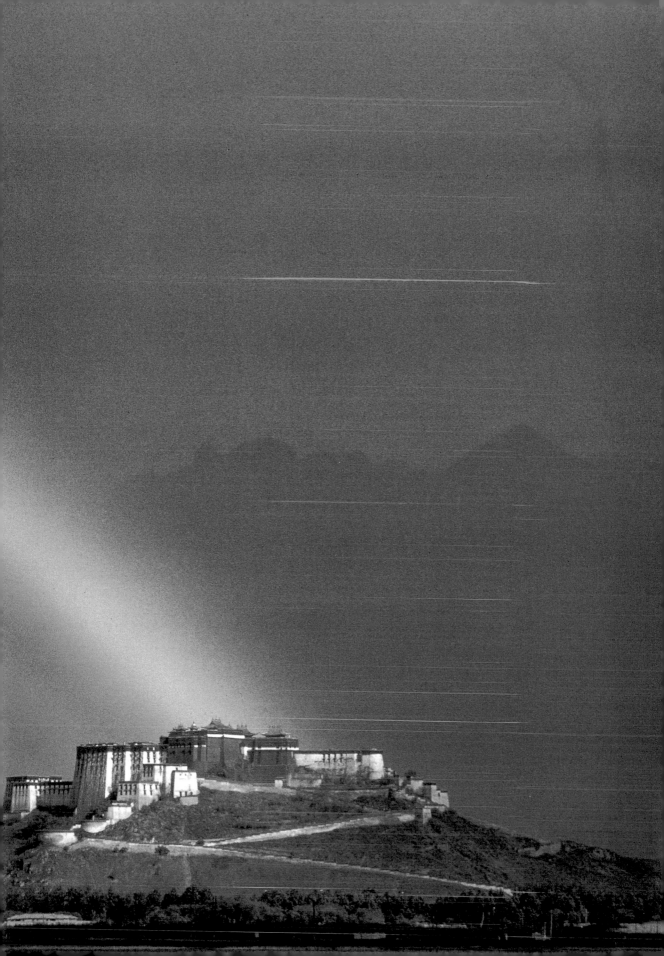

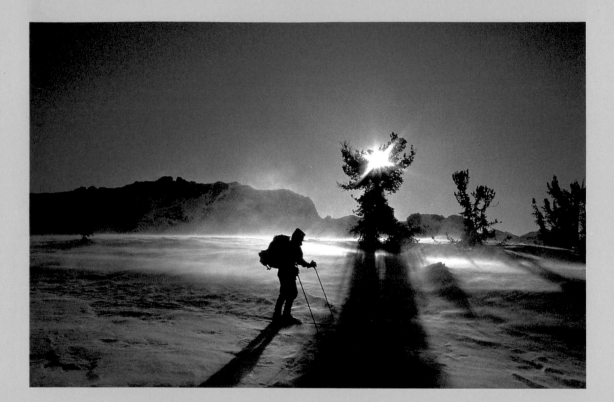

Above: Essay pages 275–79
I chose this photograph of a skier caught in a ground blizzard to accompany John Muir's text in my book, The Yosemite, *because it was not dated by obvious modern clothing or back-packing equipment. Even if Muir never skied the 211-mile route of the John Muir Trail (created after his death in his memory), this photograph from my modern 17-day journey evokes the feeling of his descriptions of Yosemite winter travels. Another photograph from the same trip that was chosen for the cover of* Outdoor Photographer *(see page 119) would be inappropriate to match with Muir's words because it is so obviously contemporary.*

Right:
I took this photograph in 1973 during my first year as a full-time photographer. Despite advances in film and equipment over the last two decades, it remains my favorite vision of El Capitan (along with a horizontal of the same scene that appeared in Mountain Light*).*

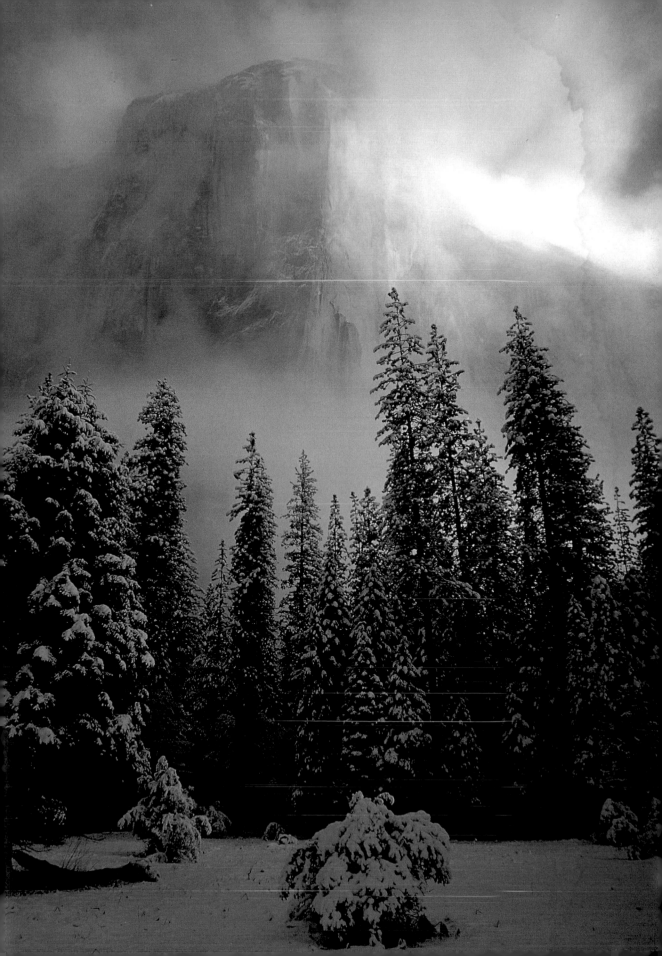

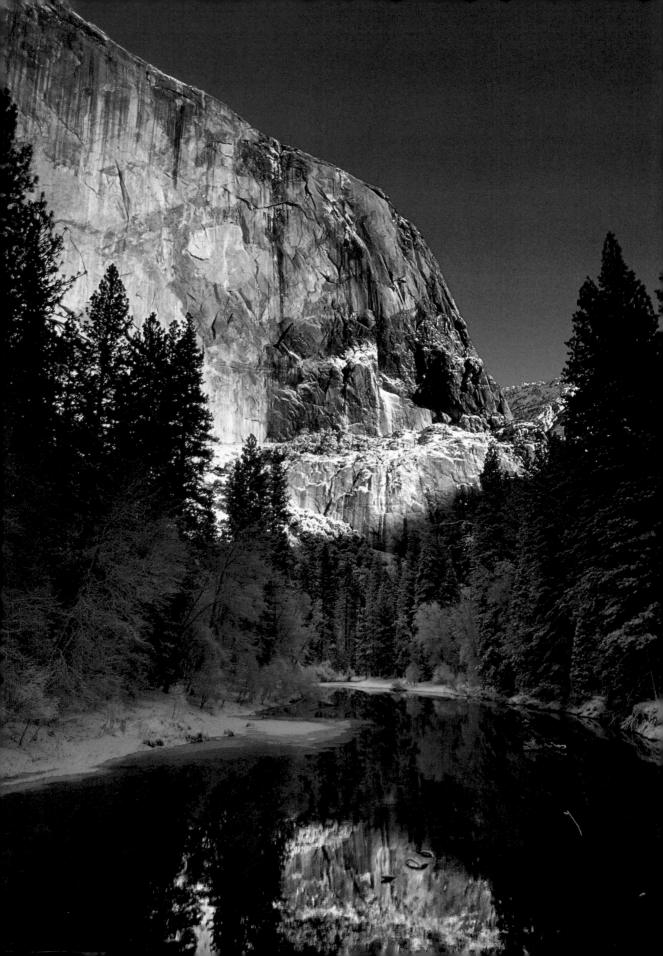

Left and right:
Essay pages 275–79
I shot the image at right of an oak tree and Middle Cathedral Rock from a turnout while my car was running. Although readers never know the difference, there is something about the best images I have made in remote and wild situations that makes me especially cherish them, whether or not they are ever published or acclaimed. For an adventure photographer, jumping out of a car after a snowstorm with just the right camera and lens on a huge tripod (left) to comfortably frame a wild-appearing landscape that ends up on several magazine covers is the moral equivalent of photographing tame or captive wildlife. The viewer or reader makes the assumption that the photograph was made in a wild setting. Only in my own books do I have the chance to make this kind of disclosure.

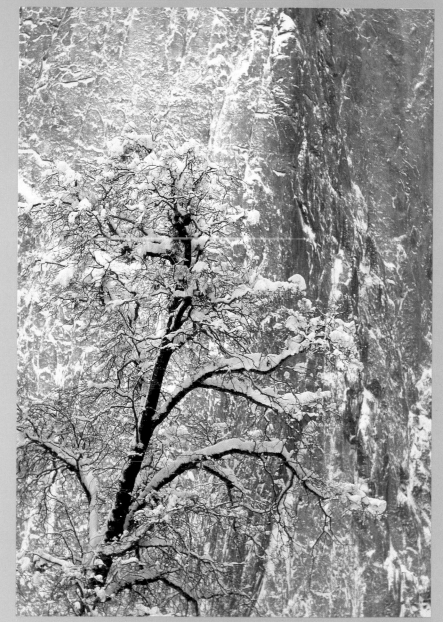

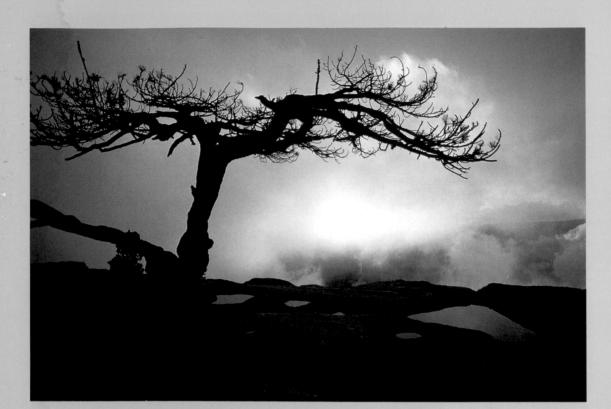

Above and right:
Essay pages 275–79

Figures atop two Yosemite domes add visual interest to these photographs. A Jeffrey pine on Sentinel Dome (above) was photographed alive by generations of photographers, including Ansel Adams, until its death after a drought that ended in 1978, the year I took this photograph. A backpacker wearing red (right) on the summit of Half Dome caught the eye of a National Geographic editor for use in a book on our national parks. The human interest factor led to its being chosen over other images of Yosemite that are my personal favorites (see page 267, for example). I often photograph scenes with and without people to satisfy not only myself, but also the marketplace.

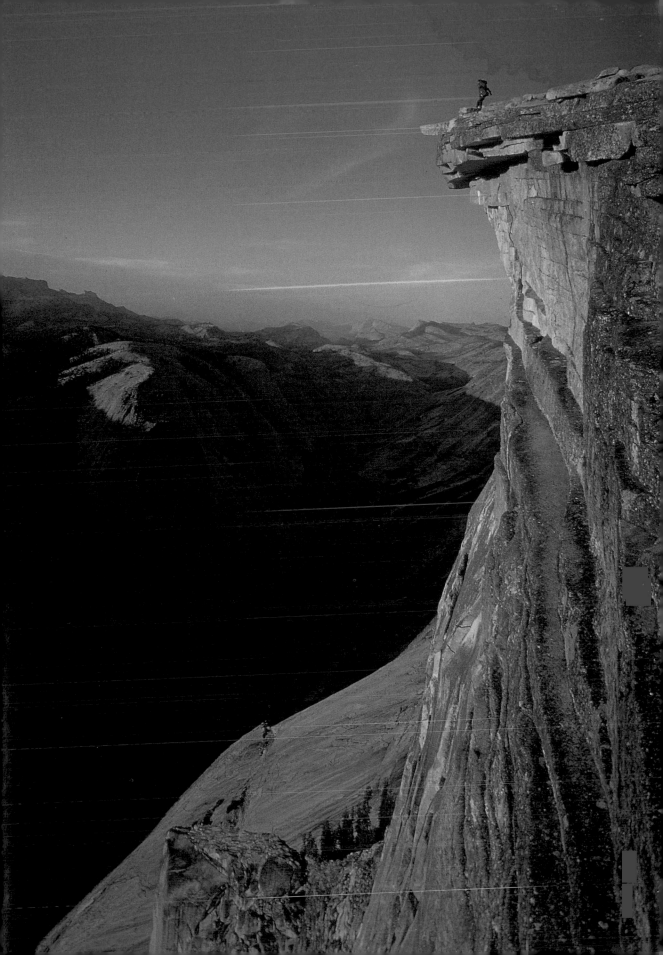

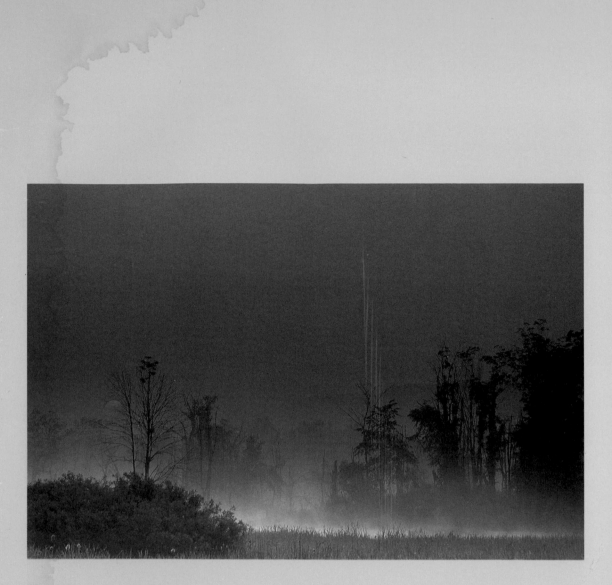

Above: Essay pages 236–37
This photograph of sunrise over the Cuyahoga River in metropolitan Cleveland, Ohio, evokes different images in the minds of people who have been there and people who have not. When we are introduced to a place only through photographs, we are always surprised by the actual appearance of the location when we go there, because, like reading the book before seeing the movie, we have built up a fanciful notion in our minds.

Photographs: Pages 119,
256–57, 267, 270–72

Photo Book Nuances

"The odds of finding a New York publisher who will jump at the chance to reproduce your work in an oversized photo book like the old Sierra Club volumes are not much better than those of finding a complete human fossil in your backyard."

When I had my office alarm system moved from one building to another, the installer informed me that my equipment was Late Stone Age. The ancient artifact was no longer in production, hopelessly outdated, and incapable of holding its own in today's world. It was three years old.

Although we understand that anything containing a computer chip may soon be outdated, we tend to look at books differently, especially books of photography, which play on the wonderful incongruity between the moment held in a photograph and the permanence that appearance in a book represents. Every serious photographer contemplates publishing a book, but few realize that book proposals on nature photography are not unlike my alarm system: Projects published just three years ago may not be viable in today's market. As the door closes on the Golden Age of lavishly illustrated nature photography books, only those with clear and powerful messages are likely to see ink.

Although it's hard to imagine a time when there *weren't* big color books, the Golden Age began only in the 1960s when David Brower restructured the Sierra Club's efforts toward influencing public awareness through its book program. Viewed strictly as a publishing venture, Brower's initial effort was a bottom-line failure. The Sierra Club lost over a million dollars during its first years as a large-format picture book publisher. Brower lost his job, and publication would have ceased were it not for success on another front: The books helped the little California outing club metamorphose into a powerful force for world conservation. Today, however, the odds of finding a New York publisher who will jump at the chance to reproduce your work in an oversized photo book like the old Sierra Club volumes are not much better than those of finding a complete human fossil in your backyard.

Most big photo books are printed overseas. The devaluation of the dollar has made it far less cost-effective to publish a photo book these days, even for mass-market efforts such as the *Day in the Life* series that can have press runs fifty times larger than normal first printings. Combine this squeeze with the fact that capable nature photographers seem to be proliferating like lemmings, and you have a far more difficult market to penetrate than just a few years ago.

Because I have published ten picture books before this one, I am besieged with requests to examine portfolios and pass them on to the right publisher. I cannot oblige, except for a very few friends, most of whom realize I have no magic touch. *Mountain Light*, I tell them, was rejected twice before I got a contract. I can, however, summarize a basic strategy for success. Picture books that sell combine two basic qualities: a marketable idea executed with a consistent personal vision. Technical and personal image sensibility do not directly translate into book contracts. The most compelling photography of the people of Burma simply can't be marketed like *A Day in the Life of America* because the subject does not hold the same general interest. Nor can a relative unknown expect a broad-based personal portfolio to be transformed into a book. Virtually all photographers begin their publishing careers with subject-driven work. Ansel Adams's first books were about places. Eliot Porter's first book was about birds. Only after their personal visions became known and revered by a large body of readers could they make the move into books about the photographs themselves.

Robert Glenn Ketchum once told me how surprised he was to discover that the final selections for his new book on Alaska were far more literal than he had expected, even though he had a strong hand in the editing. Like all of us, he had originally planned to include his most artistic work, but much of it failed to satisfy what editors call "the need to know."

Photographs succeed not when a photographer has an original vision, but when viewers can re-create that vision or another equally powerful one in their own minds upon seeing the photograph. If the vision overwhelms the substance, we say the work is self-conscious. If the substance overwhelms the vision, we call the result banal or unimaginative. It is one thing for an individual image to succeed or fail on the basis of personal vision. It is quite another to create the continuity of personal vision needed to carry off the theme of an entire book. If the book is about a subject or place, the personal vision in the images should evoke that subject or place. This is why Robert Glenn Ketchum often found himself choosing images more literally evocative of place over those more artistically evocative of light and form.

The image content of a picture book is closely related to the concept of image maturity (pages 24–25). An immature subject not well known to the viewer contains as much basic information as possible. A mature subject, well known to the viewer, can be depicted far more abstractly and often more artistically because the viewer's mind is ready to fill in gaps of missing information.

If all nature books dealt with the same, small finite group of subjects, then with each passing year we would have an increasing audience for artistic and aesthetic treatment of those subjects as viewers grew familiar with them. This is usually not the case. New books often deal with little-known subjects and exotic places rather than with carefully thought-out new aesthetics on old subjects. And it is here that the elusive key to that closing door of the Golden Age may be found. If you want to do a book of aesthetic, nonrepresentational images, then search for a unifying factor or a location so thoroughly familiar to your viewers that it is already a cliché in their minds. Then and only then will they be prepared to see the way the light strikes the bark of a tree instead of the more ordinary landscapes that get published over and over again, with good reason, to satisfy that initial "need to know."

Photographs: Pages 1, 119,
198–200, 266–71

*"Were he alive today, Muir
might well have joined us as
we ran thirty-two miles of
trail, swam the gorge, and
photographed our adventure,
all in a single day. The
camera hardly intruded on
the primary experience."*

Yosemite Is Alive And Well

When I first read John Muir's *The Yosemite* at age sixteen, the book had a profound effect upon me. I had just hitchhiked home from Yosemite after the most Muiresque adventure of my young life. The meaning of my own journey became forever entwined with Muir's words and philosophy. His descriptions of Yosemite travels continue to trigger my imagination as unwaveringly as a whiff of burning pine brings forth an image of a camp fire. Today, more than thirty-five years later, I can't separate his words from my own mental images of walking sixty miles across the Sierra en route to my first roped climb in Yosemite.

To celebrate the hundredth anniversary of the creation of Yosemite National Park in 1890, I decided to produce a book that would focus on the powerful connection between Muir's words and my images. I felt it went far beyond the personal and the coincidental. I was not the first nor will I be the last to find myself living both in the physical world Muir wrote about and in his thought world. For years I didn't question why my experience so closely matched his in a previous century. Why shouldn't I walk the same paths, climb the same peaks, and think the same thoughts?

Since then, I have come to appreciate that my modern experiences in Yosemite are not a given, but rather a direct consequence of John Muir's life. I know this firsthand after traveling through lands written about by some of Muir's contemporaries. In Mark Twain's Old West and in Rudyard Kipling's India, I have found the connection to be far weaker because the worlds they wrote about are all but gone. The modern ghost town of Virginia City only faintly echoes Mark Twain's prose, but Yosemite Falls in spring still booms with "the richest, as well as the most powerful, voice of all the falls in the Valley." A narrow footpath follows Muir's route to its top amidst "the rustle of the wind in the glossy leaves of the live oaks and the soft, sifting, hushing tones of the pines."

Yosemite became to Muir what the Galápagos Islands were to Darwin: a place where personal experience and visionary thought came together to influence broader concepts pursued for decades thereafter in other parts of the world. Both men looked closely at the primordial struggle for existence long observed by others; both saw not something life-threatening and destructive, but rather a creative, life-giving process. Darwin liberated biologists from looking at species as fixed entities. Muir freed first himself, then generations of his disciples, from the venerated tradition of adapting land to human needs, urging instead a new ethic of adapting human behavior toward preserving the natural state of the earth.

In 1973, on my first assignment for *National Geographic*, I was overjoyed at the opportunity to organize, climb, and photograph the first attempt to ascend the Northwest Face of Half Dome entirely without pitons. Nevertheless, a small group of Yosemite activists plotted to sabotage my photography to "save" Yosemite from being exploited in ten million copies of the magazine. They recruited a sympathetic pair of climbers and talked them into blocking the route up the face by purposely going very slowly right in front of us on the climb, thus hampering our climb and the photography. Once both parties reached the cliff, however, the culprits confessed the entire ruse.

I mention this personal incident for two reasons. First, it had a deep emotional effect on me that in the long run changed my life for the better. At that time, I had never been on a foreign expedition or traveled overseas. The Half Dome incident stopped me in my tracks, souring me about doing further innovative climbing in Yosemite Valley. I never again attempted a first ascent of a Valley rock face, and I began to set my sights farther afield. Today, after thirty-five mountain expeditions to such places as the Himalaya, Alaska, and Patagonia, I am able to return to Yosemite and to say with the authority of extensive personal experience how truly unique the park is. I have found nothing like it in the rest of the world, no place where so many virtues of beauty, fine weather, ease of cross-country travel, biological diversity, and wilderness come together to form such a complete mountain paradise.

The second reason for mentioning the Half Dome incident is that it is a classic example of the chasm between two philosophies of environmental preservation. Some people believe that the way to preserve wildlands is to leave them alone and not publicize them or the adventures that take place in them. They believe that stories in books and magazines bring additional people, who harm the environment and detract from the wilderness experience. And that is what the group of Yosemite activists was trying to prevent by thwarting our climb. The other school, to which John Muir clearly belongs, believes that the salvation of wild places is rooted in public awareness. Muir wrote book after book, article after article, which brought new people into the wilds, but which also helped create an informed electorate with greatly increased awareness of conflicts over natural values.

Between the lines of Muir's flowery prose are two conflicting emotions that are revealed more clearly in his notes and letters than in his polished books. On the one hand, he used language cleverly to bias descriptions of his experiences away from the cultural trappings of his era toward an appreciation of the natural world apart from human influence. On the other hand, he disliked writing and distrusted language. "Bookmaking frightens me," he wrote to his lifelong friend Jeanne Carr. "It demands so much artificialness. . . . You tell me that I must be patient and reach out and grope in lexicon granaries for the words I want. But if some loquacious angel were to touch my lips with literary fire, bestowing every word of Webster, I would scarcely thank him for the gift, because most of the words of the English language are made of mud."

With considerably more optimism, Muir wrote: "See how willingly Nature poses herself upon photographers' plates." One may question why Muir did not become a mountain photographer. In Europe, for example, mountain lover and artist John Ruskin had laid down his sketch pad in the 1840s to make the earliest-known photographs of the Alps. By the time Muir first visited Yosemite in 1868, the most famous photographers of the day, Eadweard Muybridge and Carlton Watkins, had already come to make stunning photographs.

Given today's 35mm cameras and color films, John Muir would certainly try photography. Given his artistic talent, his firm grasp of mechanics so evident in his early inventions, and his obvious passion for the wilderness, his results might well expand the present horizons of the art. But John Muir forsook photography because at the time it did not fit with his solitary, speedy, self-propelled life-style.

Consider the difference between his visits and mine to Muir Gorge, more than a century apart. The gorge is a trailless one-mile section of the Grand Canyon of the Tuolumne River where vertical cliffs confine the rushing waters to a width of twenty feet in places. Even today it is passable only in the late summer of low-snow years, and then only to experienced rock scramblers willing to swim in long, cold pools walled by water-polished sheer granite. In July 1872, Muir and Galen Clark made the first passage. In August 1987, I ventured through the gorge with two companions to make a photograph for my Yosemite book. I used a Nikon FM2 with three plastic Ziploc bags to seal the camera while I swam. Total weight: three pounds.

Were he alive today, Muir might well have joined us as we ran thirty-two miles of trail, swam the gorge, and photographed our adventure, all in a single day. The camera hardly intruded on the primary experience, fulfilling my desire to make images from the point of view of a participant in the natural world rather than that of a remote observer of the landscape and other people's actions.

Muir did not have this option. In his day, a "small" camera for landscape photographs used 8-by-10 glass plates that had to be developed almost immediately. During the same year Muir made the first traverse of the gorge, William Henry Jackson was busy photographing Yellowstone to help create the nation's first national park. A look at Jackson's equipment shows why he was able only to make photographs and not to do the sort of original explorations that were Muir's penchant. Jackson brought not only his cumbersome camera but also two hundred pounds of necessary gear carefully packed on a mule named Hypo, handpicked as the least likely of his breed to shatter his master's glass plates and dreams. Muir was not a man to compromise his many interests for photography. He wanted to pursue everything at once.

As I began to work on the idea of combining a set of my modern photographs with Muir's original text, I came to realize just how closely some of his words capture what I seek with my camera: fleeting moments of great beauty and wildness. His goal was to create pictures with words for an audience that has not seen Yosemite either in real life or in the multitude of color photographs available today. He needed a profusion of words to create the color, texture, and look of the wild things that meant so much to him.

I believe that it is more than coincidence that ornate descriptiveness fell out of favor in writing at just the time photography began to be widely published. Many factors have influenced the spare style of current nonfiction authors, but the role of photography in this regard had not been given its due. In reviewing early Himalayan literature, which flowered during the same turn-of-the-century period that marks the transition to modern prose, I have been struck by how often the writing style in books with

photography is more spare and precise than that in books with sketches or in those with no illustrations.

The power of modern photography is not unlike that of old Victorian prose. At its worst, it overwhelms the viewer with visual stimulation that does not truly reflect what the eye of an observer would see or, more important, care to see. At its best, by holding moments still for all time, it shows us something more than our eyes can see. This unswerving ability to hold true to reality while stimulating emotional empathy is not built into the mechanics of the camera, but rather into the heart and soul of its user. The same quality in Muir's prose infects countless visitors to Yosemite with a new appreciation for both the scenes before their eyes and for the man whose vision created such a national park.

What follows are the stories behind some of the photos I matched to Muir's words. Since this is my book, I finally get to say that all the photo information about exact *f* stops, shutter speeds, and lenses is my best guess. I don't keep records except when I'm doing controlled tests, nor do any other pros I know. Magazines always ask us to re-create the technical data, and we do our best, telling the editors that the information is not exact. These captions were originally written at the request of a magazine!

Twilight mist over the Merced River, Yosemite Valley; 1986 (page 200). One winter evening when the Valley was filled with mist, I found crowds of onlookers watching the last light on Bridalveil Fall and El Capitan. The light on those features was fine, but all of one color, so after I made a telephoto of Leaning Tower, I decided to continue on to find a place where warm light would be contrasted against some coolly lit element of a winter evening. I found what I was looking for and then some along the Merced River, where boulders coated in snow reflected the blue light of the sky, while the vapor all around turned vivid pink. I saw this scene only after I turned

around from intently photographing Sentinel Rock. A soft-edged, two-stop graduated neutral-density filter lined up with the horizon helped balance foreground and sky light so well that I used automatic metering to calculate the proper exposure. At most times, this particular location makes for a rather boring photograph, but as John Muir discovered for himself, to find a new heaven and earth every day, you need only look well about you. (Nikon F3, 24mm lens, Fujichrome 50, 1/2 second at *f*16)

Winter ground blizzard, Cathedral Pass; 1988 (page 266). When I skied through this ground blizzard, I lost touch with the firm boundaries of my physical world. The sky was clear and blue at eye level, while wind-churned snow veiled the ground and my feet from view. Sometimes I was moving when I thought I was standing still; other times I waited to see objects draw closer, convinced that I was still gliding downhill, when in fact my skis had stopped on some unseen obstruction beneath the moving current of snowflakes. I knew shooting directly into the sun would produce unwanted flares, so I skied out ahead, found a position where the sun would be partially blocked by a tree, and waited for the others to ski past. (Nikon FM2, 24mm lens, Fujichrome 50, 1/250th at *f*11)

Clearing storm over El Capitan; 1973 (page 267). My most intense vision of El Capitan came in the winter of 1973. I had gotten my car stuck in the snow shortly before El Capitan emerged from the clouds at the end of a long storm. Because of this unlucky-lucky event, my camera was ready, but more important, my mind was already filled with what the Sierra photographer Cedric Wright called a "saturation of awareness" that comes from "the quality of emotional knowing." I had climbed the face of El Capitan several times, once barely escaping with my life during a March storm much like this one. The rock, its light, and its surroundings were already living forever within me when I had only a fleeting moment to

record the parting of the mist on film. I resisted the temptation to use a telephoto to single out the cliff, or a wider lens to include the Valley floor. I simply wanted to show El Cap shrouded in golden mist with a fringe of blue-shadowed pines draped in snow. (Nikkormat FTN, 24mm lens, Kodachrome 25, 1/60th at f5.6)

Merced River in winter; 1987 (page 268). The striking visual tension of this photograph comes from the contrast between the warm sunlit color of the rock face at the top of the frame and the ice-blue tones of the snow-covered trees at riverside. In actuality, the cold colors more aptly reflected the temperature of the morning, near zero degrees F, which is exceptionally cold for Yosemite Valley. On that morning in 1987, I was deliberately on the lookout for situations where I could take advantage of white snow in the shadows, illuminated by blue light from the sky, rather than direct rays from the sun. Just before I took this photograph, I was about ready to pack it in for the day, thinking that the light was starting to get flat and that I had harvested just about all the possibilities the morning had to offer. As I drove across a bridge over the Merced River, this scene caught my attention. To help the film balance the wide light values between sunlight and shade, I used a two-stop graduated neutral-density filter. Unlike summer days, winter mornings in the Valley never seem the same. Each one is unique in the way that trees, meadows, cliffs, and water's edges are frosted or covered with snow. Especially after a major storm, the morning is likely to bring forth scenes that are refreshingly new, even for the most seasoned Yosemite observers.

Oak tree and Middle Cathedral Rock; 1979 (page 269). I originally made this image as half of a summer and winter pair of the same scene. When there was no snow, I had been drawn by the contrast of textures of oak bark, granite, and green leaves. With the addition of snow, however, I saw a hidden

sameness in the similar contours and textures of tree and cliff alike. The winter scene stands on its own as an example of how beauty in nature increases, not with the addition of extra colors or complexity, but with subtraction of elements to reduce a scene to its most basic simplicities. I used the smallest aperture on my 105mm telephoto lens to hold sharpness in both tree and rock. (Nikon FTN, 105mm lens, Kodachrome 25, 1/15th at f22)

Jeffrey pine on Sentinel Dome; 1978 (page 270). For more than a century, Yosemite visitors marveled at a tenacious lone pine clinging to life atop Sentinel Dome. The tree, like a tough old mountain man, was gnarled, wiry, photogenic, and very much alive. In 1976 and 1977 California suffered two years of extreme drought. The patriarch died, and as its last dry needles were falling to the ground the following year, I waited out a wet storm, which might have brought life to the tree a year earlier, to catch the evening sun bursting through clouds below the broad sweep of its curving limbs. (Nikon FTN, 24mm lens, Kodachrome 25, 1/8th at f16)

Backpacker atop Half Dome; 1973 (page 271). Just after completing a three-day climb of the sheer northwest face, I asked one of my partners to shoulder a backpack and stand on an overhanging feature called "The Visor" while I scrambled back over the edge to a ledge. Despite Muir's seeming condescension toward regular tourists, he recognized that the increased awareness they gained through their limited travels in Yosemite was the key to preserving the natural values he treasured. Had Muir chosen to remain silent and keep the wilderness experience to himself, there might not be a Yosemite National Park today. Instead of a single backpacker at sunset surveying a natural scene, the top of Half Dome in 1973 might have been a mob scene at a tramway station, once a serious proposal. (Nikkormat FTN, 24mm lens, Kodachrome 25, 1/30th at f5.6)

List of Illustrations

Acknowledgments

My debt to Steve Werner of *Outdoor Photographer* magazine goes well beyond appreciation for the fine foreword he has written for this book. When Steve asked me to write a monthly column for his magazine six years ago, I was interested but not overjoyed. I had been hoping to devote more time to writing that would deliver greater freedom of expression in the more enduring medium of books. A previous stint writing a photography column for a national magazine had turned into an editorial tug-of-war. My focused statements based on personal experiences were generalized into embarrassing platitudes for anyone with a point-and-shoot camera, often without my approval. I would rush to the newsstand each month to see what I had written.

As it turned out, my wife, Barbara, had initiated the original idea of the column with Steve. She had also anticipated how all concerned might benefit if I was given a loose rein with rights to use my writings elsewhere in the future. Steve wanted words from the heart and said that if a particular column got too far out of line with strong opinions, we would talk about the problem before any action was taken. He might suggest a subject now and then, but if I did not pursue his idea, he would not be offended.

With a sense of freedom and a book in the back of my mind, I wrote sixty essays that appeared in each issue of *Outdoor Photographer* between November 1987 and April 1993. Steve's suggestions led to the essays in this book that explain alpenglow, what makes a good workshop, and how the then-new Nikon F4 performed on an around-the-world field test instead of in a Manhattan office. He discovered that if he bit his tongue over some of my more controversial material, his next month's letters-to-the-editor section would be duly invigorated.

Barbara and I decided to produce this book through our own Mountain Light Press with a mandate to make it readable and accessible rather than big, expensive, and too clumsy to curl up with at night. Jean Partel helped us organize the writings into a single narrative by viewing them as just another wild adventure of Galen's that could be broken down into a sequence of initial goals, discussions of equipment and logistics, the travel itself, and realizations.

Jenny Barry, who also designed *The Art of Adventure* and *My Tibet*, conceived an innovative design that would give both the text and the photos their due without one seriously compromising the message of the other. Violeta Díaz and Kristen Wurz handled layout and composition on a Mac IIx computer with image scans supplied by Chris Bettencourt and Gary Crabbe, plus camera-ready text prepared by Marcia Roberson, who worked especially long hours on manuscript edited by David Sweet and me. Suzie Eastman handled additional proofreading and Barbara Roos compiled the index.

I would like to express special thanks to the many publications, manufacturers, and travel companies that have supported my projects over the years, including *Life*, *National Geographic*, *Outside*, Collins Publishers, Universal Press Syndicate, Fuji, Kirk Enterprises, Kodak, New Balance, Nikon, Patagonia, Photoflex, Quest, Singh-Ray, University of California Press, InnerAsia, Wilderness Travel, Ancient Forest International, Fundación Lahuen, National Science Foundation, Powerfood, UCSC Predatory Bird Research Group, World Wildlife Fund USA, and Yosemite Fund.

I would also like to thank all who shared in the travels and interviews described in these pages, with special mention to Kike Arnal, John Ackerly, Lee Aulman, David Brower, Bruce Bunting, Tom Cole, Tim Cully, Bob Cushman, Suzie Eastman, Tom Eastman, Rex Fuqua, Guy Guthridge, Steve Hammond, Heinrich Harrer, Marty Hornick, Johnny Johnson, Ron Kauk,

Gene Kester, Mike Kirk, Rick Klein, His Holiness the Dalai Lama, Rob Mackinlay, Brian Maxwell, Mike McBride, Colin Monteath, Greg Mortimer, Matthew Naythons, Paul Piana, Al Read, Tseten Samdup, Jim Sano, Doug Seus, Bob Singh, Todd Skinner, Tenzin Tethong, Chuck Thurston, Doug Tompkins, Hans Wain, Brian Walton, and David Wilson.

The book has been printed entirely from enlarged 70mm duplicate transparencies made from 35mm slides by The New Lab of San Francisco, a case of practicing what I preach about photographers not needing to release their best originals to publishers for months or years in order to end up with a quality book. My originals were passed once through a Barneyscan for computer-generated position layouts and then returned to permanent files. Production and printing were coordinated by the staff of Sierra Club Books, with special thanks to Erik Migdail, Janet Vail, and Jon Beckmann, editor-in-chief for seven of my titles over the past sixteen years.

Additional photographs of me at work in the field were taken by Ron Kauk (cover and page 76), Rob Mackinlay (page 77), and Barbara Cushman Rowell (pages 74, 250). Three of Barbara's landscape photos also appear on pages 42 and 132. Exhibit prints or stock use of any image in this book may be procured through Mountain Light Photography of Albany, California (510-524-9343). Traveling museum exhibits of *The Yosemite* and *My Tibet* plus spring or fall three-day photo workshops can be arranged through the same office. Subscription information about *Outdoor Photographer* can be obtained by calling 800-283-4410.

Index

Previous Books by Galen Rowell

The Vertical World of Yosemite; (anthology), 1974

In the Throne Room of the Mountain Gods; 1977

High and Wild: A Mountaineer's World; 1979

Many People Come, Looking, Looking; 1980

Alaska: Images of the Country; (text by John McPhee), 1981

Mountains of the Middle Kingdom; 1983

Mountain Light: In Search of the Dynamic

Landscape; 1986

The Art of Adventure; 1989

The Yosemite; (text by John Muir), 1989

My Tibet; (text by the Dalai Lama), 1990